LOYAL TO THE LAND

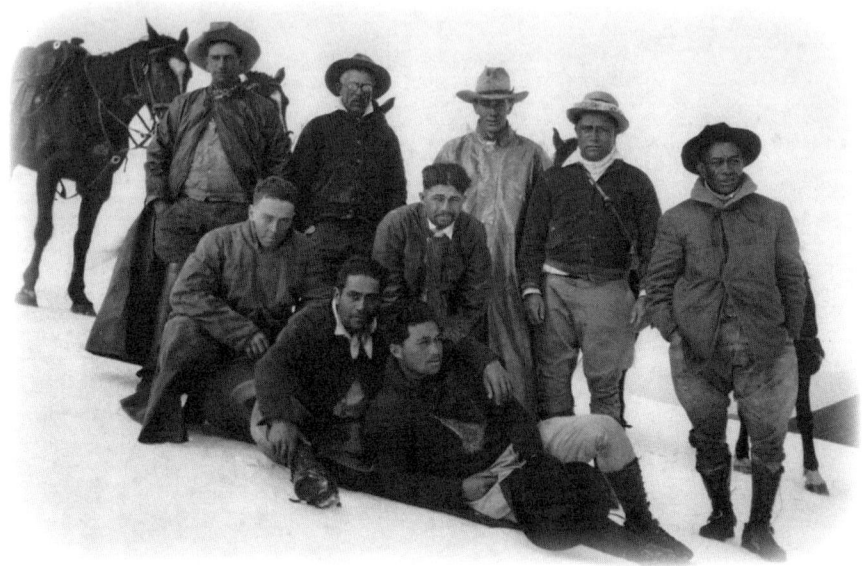

Sonny Kaniho recounts —
 The senior Mr. Martin Martinson was the cause of this trip because he wanted to know more about Mauna Kea. Since my dad married his daughter, Mary, Mr. Martinson asked my dad to give him a trip up there for a historical tour in 1934. Because of this trip, many people had the opportunity to go up to Mauna Kea. Before this, they didn't travel up there very much. The photographer was Willie Kaniho, who was my father. There were ten men and their horses. All of the men were cowboys and all of them worked for Parker Ranch.

 Coming down was the most dangerous, because of the frozen snow. It was very slippery. One cowboy, Frank Vierra, failed to follow instructions. They were all supposed to go slow, but he pulled the reins and spurred his horse. The horse, a Percheron gelding, started sliding downhill, slid on his side, and lost his rider. Both slid down the mountain and then slid across the valley. They were sliding so fast that they kept on going up the next slope, and then they seesawed between the two hills until the momentum stopped. Everybody cracked up after that. No one else wanted to do that.

 Those were the good times.

LOYAL TO THE LAND

The Legendary Parker Ranch, 1950–1970

Volume 2

The Senior Stewards

Dr. Billy Bergin

University of Hawai'i Press
Honolulu

© 2006 University of Hawai'i Press
All rights reserved
Volume 1 published in 2004
Printed in the United States of America

11 10 09 08 07 06 6 5 4 3 2 1

Library of Congress Cataloging-in-Publication Data
Bergin, Billy.
 Loyal to the land : the legendary Parker Ranch, 750–1950 / Billy Bergin.
 p. cm.
Includes bibliographical references (p.) and index.
 ISBN 0-8248-2692-2 (hardcover : alk. paper)
 1. Parker Ranch (Hawaii). 2. Parker family.
3. Hawaii—History. I. Title.
DU629.P3 B47 2004
636'.01'09969—dc21
 2003007993

Volume 2, 1950–1970
ISBN-13: 978-0-8248-3086-1 (hardcover : alk. paper)
ISBN-10: 0-8248-3086-5 (hardcover : alk. paper)

Published with the support of the Maurice J. Sullivan & Family Fund in the University of Hawai'i Foundation.

University of Hawai'i Press books are printed on acid-free paper and meet the guidelines for permanence and durability of the Council on Library Resources.

Printed by Thomson-Shore, Inc.

CONTENTS

Foreword vii
Preface ix
Acknowledgments xiii
Abbreviations xvii

Introduction 1
1. The Reign of Hartwell Carter 4
2. The Dick Penhallow Management Era 93
3. The Rally Greenwell Era 206
Pōlehulehu: The End of the Day 299

Glossary 301
References 305
Index 307

FOREWORD

This second volume of *Loyal to the Land: The Legendary Parker Ranch, 1950–1970 (The Senior Stewards)* covers the two decades following 1950. These years of changing management, accompanied as they were by different goals, resulted in turbulent times.

Dr. Billy Bergin was directly involved during this period—first as an employee and later through his veterinary practice and his contact with management and those who carried out their decisions. Changes included new breeding stock, land sales, and new sections of the ranch with new foremen managing these areas. In addition to all this, other outside problems such as transportation, marketing, and competition from imported beef greatly affected ranch income.

Billy has achieved an unbiased and balanced history of the ranch that I do not believe anyone else could do. His vast knowledge of Hawaiian ranches and his love of the land and the people who have dedicated their lives to the land are evident on every page of this precise history of Parker Ranch. He has provided the Parker families, employees of the ranch, others who have been involved with Parker Ranch, and the generations to come an in-depth story of this famous livestock outfit, a jewel in the midst of the Pacific Ocean.

I have appreciated the opportunity to read this book, as it brings back many memories of past events and people. During my sixty years of ranching in Hawai'i, I have personally been involved in many of these events that Billy has written about in *Loyal to the Land*.

Gordon Cran
Owner/Manager
Kapāpala Ranch

PREFACE

Volume 1 of *Loyal to the Land: The Legendary Parker Ranch, 750–1950* chronicled the remarkable lives and exploits of three generations of Parker men and how they laid the foundation for the ranch's progress through the years. There were others, of course, but a quick look back at the Parker legacy provided a perspective for the changes and innovations that were to come through some extraordinary efforts.

The Parker men deserve credit for building, maintaining, and moving the ranch forward. The first John Palmer Parker clearly holds a place in Hawai'i's history as not only ranch founder but as a true visionary and builder. Standing alone after the tragic loss of his brother, Ebenezer, John Palmer Parker II assumed responsibility for managing the ranch. Upon the death of the first John Parker, ranch assets were equally divided between his grandson Samuel Parker and John Palmer Parker II.

John Parker II carried the burden of managing the Parker Ranch through increasingly difficult times, dealing with weather and livestock transportation woes—but most significantly with the contrasting values and pressures of his nephew Samuel Parker. As John Parker adeptly continued his father's quest for property acquisition, he secured strategic parcels surrounding the village of Waimea. Although land acquisition to expand ranch pasturage was a secondary priority, it was nevertheless significant. Top priority was given to maintenance of existing holdings, caring for a growing cow herd, and controlling the hordes of wild cattle. During this period, Sam Parker imposed his conflicting sense of values, using the ranch as a cash cow despite the diminishing returns from a struggling livestock operation. These were difficult times, when drought-ridden rangelands went without water service while Samuel Parker pursued his involvement in building the Kohala Ditch Trail that served North Kohala, a district with no significant land holdings at that time.

The disparate roles of both Parker men reached tragic proportions as the ranch entered into trusteeship when Samuel Parker's Pā'auhau sugar venture collapsed, leaving the ranch in 1887 exposed to severe financial crisis.

While these problems were brewing, John Parker II died and left his half of the ranch to his adopted son, John Palmer Parker III, who was a son of Samuel Parker. The family experienced one of many tragedies to follow when John Parker III, a young father, died

leaving his half ownership of Parker Ranch to his only child and young daughter, Thelma Kahiluʻonāpuaʻapiʻilani Parker. Her mother, Elizabeth Dowsett Parker, had withdrawn her dower position in deference to her daughter. In his book, *The Parker Ranch of Hawaii*, Joe Brennan notes how this came about:

> The reason for the inheritance might seem a little vague without some explanation. John Parker II had adopted his grandnephew (Sam Parker's son), John III, who automatically became John Parker II's natural heir. Then, with John Parker III still a minor at the time of his death, in addition to the fact that he had made no will, one-third of the inheritance would, under ordinary circumstances, go to his widow, Elizabeth Dowsett Parker (Tootsie), and two-thirds to the child. Tootsie, however, had relinquished her dower right in favor of little Thelma. Consequently, in 1894 the little girl came into full ownership of her father's half-share of the estate.

Extensive ranch operations and holdings built by hard work of Parker men and a handful of foundation families were handed over to A. W. Carter to manage and expand when he was appointed trustee for Thelma K. P. Smart, great-great-granddaughter of the founder.

The widowed Parker's decision in 1899 to place her daughter's holdings in the capable hands of A. W. Carter, a prominent Honolulu attorney, was a pivotal move that had far-reaching impact on the growth and direction of Parker Ranch. Little did she realize her action would create one of the largest

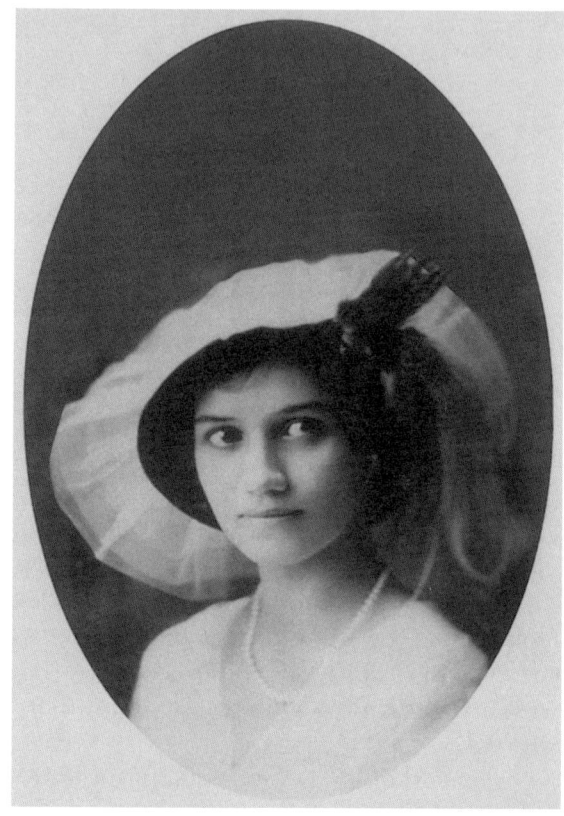

Thelma K. Parker at the time of her marriage to Gaillard Smart. PPS.

ranching enterprises in the country and set the standard for cattle ranching in the Territory and State of Hawaiʻi and the nation as well.

A. W. Carter (A. W.) left a burgeoning law and business career to tend to the needs of his ward, Thelma K. Parker. A builder like John Parker I, he took on management of the historic spread at its lowest ebb in stewardship and built it into an expansive cattle empire. At the time, ranch holdings included 37,000 acres of deeded land, 12,000 head of cattle—of which 5,000 were considered wild—and

Richard K. Smart (with Aunt Tootsie) as a seven-year-old attending a cattle branding at Waikōloa Corral. PPS.

nearly 2,500 head of horses, a third of which were owned by private parties who grazed them on Parker lands.

Between 1899 and 1949, A. W. made enormous strides. Thelma Parker had grown into a young woman. Her star-struck marriage—after the birth of an only son—was beset with tragedy. Her death in 1912 was followed by that of her husband Henry Gaillard Smart three years later. A. W. then redirected his allegiance and devotion from mother to son, when Richard Palmer Kaleioku Smart became the sole heir to his mother's share of the estate. Fortunately for young Richard, his grandmother Elizabeth Dowsett Parker continued to provide him with devoted care.

In the half century that A. W. managed the Parker holdings, his role as builder and visionary was extraordinary, embracing his ward with fierce loyalty while attending to the obligations of trusteeship. With each decision he applied a basic test: Was the proposal in the best interest first of Thelma K. Parker and later of son Richard Smart? Beyond the basic test, A. W. then called upon his own character, research, and dogged attention to business detail in developing Parker Ranch into a world-renowned institution.

Concentrating his efforts on land acquisition, improvement, utilization, and stewardship, he paralleled these efforts with goals of excellence in animal husbandry, stewarding this campaign with profound emphasis on human and animal health and welfare. To achieve this, he called upon the human resources of the foundation families of Lindsey, Purdy, Bell, Stevens, and many others to serve alongside him in institutionalizing Parker Ranch as one of America's greatest success stories.

ACKNOWLEDGMENTS

It is only fitting that I begin the acknowledgments with the resources available to me since boyhood: first, my father, who ministered to the health needs of the ranch and plantation communities; and second, John Holi Ma-e, who immersed my entire being in the world of the *paniolo*.

The next individual I wish to acknowledge and to whom I express my sincerest gratitude for help in completing this manuscript is my wife, Patricia Cockett Bergin, who patiently and diligently transcribed the document from handwritten legal tablets to computer format. In this capacity she also served as first line editor and attended to grammar, spelling, sentence flow, and continuity.

The efforts of my editor, Scott Stone (now deceased), a great author in his own right, were invaluable. He kept me on the right path, offering encouragement, suggestions, and a sense of direction that helped me focus on the final product. I have tremendous respect for him and counted him among my most cherished friends.

As a critique reader, Dexter Keawe Vredenburg provided a genuine service.

I owe a debt of gratitude to Richard Smart, who gave me the opportunity to be a part of this historic ranch when it was at its finest, for his trust and confidence in my professional expertise. Richard fully embraced and lived his personal mantra, *aloha 'āina*, which inspired everyone's love for the ranch —and the subtitle for the first volume. At some point in time, I will produce a fitting documentary to this great man's life.

The ranch managers that I knew and worked for during this period included Hartwell Carter, Dick Penhallow, and Rally Greenwell. These men, along with the men who followed them—Jim Whitman, Gordon Lent, Walter Slater, Don Hanson, Charlie Kimura, David Ramos, and Robbie Hind— must be recognized for making their singular contributions to the history and betterment of Parker Ranch. To each of you, I extend my heartfelt respect and admiration for work well done. I especially want to thank those of you who served as readers and critics of this manuscript.

I learned about the history of the fine horses on the ranch through Walter Stevens (since deceased), Alex Penovaroff, Donnie DeSilva, Teddy Bell (since deceased), and Randy Rieman. These men were among the finest horsemen of their time. For counsel, there could be none better.

For the early dairy and beef cattle history, I relied upon Rally Greenwell, Peter L'Orange, and Charlie Kimura. Charlie was

also an invaluable resource for the transition of history into modern-day Parker Ranch.

To understand the complex water system of the ranch, I relied upon the counsel of William Case, with Rally providing the early history. William also deserves credit for his photographic contributions. Stephen Bowles deserves acknowledgment for his historic expertise in irrigation, well drilling, and water resource management.

For the bountiful array of grasses, legumes, shrubs, weeds, and pests, Hisa Kimura was a steady and reliable background resource. As the agronomy component of the ranch matured, Hisa teamed with Edward Hosaka and later with Josef Tamimi of the University of Hawai'i College of Tropical Agriculture and Human Resources. Dr. Tamimi also provided useful advice on soil chemistry. Hisa has since passed on, but his contributions are everlasting. Earl Spence was vital to the later history of the agronomy program.

For saddlery and tack, Donnie DeSilva, a noted saddle, tack, bit, and spur maker is unsurpassed in providing counsel and contributions, having been mentored by artists of old Hawai'i.

For Hawaiian language editing, Kepā Mali's assistance is gratefully acknowledged. Special thanks also go to Dr. Kalena Silva for his counsel.

I am profoundly grateful to the many *kama'āina* (native-born) families who shared their priceless family photographic collections and generously allowed me to replicate them for this text. I sought and appreciated the help of Coco Vredenburg Hind, Elaine Kurokawa, Roy Ishizu, Mary Ha'ena Bell Lindsey, and Yutaka and Hisa Kimura (all now deceased), as well as Tida Kimura, Rally and Pat Greenwell, and most notably, Jiro Yamaguchi (also deceased) in identifying the photographs. Matt Pearce deserves special thanks for his lasting contribution in photographic reproductions. Bill Long of Kamuela Museum also kindly opened his collection of materials to me. Ned and Chris Quick of Quick Photo are kindly acknowledged for their expertise.

Archival contributors were immensely important—notably, Becky Carter (deceased), Pat Clifford Penhallow, and Gordon Bryson of Hawai'i Preparatory Academy with his generations of history students, who gleaned every fiber of information from the old Parker Ranch files. Kiyome Yoshimatsu, Richard Smart's faithful secretary of many years, was a special reader who provided vital historical support.

Without a doubt, the consistently helpful support for genealogical research created the interwoven *'ohana* (family) matrix for this book. Patrick Cootey, Tida Lindsey Kimura, Tita Ruddle Spielman, Aletha Lindsey Barkley, Bernie Lindsey Cacoulidis, Eva Lindsey Kealamakia, Stella Ka'au'a Akana, and Aloha Stevens Tanimoto were invaluable resources for this book. Lani Akau played a vital role in providing genealogic clarity to not only her family but to those of Awa'a, Chock, Doi, Kealanahele, Hui, and on and on *a pau loa* (to the end).

Nui nui mahalo to Molly Frankel for her detailed critique of the final manuscript as well as production of the index.

Regarding the history of Kawaihae, gratitude is extended to Owen Chock, a scion of the Chock Hoo family, who preserved the old history of the coastal town that served commerce, including livestock, for more than 150 years. In terms of the modern (postwar) history of the port of Kawaihae, I turned to Alcy

(Shorty) Johnson of Kawaihae Terminals, Inc., and Pete Hendricks of Kawaihae Canoe Club.

There is one individual who stands out above all others whom I wish to especially thank: Rally Greenwell, who has served as a lasting resource of factual ranch history. Rally's door was always open to me and, without a doubt, I have enjoyed and appreciated his counsel immensely over the past thirty-five years.

And above all, *nui nui mahalo* to each of the many cowboys—numbering more than a hundred—whom I have interviewed over the last half century, as a result of my genuinely and incurably inquisitive Irish nature. To the man, each of you has a valid claim to coauthorship of this book, which is dedicated in your memory.

Kauka Billy Bergin

ABBREVIATIONS

PPS Paniolo Preservation Society
PRC Parker Ranch Collection
WCBC W. C. Bergin Collection

Note: Unless otherwise indicated, graphics were provided by the author.

LOYAL TO THE LAND

INTRODUCTION

Nearly a decade ago, I set out to produce a single volume of a book chronicling the birth and progress of the remarkable Parker Ranch. Early on, I recognized the magnitude, depth, and importance of the history of the ranch to the Territory and State of Hawai'i, our national and global economy notwithstanding. I knew then that no single volume could adequately serve this magnanimous responsibility. The process grew first to two volumes, then to a trilogy. As the subject unfolded, it expanded further and now rests on four premises in time. This second volume covers the years from 1950 to 1970. It will be followed by a third volume spanning the period from 1971 to 1992, the year of owner Richard Smart's death. The final work will encompass the years following his passing.

Through his son Hartwell, A. W. Carter ensured a firm pathway for continuity as the torch was passed from one generation to another. This second work, *Loyal to the Land: The Legendary Parker Ranch, 1950–1970 (The Senior Stewards),* opens with the dynastic transition from father to son.

This volume records the chronological progress of the Big Island's Parker Ranch beginning with the stewardship of Alfred Hartwell Carter, as it evolved toward modern management. Topics include livestock breeding programs, feeding practices, range management, land acquisition and disposal, the cowboy and roughrider gangs, feedlot and packinghouse issues, and human relationships. Interspersed throughout the text are profiles of noted field leaders who gave their heart and lives to the ranch, testimony to the fact that throughout its history Parker Ranch was built upon the shoulders of many great men.

Hartwell, as he was best known, lost his closest friend and mentor with the passing of his father, Alfred Wellington Carter (A. W.), in 1949. Although ranch management had officially shifted from father to son in 1937, A. W.'s influence was omnipresent for another ten years. Hartwell was later subjected to the whims and shifting ideas of ranch owner Richard Palmer Kaleioku Smart, who became an increasing influence when he returned home to stay after a career on Broadway.

With Smart in charge of the ranch, he replaced A. W. as Hartwell's overseer, a role that continued through the next decade. Throughout his tenure as ranch manager, Hartwell served with dignity until his retire-

ment in 1960. As a young man, I was fortunate to work for Parker Ranch for a brief period in 1959 during Hartwell's management.

Hartwell was faced with major challenges during a period when the ranch, through Hawai'i Meat Company, was gradually converting to a grain-fed finishing program under the direction of longtime packinghouse manager James (Jimmy) Greenwell. One of his primary objectives was to raise the mother cow numbers to 12,000 head.

Approaching the end of his career after successfully achieving his major objectives, Hartwell left the ranch in late 1959, influenced by Richard Smart's desire to move the ranch in a different direction. It can be said that Smart in effect reclaimed Parker Ranch from the Carter dynasty.

Richard (Dick) Penhallow, who served as Hartwell's assistant, followed him as ranch manager. Penhallow set goals for improvements in water, land—pasture and commercial development—livestock, personnel development, and economics of the beef industry. In the last of these, as early as 1960 Penhallow proposed moving the Hawaii Meat Company packinghouse and feedlot to the Big Island, a move that likely would have safeguarded against the gradual demise of both service industries that occurred between 1988 and 2003.

Richard Penhallow's tenure is given a detailed overview that illuminates his grand scheme for reorganizing an inefficient and divided meat industry into a single cooperative using state-of-the-art facilities. That his mission failed can be attributed to the many and varied circumstances outlined here, while the concomitant history of beef marketing in the Islands illustrates the soundness and wisdom of Penhallow's plans.

Penhallow's foresight as president of the Mauna Kea Soil Conservation District brought about flood control improvements currently enjoyed by the Waimea community. He was largely responsible for the detail work required in moving the military from Lālāmilo to Pōhakuloa Training Area. He also successfully expanded the cow herd from 12,000 to 14,000 mother cows.

Despite diligent efforts to achieve most of his goals, Penhallow and Richard Smart agreed in 1962 that he should leave. Given his foresight and strength, left to his own devices Penhallow had the potential of becoming a true builder of Parker Ranch.

Richard Smart selected Radcliffe (Rally) Greenwell as Penhallow's successor. Rally served as assistant manager under Penhallow after working his way up from a twenty-year-old Kona cowhand in 1934 to ranch manager in 1962, including a brief interlude at Kahuā Ranch. Rally came with strong, traditional values of stewardship handed down from his father and grandfather, who were noted Kona ranchers, and from his predecessors of Parker men through the Carter eras. In 1962, his brother Jimmy Greenwell left Hawaii Meat Company. In 1965, an experienced meat packer named Leonard R. Bennett grasped the reins of Hawaii Meat Company and carried the packinghouse/feedlot complex to a newer and higher plane.

Leonard R. Bennett's advent into Hawai'i's meat industry is a story movingly told by his son Leonard R. Bennett III. The senior Bennett's leadership years resulted in huge initiatives in the industry, and aggressive procurement and marketing led him to become a close confidant of Richard Smart.

As the nine-year management of Rally Greenwell unfolds, it offers close looks at the

leadership team of that era, which included Harry Kawai, John Kawamoto, Willie Kaniho, Yutaka Kimura, John Lekelesa, and Harry Ah Fong Ah Sam.

Rally's initiatives were clear: to further enhance water development and increase the mother cow herd from 14,000 to 18,000 head. He also instituted research to determine the cause of a scourge among the young cattle called yellow calf syndrome.

On a personal note, I provide insight into the 1970 change in veterinarians that brought me back to the Parker Ranch and give credit to my predecessors, Dr. Leonard Case and Dr. Wallace T. Nagao. What follows is a detailed look at the mineral program, which includes the tremendous contribution of the element copper to the growth and health of Parker Ranch cattle. Also shared are direct insights into the birth and expansion of the ranch's Animal Health Program, which not only benefited the horses and cattle but heightened staff morale and personal development.

On July 1, 1970, at age 29, I assumed the animal health reins of Parker Ranch, which at the time owned more than 50,000 head of cattle and 2,000 horses. After twenty-five years to the day, on July 1, 1995, the Animal Health Program for Parker Ranch was turned over to Veterinary Associates, Inc., and the capable hands of Drs. James Gressard, H. M. (Tim) Richards, and Lisa B. Wood.

After his nine-year leadership post on the ranch, Rally chose to retire, and the mainland management team of Jack Rubel and Gordon Lent entered the scene. Richard Smart named Gordon Lent general manager, Walter Slater livestock manager, and James Whitman business manager. Taking Parker Ranch by storm, Rubel and Lent arrived with the full blessings and support of Smart, who by this time had a reputation for rapid turnover of ranch management. Rally Greenwell's nine-year span was an exception.

Richard Smart developed a position of his own that integrated management of the 100 percent owned ranch with that of Hawaii Meat Company. The meat company and its subsidiary was 83 percent owned by Parker Ranch, with the balance of shares controlled by other member ranches. Smart used both entities as counterbalances for each other —likely his own way of keeping everybody honest. The complication of this system was that modern managers of the meat company —first Jimmy Greenwell and later Leonard Bennett—were outspoken about the management practices of Parker Ranch and others. A stabilizing force amid these times was Arthur B. Reinwald, an attorney serving both the Hawaii Meat Company board and Smart himself. Reinwald served over the next two decades as a bright and steady influence on these combined entities.

This volume records progress through the management of Hartwell Carter, Dick Penhallow, and Rally Greenwell in which several significant events occurred: first, the 50 percent increase in cow herd size from 12,000 to 18,000 head; second, the conversion of beef marketing from a range-finished animal to a feedlot-confined, corn-fed, marbled carcass acceptable to the modern housewife; third, the evolution of a functional cow horse from the basic Thoroughbred/Morgan cross to the Quarter Horse prototype; and finally, the progress in water resource development that stabilized water delivery to all points of the operation in perpetuity.

THE REIGN OF HARTWELL CARTER

Alfred Hartwell Carter, only son and protégé of the esteemed A. W. Carter, who built the Parker Ranch to a level of greatness far beyond anyone's imagination, embarked upon his career as manager of Parker Ranch while under the direct scrutiny and oversight of his father. Considering his lifetime investment toward building this powerful organization, it is not surprising that A. W. had difficulty giving up complete control of this empire to anyone—even his own son.

As ranch manager, the position he held during the second half of his twenty-three-year tenure, Hartwell Carter executed the following six significant changes:

1. First, he rounded out the cow herd to a consistent 12,000 mother cows of uniform Hereford breeding.
2. Second, he began conversion from the Thoroughbred horse for an off-ranch market to a cow horse mount of Quarter Horse, Morgan, and palomino breeding for use on the ranch.
3. Third—and important historically—Hartwell was instrumental in the movement of the military camp and training site from Lālāmilo, a tract of land adjacent to Waimea, to Pōhakuloa, where present-day exercises occur far removed from populated areas. Hartwell created the policy and directed the basic plans for the movement, while Penhallow did the detailed planning and execution of the movement.
4. Fourth, Hartwell preserved the ranch's pastoral resources in the face of severe pressure at public land auctions.
5. Subsequently—and equally important historically—Hartwell complied with a mandate of the Hawaiian Homes Commission (HHC) to return more than 20,000 acres for homesteading. Further, he entered into an agreement with the HHC to provide foundation stock of sixty head of Hereford heifers via a chattel mortgage arrangement to homesteaders and to provide fencing and water resources to the fifty-two homesteaders. To this end, Hartwell deserves a prominent place in Hawaiian history for his contribution to the pastoral program of the Hawaiian Homes Commission on the Big Island.
6. Finally, Hartwell was a passionate advocate of animal health and welfare. This mission resulted in a long-standing relationship with Dr. Leonard Case, whose career is chronicled in the section on early animal health consultants. Additionally, Hartwell's initiatives on range management, which di-

rectly influence animal health and welfare, are highlighted in the section on agronomist Harold Baybrook.

The Hereford Cow Herd

The Hereford cow became well established in the early modern American beef cattle industry, although certainly Angus and Shorthorn (Durham) cattle began gaining favor throughout the United States and Canada at the turn of the twentieth century. While there was some crossbreeding of the latter two with Herefords, it was the Hereford cow that remained the standard for the sixty years of Carter leadership at Parker Ranch.

A. W. Carter began the process of supplying replacement bulls for a controlled and purebred (registered) Hereford herd. With the expert help of Yutaka Kimura, Hartwell Carter expanded the purebred numbers, gradually shifting emphasis away from horned to polled Herefords.

Selection of bulls for range cows came

Alfred Hartwell Carter during his junior management years. PPS.

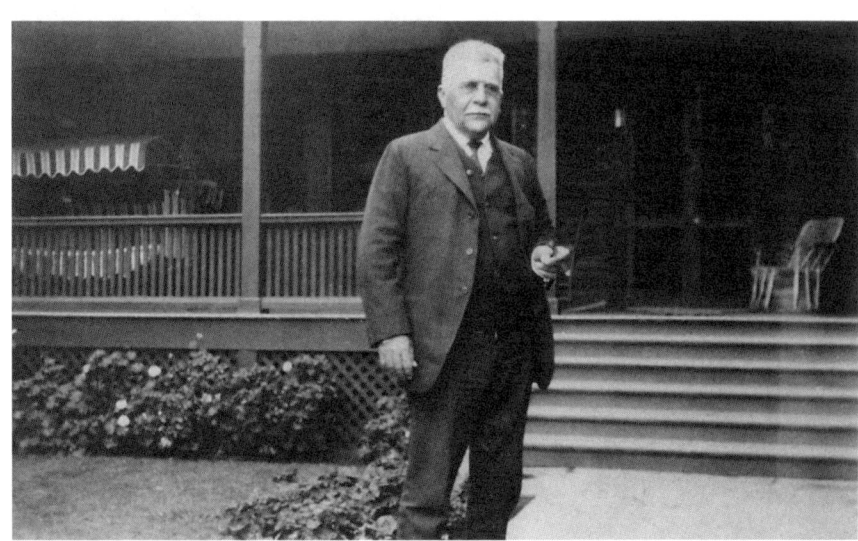

A. W. Carter at his ranch residence, currently the Jacaranda Inn. PPS.

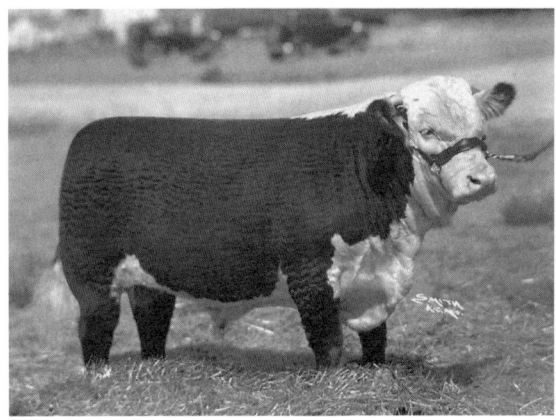

Old type of Hereford: short, deep, and chunky conformation typical of the pre-1960s cattle industry. Courtesy of Larry Wight.

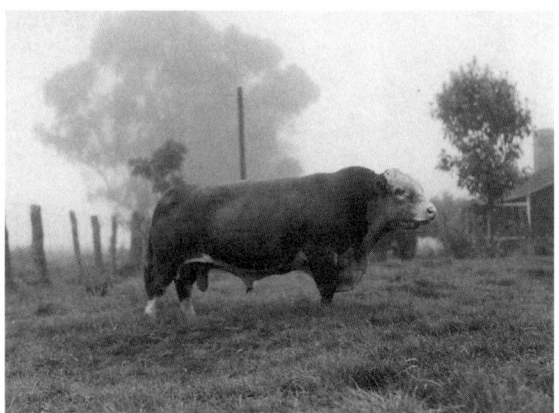

Modern type of Hereford: a polled Hereford bull of greater height and length, yet retaining depth. PPS.

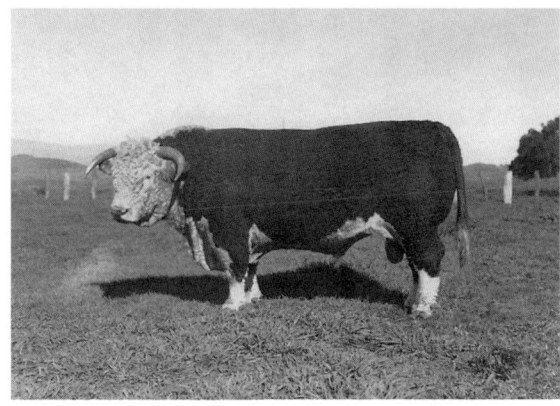

Modern type of Hereford. Note well-developed hind quarters typical of the early 1960s. PPS.

from this source, but considerable upgrading was necessary both in breed and in type throughout the ranch. Acquisition of new lands in Kahuku and Kohala brought variations in cattle breeding and quality to the ranch, a situation Hartwell set out to change. He advised Martin Martinson of Kahuku Ranch and later John Kawamoto of the Kohala section to cull for quality and develop better market animals through the crossbreeding of Angus, Shorthorn, and Hereford cows. Change also meant ridding adjacent fields of wild cattle. Upgrading on the Main Ranch in South Kohala and Hāmākua was necessary as well, but not to the extent required by other sections.

The decision to move toward polled cattle was a practical one. Because of a change in shipping practices and methods, horns were no longer needed to lead cattle through water or to lift them onto the cattle ships. There were arguments that horned cattle made more protective mothers, but this argument faded in light of the overwhelming losses from bruised carcasses in shipment, plus the pain, stress, and loss of blood that resulted from dehorning calves. These losses run counter to claims that the best-quality Hereford breeding comes from horned cattle. To this end, Hartwell continued a significant horned Hereford single-sire bull battery at Makahālau. Tracing back to the Plutonium and Tiberius lines of horned Hereford sires, he maintained the core quality in the purebred herd that matched his father's zeal.

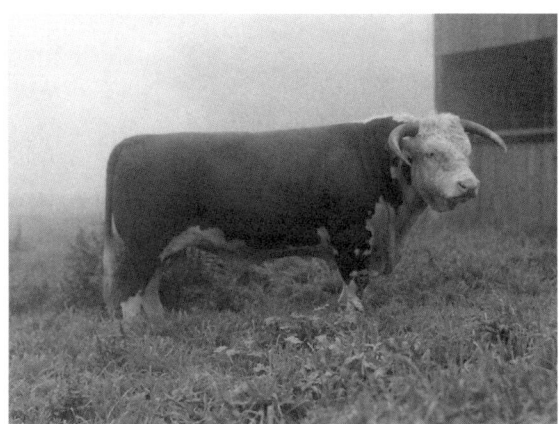

Modern type of Hereford: typical single-herd sire of the late 1960s. PPS.

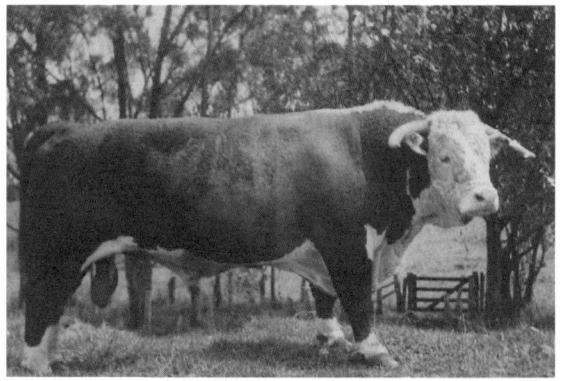

Modern type of Hereford: large-framed bull considered the ideal type of the early 1970s. PPS.

During the last phase of Hartwell's tenure, the feedlot industry in Hawai'i began to emerge, and this aspect of the beef industry on the U.S. mainland continues today. In this environment, polled cattle feed better at the bunkers, while horned cattle are more disruptive. Despite the practicality of moving to polled cattle, the concept of horned cattle would not go away. In the 1970s, during the tenure of Rubel and Lent, hundreds of horned registered bull and heifer calves were purchased from the Mitchell Ranch in New Mexico to "upgrade" the Parker Ranch Herefords. The superior horned sires that traced back to Plutonium and Tiberius were sold en masse via dispersal sales.

Hartwell's evolved cattle product was a medium to dark red Hereford cow weighing 1,100 pounds with a large frame, roomy pelvis for birthing, and a large bag for lactation. This was the standard ranch cow, and she was culled by the year branded on her left gaskin (indicating her birth year) before her tenth year. Calving rates were in the mid-80 percentile. Early culling for cancer eye, lameness, and infertility was a high priority.

While there was small-scale crossbreeding with Angus and Shorthorns and in later years with Santa Gertrudis breeds, as a whole Parker Ranch was a purebred Hereford ranch under Hartwell's management.

The Horse Program: Early Era

It was not generally known that Hartwell was fond of quality horses. He had as keen an eye for a fine horse as he did for a blue ribbon show bull. He also enjoyed being on horseback—not as a sportsman, but as a manager who understood that the finest view of a ranch and its animals comes from the back of a good horse. He never sought to rope or wrangle but merely to ride among the herds and over the meadows in quiet but intense observation. Nicknamed *Wawae* (legs) by some of the cowboys, the long-legged manager rode exceptionally long stirrups, reflecting an unwitting resemblance to the Spanish *la brida* posture. His more commonly used nickname was the Hawaiianization of his first name, *Hakuwela*.

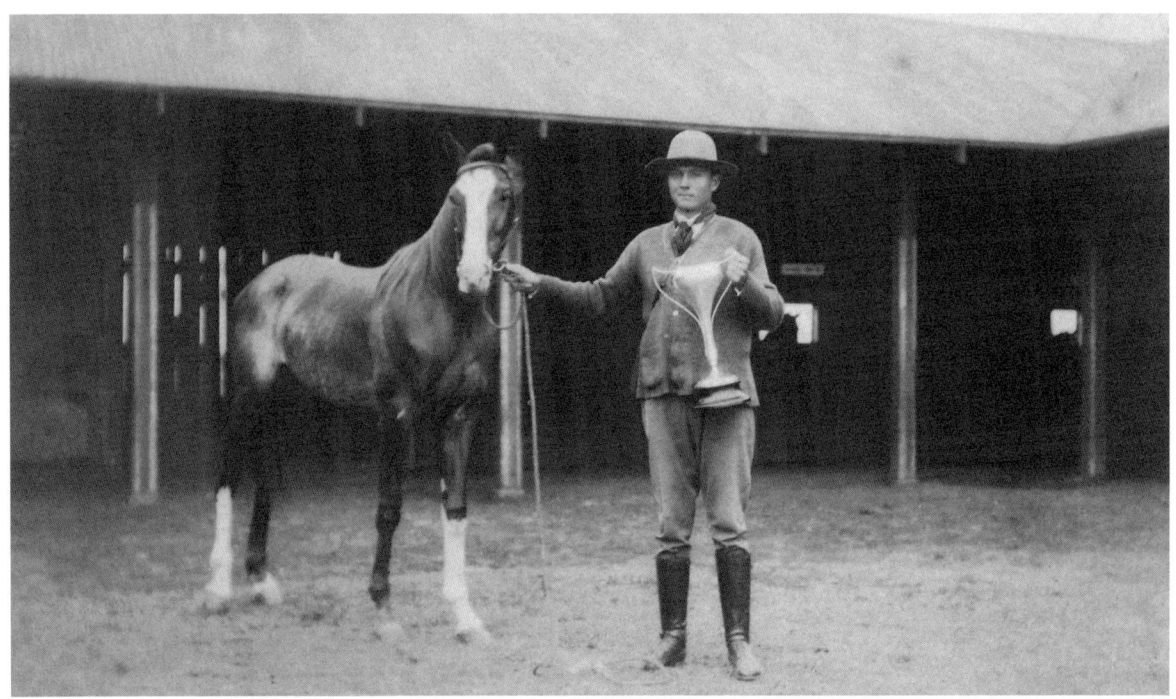

Hartwell with trophy and roan son of Frolic after winning at the Maui County Fair, circa 1930. PPS.

Hartwell on horseback with slicker overseeing ranch operations. PPS.

Hartwell set out to make the ranch horse more user-friendly. During his father's time, appreciation of the Thoroughbred was heightened by external factors that included two world wars, polo, and racing markets. Hartwell sought his father's advice even on the individual sale of horses, as indicated by his memo of February 9, 1935:

Dear Papa:

King asked me if we would sell him the Overall-Nellie Harper Gelding. He said he would pay cash for it and take it along with him. He said he figured this gelding could win several races within two or three months, and he would offer $500.00 for it. I don't think this gelding is one that will last very long. I wouldn't

pay that much for him myself. I guess we had better sell him to King. Don't you think we might as well?

> With love,
> Hartwell

Hartwell began management of Parker Ranch between the two world wars. It was a time when two major forces in the development of the American horse industry were coming into their own. For Parker Ranch, the timing could not have been better. The first force, the U.S. Remount Service, was already well connected to the ranch through the efforts of A. W. Carter, who, as early as 1906, formed a long-standing relationship with the U.S. quartermaster general, the military officer who regulated the sourcing of horses. The second force, the gradual formation of what would become the American Quarter Horse Association, dovetailed with the military efforts because of the common prototype of what was expected in a good "using horse," whether in the war or at a roundup.

Cementing these forces were the respected and knowledgeable horsemen who—probably unknowingly—served bilateral capacities in a mission that would restore forever the horse's role in modern America. One such individual was William (Billy) Anson, a rancher from San Angelo, Texas. He was an English lord with deep commitment to horses as noble creatures. Before long, he was in the business of

A. W. Carter with General George Patton negotiating the acquisition of the famed remount sire, Gold Oak. PPS.

selling polo horses off the Texas ranch to East Coast social circles. He began breeding Quarter Horses before the name of the versatile mount was coined. A champion of the adage "blood will tell" and a student of bloodlines, he advocated developing the Quarter Horse as a separate breed and authored some of the first publications providing the basis for his premise.

The stallion Harmon Baker was a descendant of Peter McCue and Ballymooney, noted foundation sires owned by the transplanted nobleman. Sons of Ballymooney were advertised in sales catalogs and sales attended and bid upon by Hartwell Carter in search of a more modern and versatile Parker Ranch horse. As a result of his father's early efforts, many fine bloodlines already existed on the ranch. The following quote from *War Horse*, by Livingston and Roberts, gives testimony to A. W.'s early efforts:

> Between 1921 and 1948 leading ranchers and horse breeders in America took advantage of the Remount program. The economic benefits were too strong for a successful ranching operation not to participate. Some individuals stood a Remount stallion to their own and to public mares. Others, large cattle operations that used many horses in their activities, maintained a Remount stallion on their own mares to sire ranch mounts. The excess geldings were sold to the army, other ranchers and dealers. Included in the long list were: Texas-Burnett Estate, Guthrie; King Ranch, Kingsville; Spur Ranch, Guthrie; JA Ranch, Clarendon; SMS Ranch, Seymour; William M. "Port" Daggett, Pecos; Pitchfork Land and Cattle Co., Guthrie; L.J. "Buster" Burns, Yoakum; Bryan Hunt, Sonora; E.S.P. Brainard, Canadian; Pfefferling Brothers, San Antonio; New Mexico: CS Ranch, Cimarron; Teqesquite Ranch, Teqesquite; Bell Ranch, Bell; Colorado: H.J. "Hank" Weiscamp, Alamosa; Marshall Peavy, West Plains; Coke T. Roberds, Hayden; Nebraska: Hans Fogh, Strool; Pine Ridge Indian Agency, Pine Ridge; George McGinley, Keystone; Montana: Luther Dunning, Ashland; Wyoming: Ed McCarty, Chugwater; Kansas: E.C. Roberts, Strong City; Hawaii: Parker Ranch, Honolulu.

Some of the noted remount sires used by Parker Ranch included Rodgers, Frolic, Lindsley, Ormesby, and Querido. Frolic's tenure on Parker Ranch began with his original ownership by Samuel Parker Sr. A. W. acquired Frolic in 1914 as part of the Humu'ula purchase that included not only cattle, sheep, work horses, and mules but many of the fine stallion's progeny that were immediately set aside for the military market. Frolic developed further distinction by siring a remount son in his own right—Maunalani, who stood (stabled for breeding) in the California Remount Depot. Ormesby also produced a son that stood at the Fort Reno, Oklahoma, Remount Depot, named Reno Jamboree. A Parker Ranch–acquired Morgan stallion, Querido, produced a remount sire son named Tehachapi Allen, who stood also at the California Remount Depot.

In addition to Parker Ranch, other Hawaiian remount stations included Kapāpala Ranch under the ownership of C. Brewer & Co., W. F. Dillingham's Mokulē'ia Ranch on O'ahu, Harold F. Rice's Ka'ono'ulu Ranch on Maui, Kīlauea Sugar Company on Kaua'i, and George

Son of Molokaʻi Boy, a remount sire of many officer's mounts. PPS.

P. Cooke's Molokaʻi Ranch on the Island of Molokaʻi.

Both the military horse and the cow horse had similar requirements: soundness of bone, well balanced with a deep girth and well-sprung ribs for lung capacity, withers prominent enough to hold a saddle in place, and strong bones in the legs and feet that would support such a conformation. The horse also needed an alert expression, large and wide-set eyes, and moderately sized ears. Acceptable heights were between 15 and 16 hands, while weight could vary from 1,000 to 1,200 pounds. Geldings were preferred for both military and cow horses, for they adapted better in strings than did mares.

For the remount horse, too much color was a deterrent, whereas browns, bays, blacks, chestnuts, and sorrels would give some degree of naturally blending camouflage, as well as being easier to find in the open market owing to their genetically predominant color. Duns, palominos, roans, or varicolored Appaloosa and pinto horses had appeal to the cow horse breeder but were off limits to the remount buyer. An occasional and truly exceptional grey or roan might pass muster—but only to be used as an officer's charge.

Although grey horses were not uncommon on Parker Ranch, it was only after Sappho—a palomino-colored horse of Quarter Horse type—arrived on the ranch in 1949 that duns and palominos became commonplace, as they already had in all the western states of the U.S. mainland.

With the arrival of Sappho, Hartwell began a gradual process of developing the ranch mount into more of a Quarter Horse. To his advantage, he had a large band of Thoroughbred mares upon which to cross the early Quarter Horse sires that were somewhat of the original "bulldog" type, usually under 15 hands and very chunky. Hartwell did not like smaller horses that lacked the mettle to withstand frequent brandings and other heavy cow work that was peaking because of a growing cow herd. He also continued to look to the Morgan breed to add endurance and stamina to the heart of the ranch horse, as well as soundness of feet and legs.

Hartwell must be credited with retaining a circle of some of America's finest breeders during his life on the ranch. Some of these men included Billy Anson's protégé Dan Casement and his son Jack of Manhattan, Kansas, and Alamosa, Colorado. The Casements and the Carters had more in common than being a famous father and son team of livestock men—they loved the Hereford breed of cattle and made exceptional contributions to the promotion of this pedigree. They also shared a reverence for fine horseflesh. Over the years, Hartwell attended production sales of Casement stallions and bulls and that of another founding member of the American Quarter Horse Association, J. E. Browning.

Palomino broodmares of the Quarter Horse type sired by Sappho and Diablo. PPS.

Palomino weanlings sent to the Breaking Pen for halter breaking. PPS.

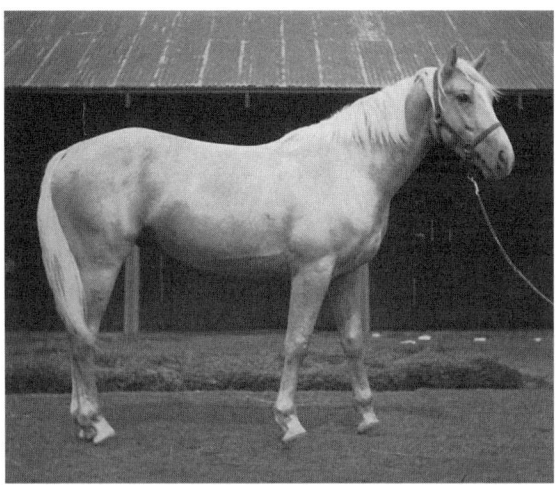

Palomino Coconut Island—an ideal expectation of Hartwell Carter's Palomino horse-breeding program. PPS.

As 1950 loomed, the ranch was no longer replacing aged Thoroughbred bands with improved lines since the external markets had disappeared. The U.S. Cavalry was mechanized and/or airborne. Polo in the Islands was in a slump. The Western mainland racing industry looked east to Kentucky for prospects. Consequently, Parker Ranch was overstocked with some three hundred Thoroughbred mares, many of them registered with bloodlines no longer sought after.

Thoroughbreds often have within them an innate "cow horse" factor. Some lines of Thoroughbreds have an affinity for cows and love to work with them. On Parker Ranch, this was proven five years earlier with the offspring of Frolic, Eastertide, Gold Oak, and others. Frolic became a nationally ranked re-

Stud prospect Mickey Free, of J. E. Browning Ranch of Willcox, Arizona, a three-year-old son of Billy Byrne, a speed-horse sire. PPS.

Casement Estate Dispersal. Hartwell Carter gave serious consideration to several prospects included in this sale but ultimately did not bid upon them.

The Reign of Hartwell Carter

Gold Bryan at Kapiʻolani Park, Oʻahu, enroute to Tanforan Park Race Course. This prominent racing product of A. W.'s Thoroughbred program was sired by Gold Oak and out of Miss Bryan, a New York–bred broodmare. PPS.

mount sire during the World War I cavalry efforts. Through the years, the quality of the Thoroughbreds declined and some bad traits crept into the genetics, countering the Standardbred horses' positive qualities. Two prime examples of this were Herodiones and Heine. Gold Oak was a more positive influence, but he was inclined to buck, and mean streaks often surfaced in his offspring.

Hartwell redirected the ranch horse in an attempt to produce an animal with a good mind and back, sloping shoulder, prominent withers, stout legs, and black feet. He didn't always get what he wanted, but he went to the right sources in the early foundation Quarter Horse and palomino horse circles. He did not totally shun the Thoroughbreds, but he did rely heavily on the Morgan horse to crossbreed. When such crossbreeding was at its height, Parker Ranch had a cow horse of its own standard. These horses carried the heavier hips and smaller heads of the Morgan, coupled with a large frame, strong withers, and good legs of the Thoroughbred. There was a downside—some Morgan horses had a cantankerous personality—but as a whole, the crossbred home-raised ranch horse was functional and not bad looking. Still, they weren't entirely cow horses.

When Hartwell set out to make them more into cow horses, he used his well-established relationships with several key horsemen on the mainland; they were the most noted horsemen of the livestock world and the eventual founders of the American Quarter Horse Association (AQHA).

Hartwell also looked to the palomino horses for "cow sense." Palomino simply refers to a horse that is cream to deep, dark gold in color, with a white mane and tail. This color pattern was never seen in traditional breeds such as the Thoroughbred, Morgan, and Standardbred but did show up in the western United States from Mexico through northern California. The palomino and Appaloosa cow horses were products of the western areas of America where cattle were common. From 1947 through 1949, Hartwell ensured that Parker Ranch was an active member of the Palomino Horse Association of America, giving him access to some prominent breeders. Sappho and Diablo were products of this relationship. However, the Palomino Horse Association lost its appeal as a stand-alone group with the increasing prominence of the AQHA, which became the showcase for Quarter Horses of all approved colors, including the palomino.

In the ensuing years Parker Ranch became almost exclusively a palomino ranch because of the multiple sires covering the large band of mares. As a whole, the horses were not particularly inclined to buck and had decent conformation and size.

Palomino Horse Breeders of America.

The Morgan Horse Club, Inc.

The ranch sold some stud colts to other ranches, and I rode some of these when I was at Kapāpala Ranch in Ka'ū. They were decent horses, but their hooves had a tendency to split, and they were not very big. The sire was a Parker Ranch palomino that was a cryptorchid (having an undescended testicle remaining in the abdomen). The sire also was afflicted with a condition known as stringhalt, which is a halting, goose-step stride of the horse's hind legs when stepping forward. Today this is surgically corrected by severing a congenitally constricted tendon (the lateral digital extensor tendon). The sire passed this on to his offspring, the males of which were often cryptorchids and stringhalted. It was a time when no veterinarians were doing abdominal surgery to correct the condition by removing the hidden testicle *(hapa laho* or *laho pe'e)* or the lateral digital extensor tenotomy.

I was not impressed with the Parker Ranch stud, the son of Diablo that was sold to Kapāpala Ranch, a ranch noted in those days for breeding fine horses. Even as a teenager I knew the impact of a poorly selected cow-horse sire. It is possible that Hartwell gave the stud to Kapāpala, where Bradford (Haole) Sumner was manager and Ioane Kanakaole was foreman. Kapāpala itself was a subsidiary of C. Brewer's Hawaiian Agricultural Company in Ka'ū. This ranch was noted for fine Thoroughbred mares that had come from the polo circles of O'ahu. These mares provided the basis of their military Remount Horse Program. Crossed with the palomino, marginal workhorses were all that Kapāpala got out of the deal. It was unusual for Parker Ranch to make available inferior genetics to another ranch. During this same period, Shipman's Pu'u'ō'ō Ranch acquired the flaxen-maned sorrel Irish Lad, son of Gold Oak; his offspring were apt to buck but were tough, sound workhorses. Working on these ranches as a young cowboy, I had firsthand experience riding these mounts.

Hartwell was sensitive to the ranch cowboy's needs, including heavy horses for branding. He kept some draft mares for breeding and eventually brought in a young roan Belgian sire. Most of the heavy horse breeding of ranch horses involved Percherons. The draft mares and stallions were crossbred with select Thoroughbreds, and eventually quarter-bred horses carried enough height, weight, and draft to work cattle on the open range as well as in heavy roping as in *hō'au pipi,*

which refers to the swimming of market cattle from shore to a waiting lighter. Cattle were roped in shoreside pens and led into the surf to a launch for transport to the interisland steamer. Cattle brandings and *hao komo* (ingrown horn) ropings also demanded the use of heavily built mounts. At cattle handlings, cows whose horns were ingrown because of faulty dehorning as calves or whose horns simply had curled back into the skull were roped and cast for dehorning by cowboys.

Hartwell never completed his goal of converting the Parker Ranch horse to pure Quarter Horse, but he made significant strides in that direction. Yet he never lost his love for the better-bred Thoroughbreds. It was to be another fifty years before Parker Ranch became entirely a Quarter Horse ranch. In the interim, the Thoroughbred forged a significant comeback.

The Real Rough Riders

The Breaking Pen facility stands alone today as the bulwark of Parker Ranch's history with horseflesh. Built and rebuilt since 1909, the barn itself measures 65 feet square and houses four identical round pens of 30 feet in diameter. Each pen has walls 8 feet high made of sturdy 2 x 12-inch (lowest), 2 x 8-inch (middle), and 2 x 6-inch wooden bars. Each round pen is served with three 12-foot gates of similar makeup allowing traffic between pens and to the exterior corrals. Along the barn's southern flank is an alley 4 feet in width and 60 feet in length that is serviced as a crowding alley from a spacious corral. Once in the alley, two parting gates that divided the crop of green horses according to the assigned rider separated a stream of young mounts. Along the north wall of the barn a horse chute was serviced from an adjacent round pen. That chute snugly confined a mount for branding, doctoring, pregnancy checking, tail cleaning, and so on.

A senior horseman of utmost respect—appreciating gentleness—managed the Breaking Pen. In the first volume, *Loyal to the Land, 750–1950*, the contribution of James Palaika was heralded as the greatest, but several other men provided genuine leadership, including Albert Lindsey, Harry Kawai, George Purdy, Joe Pacheco, Louis Akuna, and later Donnie DeSilva. Of these, George Purdy stands out as foremost.

The Breaking Pen was the historic home of the Rough Rider Gang, a moniker likely borrowed from the days of Teddy Roosevelt's presidency. The name was a perfect fit and is invoked by knowledgeable *kama'āina*, with due respect given the tedious and risky tasks executed day in and day out for years before a hopeful promotion to the elite Cowboy Gang. More than a proving ground for one's mettle, the Rough Rider Gang and the Breaking Pen provided the launching pad for some of the ranch's greatest leaders, cowboys, and horsemen.

In a 2000 interview, biographer Anna Loomis (AL) queried Abraham Akau (AA) regarding the Rough Riders:

> AL: How did you get the name "Rough Riders?"
>
> AA: That was the team that was the Rough Riders, the old name—that's—if you—they get "Cowboys," "Rough Riders," and "Plaster Gang." And "Plumber," all them get their own names.

AL: What was the difference between a Rough Rider and a Cowboy?

AA: A Cowboy, you Cowboy only. That's all you do every day. There's sixteen Cowboys. Get sixteen Cowboys, get eleven Rough Riders. Actually only ten and one foreman. And then get sixteen Cowboys, plus all the stations—we don't see them, they just take care of the stations. Only the Cowboys see the station, not us, because we Rough Rider. Only if they need help—then they ask the foreman in the office that they need so many guys, then us guys go help them.

So. We got to train the horses for these sixteen cowboys. They have thirty horses apiece, thirty horse to their string. These guys get thirty, these guys get thirty, these guys get—and that's personal, it's their own, nobody can touch 'em. Maybe thirty-five they can have. That's all their horses for work throughout the year; your horse not good, you turn 'em in, they come to us, we send 'em a different one and they can train 'em. And that's how we work. The Cowboys that's all they do; is Plumber is Plumber, Cowboy is Cowboy.

AL: . . . What your job was.

AA: Okay. The Rough Rider's job is just to train horse. Thousands of them. And that's what we have to do, because we train for all the different stations, yeah? They get Waiki'i, they get Humu'ula, they get Pa'auhau, they get one . . . they get one in Kohala, they get one station over there. So we trained the horse all for those guys.

And we trained horses for—"children's horse" they call that—they get the first choice, and it's for Richard Smart. Richard Smart—they come they pick the best horses, and we train them—they call them "children's horse," and they're for all these guests. Okay, we train all these horses, and that's most what we do, but it's every-day job, every-day. We ride ten horse a day. Every day, ten horse you ride. And when the horses are all gone out, or not, if not all gone out, then they bring maybe another hundred inside. Every six months they bring another hundred inside. And we all pick again. We had to pull numbers for all the horses, because get all different kind of breeds, eh? Wild breeds over there, they had, oh maybe ten, fifteen different breed of horses. And the worst ones always stayed last. You know, you pull number, can't help, you got to get them, that's the name of the game.

In the fifty-year span between 1920 and 1970, the Breaking Pen was the rotational axis for more than 150 men, the bulk of whom went on to become members of the Cowboy Gang, foremen, and superintendents. Harry Kawai is the stand-alone icon that went from being one of the roughest, toughest horse breakers to becoming a refined and respected reinsman. With rapid upward mobility, he became cowboy foreman, retiring as general superintendent of Parker Ranch—in effect, assistant manager to Rally Greenwell.

This section of the current volume of *Loyal to the Land* delves as deeply into the handful of solid individuals who stayed the course; men who endured the pounding, thrashing, and relentless bucking of the offspring of notorious remount sires such as

Four Rough Riders: Joe Hui, Isaac Kaleikula, Sam Akina, and Sonny Akau. Paula Hui Boteilho collection.

James "Palaika" Brighter with Poʻai Nahaleā at the Breaking Pen. PPS.

Harry Kawai in 1943. Note "banana wagon" in background with blackout headlights. PPS.

Right: George Purdy at the Breaking Pen in 1936. Horse chute behind him was used for grooming, treatment, and so on. Photo courtesy of George M. Purdy III.

Heine and Lindsley without complaint while standing proud of their service to Parker Ranch. And when needed as emergency hands in drought years, as bearers of galvanized piping high into the Kohala Mountains or to *hana kipikua* (pickax) digging of lantana or fountain grass, they served without complaint.

Abraham Akau shared his insight regarding the supportive role of the Rough Riders with Anna Loomis:

AA: The brandings was nice. People never brand like us. I mean, we go out go branding, us guys Rough Riders, we never give us a chance for even rope one cow as long as I stood there. You always got to be on the ground. Thousand, five-hundred calves a day. Brand thousand, five-hundred calves a day! And what we do, we got to get up at 1:00—yeah, 1:00 [AM]. Coffee at 1:00—that means you get up at 1:00, you have coffee at 1:30,

Abraham Akau. Courtesy of Paula Loomis.

AL: Five horse?

AA: Five ropers.

AL: Oh.

AA: Five ropers. And five ropers, maybe two castrate guys, dehorners, and tar man, all that guys, injection, everything got to be going. And these guys they rope the cattle, they bring one man, one calf. One man, one calf. You pick the wrong calf (already branded), boy, you gone. They too fast, the cow, you no more hands. So before they come, before they brand, "Us two partner today?" you go ask your partner. And only one guy, one calf, one roper, that's all.

You come home. The dust. The blood, all over you—you like throw away you clothes! But they dehorn, eh? When they dehorn, the blood all over, all on top you, boy! And we get up 1:00. We no get home till 9:00 in the night. We no get home. Eh, but, we never complain. We never complain. Nowadays [if] you go tell those guys, "You go over there," [then] he complain. Eh, that was life. I mean we went out, we went do 'em, we never see that there was something more better.

and then 2:00 it's time for ride already. Going—going *mauka*, going get paddocks to the way up. You see, they take the horses before that, before, the day before. They lock up in the pen, you make sure that you change horse again. Then go from there, you drive. Drive all the cattle in you know. And when you look outside, when you get down to the branding place, you go, "Where all these guys come from?" But they come from all the different stations. They help us drive—"Hey brah, how you?"—you shake hand, you meet each other. Whatever—all drive the cows. And when start branding, they put five horse on each side the fire.

This special breed of *paka paniolo* deserves celebration. They include the Akau brothers—Theodore Akeni (Sonny) and Abraham (Manny)—Joseph Kekahuna (Joe) Hui, David (Bud) Kaula, Manuel Nobriga, William (Willie Palaika) Brighter, Joseph (Mickey) Perreira, and the brothers Quintal—Adam and Jordan (Red). Although a Hanaipoe section overseer, the story of Saichi Morifuji is included as part of the Rough Rider narrative for his sterling reputation as a broncobuster.

Theodore Akeni (Sonny) Akau II

Sonny and his younger brother Manny were the third and fifth children born to Theodore Akeni Akau Sr. and Mary Mililanionapuahekila Keawe. Mary descended from the Alapaʻi/Keawe line of Puʻuanahulu, but the village of Kaʻūpūlehu (Kaʻulupūlehu) is considered by many to be the ancestral home of this distinguished line of Native Hawaiian people. It is noteworthy that the names Alapaʻi and Keawe are significant names of ruling chiefs in early Hawaiʻi. Sonny and Manny looked to their paternal grandfather William Paul Mahinauli Akau as the progenitor of the *paniolo* image. Combining the Akau, Alapaʻi, and Keawe lines not only brought the blueblood of royal lineage but the well-established reputation of being great men of the sea as well as of the mountain.

Both boys were on horseback by their early teens, riding bareback on family mounts. They looked up to their uncles, Alex Ahileka Akau and Kaliko Mainaʻaupō, as the kind of *paniolo* they aspired to become.

Their father, Theodore Akeni Akau Sr., was a long-standing and respected ranch employee, a relationship that opened up opportunities for them to join the company as novice Rough Riders—Manny in 1946 and Sonny in 1947. A few years older than Manny, Sonny followed the lead of his sibling in going to work under George Purdy, who inspired much pride and respect from the young lions assigned to him. Sonny and Manny likely rank as the rowdiest of the Rough Rider Gang of that era. But George had a patient manner that was used firmly and strategically as he guided many a young man toward successful adulthood.

A fitting tribute to George's firm and fatherly manner is reflected in his handling of a serious mishap involving four of his young charges. During the early 1950s, Sonny, Joe Hui, Bud Kaula, and Isaac (Aikake) Kaleikula got themselves in a quandary that more than likely would have caused them to be fired.

It was not unusual that cowboys and Rough Riders used their *ahiahi* horses (those rode to and from work on weekdays and weekends) to allow their family members to have brief horseback rides on a Sunday afternoon. However, to use a ranch horse to fish or hunt on such occasions was forbidden—a rule cast in stone. Yet to the young *paniolo*, such recreation was not only part of their life, it served their barren family tables with pork, goat, sheep, and fish to augment their meager pay.

On one of many such stealthy escapades, the four Rough Riders set out at 4 a.m. on a Saturday equipped to spend the weekend hunting and fishing on a trip to ʻAnaehoʻomalu. Well encamped at the beach, the men fed their horses, set up their tents and cookery, and spent the late afternoon engaging in ʻupena kiloi (throw net) and picking ʻopihi (limpet). Frequent cups of Tokay wine added to the splendor of the *paniolo* life as many tales regaled them through the night. At daybreak, numerous ʻanae (full-sized mullet fish) were netted and iced down for the long ride home, with some hunting along the way. Between copious use of salt and ice, the seafood was carefully packed in rice bags wrapped securely within *kapolena* (tarpaulin) duffel bags.

Headed *mauka* toward home, the four *paniolo* happened upon an ʻāuna (drove) of fat hogs, and they split in four different directions, each man for his prey. When Joe, Aikake, and Bud heard Sonny's .30-30 Winchester fire, they assumed he scored a fat

ohi (young female pig), and they proceeded to rope and *kūpeʻe* (hogtie) their prey. But it wasn't long before the men heard the *kani ka ō* of Sonny, a faint cry of *"kokua, kokua"* (help, help), coming from a distant stand of low-lying *kiawe* trees. The three of them rushed in that direction, worried that Sonny was hurt. Reaching him, they found Sonny ashen faced and *uluhua* (upset). He led them to a nearby thicket, where his horse laid in a pool of blood—accidentally shot through the neck by his master, who had fired hastily in pursuit of a huge *lahoʻole* (barrow, a castrated male pig). One of his better ranch mounts, a stout palomino gelding lay there, still breathing, with a gaping wound through his midneck. Sonny handed his rifle to Joe and asked him to provide the coup de grace—but to no avail. *"ʻO oe ka hewa!"* ("It's *your* problem!") was Joe's immediate reaction. Sonny was left to deliver the final humane round while Joe, Aikake, and Bud rearranged the gear on their heavily packed mounts for the long and weary trip home. Sonny rode double with Joe, seated on the *pale huelo* (rear saddle covering), as the two bemoaned the tragic ending to a wonderful—albeit stealthy—weekend of *paniolo* recreation.

The four men agreed to stand together and be totally honest in the dreaded encounter with George Purdy early the next morning. With hats in hand, they asked the foreman to join them in the adjacent *hale kope* (coffee shack), where Sonny, still shaken, stuttered a detailed description of their weekend escapade. All four Rough Riders knew their days on the ranch were numbered, but they approached their boss with an open and contrite admission, with no holds barred.

Leaning back against the wall, George Purdy shifted his weight on the bench to accommodate his burly folded arms and, in a soft but deep monotone, he responded to the men. He made them aware that he knew all along they had been using their ranch mounts to *hana kolohe* (outlaw) and that the weekend hunts were suspect, given the *ʻōpaha* (gaunt) appearance of their *lio ahiahi* (evening horse) on many a Monday morning. He shared with them that he worried deeply about the consequences of such accidents, knowing that their occurrence during working hours was serious enough, but to have this tragedy occur during an outlaw escapade, things couldn't be worse. Purdy sat quietly, letting the boys reflect on their misconduct before proceeding with the rite of *hoʻoponopono* (to correct, make right).

He first acknowledged appreciation for their honesty and remorse, then went on to make a request that they forever abstain from such *kolohe* (mischievous) activity as long as they lived—on or off Parker Ranch. The four horsemen were prepared to embrace that covenant despite losing their jobs. But Purdy went on to put forth two covenants on his part. First, given their promised firm abstinence, he would hold within himself knowledge of the incident. Hartwell Carter and Rally Greenwell remained unaware of the incident, and the four horsemen kept their jobs. In a fatherly way, Purdy offered a second covenant, knowing how poor these families were: If and when the Rough Riders needed to *hele kahakai* (spend a weekend on the beach) and hunt wild game on horseback, the foreman himself would secure clearance from management. Hartwell Carter died in 1985 never having been told of this incident. When I gave the eulogy at Theodore Sonny Akeni Akau's funeral, this epic scenario was shared with his family and friends in order to

Theodore "Sonny" Akeni Akau warming up his mount for the Anna Ranch "Old Hawai'i on Horseback," 1968. PPS.

reflect on his *kolohe* days. For Rally Greenwell, it was the first he had heard of the infamous weekend at 'Anaeho'omalu—testimony to the bond between George Purdy and his four horsemen.

Sonny's career on Parker Ranch is epitomized by the distinctly handsome profile of a man on horseback in an interrelationship that was both natural and unrehearsed. While Sonny was known for having a "heavy hand" with horses, two facts are salient: The end product was a mount that brought pride to the Parker Ranch horse program and that horse was likely a Lindsley or Heine offspring

The Reign of Hartwell Carter

dreaded for their deep-seated, ornery nature. When Sonny was done with the training, the horse would fit well as an officer's mount in the U.S. Cavalry—well-groomed, well-mannered, and with a neck rein as soft as any horseman would want.

The first volume of *Loyal to the Land* noted that Sonny's career evolved into agronomy work, in which he became foreman. All five of his sons developed relationships with the ranch, with one son, Arnold, rising to superintendent level. In a bittersweet ending, Arnold left the ranch with the Voluntary Separation Program exodus in 2002, while his wife Tracy Murray Akau carries on as manager of the Parker Ranch Store.

No sketch of Sonny Akau would be complete without including his wife, Rita Puhi Akau, who patiently worked through their many years of marriage, birth, and raising their five sons and a *hanai* (adopted) daughter, A'oi Akau Gaspar, in a household that was a flurry of activity. Through it all, Rita was forever a lady. When asked at a *lū'au* to sing, Rita would come forth with a heartrending performance of her signature song, "Kalama Ula." The memory of Rita Puhi Akau lingers on in this community when the verses of "Kalama Ula" echo from Kahilu Hall through the evening mist of cozy Kamuela.

Abraham (Manny) Akau

Elders describe Abraham as a small boy having a "serious little man" persona about him—hence his *inoa kapa kapa* (nickname), Manny.

In a 2000 interview with Anna Loomis, Manny shared some aspects of his early days on horseback:

AL: "Do you remember how old you were when you knew that you wanted to work with horses?

AA: Aw, when I was—I was young already. We had our own horses. I never did use a saddle until maybe about twelve, thirteen years old. I always ride bareback. I go all over with the cowboys, I follow them, I go—stay with them, with the cowboys, they let me come, eh? The Parker Ranch—not supposed to, but I see them go, I follow, I go with them. As I think maybe, we were put in the saddle when we were young, like my grandchildren, they're two years old they're on the horse already. Not alone, but we carry them. And I believe I was from that part, I'd think, from that part.

Because when I was maybe about ten, eleven years old, I was hunting myself already. I try to get the pig on the horse myself, or one way or another I get it home. I'd drag it all the way home, I'd—you know? I'd bring 'em home, my dad, "Yeah, he-e-y! We get something!" Drop it over there. My sister used to take care all that. My sister she'd skin the pig, she'd chop it up, she salt it, smoke it. Sometimes we help, but I wasn't for that. I just like go hunt.

But yeah, I was young that time, I started from young. From my parents, yeah, my parents, grandparents, they all were horsemen. And I think I just found my place.

Manny became a Rough Rider in 1946 at the tender age of fifteen, and it wasn't long before he took on a more "rough and ready" style, especially around horses. He reported

to George Purdy, the same foreman who terminated him four years later.

In the span of four years, Manny went from a novice horse trainer to one of high regard. The men of the Cowboy Gang eagerly sought after mounts that Manny trained for their gentleness and well-started neck reining. Frequently helping the Cowboy Gang at brandings and shipment, he further developed himself into an all-purpose cowhand.

In 1949, in one of his wilder moments, Manny found himself in trouble with ranch bosses when he combined wrangling a workhorse herd destined for Humuʻula with more than a few shots of liquor. By the time the Rough Riders reached Waikiʻi Corral to rotate horses, Manny launched a *kolohe* scenario that regretfully affected him for the rest of his life. In the same interview with Anna Loomis (2002), the story unfolds in his own words.

> But I was working for Parker Ranch, and we were all the Rough Riders certain time of the years. And about June, July, we need to go Mauna Kea [to] drive sheep. They get a big sheep herd up there. So we were going up for dipping—or I think was shear, I forget already. I think it was for dipping time. Shear is early, and dipping time we [used to] go around. So we got up early that morning and brought some liquor (laughs). And we were drinking, going up the way, you know. And when we got to Waikiʻi, and then we change horse over there, you know, we change horse, because it's a lot—it's about 80-something miles we got to go, you know. Second horse.
>
> So we get this guy's horse—now, he's the foreman, the Rough Rider, our boss [George Purdy], Parker Ranch. He got one horse used to give us *bad* time—that's his horse. So I caught the horse. I rope him. I throw my saddle on top. I rode the whole ranch. And when we went up, I jumped down for—you know, go to the bathroom. Jump down. And this other guy come up, "Eh brah! Here, brah! Come on, now!" I went, "Oh!" That dumb horse while I was down, he went turn around, he went give two kicks, they almost catch me right here [in the chest], boy. The one I was riding. Horse went run away. I saw my brother going down the hill trying to hold the bunch [of horses together], I yell him, "Let the horses go! Let the horses go!" I don't know how many horses, I think maybe seventeen, eighteen, I think. So, "Let go the horses!" [The other Rough Riders] come. I tell, "Come back, eh, you know what, take off all the saddle, let it go, the horses." And we about—not even halfway to Humuʻula. To Mauna Kea. I mean, up the sheep house. I tell them, "Let 'em go, the horse."
>
> Okay, so we're sitting down, waiting for one car to go Hilo, eh? Sitting down, waiting. Eh, the car coming. "Eh, brah, oh!" Was Morgan (Buster) Brown. He asked us, "What's the matter, brah?" Ah, us kids all crazy, all crazy already. He was taking us up Humuʻula, take us up there, go sit down, we go inside, drink coffee in the kitchen, we all sitting down. Tell my brother, "Eh, go call George [Purdy]. Tell him the horse all run away." He call him up. He tell my brother, "I know already! I knew! I knew something going

happen when your brother Manny make like that, you going get trouble!" Say, "You guys go back down there, go *get* the horses." George Purdy tell me. Because that's for one week, one more—for two weeks was up there for drive the sheep, eh? Uh, he tell me got to go back! How you going get thousands of acres and how you going catch the horse?

So we went to my cousin, he work up there, Kaniho. I say, "Daniel, you can take us go down? We got to go back down, get the horse, all run away; I let 'em go." "Yeah, okay." So we go down. I saw the bunch once, under the trees. And only one way they can come out. They was all underneath the trees, they was resting. It was kind of getting dark already. So I tell my brother, "You guys run through there, I stay over here." I tie the rope to the stump, eh? Ho, the horse—when the horse run away, I rope him. One loop, I get 'em. I tell my brother, "Put the saddle on top the horse." [He] put the saddle on, we start go driving the other horses, they—we going catch that thing too. And then we take the horses up.

I think that out of—I forget how many horses we had, but we was short, boy. For the whole week. So we go up there, and we all family-like, we all know each other. I start talking, "But we need horse, boy!" They start, "No way! We lend you guys horse." They lend us—we was all right, everything was all right. We get home after two weeks, [and we] was in the Breaking Pen. Somebody come up, I forget who, hell, "Eh, Mr. Carter [Hartwell] like see you." "Yeah, he like see me? Okay."

I think that was the longest walk for me to his office, boy, to the front door. I walk inside. "Oh"—and he called me Manny—"hey, Manny," oh boy. Aw. Too bad, what went happen to you. But you shouldn't have ride George Purdy's horse. You shouldn't have ride 'em. I tell him, "Aw. It's okay." But I was young, yeah? Then he tell me, "You know something? Well, we got to fire you." I tell him, "Okay. That's alright." I was wrong too, eh? But the part that was kind of bad, I got [George] Purdy to make 'em bad for me. He tell me I like—but I was wrong. He could have backed me up. But it's okay. So I tell him "Okay, thank you very much," and I left. When I went out of the office, I went back there, everybody was going quit. Everybody was going quit the ranch because of me and what had happened to me.

In reflecting on the sorrow of leaving the ranch, it is in moving detail that he describes peers and favorite mounts he left before, an emotion that is found within all former Parker Ranch horsemen that left—still loyal to the land.

But I break my heart when I left. I have to leave them behind, eh? You know, I cry —when I left Parker Ranch, when I got fired. I had two racehorses. In the first race, in the beginning of the race, the racetrack it opened up in 1947 I think, so they went open up and get the racetrack again. So everybody pick one horse, you know, for horse, whatever horse. So everybody pick, so they brought the rest, "OK, Rough Rider's chance now for go pick."

So once the horse went run, I see this horse. He look ugly because his mane was all tangle up everything, but, ho, to me he get good conformation, everything. So I tell some of the guys, "Please"—we're going to pull numbers, see—"see that horse over there? Leave him for me, I like that horse." So they don't pick it, you know, that's for me. 'Cause we're all friends. But if they like him that's up to them. So I picked those horses. Put them in the pen. Ho, and I clean them up. They look beautiful! One palomino and one sorrel horse, aw, look so nice!

So then they came, I don't know how long after that, maybe not even a year I think. The boss said, well, we're going to get racehorse, going start a racehorse again. Ho, everybody look and, "Racehorse? We going race?" So I train these two horse, I was riding them. Ho, they could move, you know! So I train them. People tell me, "What horse you going use?" I didn't say anything but, "Aw, no, I don't know yet," but I knew I was going use these two ones. So I train them, I go in the backyard, nobody stay in the pasture [Waiemi], ride them, I try train them, make them run. Then we take them down to the track, we get seven-eighths track—almost one mile, you know, going around. Go the track—ho, beautiful! And the day come when we race. Those horses came inside 23—21, 23, and 22 seconds quarter mile. And that's fast! That's fast. That's two horses.

So when I got fired, ho, I look at that two horse—broke my heart. I had a lot of horses, too, they were beautiful horses. But I lost my job, you know? I cried for the horses. Then, I wanted my brother to get them. I wanted my brother to get all these horses. Go see the boss. By the time he had chance, the foreman went pick all my horses and keep them. The foreman from the ranch, took all my horses. More, I felt more sick, too, because he get my horse, you know, what happened. But that's OK. But I left those two horses behind. I left a lot of good horse behind. But I left—those horses broke my heart. Was Billy and Lightning. Billy-Boy and Lightning. Yeah, they were good.

Yeah. With the Rough—Rough Riders you call 'em. We was real close. Even when we get home and we go places, we always stay together, it's just natural. And when I left there, I kind of missed them, that time, but I had to—I had to move on, eh? And I never forget them. And some of them gone home already, most of them gone home already; they died. And we had good times, because I remember sometimes, we go outside, and the horse fall down and we stuck underneath, ah, and they give their life, boy. They jump on top the horse, they hold 'em, they grab everything until you get out. And that's da kine, you know. And they always need help, they always need help. You tell, "Brah!" You went say, "Brah!" the guys round over there open the gate for you, because all these horses cannot open gate, they cannot turn, eh— I mean that's how close we was. Really close. And I think from there we kind of start off with me, I went go out, go different places. I remember back where I

The Reign of Hartwell Carter

was, that's why. And we had good time, we go branding.

Once he was gone from Parker Ranch, word spread rapidly among ranching circles that the young, wild and woolly horse breaker was available. Through his uncle Kaliko Maina'aupō, he was called to Keauhou Ranch where he trained young horses under Tommy Lindsey of Shipman Ranches. After a few years of cowboying at Keauhou Ranch in the Volcano area, Manny was handpicked by Lindsey to come to Pu'u'ō'ō Ranch, where he continued as a horse trainer while developing skills in the gathering of wild cattle that ran amok among the hills and gulches of that mountain ranch.

On a trip to O'ahu, Manny met and later married Fannie Opiopio, an influence that caused him to leave the ranch life for Honolulu. In 1953, at the suggestion of Jimmy Greenwell of HMCo to Franny Morgan, owner of Kualoa Ranch, Manny was offered a chance to return to ranch life under the management of Ed Hedemann, a fellow he grew to highly respect. By 1973 he had become the foreman of Kualoa Ranch, with great support of the company, his church, and his family, which included three children: Abraham Jr., Beautiann, and Miracle. Manny retired from Kualoa Ranch in late 1995 after serving forty-three years with the outfit. In 2005, he remains O'ahu's true icon of the *paniolo*. At his induction upon entering the 2000 Paniolo Hall of Fame, sponsored by the O'ahu Cattlemen's Association, Manny made a most prophetic statement: "There's nobody going be after this. After us. Maybe the next generation one more down, I think, that's all. It's gone already. But like this—you take this, you write, you keep something in the museum—people they can see, they can see Hawai'i. Because I think people went far gone, they left the cowboys behind."

Joseph Hui

Joseph Kekahuna Hui was born in 1930, the second child and first son of Joseph Kuhio Campbell Hui and Esther Kawaihalana Awa'a. Esther Awa'a was a daughter of Samuel Awa'a Sr. and Helen Alo Hulupi'i Lono of Kawaihae Uka, while her husband Joseph hailed from the Waianae coast where his family were noted fishermen. While their first daughter Momi developed no ties to Parker Ranch, the second daughter, Edna, was destined to marry a young cowboy from Pu'uhue named Albert Dela Cruz.

In addition to Joe, the senior Hui 'ohana included sons Campbell, Elmer, Francis, Albert, Samuel, and Jeremiah. Besides Joe, only Campbell and Francis were Parker Ranch cowboys, and all three started their careers at the Humu'ula Sheep Station under their uncle Willie Kaniho.

Like many families of those times, the Hui 'ohana struggled to raise large families. Joe Hui Sr. worked as a cantoneer on the territorial road to Kawaihae from Waiaka Bridge to Spencer Park. His only equipment was a wheelbarrow, shovel, rake, and hoe. The entire span of Kawaihae Road was maintained by him on foot, with little respite for shade and rest. The Hui home was located where the Makiki Nursery later was developed, and their *kuleana* (property) abounded with fruit and vegetables. Every Saturday the nine Hui children gathered mangoes to sell along the roadside at the price of a penny apiece. All proceeds went to the support of the household. While the sea provided an abundance

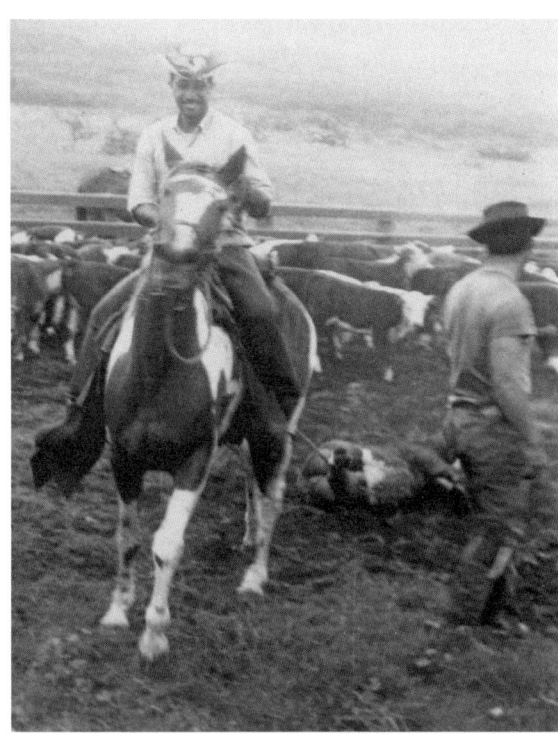

Joseph Hui dragging a calf to a branding fire at Puʻu Kīkoni Corral. His paint mount was a rare sight on Parker Ranch. The handsome gelding was a "catch colt" from neighboring rancher George Vierra's pinto stallion. PR.

of fish, their Uncle Sam Awaʻa II provided fat hogs poached from the verdant hills of Kawaihae Uka for the family table. The pork was usually salted and stored in the family *kelemania* (crock).

Being the eldest son, young Joe left Kawaihae School by the age of twelve, becoming fully employed by storekeeper T. Doi, who farmed vegetables and fruit while maintaining a piggery of mixed feral and domestic hogs. It is likely at this young age that Joe developed skills in the slaughter, skinning, and dressing of hogs for household use. By this juncture, Joe assumed the "provider" role previously carried out by his Uncle Sam in supplying the large Hui household with fat pork. Whatever Joe received in salary from Doi went directly to his parents to help support his brothers and sisters.

At age fifteen, Joe was tapped by his uncle Willie Kaniho for a cowboy job in Humuʻula, where Joe camped for several years. On the occasional trip home, his family was delighted to receive fresh mutton as well as smoked, salted, or—at times—fresh pork and beef.

In his early twenties, Joe met and married Carol Iwalani Kawai, daughter of David (Dick) Paukeaho Kawai and Elizabeth Rosy Lindsey, granddaughter of the orginal George Kynaston Lindsey who emigrated from England. Not long after Joe and Carol wed, he was transferred to the Breaking Pen under George Purdy. Already an able horseman, Joe's skill as a horse breaker was based on enduring patience and gentle hands. Here he worked alongside Mickey Perreira, Sonny Akau, Adam Quintal, Manuel Nobriga, and Isaac Kaleikula. Noted for their rowdy lifestyle, the Rough Riders were as well noted for their diligence in turning out trained mounts for the cowboys while laboring under the watchful but paternal eye of George Purdy. While many of the Rough Riders lived at the single men's camp—a row of sleeping rooms with a common kitchen where many gallons of wine were enjoyed in *pau hana* (after work) hours—Joe was usually found at home in a ranch house located near Waimea Park, where he and Carol started a family.

Joe was being viewed by management as a serious and honest cowboy with potential for upward mobility. When an opening occurred in the Cowboy Gang, Joe joined the

ranks of the top hands of the ranch with ease and mutual respect.

Joe was as good a roper as he was a horseman, and the ranch ropings and races found him a frequent visitor to the pay window. The annual Hawai'i Saddle Club rodeo in Honoka'a was another venue where he showcased his roping talent. Later teamed with his son-in-law Franklin Boteilho, he was a tough competitor in Kona and Hilo ropings.

Few *paniolo* on the ranch struck as handsome a profile as Joe Hui, on or off a horse. His well-trimmed mustache and sideburns added character to a ready smile that he shared with good company. Like David (Bud) Kaula, a fellow Rough Rider, he was frequently called upon to participate in Aloha Week Festivities as Mo'i Kane—King David Kalākaua.

Joe's appearance grew more distinguished with age. Even as he approached seventy-five years, his facial skin was smooth and unwrinkled, save for the leathery creases that lined his face—the result of years in the sun, wind, and rain astride a stout ranch gelding.

Joe and Carol's granddaughter, Kacy Boteilho, carries on not only the rodeo interest but the Parker Ranch tradition by working in the bookkeeping department for more than a dozen years. Securing a sixth-generation ranch employee status on the Lindsey line, Kacy carries with pride the ancestral lineage of Awa'a, Kawai, and especially the Hui 'ohana, reflecting due credit on the great men and women who came before her. With sons Kepa and Austin destined for Keiki Rodeo, the cowboy tradition lives on.

Joe Hui stands special as a Parker Ranch cowboy of note who came from great stock and passed on through his children and grandchildren the tradition of loyalty to the land.

The Brothers Quintal

The marriage of John Quintal to Julia Correia brought forth nine children. Of these, two sons were destined to become *paniolo* on Parker Ranch: Adam and Jordan were the second and third sons born of a father whose only connection to the ranch was in lawn service. Several of the children were born with red hair, but only Jordan retained his hair color through adulthood—hence his nickname, "Red."

Born a couple of years apart in the late 1920s, the Quintal boys wasted no time getting close to the cowboys and horses of the ranch, exposure they enjoyed on a daily basis. In a staggered fashion, both gained employment at age fifteen doing utility work until opportunities opened up at the Breaking Pen. James Palaika was still the foreman there, but in his twilight years other men followed, such as Albert Uiha Lindsey, Joe Pacheco, Harry Kawai, and George Purdy. The Quintal boys were "lean and mean" in condition, and with a few years of mentoring they grew to become respected horsemen.

Adam, the older of the two, worked at the Breaking Pen several years beyond Red, who came across as more settled down. Red was called to the Cowboy Gang early on and earned the respect of his peers. Adam was rough and ready, especially after work hours when he hung out with the likes of Bud Kaula and Sonny Akau—a typical lifestyle of the Rough Riders. Hartwell Carter likely extended the tour of duty at the Breaking Pen for the young ruffians in hopes that they, as well as the mounts they were riding, would settle down. For some of these men, it meant a decade before assignment to the Cowboy

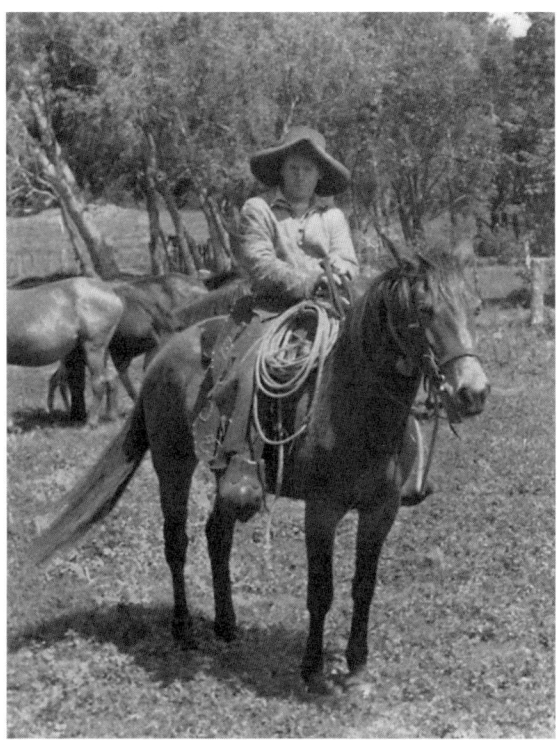

Jordan Quintal on a cowboy horse with his signature V-shaped hat brim. PPS.

Gang. On more than one occasion, Adam was assigned to the utility gangs when his rowdy lifestyle got in the way of work. But he was always called back, until he finally earned a place on the Cowboy Gang.

As the Quintal boys aged into seasoned men, so did their horsemanship. Adam was viewed as one of the ranch's finest reinsmen, and at gate-cutting and counting of cattle, few men could match him. Red, on the other hand, was more of a cowboy—fond of the open range and long cattle drives. His best days included shipping out of Kawaihae when the Cowboy Gang would *hōʻau pipi* (swim cattle).

Jordan (Red) Quintal: The Wrangler

Red's most notorious feat however, was in handling the vicious Standardbred remount stallion Heine, who had a penchant for attacking mounted men as they drove cattle through his home paddock, Puʻu Kaʻaliʻali, where he jealously guarded a band of forty mares.

The situation arose when Hartwell Carter visited a branding at Puʻu Kīkoni corral, adjacent to the Puʻu Kaʻaliʻali home of Heine. Upon spotting the stallion pacing up and down the corral fence, Hartwell decided that Heine be immediately led back to the stallion station at Pukalani Stables. Cowboy foreman Willie Kaniho turned to his band of a dozen cowboys and asked for a volunteer for this life-risking task and, aside from the bawling calves, not a sound was heard. Off in the corral corner, the wiry forearm of Red Quintal was firmly raised, immediately eliciting chuckles from his cohorts. Heine was roped by two mounted *paniolo* and led into the corral away from his mares, raising quite a raucous response from the stud, whose nostrils by now were flaring above two rows of long ivory incisors that he chomped while grinding his molars. The stallion's roar of discomfort was shrill when the foreman fashioned a *pūnuku* (rope halter) before handing the lariat coils to Red, who was mounted immediately outside the gate leading toward Waimea where Pukalani Stables sat in the distant mist. With the steep face of Puʻu Kaʻaliʻali to his back, he signaled for the release of the dreaded Heine, teeth bared and squealing in a hoarse signal of attack. Red was prepared for the onslaught with the *piko* (end) of his *kaula ʻili* (skin rope) in snug *nākiʻi* (tied tightly) to his wide Hamley pommel. Awestruck, the Cowboy Gang,

Adam Quintal sorting cattle at Puʻu Noho Corral, 1976. Photo courtesy of Leilani Hino.

with Hartwell in full presence, watched Red pivot his mount 180 degrees and head straight up the 45-degree slope of Puʻukaʻaliʻali with Heine in hot pursuit. With his speed horse beneath him, Red exhausted the stallion over the 300-yard incline and turned the tables on the hilltop, doubling his *kaula ʻili* into a couple of firm whacks over the stud's lathered rump. Now Red was the boss! With a few more whacks, Heine headed down the slope and trotted past the astonished cowboys and ranch manager, followed closely by his new master. The last they saw of Red was his shadow passing through the *uhiwai* (mist), trotting along behind Heine. Once at the stallion station, Heine was cooled down and bathed by George Lindsey and Kanakanui Iokepa before being placed in a spacious stud stall lined with straw and serviced with grain and grass cuttings. Word quickly spread throughout the ranch, acknowledging the grit, skill, and superior horsemanship of Red, who, without fanfare, rode his *lio ahiahi* home and enjoyed a steaming *furo* (Japanese hot tub bath), savoring his moment in the sun. No one ever dared Red the wrangler about anything after that.

Red left the ranch in good graces, seeing opportunities for a better lifestyle on Oʻahu and the mainland, leaving his older brother Adam to carry on the tradition of the Quintalesque horsemanship. He did so with passion.

Adam Quintal: The Reinsman

Corral work was Adam's forte. The remarkable feature of his reining and gate-cutting work was his ability to bring out the best in every horse he rode. This prevailed over the years, as Adam became the "go-to guy" when a cowboy found a mount to be irretrievably hopeless with regard to neck reining, standing, side passing, and so on. It was those throw-away nags from which he built his quality work string.

Adam's appearance was just as bewildering in terms of form to function. By his mid-fifties, he had developed quite a large *barriga* (Portuguese for beer belly) that occasionally chafed on his saddle horn when roping. His legs were short and spindly, yet he could outrun a fat hog through a thicket. His shoulders were crowned with a bull neck and his sunburnt complexion was reddish bronze. Mounted beneath his forehead were azure blue eyes that twinkled vividly with laughter. Rarely in a foul mood, his eyes twinkled even then. Always with a wad of tobacco in his mouth, Adam could bellow like a bull, with every word audible—whether it be in pidgin, Portuguese, or Hawaiian. Of these, he used Hawaiian most freely.

When the Cowboy Gang was dismantled, foreman Kale Stevens selected Adam, who he nicknamed Gaja, to become a Makahālau

Station hand. Later, Adam worked for Sonny Ke'akealani, with whom he enjoyed rapping in *olelo kanaka* (Hawaiian language), always punctuating their conversation with shrill laughter. They could make fun of the most unlikely situations.

While the Quintal brothers went on to a higher calling than just being Rough Riders, it was their extended tours of duty at the Breaking Pen that set them apart from many a ranch hand. They were true Rough Riders.

David (Bud) Kaula

David Kaula Jr. was born in Waimea to David Kaula Sr. and Susan Kauwe, a daughter of David (Hogan) Kauwe. Of the five children born of this marriage, only Bud developed a lasting relationship to Parker Ranch. Aspiring to be a cowboy like his *tutuman* (grandfather) Hogan, Bud left Waimea School after the ninth grade at age fifteen and went directly to work as a Rough Rider under George Purdy.

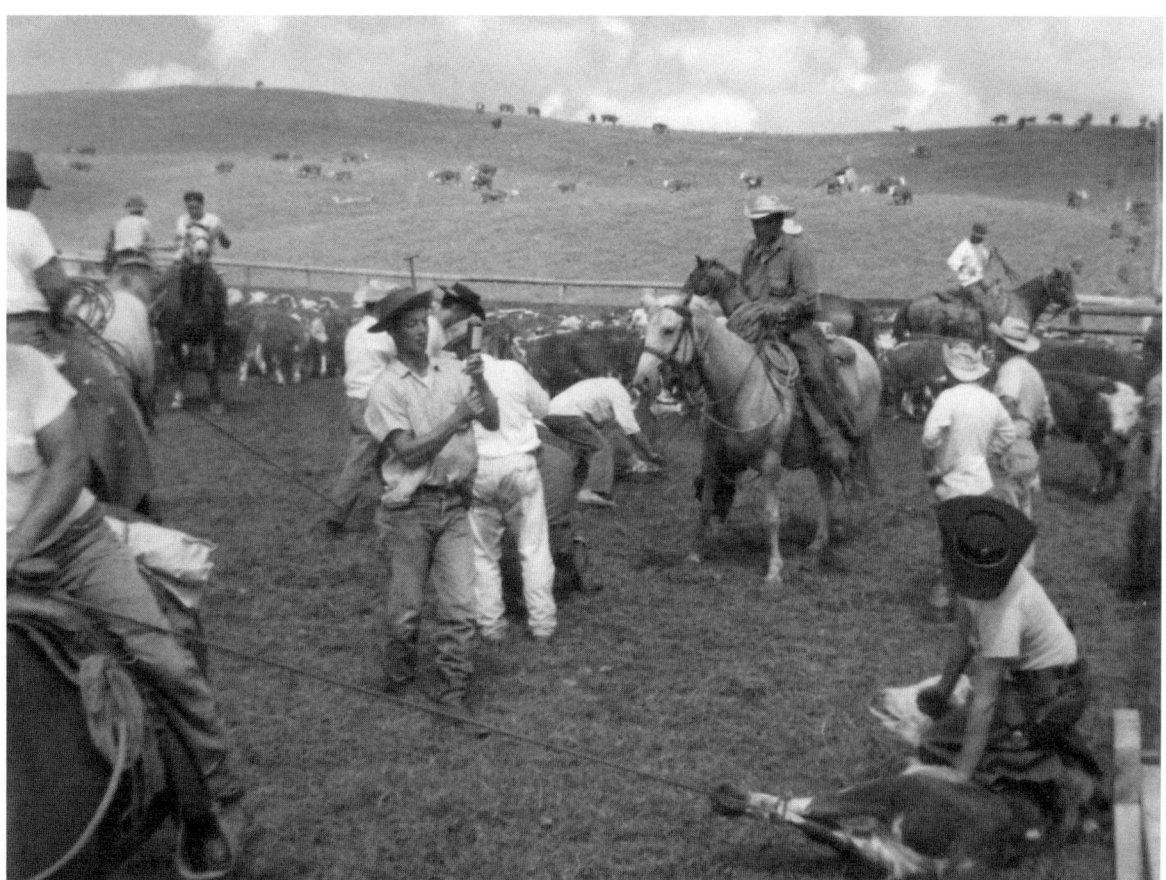

David "Bud" Kaula mounted on his palomino gelding at a branding in Pu'ukikoni Corral.

Tall, lean, and wiry, Bud had the physique, endurance, and dedication for the Rough Rider life, of which he was very proud to be a part.

Bud developed a very close working relationship with his cohorts, Joe Hui and Sonny Akau. The daily guts, grit, and occasional glory that came with the Breaking Pen territory bonded them.

Largely due to his rangy physique, Bud was always attracted to the Thoroughbred horse, although in his long decade as a Rough Rider he took all comers—good, bad, and ugly. The ugly mounts were not unpleasant in appearance (conformation), but like the Heine line, they had an innate streak of meanness that caused the horse breaker to be wary of unprovoked biting and cow kicking. Hence it was common to use the *pani maka* (blinders) in taking on the green mounts.

Bud courted a kindly O'ahu lassie named Jill Barker, and before long they developed a nice family of *hapa haole* (Hawaiian/Caucasian) children. Through these lean and hard years, Bud and Jill became very close to Carol and Joe Hui, whose children enjoyed growing up with the Kaula clan. Much like other young ranch families, the Kaula, Hui, and Akau households depended heavily on subsistence hunting of game. Jill (Kaula) DeLuz, in recalling those austere days, fondly related to me in a 2004 interview that no matter how poor they were, the families were looked after very kindly by ranch management, securing meat, milk, poi, and housing; but most importantly, she expressed appreciation for the *paniolo* loyalty to the land, brethren, and animals of Parker Ranch. According to Jill, beyond his family, Bud often openly expressed his love for and pride in 'Āina Paka. No task was too great to ask of Bud and his brawny back in behalf of Richard Smart and his beloved ranch.

During his tenure as a horse breaker, the periodic *"kokua"* assignments to do cowboy work or "grunt" work led to appreciation of his work ethic by the ranch management. While Bud always seemed challenged by alcohol use, it never interfered with his prompt arrival at work on the dark and foggy mornings, mounted on his *ahiahi* horse with his *kini ai* (lunch pail) strapped to the *aweawe* (strands) of his Hamley Hawaiian tree saddle.

Gradually, Bud, Sonny, and Joe were promoted to the Cowboy Gang, first under John Samoa Lekelesa and later under Kale Stevens. Through these years, Bud's work ethic became even more noteworthy: He frequently outlasted his cohorts when engaged in the chores and drudgery of cowboy life. When hundreds of cows were processed through a Teco squeeze chute, it was always Bud that stepped up to the plate to handle the head catch—the most dreaded of all processing tasks, given the slam, bang, and squeeze functions of cattle restraint. Coordination, timing, and brute strength are key elements of this chore—not to mention endurance. While other crews would rotate the head-catching chore among three to four men over a day's work, Bud never stepped away from the Teco chute over long days that went until dusk. On more than one occasion, I pregnancy-checked hundreds of cows until dark under the beam of headlights, and Bud would persevere until the job was done, never uttering a sound, let alone a complaint.

Bud's Native Hawaiian appearance and warriorlike physique brought significant photographic and festive attention to the bashful and unassuming *paniolo*. Always groomed with a well-trimmed handlebar *'umi'umi*

(mustache) and woolly *pēheuheu* (sideburns), Bud struck a profile much like that of King David Kalākaua. Despite his *lahilahi* (lean) physique, the resemblance to King Kalākaua was more than a passing fancy to the general public of the Big Island in a time when the Merrie Monarch Festival was a budding dream of the founders Gene Wilhelm, Dottie Thompson, and George Naope of Hilo. Decked out in his father's three-piece wedding suit, complete with vest, long-tailed coat, and tie, he entered the first competition for Kalākaua look-alike. Upon winning the contest, Bud accepted the prize of $10 and proudly served as Mōʻī Kane for the weeklong affair. After repeated annual victories in this contest, Bud was graciously asked by Naope to step back from further competition, as no other Hawaiian man could come close to his likeness. Bud not only graciously stepped back the following year, he turned to his buddy Joe Hui, who was comparably endowed with the same regal countenance and the *ʻumiʻumi* and *pēheuheu* to boot! Joe provided a stunning, royal likeness to the king himself and served proudly as Mōʻī Kane. A few years later, his cousin, young Alex Akau, became the third Parker Ranch–born Mōʻī Kane, with a physique that probably bore the closest resemblance to King David Kalākaua. To Joe, Bud, and Alex, it seemed like a fun thing to be a part of, but they also shared deep and moving reverence for their Native Hawaiian heritage.

Bud, astride a favorite horse like his brown gelding Bear Cat, struck an impressive pose, accented by the long rabbit-eared *tapaderos* that he used as a standard. A striking pose of Bud on horseback adorns the cover of the popular 1960 *paniolo* record album, *Paniolo Country*, by Sanford and Marcus Schutte, et al. Mounted on a big iron-grey gelding, Bud's image on the cover brought him deserved honor and attention, enhancing the genuine nature of Schutte's musical contributions. The name of his grey gelding became Paniolo Country from that point forward.

Bud was as aware as anyone that his alcohol burden was real. With family support, he more than once sought help through appropriate agencies, including Alcoholics Anonymous. It was an uphill battle for Bud, but one he faced realistically. On one occasion, I witnessed a very moving incident that occurred in the Village Inn bar on a late Sunday afternoon. A frequent visitor to the Village Inn myself, I noticed a cohort of Bud's at an adjacent table with several friends. Bud entered the bar and pulled up a chair next to his buddy, who was also battling alcoholism. Bud was in a "dry" state and soberly pleaded with his partner to muster the strength to turn away from drink, leave the bar, and go home. I was touched by Bud's soft and deliberate sincerity in giving support to an afflicted friend. Before long, they both left, with Bud's long arm over the shoulder of his buddy with reassuring strokes. What a struggle it seemed for both of them—but especially for Bud, who was reaching out to salvage a friend from the very perils that left him with permanent tremors. He was trying, and that meant everything to me, who—like others in the community—respected Bud for his dedicated work ethic and kindly demeanor. Despite his valiant efforts to abstain, alcohol returned to haunt this gentle soul. Surrounded by a very loving wife and children, Bud died shortly after retirement.

In his final years on the ranch, Bud went from the Cowboy Gang to the Keʻāmuku Di-

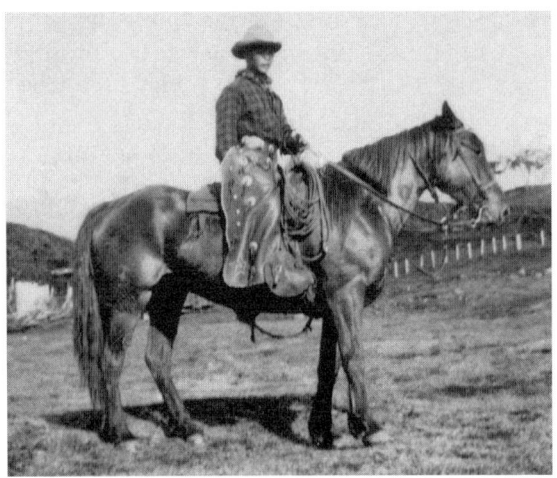

Saichi Morifuji at Shipman's Pu'ukala Ranch. Note batwing chaps, kaula ili, *anchor brand on right thigh of his mount. Courtesy of Yukie Morifuji Wakayama.*

Saichi Morifuji and his wife Tsueno at their Waimea home. Courtesy of Yukie Morifuji Wakayama.

vision in 1971 when that crew was dismantled by the Rubel/Lent management team. Bud and his family lived in the old Alex Bell home at Waiki'i as he oversaw the upper reaches of Pu'u Ke'eke'e, Big He'ewai, and Old Waiki'i Makai under Walter Stevens' direction. Bud served ably as an assistant foreman, overseeing some young ruffians such as Harry Kala and Godfrey Kainoa. Irwin Ching and Jeffrey Dias also reported to Bud and appreciated his wisdom and work ethic.

Bud's love for the ranch, like many of his colleagues, was immeasurably deep. His pride in ranch employment was immense. He was loyal to the land.

Saichi Morifuji: The Broncobuster

In his oversight of the Hanaipoe section of Parker Ranch, "Mori," as he was commonly known, carried a reputation as a horseman that was equal to his excellent name in stewarding the land and cattle of this rich grazing region.

While many of his peers heralded his abilities, there is no finer testimony that could be provided than that of his own family. With some help from his mother, Yukie Morifuji Wakayama, Mori's grandson Alvin included a moving biographical glimpse of the great man in his *Grapevine Lines*, a quarterly mailer produced by Kamuela Liquor Store. It was entitled "*Paniolo* Story," and it appeared in May 1998:

> In the spirit of the Year of the *Paniolo*, we would like to honor our all time favorite *paniolo*—the late Saichi Morifuji, our grandfather. In the early 1920s, Saichi, whose parents were first generation sugar plantation workers in the Hilo/Hāmākua area, eschewed the plantation career and followed the calling of the

mountains and the *paniolo* lifestyle by choosing employment with the Shipman Ranch at Pua 'Ākala, on the slopes of Mauna Kea. Soon thereafter he courted a young lady from Hilo named Tsueno Okimoto and convinced her to wed and move with him to Pua 'Ākala. Since the train from Hilo only went as far as 'Ō'ōkala in those days, it was necessary to ride horseback from 'Ō'ōkala to Pua 'Ākala, about 15–20 miles! To Tsueno's chagrin, this would be her first real experience on horseback; and she would relate to her children and grandchildren years thereafter the horrors of this first ride. In the years to come, Tsueno would become a very able horse rider. Although Saichi reveled in the life of horses, cattle, hunting, etc., Tsueno often found life to be too lonesome; and soon after the second child (Yukie—our Mom!) was born, she convinced Saichi that children would need proper education and that they therefore needed to move back to Hilo. Reluctantly, Saichi agreed and the family moved to Hilo where Saichi pursued a career as a fisherman.

Nevertheless, the calling for the mountains and the *paniolo* lifestyle was in Saichi's soul, and consequently in the mid-1930s he took a job with Parker Ranch and moved his young family of four children to Waimea. At Parker Ranch, Saichi was eventually assigned to oversee cattle at Hanaipoe, high on the eastern slopes of Mauna Kea. The Hanaipoe cattle were part of the famous Parker Ranch cattle drive that started at Humu'ula/Laumai'a on the eastern side of Mauna Kea and eventually ended about 50 miles later at Kawaihae on the western shore of the Big Island, where the cattle were loaded on ships to be marketed on O'ahu. For most of the time, Saichi manned the outpost at Hanaipoe alone. His family lived in Waimea, and he would commute on weekends via horseback, a round trip of some 25 miles.

Saichi retired from Parker Ranch after 30 years of employment. At retirement his most cherished possessions were his horses, *kaula 'ili* (handmade leather rope), handmade spurs, hunting rifles, and his dogs. He cherished those items as much as we do our Lafite '59, Margaux '83, Latour '66, Ramanee Conti '909, Pichon Lalande '82, and Beringer Reserve Cab. '85 today!

Often times when we are running alone on the Mānā Road through Parker Ranch pastures, we gaze at the purely poetic *pu'us*, the majestically powerful Mauna Kea and smell the cool mountain air filled with freshness, spaciousness, and freedom. For an instant, we feel and understand the calling that drove Saichi Morifuji to become a *paniolo*.

In this month of May and in this year 1998, we salute the Hawaiian *paniolos*, Cowboys Second to None!

Joseph (Mickey) Perreira

In his twenty years on Parker Ranch, Mickey Perreira forged an indelible print that reflected the life of a runaway youngster who grew into a respected Rough Rider, cowboy, and jockey through two decades on Parker Ranch that began in 1940.

Born on December 8, 1928, in Pāpa'ikou to Agnes Koilihala, little Joseph Perreira

Mickey Perreira with Junior, a Morgan stallion, at Pukalani Stables, 1961. PPS.

never developed a bond to his father Manuel. In a small house filled with siblings and cousins, there was little food and clothing to go around, and at age twelve Mickey slipped away and headed to Waimea to seek a better life with relatives—the Kauwe, Ninio, and Maertens families.

His diminutive size quickly earned him the name Mickey, given to him by the cowboys as the young boy aspired to an exciting life aboard Parker Ranch horses. His first exposure to breaking horses came from Fred (Nepia) Maertens, with whom he went to live. Nepia had a ramshackle house next to his rickety round pen on the street corner leading to Kūhiō Village, where Māmalahoa Highway and Kamāmalu intersect. Mickey was fearless, athletic, and tough to boot, and it wasn't long before people about town got to know him as a promising horse breaker.

Although these early unbroken horses were from Waimea townfolk, they gave him the opportunity to be observed at work on these unruly mounts, often seen by passersby as they squealed, pitched, and reared with Mickey glued in the saddle, fanning his hat for more action.

Mickey's ability did not go unnoticed by key ranch personnel. In 1943, at age fifteen, he was given a full-time job under amiable and fatherly George Purdy, the respected Breaking Pen foreman. Little did Mickey know that ten years would pass before management offered him a station position. But moving on from the life of a Rough Rider was the last thing on the wiry horseman's mind, especially with the great opportunity to learn and work under George Purdy, training Parker Ranch's rank but well-bred horses.

Mickey's Rough Rider peers were as wild and woolly as he was—they needed to be to work, day in and day out, on the progeny of great remount stallions such as Querido, Ormesby, Moanalua, Lindsley, and Rodgers. These hot-blooded Thoroughbred colts and fillies never reached the breaking pen for training until they were five years old—snorty, stout, and rank. The *pani maka* (blinders) and *kaula hele* (stirrup hobbles) were daily fare.

Mickey fondly recalls his peer horsemen, notably the Akau brothers, Theodore (Sonny Akeni) and Abraham (Manny), and Adam Quintal. Other top hands were Tony Duarte and Jimmy Walker out of Kona and Daniel Pai, Isaac Kaleikula, and Lawrence Kea from Oʻahu. Akina and Kaʻehalio were each named Sam, and they hailed from the Mud Lane/Āhualoa end of the ranch, along with Alfred (Cisco) Stevens Sr. Toward the

end of his Breaking Pen tenure, Mickey rode alongside the Stevens brothers, Charles (Kale) and Walter (Pancho).

On a given day, each horse breaker was expected to ride eight green mounts, first in the round pens, then eventually on out into the vast 300-acre field that extended east of Puʻuhihale Corral. With George Purdy in the lead on a solid, big mount, the Rough Riders would "peel out" of the Breaking Pen over an adjacent stream, Lyon's Ditch, and out onto a 10-acre holding pen surrounded by 6-foot-high stone walls. Using *palaka* (block) lines, these horsemen would hang on for dear life, especially as the bronc leaped across the cold stream and landed "on the buck," with their long necks between their forelegs as they tried to unseat the riders. If a rider was thrown, it was the fast loop of foreman Purdy that would snare the bronc for a return trip to the round pen and a more vigorous reride by a determined Rough Rider.

Once settled, the handful of Rough Riders would follow Purdy through a 12-foot gate that opened into Pāuweanui (pronounced Pāwainui), the 400-acre paddock where Kūhiō Village was later established. A full circle of the paddock was a thirty- to forty-minute workout for the green-broken mounts. A small pond named Pelekuai was on the farthest corner of the paddock, and circling this waterhole signaled the moment to head home for the Breaking Pen, usually at full tilt, rain or shine, Monday through Friday on a mount destined for the Cowboy Gang after a two-month stint with the Rough Riders.

The headgear used by a Rough Rider was called a *kaula waha kekake* (jackass bridle) since it was simply made of a typical heavy-duty leather halter with a snaffle bit tied with rawhide straps to the lateral rings of the nose band. A simple rawhide curb strap kept the bit rings beneath and behind the horse's mouth corners. Topped off with *pani maka* that sported a separate throat strap, the Rough Rider then applied his *laina palaka* (block reins) that threaded through each bit ring and back to the *lina ʻaweʻawe* (rigging ring) on each side. With the *kaula hele* (stirrup hobble) snug and the *kaula ʻōpū* (front saddle cinch) *paʻa* (secure), the Rough Rider was good to go.

Mounting was preceded by firmly lowering the *pani maka* over each eye; then aboard went the rider. Once settled in, with toes turned out in stirrups snugged up by a tight *kaula hele*, the rider reached forward, lifted the *pani maka*, leaned backward, and slackened the reins (*ʻalu ka laina*).

Mickey's decade at the Breaking Pen was unusually long relative to other horsemen, who came and went on to the Cowboy Gang or a station assignment. Few men could endure the day-to-day pounding of one's body frame against that of rank horses and not long for relief. Sonny (Akeni) Akau was somewhat of a parallel to Mickey. Both of them were excellent horsemen, putting good mouths and attractive head sets on their green-broken mounts that would eventually be enjoyed by the cowboys. Both men had rough-and-tumble lives with a penchant for carousing, and it is likely that Hartwell's logic in extending their tenure at the Breaking Pen was guided by hopes that the pair of rowdy Rough Riders would eventually settle down into the more serious lifestyle that was expected of Parker Ranch men. But in the minds of Mickey and Sonny, it was frustrating to watch the flow of other men through the Breaking Pen and on

to better assignments in a three- to five-year span, as opposed to their ten-year tours of duty. But Hartwell also appreciated them for their skill, endurance, and experience, probably doing as much to develop young horses as developing young peers into good horsemen. He may well have left them so long as Rough Riders in the best interest of the ranch as a whole. Hartwell was noncommittal by nature, and interviews with him shed little light on his management of personnel. Eventually, Sonny went on to the Cowboy Gang and Mickey was transferred to the newly reacquired Hanaipoe section under Joe Pacheco. By this time, his reputation as a jockey broadened his image in horsemanship, and few people could appreciate the well-rounded Mickey more than Joe Pacheco, the consummate horseman himself.

Living and working at Hanaipoe was a lonely existence, seeing his family and friends only on weekends. Joe Pacheco was a taskmaster, expecting perfection from his men while being supportive and understanding. Life at Hanaipoe, however, gave Mickey ample opportunity to put a fine finish on many a mount, sealing his reputation as a horse trainer. Also at Hanaipoe was Saichi Morifuji, who shared Mickey's reputation as a bronc rider, rarely if ever being unseated by a bucking horse. Mickey and Mori shared the love and excitement of horse racing, and the Fourth of July races featured these Hanaipoe men in the winner's circle.

When Dick Penhallow became ranch manager, his appointment of Teddy Bell as horse foreman signaled an opportunity for Mickey to get back into the heart of the horse program. Teddy Bell summoned Mickey to the racetrack stables as the horse program was reorganized according to the vision of Penhallow. A more disciplined breeding improvement program was launched with emphasis on registered Thoroughbreds and Quarter Horses. This was paralleled by advanced training techniques starting the green-broken horses as two- to three-year-olds, with an emphasis on gentler methods. While Mickey no longer was expected to serve as a Rough Rider, he played a strong supportive role in the breeding programs as well as processing weanlings, yearlings, and two-year-olds in preparation for training.

With pay and benefits being quite meager to support a family of four daughters, Mickey chose to leave the ranch for the construction industry, leaving behind two decades of excitement, hard work, and good times.

Manuel Nobriga

While Manuel Nobriga became a career cowboy on Parker Ranch, it is important to note that his older brother Joseph had joined Parker Ranch on the same occasion, as ranch hands at the Humu'ula Sheep Station under Willie Kaniho. The Nobriga boys joined the ranch in 1941 after a stint with the Civilian Conservation Corps camp, stationed out of Waimea. The brothers were responsible with reforestation programs in Keanakolu and Pōhakuloa after they completed similar work on the slopes of Hualālai, which hovered majestically above their birthplace in Honokōhau, North Kona. Their father, Manuel Nobriga Sr., lived and homesteaded adjacent to Palani Ranch and worked independently as a fence contractor for Frank Greenwell. Through their father, the Nobriga brothers developed a yearning for ranch life, and Rally Greenwell—who was already situated on the ranch—suggested Parker Ranch. The brothers worked well at Humu'ula, largely because

Manuel Nobriga shortly after U.S. Army induction. Courtesy of Richard Nobriga.

of their excellent work ethic, experience, and familiarity with the Keanakolu and Waipunalei sections of the Humuʻula Sheep Station. When his younger brother Manuel was called to the Breaking Pen as a Rough Rider, Joe moved home to Kona and became a lifetime employee of Palani Ranch. Well before retirement, Joe became a skilled leather and rawhide worker, which developed into a significant avocation. Their only sister, Mabel, married Freddy Gouveia, a Kona cowboy who developed a successful career on Oʻahu as foreman at the Hawaii Meat Company feedlot. Gouveia was often sought after to train horses, and as a farrier he was considered a master in status.

Manuel had his sights set on a pretty Native Hawaiian named Beatrice Hoʻokahi, and the move to the Breaking Pen brought them together. Joe Pacheco was Breaking Pen foreman at the time and found Manuel to be a dependable Rough Rider. At that time, the unbroken horses were arriving by the dozens for rotation through the raucous train-

Manuel Nobriga mounted at branding at Puʻu Papa Corral. PRC.

Jiro Yamaguchi branding at Puʻu Mahoelua on a half-Percheron product of the Breaking Pen, a finished gelding of Larry Hoʻokahi. PRC.

ing regimen. Pacheco was disappointed to lose Manuel to the war effort when the Kona cowboy volunteered to serve his country. Alongside young Henry Ah Sam, Manuel left for boot camp at Schofield Barracks, after which he was shipped off to the battlefields of Eniwetok, Saipan, Espirito Santo, and finally, Okinawa. Wounded there in 1945, Manuel, decorated with a Purple Heart, left for Tripler Army Hospital for convalescence. Exactly two years after he left Waimea, Manuel was back on the ranch payroll.

Less than a year on the ranch, opportunities beckoned Manuel away. After a short stint as a bus driver with Honolulu Rapid Transit Company, Manuel was back in Waimea as a forest ranger working for Duke Kawai. A forest ranger position opened up in Kona shortly thereafter, working mostly at the higher elevations on Hualālai using a string of pack mules to deliver tree plantings, camp equipment, and implements.

Largely for family reasons, Manuel moved back to Waimea, where his new wife Bea resided. After a try at county work, Manuel joined the ranks of the ranch for good. Assigned to the Breaking Pen, Manuel reported to George Purdy and immersed himself in an eleven-year span, riding some of the ranch's best mounts to a point of genuine satisfaction. Like Mickey Perreira, it seemed as if he was locked into a lifetime career as a Rough Rider, with no hope of upward mobility. Enduring these tough years was made possible by pride in their work, appreciation for the fatherly boss George Purdy, and by their loyalty to the land.

In 1961 Manuel was called to the Cowboy Gang, reporting to John Samoa Lekelesa and his assistant Bob Sakado. After a chronic

and recurring injury and an eight-year span on the Cowboy Gang, Manuel was furloughed to the ranch nursery under Hisa Kimura, but he was not happy with a life without horses and cattle. In January 1970, he was promoted to assistant foreman under Goichi Fujii, who oversaw the First Gate, Second Gate, and Paʻāuhau sections.

Manuel had a brother-in-law, Larry Hoʻokahi, whose career in the Breaking Pen followed Nobriga's over a four-year span. A left-handed *paniolo*, with a slight but tidy physique, Hoʻokahi matched his brother-in-law's prowess as a Rough Rider. Larry Hoʻokahi's career on the ranch ended when he left for the construction industry, but his reputation lingered as a producer of gentle mounts with soft mouths.

I became well acquainted with Manuel, as that section he worked was an intensive preconditioning area for feeders headed for the Oʻahu feedlot. Manuel was a noted caregiver of these calves, sometimes being overly concerned with their welfare. I deeply appreciated Manuel's love and care of the animals he looked after despite his "mother-hen" approach to care giving. Manuel died shortly after retirement, but his memory lives on through his widow Bea and their fine son Richard, an image of his father.

The Twilight of Hartwell's Horse Program

In reviewing the fifty-year history of the AQHA, it appears that the presidents of the organization more often than not were acquaintances of the Carters or individuals who otherwise engaged in business transactions with Parker Ranch. These contacts were invaluable far and beyond Hartwell's management period. But their backgrounds shifted away from the remount commonalities or the "bulldog" men (those who advocated the smaller cow horse with disdain for the Thoroughbred) to more of racing, cutting, and performance horse people. The Carters and their peers advocated bigger, faster mounts that had inherent cow sense.

While names such as Kleberg, Kieckhefer, Ellsworth, Norris, Vessels, and others represent the latter era of the half-century relationship between AQHA and Parker Ranch, no one could match the enduring and close relationship of William "Bill" Verdugo of Clovis, California, who descended from the Castilian caste of the original owners of Alta, California. Verdugo grew up on horseback in the fine Hispanic tradition—but with a progressive flair. Securing an education, he joined the faculty at Fresno State College. During his college years, he befriended several young men from Hawaiʻi who were well engrained in the Hawaiian livestock industry. This relationship with his students continued during the seventeen years he headed the Horse and Cattle Breeding programs while on the faculty of Fresno State. His tenure there began in 1948, during the formative period of AQHA, in which he served on the executive committee for several years before becoming president in 1971. Although youth and foreign committee activities kept him busy, along with teaching and livestock judging, Bill gradually became more involved in livestock transportation and agricultural consultation on a national and international level.

By 1965, Verdugo left Fresno State for

a career in the livestock business, with an emphasis on locating and delivering blooded stock all over the world. Largely through the nature of his work and his historic ties to Hawai'i, the Verdugos, Bill and Joan, became close friends of Hartwell and Becky Carter. The Hereford bull provided the link between the two families, and their prominent role at the annual cattlemen's Bull and Horse Sale each November sealed Verdugo's relationship with Parker Ranch as its most noted mainland livestock industry liaison. By this time, Hartwell had long retired, and the progress in the horse department of Parker Ranch reflects on his stewardship. The full impact of the Quarter Horse was yet to come, and Bill Verdugo was a significant architect of Hawai'i's continued progress in modern horseflesh. Excerpts from his obituary attest to the fact that Parker Ranch and the entire state were not the only beneficiaries of his expertise.

Bill Verdugo

William Rowland (Bill) Verdugo was born September 1, 1919, in La Puente, California, a direct descendant of the Spanish pioneering families of Verdugo, Rowland, and Yorba that settled in California with Father Junipero Serra in the mid-1700s.

Growing up on family cattle and horse ranches, Bill was exposed early on to the true *vaquero* tradition of excellent horsemanship. Appropriate stewardship of the livestock, land, and people around him was ingrained deeply in his mindset and values. His devout Catholicism was a lifetime passion. After high school years in southern California, Bill chose to attend college at California Polytechnic Institute in San Luis Obispo, where he majored in animal science. He befriended several classmates from Hawai'i, with whom he maintained longtime friendships over the years. Despite the interruption created by World War II, in which he served as a recruit trainer, Bill graduated from Cal Poly in 1947.

Shortly after graduation he was selected to design and execute the cattle and horse breeding operations for Fresno State College (FSC). Armed with intensive exposure to fine cattle and horseflesh during his upbringing, coupled with college training in livestock breeding and judging, Bill built the Fresno State College program from the ground up. Soon recognizing his natural teaching ability, FSC placed Bill on the faculty with a full teaching load, while he remained overseer of the college livestock farms.

It is known that during his teaching years, he became further acquainted with students from Hawai'i, and they likely piqued his interest in the livestock industry of the Hawaiian Islands. Between his years at Cal Poly and FSC, Bill developed special aloha for the Islands that carried on throughout his professional life in the field of livestock transportation, purebred cattle, and registered Quarter Horses.

His marriage in 1962 to Joan Gallagher, who hailed from a noted ranching family, reinforced his place in better circles of the horse and cattle industry. Witty and ranch-wise herself, Joan added to the Verdugo stature of respect among cowboys and corporate leaders alike. As a couple, they were welcome everywhere from Honolulu to Florida and from Calgary to Rio de Janeiro. His Hispanic/caballero aura underscored the mystique, cementing his comfortable presence among the working cowhand as well as the leaders of governments throughout the Western hemisphere. These national and international relationships were further enhanced

beyond his faculty years when he launched a private enterprise in livestock consultation and transportation. In partnership with William Eby of Maui, a Cal Poly classmate, Pacific Airlift, Inc., was born, providing winged transportation for purebred cattle and horses all over the world. Bill appropriately received the Pioneer Award of the Animal Air Transportation Association in his later years.

During the late 1960s I became closely acquainted with the Verdugos, first through social interactions surrounding the annual Hawai'i Cattlemen's Association Bull and Horse Sale. Very quickly, I grew to depend on Bill's expertise on a variety of fronts, including the regulatory and animal safety requirements of both air and sea transport of livestock. For the remainder of our relationship, I relied heavily on Verdugo's judgment and advice whether about livestock, people, or property while observing him groom and nurture a young Vincent Genco into a promising protégé in the international livestock business.

On several of my trips to the mainland, often to buy bulls or horses for clients, friends, and occasionally for myself, it was a distinct pleasure to cover ranch country by car with Bill through California and Nevada and witness the respect afforded him through every gate or door he crossed. On great ranches, hallowed horse farms, in smoky bars or Basque restaurants, people honored Bill as a native son. Always calm, congenial, and respectful, his native tongue gave comfort to the *vaquero* and shepherd alike, while his rich sense of humor would humble the Irish.

Bill's contacts with Hawai'i's livestock industry were typical of his demeanor—high tea with the Baldwins followed a day of observing the progress in beef production by fine sires he had secured. His day would have opened with early morning Mass and ended with raucous cowboys at a Makawao bar. Endeared to Hartwell and Rebecca Carter through the Hereford breed of cattle, he was as comfortable sharing a drink with the likes of the rowdy Ed Hedemann of Kona, with the Angus breed of cattle serving as their common link.

As for his service to the Parker Ranch, it spanned the management regimes of Hartwell Carter, Dick Penhallow, Rally Greenwell, Gordon Lent, Don Hanson, Walter Slater, Charlie Kimura, and Robbie Hind in capacities that varied from livestock consultant to breeding programs, bull and stallion selection, and transport.

In a memo from Vince Genco in 2004, several poignant points were made: "Probably the most outstanding memory is how many Hawaiian Ranches trusted Bill to buy their bulls and horses and ship them sight unseen to Hawai'i for years."

Bill passed away on December 28, 1998, leaving a great void in the livestock industry of America. The Verdugo-Genco enterprise carries on well into this day, however, still forwarding top cattle and great horses to the Hawaiian Islands, where his wife Joan has chosen to reside and where ranch folks still consider him a native son. Vaya con dios Señor Bill. . . .

Military Occupation and Initiatives: Camp Tarawa

Few *kama'āina* of Waimea remain today who can recall the early advent of the military to the district of Waimea in South Kohala. We commonly think that Camp Tarawa was a U.S. Marine Corps initiative born out of

Leading the grand entry is rodeo queen Marge Wilson, escorted by outriders James Palaika (left) and Kuakini Lindsey. Below, grand entry of the ranch paniolo *procession continues, followed by a jeep convoy. Courtesy of Pacific War Memorial Foundation.*

emergency war efforts and located originally where the bronze commemorative memorial plaque now rests. In fact, the military established its presence in the sleepy ranch village months before the December 7, 1941, bombing of Pearl Harbor by Japanese aircraft.

On June 1, 1941, Company F, 299th Infantry of the U.S. Army established its headquarters, complete with a medical detachment, at the former Civilian Conservation Corps Camp in Puʻukapu, a 10-acre site where the Department of Hawaiian Home Lands office now sits in the Prince Jonah Kūhiō Hale.

Three months after the bombing of Pearl Harbor, the U.S. Army chose to expand its presence in Waimea, with the 27th Infantry broadening its areas of occupation to include a campsite and bivouac area across from ʻImiola Church on the old Māmalahoa Highway, where a battery of olive drab–colored pyramidal tarpaulin tents were erected. By June 1942, defense posts were set up across North and South Kohala, where area ranchers—including Parker and Kahuā Ranches—granted licenses for $1.00 per year for U.S. Army troops to occupy the areas. The Waimea District became the heart of support services, as the troops were part of the perma-

Marines await movie attendance outside the USO Club (formerly Barbara Hall, later Kahilu Hall). PPS.

nent U.S. Army garrison of the Territory of Hawai'i. Destined to become a training camp for 19,000 men, it was planned as the divisional headquarters for four regimental combat teams. In early 1943, the U.S. Army and Navy forces were mandated to form, train, and equip such military contingents, and the dramatic expansion of the Waimea presence was beginning to unfold.

The new venue was chosen after detailed consultation with A. W. and Hartwell Carter. Waiemi, a 441.5-acre parcel located on the western border of Kamuela village, was traditionally used as a holding area for market cattle destined for shipment to Honolulu. Divided into paddocks named Honolulu, Lihue, and so on, its convenient location at the trailhead to Kawaihae Harbor was sacrificed to provide the armed forces with a campsite location of their choice, given the blessings of the Carters. Before construction of the new training facility that was to be christened Tarawa, the site was formally transferred to the U.S. Navy for a marine camp and training area for the amphibious assault on the Japanese-occupied Gilbert and Ellice Islands and Nauru. The first improvements included erecting a battery of wooden warehouses and a quartermaster bakery. Expanding the holding capacity of the new facility to accom-

Left: Bandaging mates at Camp Tarawa. PPS.

Below: Marines marching at Camp Tarawa. Note Buster Brown Hill (Puʻu Hōkūʻula) in background. PPS.

modate 25,000 marines, the commander of the Naval Air Station in Hilo sent a 100-man detachment of the 59th and 99th Naval Construction Battalion in November 1943 to prepare the campsite and messing facilities for the construction crews as well as the soon-to-arrive hordes of marines.

Within a month, battered survivors of the bloody Battle of Tarawa, the 8th Marines of the 2nd Division, began to arrive at the new campsite only to find the facility incomplete. Soon after came the 18th Marines (Artillery) and the 19th Marines (Engineers) of the same division. The 8th, 18th,

and 19th Marines, battleworn as they were, ably stepped in to help the naval construction battalions erect the mess hall Quonset, pyramidal tents, Quonset supply warehouses, and wood-framed administrative buildings. Water resources were developed via dirt reservoirs in the Kohala foothills above Kamuela, linked by pipelines that served the entire campsite, including the mess hall and bathing facilities.

In April 1944, the 2nd Division left Camp Tarawa for the Battle of the Marianas, and within months the 5th Marine Division came to rest, recuperate, and then train for the Battle of Iwo Jima. Following the assault on Iwo Jima, the battered 5th Division returned to Camp Tarawa in March 1945, again to rest, recuperate, and train for the proposed invasion of Japan. Within six months, all such training ceased, as World War II ended. The 5th Division was sent to Japan for occupation duty. Except for a security detail, Camp Tarawa was entirely evacuated.

Only in December 1945, with the war well over, did the U.S. Army regain control of Camp Tarawa, at which time an inventory of facilities, fixtures, and materials was executed in preparation for public sale and distribution to appropriate parties. Bids for buildings and equipment were opened in March 1946.

It is quite likely that the Carters heralded the development of water resources, as well as the military-established oil-generated electricity and ice plant for eventual community and ranch use. Certainly the many Quonset huts and wooden buildings erected by the hundreds were eyed as potential ranch facilities. Weighing heavily on the Carters' minds, however, was the displacement of cow herds, loss of grazing resources, and environmental degradation. While the open-pit latrines were treated daily with lime and the weekly burning of the contents with diesel fuel was viewed as a necessary nuisance, the bombing of the Waikoloa lands that A. W. so ably sought in behalf of his ward Thelma Parker, the pounding of thousands upon thousands of artillery shells, offshore missiles, and aircraft bombs on the cherished *'āina* likely turned his stomach. Aircraft carriers were busy practicing close support exercises with live ordnances as infantry, tank, and artillery forces with live firing maneuvered about the area between Pu'u Pā near Waimea Airport and Pu'u Hīna'i, a hill just west of Waikoloa Village. Able-bodied marines were occasionally killed during these mock battles as a result of short-falling artillery and bombs or misplaced targets.

Even the County of Hawai'i suffered collateral damage from military exercises. In the winter of 1944, a tractor, a Caterpillar, a rock crusher, and two sheds were destroyed by bazooka and machine-gun fire. Shortly after the war, the U.S. House of Representatives Subcommittee settled the county's claim for $2,200 in damages with an award of $1,550. Later, in a separate gesture, the military forces turned over to the County of Hawai'i 250,000 board feet of lumber, 20,000 sheets of plywood, and 6,000 drums of high-octane gasoline as generous frosting on the cake.

The Territory of Hawai'i was granted eventual ownership of the three military reservoirs, totaling more than 14 million gallons, which vastly improved municipal water resources for the Waimea District. For Parker Ranch, receipt of the ice plant (then located at the western apex of Church Row), several Quonset huts, and the bakery building in lieu of property restoration was likely crafted with

significant involvement of A. W. and Hartwell Carter.

The public sale of the disposable military inventory garnered about $75,000 for the U.S. Army. The list of facilities reflects the magnitude of Camp Tarawa:

- 400 wood/canec buildings, various sizes
- 30 20-foot Quonset huts, various lengths
- 29 40 x 100' Quonset hut warehouses
- 17 40 x 100' Quonset galleys with refrigerators and steam plants
- 7 gasoline pumps with tanks
- 3 batteries of refrigerators with 6 units per battery
- 1 10,000-square-foot cold storage plant
- 1 60 x 150' wooden warehouse

In addition, several 10,000-gallon water tanks, 16 x 20' portable barracks buildings, and miscellaneous fixtures were offered for public purchase.

Defusing History

In 1946, the U.S. Marines assigned a detachment of 120 men to begin clearing ordnance from the Parker Ranch impact areas. They began with the Pōhakuloa area and combed for unexploded shells and bombs up to the 6,500-foot elevation. Simultaneously, an 80-man unit was assigned to the Kawaihae area, combing the coastline from Kapaʻa in North Kohala and on to ʻAnaehoʻomalu Bay. By the end of this cursory campaign, more than 90,000 acres had been superficially swept for ordnance, but the worst civilian incidents were to come nearly sixty years after the military left the Waimea facility.

In May 1954, while a Parker Ranch fence crew was digging a corner posthole in Keʻāmuku, a 60 mm mortar projectile was inadvertently disturbed. Nineteen-year-old Russell Iokepa and twenty-year-old Theodore Lindsey were killed, while Theodore's brother Edwin Keao Lindsey, John Alameida, and Gene Mitsunami were severely injured. Although the navy immediately dispatched a three-man explosive ordnance disposal unit to investigate, the surge of public awareness in the Waimea community was profound. Kohala police located a 75 mm artillery shell, while area residents located eight more dud projectiles. Later the same year, a four-man ordnance disposal team on ranch lands detonated a 37 mm antitank shell, a 60 mm mortar projectile, a 4.2-inch mortar projectile, and two hand grenades. Hartwell was deeply concerned about the continued discoveries, accidental or deliberate.

These repetitive ordnance findings generated enough concern that a joint army-navy explosive ordnance disposal team was assigned to comb over 100,000 acres of ranch lands used in World War II maneuvers—the largest clearance operation ever up to that time.

In September 1954, an advance party established headquarters at Camp Tarawa. The combined party represented the U.S. Army Pacific Explosive Ordnance Unit, and their first assignment was a 15,000-acre parcel in which forty shells per 100-acre units were routinely uncovered and disposed of. The 92-man team was then assigned to a 40,000-acre impact area with a much higher concentration of unexploded ordnance. This degree of concentration was reflected in the finding of more than 900 rounds in a third target area of nearly 51,000 acres, yielding an average of more than 181 per 1,000-acre units. While another 3,500 acres were thoroughly searched,

a final 50,000 acres received only superficial examination. All told, the 1954 campaign yielded hand grenades, rifle grenades, 60 mm and 81 mm mortar projectiles, 75 mm, 105 mm, and 155 mm artillery shells, and aircraft bombs. Other findings included 2.75-inch rockets, Mark 2 hand grenades, and practice land mines. Considering the missed findings coupled with the trampling of animal and man, highway and home construction, as well as the natural forces of wind, rain, and erosion, it is no wonder that the issue of unexploded ordnance seems never to go away. Hartwell's concerns were deeply prophetic: Since 1940, nine people have been killed or injured in the Waimea area due to ordnance explosions.

Nearly thirty years after the 1954 campaign, a pair of soldiers was injured by ordnance near Puʻu Pā as they participated in a military exercise ironically dubbed "Opportune Journey." Such findings causing injury and in some cases death would haunt Camp Tarawa into the new millennium. In 2004, the U.S. Army retained the private services of American Technologies, Inc. (ATI) to retrace the vestiges of ordnance of the military's mission and maneuvers of sixty years before.

American Technologies' contract for the ordnance project covers the 123,000-acre area known as the Waikoloa Maneuver Area with a five-year federal budget of $50 million. Overseen by the U.S. Army Corps of Engineers, the ATI team came equipped with archaeologists, surveyors, geophysicists, and an array of field technicians using GPS (Global Positioning System) technology to grid-block 50 x 100-meter units for magnetic examination. Congressman Ed Case, most instrumental in securing the federal funding, stated, "Our military needs places where it can train fully to protect our country, but when they have completed their mission, it is only right that they clean up and assure those of us that come after them can use the land safely."

Defense spending on the Big Island opened up a new avenue for detection of unexploded ordnance using a system called the Airborne Ground Penetrating Radar, which can detect buried metallic objects from a remotely piloted aircraft.

Relocation of Military Operations

Hartwell, likely with the support of Richard Smart, was instrumental in relocating military operations from Lālāmilo to Pōhakuloa. Lālāmilo is a long strip of land of 9,000 acres that has its *mauka* end near Richard Smart's home in Puʻuʻōpelu and the *makai* portion near the Kawaihae coastline. In retrospect, Waimea village would never have remained the quaint cow town had a military base been part of it. It is highly likely that it would have become what the town of Wahiawā on Oʻahu has become with Schofield Barracks located there.

Further, Richard Smart was critically aware of the overwhelming wartime generosity extended from the ranch to the U.S. Marine Corps. In the history of Camp Tarawa and adjacent training areas, the ranch

- Lost two employees to live grenades—Theodore Lindsey and Russell Iokepa;
- Provided private medical and hospital services to three employees severely injured in the same Range I accident—Edwin Keao Lindsey, Gene Mitsunami, and John Almeida (Tripler Army Hospital would not receive them);
- Provided a total of 202,674 acres for

> **UNITED SERVICE ORGANIZATIONS**
> For National Defense, Inc.
> Box 1494
> HILO, HAWAII, U. S. A.
> July 17, 1944
>
> Mr. H. Carter
> Parker's Ranch
> Waimea, Hawaii
>
> Dear Mr. Carter,
>
> I am enclosing a set of the pictures taken at the opening of the Kamuela USO Club as I feel sure you will enjoy having them.
>
> I was happy for the opportunity of talking with you on my recent trip up there, and I hope that in the near future everything can be worked out to your satisfaction.
>
> Very sincerely yours,
>
> Richard W. Palmatier
> Island Supervisor
>
> RWP:ap

USO Letter to Hartwell Carter indicating the military's desire to remain in good graces with the Carter regime.

maneuvers, with 85,000 acres held over two years beyond the war's end;
- Suffered significant pasture shortage as military areas were evacuated of all livestock;
- Suffered the exacerbation of the cactus and fountain grass infestation as control measures were suspended;
- Stood for property tax liability through the entire use period; and
- Continued to be exposed to undetonated ordnance through 2005.

For all of the ranch's patriotic sacrifices, the federal government paid only $1.00 per year for the use of the properties.

Despite all of this, Hartwell graciously offered to give up adjacent pasturage in Kaʻohe 3 and 4 and part of Puʻu Keʻekeʻe if the military would move operations entirely to Pōhakuloa. On December 11, 1952, Hartwell wrote a memorandum to Lt. General Franklin A. Hart of the U.S. Marine Corps, quoted here in part:

Lalamilo. The land of Lalamilo is situated in the district of South Kohala on the north west side of the Island of Hawaii. As you can see from the map it is a long, narrow parcel. It contains approximately 9,000 acres and is eight miles long and two miles wide. The terrain is rough. The distance from this site to Hilo is 62 miles. Hilo, as you know, is the only sizeable town and the only real deep water seaport on the island. If the land is to be used for a camp site and training area we believe that ultimately you will find it inadequate. In viewing the land on the ground it is not too easy to envision the boundaries since there are no distinguishing marks between Lalamilo and the adjacent land, which is owned by us in fee simple. . . .

During the war Parker Ranch, in order to cooperate fully in the war effort and particularly with the Marine Corps, made available an area of land approximately 70,000 to 80,000 acres, rent free, which was used for approximately two years. This involved the normal problems of any area where a full division or more was stationed. We enjoyed good relations with the command and the officers and men.

Since the war we have lost large tracts of land and are now unable to surrender additional areas without suffering a serious handicap in our operations. . . .

Kaohe 3 and 4—Pohakuloa. This land contains approximately 27,000 acres, a part of which is a territorial game reserve and Kaohe 3 [Ahumoa–Pu'u Ke'eke'e] is a horse pasture used by us. This particular site was indicated to your officers making the land inspection and it has since occurred to us to be more desirable than any of those heretofore under consideration. The area is adequate and it is not objectionable from the standpoint of being a long sliver of land such as Lalamilo. This tract is 35 miles from the city of Hilo and contains a spring, which could be used to supply water tanks for storage if that is desired. At the same time there is a 500,000-gallon tank in use on the land. If this area were selected as the maneuver area it would be feasible and convenient for you to have a camp site on the saddle road at the location of the old Prisoner-of-War camp. There is in this area approximately 100 acres which camp would be 9 miles from the city of Hilo and 26 miles from the maneuver area of Pohakuloa. Assuming that Lalamilo could not be used for both a maneuver area and camp site and that you would be obliged to acquire other lands for a maneuver area in the event you chose Lalamilo as a camp site, we point out that the distance from Lalamilo to Pohakuloa is 26 miles and the distance from Pohakuloa to the POW camp is likewise 26 miles. . . .

If the proposed site at Pohakuloa meets with your approval and you are willing to forego the use of Lalamilo as a camp site in favor of the one which is nearer the city of Hilo as suggested, we would be quite willing to make available to the Marine Corps an area of Parker Ranch land adjacent to Kaohe 3 which is now used as our horse pasture, of approximately 6,000 acres. Moreover we will turn these areas over to the government for a reasonable period without rent.

Richard Penhallow with Pōhakuloa Training Area brass. Brigadier General Jonathan O. Seaman is on Penhallow's right. Penhallow collection.

By early 1953 the U.S. Marine Corps responded with interest to Hartwell's proposal, and from that point forward it became Dick Penhallow's function as Hartwell's assistant to follow up on the details with Richard Smart's knowledge and consent. Accommodations also were made in the Keʻāmuku area for specialized maneuvers, but all heavy artillery activity was limited to the lava wasteland of Mauna Loa in the area known today as the Pōhakuloa Training Area. Later a tank road was added, traversing Parker Ranch from the LST harbor in Kawaihae to the Pōhakuloa Training Area. Most recently, the U.S. Army offered, in principle, to buy 23,000 acres of Parker Ranch's Keʻāmuku Division. While Smart was elated to have the military out of Lālāmilo and into Pōhakuloa, he would likely have cringed at the thought of taking a productive division of the ranch and selling it to the military. While he would never be considered a dove, Smart abhorred war, having lived with his wife and two sons in Honolulu during the Pearl Harbor bombing.

Kawaihae: The Portal of Parker Ranch

Throughout his career on Parker Ranch, Hartwell witnessed dramatic progress in cattle shipment in which both the military and sugar interests fostered vast improvements in Kawaihae Harbor, which was so vital to the marketing of beef since the early days of maritime commerce.

Often told is George Vancouver's landing of a cow and bull via canoe from the HMS *Discovery* on February 19, 1793, with horses arriving a decade later in the usually calm bay of Kawaihae. Two centuries and a dozen

A view of Kawaihae village in 1939. Courtesy of Owen Chock.

years later, the seaport of Kawaihae remains the gateway of the livestock industry on the Big Island. The journey to the present, however, traversed many a storm.

Typical maritime commerce did not begin until nearly forty-five years after the first cattle arrived. William French, the American businessman and sandalwood trader, built a stone building that served as a depot for incoming and outgoing freight. In the following decade, John Palmer Parker established the Parker Ranch, which was destined to export more cattle out of Kawaihae than the sum total of all other Big Island ranching concerns—a fact that holds true to the present day. In the last half century, the ranch has shipped more than 720,000 cattle out of this seaport. In the same period, other ranchers shipped cattle numbers that would round the total into well over a million head.

By 1850, the port of Kawaihae was opened to foreign commerce, with whaling and freight vessel visitations frequenting the bay on nearly a weekly basis. Exports included salt beef (1,500 barrels) and Irish potatoes (5,000 lbs). Cattle hides (1,200) and goat hides (5,000) were shipped out, along with more than 40 tons of tallow. As for interisland freight, the 87-ton schooner *Mary* paid weekly visits, often returning to O'ahu with live cattle for Honolulu slaughterhouses near the wharf.

G. W. Macy, another Kawaihae business agent, assumed French's agency but was soon a neighbor of another shipping and merchandizing concern, Louzada, Spencer, and Co., which was also active in the early beef industry. Macy, however, took the initiative to build the first Finger Wharf, 12 feet wide and 90 feet long, made of oak pier posts and planking. The new facility boasted a railway and rail cars for freight transfer. For purposes of maritime safety, Macy built a lighthouse near the mouth of the bay. This was 1859, a century before one of several storms would plunder the wharf in Kawaihae. The whaling industry had moved elsewhere, while Kawaihae remained the main outlet for cattle in the modern maritime history of Hawai'i.

A series of days of high surf in 1888 damaged the freight dock of the wharf but did not affect the ranchers, since cattle were still being swum out by lasso behind a *paniolo*'s draft horse, then lashed to a lighter that took the steers schooner-side for lifting into the vessel. It wasn't until 1905 that a new wharf was built. As in the case of Macy's wharf-building efforts, *kama'āina* seamen strongly cautioned that the designs had inherent problems from placing the structure directly in harm's way—the pathway of Kona storms. It took a dozen or so years to prove the native seamen correct: A 1918 storm ravaged the peripheral planking. Largely through the persistence of A. W. Carter, plans started in 1936 by the Territorial Board of Harbor Commissioners called for a reinforced concrete wharf at Kawaihae. Dedicated on November 17, 1937, the new wharf was 60 x 100 feet, covered with a 24 x 48-foot shed. Extending out

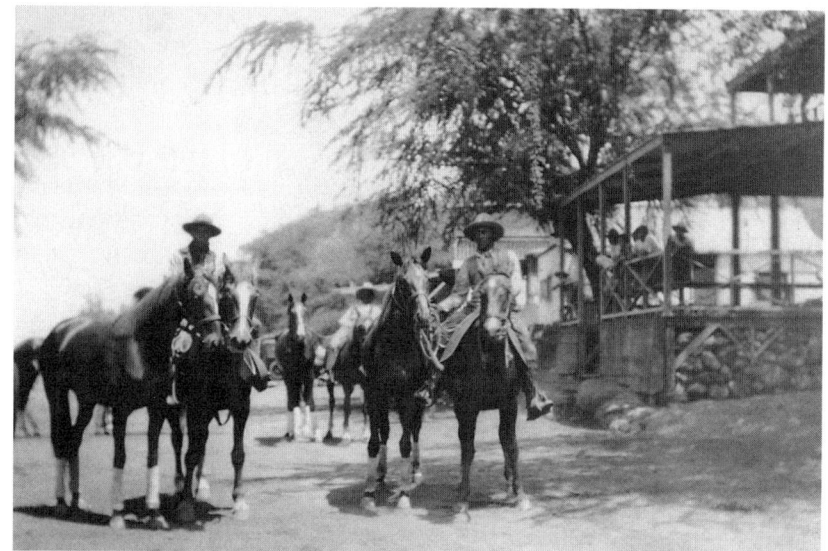

Old Kawaihae. Two-story building is Chock Hoo Store in Kawaihae. The four Thoroughbreds are bound for mainland racetracks. James Palaika is on the right, Kamaki Lindsey on the left. PPS.

New wharf dedication, 1937. A. W. Carter, with coat and tie, oversees the lūʻau preparation. PPS.

into deeper waters, a 20-foot wide and 325-foot long railed approach stretched from the cattle pens on shore to the dock's end. Named the "Finger Wharf" by the Kawaihae people, only three weeks passed before a Kona storm plundered the shoreside section of the wharf, leaving a 60-foot gap between land and the rest of the pier, now standing alone offshore. Within a year of its dedication, the repaired wharf was again plundered by high surf.

The Second World War's activity on the Big Island was dependent on Hilo's wharf, which then featured the only deep-draft harbor. But things changed quickly when Hilo

Harry Kawai and Kuakini Lindsey at Kawaihae in 1939. Photo courtesy of Eva Lindsey Kealamakia.

Harbor was severely damaged by the April 1, 1946, seismic wave. While the tsunami left Kawaihae Harbor sufficiently able to export livestock, even these facilities were plundered by a Kona storm on February 10, 1947, severely damaging the cattle loading facilities and stranding several hundred Parker Ranch animals that had to be walked back home to Waimea.

Territorial district engineer Edward Stanley (Blue) Kaʻauʻa, son of the famed roper Archie Kaʻauʻa, announced in 1947 plans to reconstruct Kawaihae Wharf that included new concrete footings and decking. Also, the plans included a telescoping cattle chute that allowed the animals to walk directly aboard from the dock. Within a couple of years, then governor Farrington spoke of establishing Kawaihae as a deepwater shipping harbor with the support of federal dollars and design by the Army Corps of Engineers. These plans included deepening the "draft" of the harbor to include a turning basin that would be entirely protected by a breakwater. As ranch manager responsible for the bulk of livestock shipments, Hartwell Carter was kept in the loop during all stages of planning.

Another pressure to improve Kawaihae Harbor came from the sugar industry. The Territorial Board of Harbor Commissioners was closing the Māhukona Wharf, which meant that the Kohala Sugar Company would have to convert from bagged to bulk sugar and truck the product 95 miles one way to Hilo Harbor. A consortium of Kohala Sugar Co., Honokaʻa Sugar Co., and Hāmākua Mill Co. formed Kawaihae Terminals Inc. to receive, store, and ship all of their sugar and molasses, sharply reducing their cost of doing business.

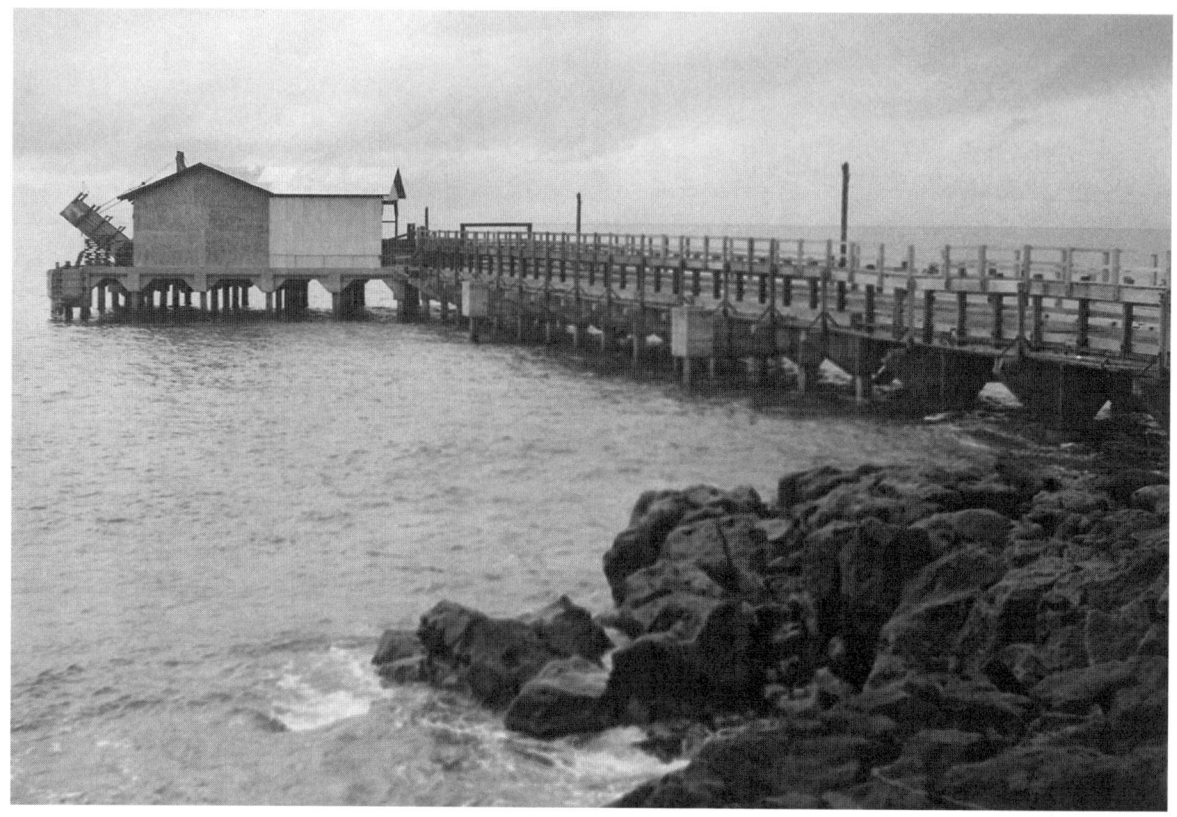
Brand new Finger Wharf ready to service the cattle industry, 1946. PPS.

An even greater pressure to upgrade Kawaihae Harbor to a deep-draft facility came from the territorial (and later state) government, which in 1956 transferred nearly 800,000 acres of land to the federal government to establish the Pōhakuloa Training Area, and Kawaihae was vital to the military plans for such a training expansion.

By 1958 the dredging project was complete, utilizing an entrance channel 400 feet in width, 2,900 feet long, and 40 feet deep. The turning basin was 35 feet deep and 1,250 feet square. Soon thereafter, shore facilities were built that included a bulk sugar warehouse, a loading conveyor system, and a 200-foot marginal wall. Large wooden cattle shipping pens were built in secure locations to service the cattle industry.

But the storms kept coming out of Kona to the exposed facility. In December 1958 and January 1959, severe surf pounded the breakwater, cattle loading facilities, and even the small-boat harbor. Navigational problems were real. I worked on the Hawaiʻi Transportation and Terminal tugboat, the *Hilo Packet*, a powerful 90-foot vessel propelled by two 900-horsepower diesel engines that frequented Kawaihae to assist large vessels and barges. Captain Manuel Martins dreaded the Kawaihae Harbor because of the treach-

Above left: Storm damage, 1959, Finger Wharf: alley with damaged planking. PPS.

Above right: Storm damage, Finger Wharf: crowding/loading chute totally demolished. PPS.

Left: Storm damage, Finger Wharf: gateway plundered by high surf. PPS.

Right: Reverting to the swimming of cattle—leading steers into the surf. Note SS Humu'ula *anchored offshore adjacent to damaged wharf. PPS.*

Below: Longboats in tow to the waiting SS Humu'ula *for loading by overhead winch. PPS.*

Left: John Holi Ma-e, complete with wool chaps, bids aloha 'oe—*the true and final ending of* ho'au pipi, *the swimming of cattle to the* SS Humu'ula. *PPS.*

Above: Henry Ah Fong at Kailua pier. *PPS.*

Dredging Kawaihae Harbor: blast #1. Penhallow collection.

Dredging Kawaihae Harbor: blast #2. Penhallow collection.

View of Kawaihae Harbor from Puʻukoholā Heiau. Penhallow collection.

erous currents, surf, and severe winds. As a deckhand, I enjoyed the excitement.

During the 1960s and 1970s, Young Brothers' cattle barges were essentially sea-going corrals where cattle were loaded and offloaded in a variety of weather and surf conditions, with Kawaihae Wharf being one of the more challenging. In a 2002 interview with Anna Loomis of the Oʻahu Cattlemen's Association, Walter Slater aptly recalled the rigors of shipping during this period:

> When we first started, they'd load these cattle right on the barge, in pens on the barge, and that was quite an operation. When the weather was bad, the surge of the ocean would go way up and down, and the old chute that goes to the barge would go up and down maybe 5 feet. The animal would be walking up and all of a sudden going down and would have to jump off into it. The surge would come up and the chute would rise up with the barge, and then it would go down. So an animal going up there might be walking up a hill one minute and the next minute he's walking downhill to get into the barge. It was quite an operation.

Slater was an integral force in the Young Brothers conversion from stationary cattle pens to the roll-on, roll-off method using double-decker aluminum stock trailers.

In the interim, Hartwell Carter dealt with the challenges of interisland shipment of cattle under circumstances that rendered no practical alternatives.

Rangelands at Risk: State Land Lease Auctions

Leading up to the February 14, 1951, Territorial Land Auction, in which several Parker Ranch grazing leases were open to public bid, Hartwell kept himself in a knowledgeable position as to the governmental research and preparation for this milestone occasion. He also kept tabs on some of the rumblings from Senator William J. Nobriga of Honokaʻa, together with the Small Ranchers Association (SRA) headed by Daniel Correia.

As early as 1948, A. Lester Marks, who was then a land commissioner from Oʻahu, authorized a study on all aspects of territorial pastoral lands. Frank G. Serrao held the same post for the Big Island but was shortly thereafter appointed to the Territorial Land Commission.

Nearly 110,000 acres were scheduled to go on the block for the Valentine's Day land auction conducted at the Hilo Armory by A. M. Osorio, who by 1951 had assumed Serrao's Big Island Land Commission slot. The leases auctioned off that day would not become effective until January 1, 1952, giving the existing tenant time to relocate livestock or other portable fixtures.

Marks' study was based on valid reasoning. One purpose was to establish a requirement of expenditures for pasture improvement during the ongoing life of a given lease. This in effect could serve as a deterrent to speculators, while assuring that the land would not deteriorate from overwhelming or inappropriate use. Another problem lay in addressing the small rancher's concerns, which were compounded by their desire to secure parceled-out portions of larger leases, tak-

WHAT ARE YOU GOING TO DO About Our Land Monopoly?

Adapted from a Tribune-Herald ad, February 10, 1951. This campaign was largely led by Senator William Nobriga of Kalōpā. Combined charts—large private holdings, government leases, present leases—reflect the legitimacy of the concerns of the Small Ranchers Association.

ing the prime meadows and leaving the arid plains. Marks did not want the land office, after parceling up large leases according to one party's whims, to be stuck with having only the marginal properties of little or no interest or value.

By this time, Senator Nobriga and the SRA were heating up their rhetoric, sometimes in territorial newspapers. Marks' objective was clarity in the disposition of these lands, and to get it he appointed a committee headed by Dr. Harold A. Wadsworth of the University of Hawai'i College of Agriculture and including Colin Lennox, chief of the Territorial Department of Agriculture and Forestry. A valuable addition was Frank G. Serrao, a veritable library of knowledge regarding land issues. In the winter of 1948 the committee also considered protecting the interests of the larger ranching operators, who for the tenure of previous leases demonstrated a willingness to take on stewardship of the larger leases that were marginal and less productive. There was considerable intensive study by field and land offices in regrouping the land parcels in a fair and equitable way.

Serrao, a specialist in territorial and private land values, covenants, conditions, and agreements, became the public target of Senator Nobriga, but he calmly responded with a series of seven weekly articles in the *Honolulu Advertiser* leading up to the February 14, 1951, auction. The articles, in which he reminded readers that it was "their land" that was up for bidding, were highly informative to the general public. Nobriga and the Small Ranchers Association countered with full-page ads against the process, calling for a delay or cancellation of the auction.

The auction took place as scheduled in the steamy Hilo Armory along the Wailuku River, with Ernest Apoliona as auctioneer. Of the thirty parcels scheduled on the docket, Dick Penhallow as Carter's representative was prepared to retain the ten existing leases for the ranch. He actually went one better by securing back for the ranch the cherished Hanaipoe lands, which had been lost at auction twenty-one years prior to Nobriga, et al.

In the February 15 issue of the *Honolulu Advertiser,* Dick Penhallow scored the SRA and their methods and stated,

> I deplore the fact that this type of slanting attack goes too often unanswered. It is definitely in the interest of all of us to operate public grazing land in such a way that it will be improved, not impoverished, and at the same time produce the maximum that such land is capable of producing as food and income. At the present time I am employed by one whom the small Ranchers choose to call a "land baron." From forest and waste he converted those lands to productive use by managerial foresight and at great expense. While doing so he has always paid his rent and taxes and has created employment for hundreds of citizens of Hawaii nei. I have faith that the public will not allow such intimidating tactics to hamper the bidding, so long as the rules of the sale are applied to all.

Hartwell was relieved to have this milestone auction behind him. He also welcomed the reacquisition of the verdant Hanaipoe lease, where Joe Pacheco was soon assigned to live and operate.

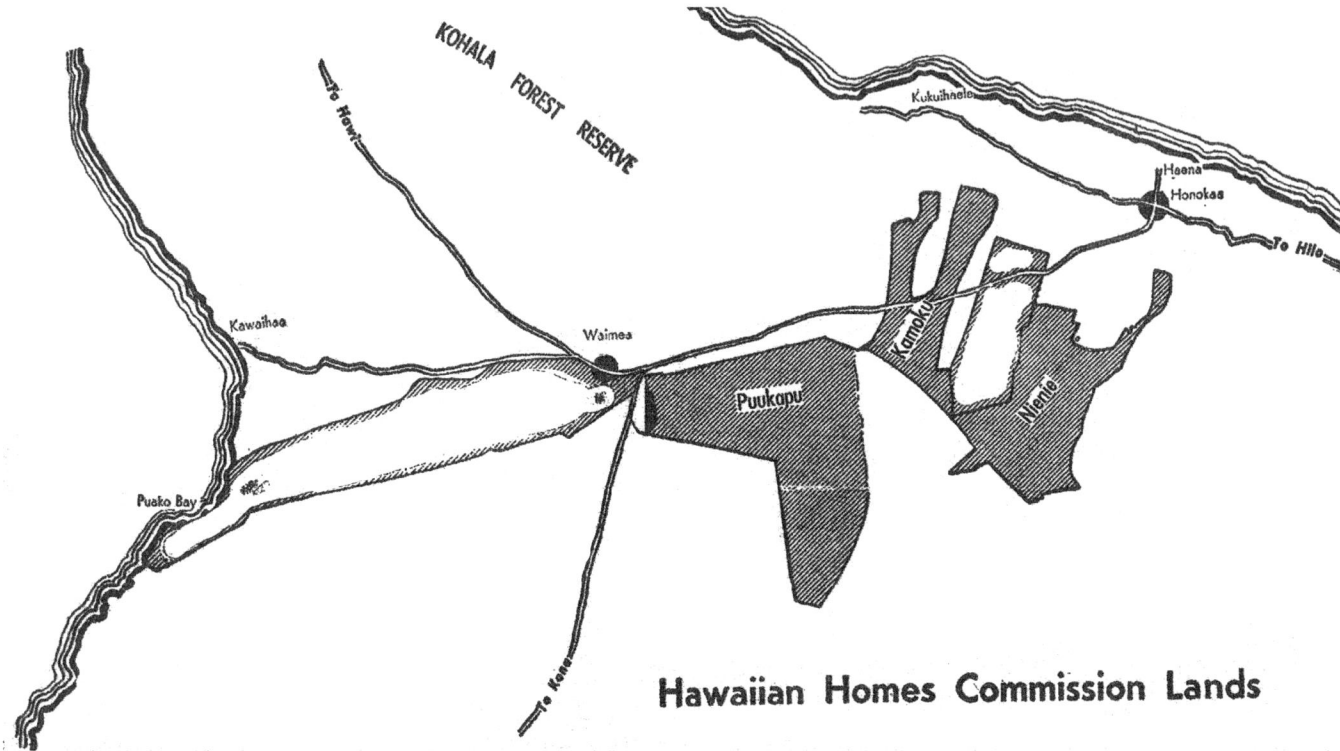

SOME OF THE HAWAIIAN HOMES commission lands over which the HHC and the legislative holdover sub-committee on lands are disputing disposal are shown in the shaded areas of the above rough sketch. The lands of Puukapu, Kamoku and Nienie comprise nearly 20,000 acres. An HHC plot not shown is another 12,000 acres of lands of Pauahi and Kawaihae No. 1, which the territory on Friday re-leased for 21 years to Kahua Ranch Co. Territorial lands whose leases expire soon are Lalamilo, 13,000 acres, depicted by the partially shaded area leading from Waimea to Puako bay, and Honokaia, 3,000 acres between Kamoku and Nienie. The sub-committee feels that portions of HHC lands not to be developed soon should be cut up for use of small ranchers and that territorial lands should be sub-divided when the present leases expire for the same purpose. Besides the three plots shown, HHC controls six other areas on this island, Kamaoa in Kau, portion of Puu Oo ranch, Kapulena, Piihonua, Keaukaha and Humuulu, totalling more than 100,000 acres.

Map of Hawaiian Homes Commission Lands, illustrating the magnitude of homestead property within the heart of Parker Ranch.

The Hawaiian Homestead Pastoral Lease Program

A significant portion of Parker Ranch's growth in acreage included lease of pasture from the Hawaiian Homes Commission. The leases could include as much as 50,000 acres, as in the case of Humu'ula. Some of the leases included the best grazing lands in the territory, including a tract of more than 20,000 acres in the heart of Parker Ranch. Bordered by Pā'auhau fee-simple rangelands on the east, Hanaipoe and Makahālau fee parcels to the south and southwest, state forest reserve to the north, and Kūhiō Village (Hawaiian Homes Commission home sites in Kamuela) to the west, these lands were mandated to revert back to the HHC by 1952 to be subdivided into fifty-two ranch lots of 300 acres each. The lands went back to the HHC in 1950. Looming on the horizon as a prelude to awarding these lots, a fierce political battle was waged in an effort to convert Hawaiian Homes Commission lands back to territorial lands for small non-Hawaiian ranchers.

By 1952 I was well immersed into the

John Holi Ma-e at Kūkaʻiau Ranch, 1949. Photo by Dougie Davidson (WCBC).

small family of John Holi Ma-e of Kūkaʻiau Ranch, who in 1950 applied for and prayed he would be awarded one of these lots. Holi was both *makaʻu* (fearful) and *kanalua* (doubtful) of the likelihood of obtaining his lot, because the awards were somewhat political and he was mistrustful of anything having to do with politics. But his reputation as a highly respected stockman was enough to make a difference. It also helped that Roger Williams, then manager of Kūkaʻiau Ranch, was fond of Holi, who was his lead cowboy. Williams was close to Hartwell, and both Hartwell and his assistant at the time, Dick Penhallow, appreciated Holi's prowess as a fine horseman and cattleman. So it happened that in 1952 Holi's dreams were realized, and he always acknowledged the help of Roger Williams, Hartwell, and Penhallow. Holi often talked of the generosity and foresight of Parker Ranch in providing private ranching opportunities for Hawaiian homesteaders.

Hartwell and Penhallow were, however, keenly aware of the loss of grazing lands, the drop in mother cow and calf crop numbers, the inconvenience of being neighbors with several dozen homesteaders, and the severe pressure created on a privately owned (Parker Ranch) water system. A four-part solution emerged.

1. The loss of grazing lands was alleviated by a gradual spread in mother cow numbers over the rest of the ranch, so that a 12,000-herd was maintained.
2. There was the sale via chattel mortgage to each homesteader of sixty pregnant replacement Hereford heifers. Bulls could be leased from the ranch or bought outright.
3. Holi chose to buy a sire of high quality from Kūkaʻiau Ranch. Over the next several years, annual calf crops (less retained replacements) were "sold back" to Parker Ranch in payment of the chattel mortgage principal plus 3 percent interest. This financed the purchase of homesteaders' herds while maintaining steady calf crop numbers for marketing by the ranch.
4. Parker Ranch continued with the HHC to fence all of the awarded 300-acre parcels with *kiawe* posts and high-quality hog wire. Parker Ranch paid for half of any fences built on boundaries abutting its own lands. This helped to quickly launch the pastoral leases and protected the ranch

from fences that might be less than secure. Interior fencing and corral-building was the responsibility of the awardees. Additionally, Parker Ranch cowboys often helped with the annual gathering of kanaka pipi (awardees' calf crops) in former ranch corrals such as ʻŌhiʻa Corral (Kīpuka ʻōhelo) in the Tony Phillips ranch lot, but mainly in central transaction areas. Finally, Parker Ranch extended water services to each HHC ranch lot. It was provided early on at no charge to the homesteader, who was responsible for water service and maintenance within his or her ranch. It was a system that grew to be a burden for Parker Ranch, as it drew on the needs of other sections of the ranch in the Kaʻala and Hanaipoe sections as well as the Puʻuʻio and Makahālau cistern/pump systems. In 1964 the Hawaiʻi Island County Water Supply put in its own system, finally relieving Parker Ranch of a generous gesture that spanned more than a dozen years and involved millions of gallons of water each year. Conservative estimates indicate that Parker Ranch made available more than three billion gallons of water to Hawaiian homesteaders at virtually no cost over the twelve-year time span.

It was Hartwell's direction, with the support of owner Richard Smart, that allowed HHC to launch its vast undertaking. In the last fifty years the HHC has struggled to award only a small percentage of house, farm, and pastoral leases throughout the Hawaiian Islands and has become the target of much criticism. Some of the current 10-acre, 40-acre, and 100-acre lots in Puʻukapu languish for lack of access, water, and utilities. It is reasonable to assume that if Hartwell

Hartwell Carter at the manager's residence in 1955. The building currently houses the Jacaranda Inn. PPS.

and Parker Ranch (Richard Smart) had not intervened with the development of pastoral leases in 1950—providing solutions in such a magnanimous way—those early awardees could not have prospered or survived as viable homesteaders.

I have fond memories of riding horseback, packing ukana (gear) across from ʻUmikoa Village at Kūkaʻiau Ranch through the Pāʻauhau section of Parker Ranch to arrive at daybreak to brand Holi's calf crop. We always left at 4 a.m. with Holi's nephews, Paul and

George Kealoha, and would *holo haole* (ride at a slow lope) the entire distance. Then we would drive the herd, separate, and brand the fifty-eight or fifty-nine calves of Holi's sixty cows. After other maintenance chores were finished, we would leave for 'Umikoa around 4 p.m. via *holo ku ku* (a fast trot) and be home by dark to cool and wash our horses and put away our gear. Cool, clear moonlit nights added to the aura.

On Sundays Holi rose early and donned his dark suit and tie to spend *la pule* (Sunday) at the Honoka'a Stake of the Mormon Church. I caught a ride to 8 a.m. mass at St. James Church in 'O'ōkala with 'Umikoa village neighbors Manuel Miranda, Daniel Miranda, and Daniel's wife, Vera. The long, routine saddle-bound days with Holi ended in the evenings with his wife Esther and her mother, Malia Ako, sharing lessons, legends, histories, and prayers of old Hawai'i. During these sessions, Holi always had kind words for Hartwell Carter.

Animal Health Consultants

Dr. Leonard N. Case

Not unlike the influence of A. W. Carter on the success of Parker Ranch, Dr. Leonard N. Case left an equally significant legacy on ranch history from a medical and animal health perspective. He achieved all this in addition to fathering twelve children in the process. Several of these children went on to careers at Parker Ranch. This unique family deserves a special place in the history of 'Āina Paka.

Dr. Leonard Newton Case was born in Norwich, Connecticut, on February 18, 1881, and attended elementary and secondary schools in that community. On June 25, 1901, he graduated with honors from the Norwich Free Academy, well prepared for admittance to the School of Veterinary Medicine at prestigious Cornell University. His younger brother Lloyd followed him into veterinary school. In 1908, Leonard was awarded the degree of Doctor of Veterinary Medicine, again with honors. Both Case veterinarians ventured to the Hawaiian Islands, launching parallel careers.

In 1909 Dr. Leonard Case was appointed to the Territorial Board of Health, headquartered in Honolulu. This was an era in which human tuberculosis had taken hold of the communities of the Islands, largely due to milk consumption from infected dairy operations.

Shortly afterward, the Case brothers joined forces in operating the animal pathology laboratory of the Territorial Bureau of Agriculture and Forestry. Both men received special training in veterinary pathology while at Cornell University and were well equipped to provide progressive diagnostic services for the livestock industry of the territory.

By 1920, Leonard Case was appointed territorial veterinarian, a post he held for three years before he and his brother left government work and entered private horse practice at Kapi'olani Park in Honolulu. In 1921, Governor Wallace Farrington appointed him to the Territorial Board of Veterinary Examiners. In 1960, Governor William Quinn reappointed Case to this prestigious post.

After a four-year stint in practice, the brothers went separate ways. Lloyd Case moved back to the mainland, while Leonard moved to the Big Island, reentering government service in 1927 as deputy territorial

veterinarian for west Hawai'i. About this time, his first wife returned with their four daughters to live on the mainland.

The west Hawai'i district was broad—from 'O'ōkala in Hāmākua, through North and South Kohala, North and South Kona, with Kahuku Ranch at the southern tip. During these times, plantations and ranches abounded with thousands of workhorses and mules, in addition to large cow herds, a scattering of dairies, and a plethora of piggeries. Case based his headquarters in Waimea, largely at the behest of A. W. Carter, who was influential in securing private and regulatory veterinary services for the Big Island region. He was again confronted with a livestock community (excluding Parker Ranch) that was laden with serious livestock diseases such as anthrax, tuberculosis, and brucellosis in cattle, glanders, strangles, and a perplexing cerebromeningitis in horses, and brucellosis and cholera in swine.

Once settled in Waimea, Dr. Case married Mabel K. Hussey, a Native Hawaiian woman of North Kohala. They enjoyed a long and fruitful life together. With her, Dr. Case fathered eight more children, the youngest of whom was born when Case was seventy-seven years old and still active in veterinary practice. By this time he was retained by Parker Ranch as its veterinarian, spawning a relationship that was at times tenuous, given A. W.'s demanding and exacting disposition as opposed to Case's calm, methodical, noncommittal, and "laid-back" posture.

Beyond the borders of Parker Ranch, Case worked equally hard to establish improved animal health status for Big Island cattle, stamping out disease and parasitism with all he could muster, given his broad territory and limited resources. Fortunately his

Dr. Leonard N. Case portrait. PPS.

strong background in animal pathology made him an effective field diagnostician, even with little or no access to laboratory support from Honolulu.

He inadvertently crossed swords with A. W. when he discovered blackleg in Parker Ranch cattle. A. W. was in absolute disbelief that this could happen to Parker Ranch's closed and carefully guarded cow herds. Certainly the rumors of the Germans planting anthrax spores on Kaua'i, Maui, and O'ahu in previous years (World War I) came to mind as blackleg struck the ranch. Carter would not accept this diagnosis and rebuffed Case's report as inaccurate. About this time, a young Cornell graduate was appointed deputy territorial veterinarian for east Hawai'i. Dr. Leslie Weight, a Maui-born part-Hawaiian veteri-

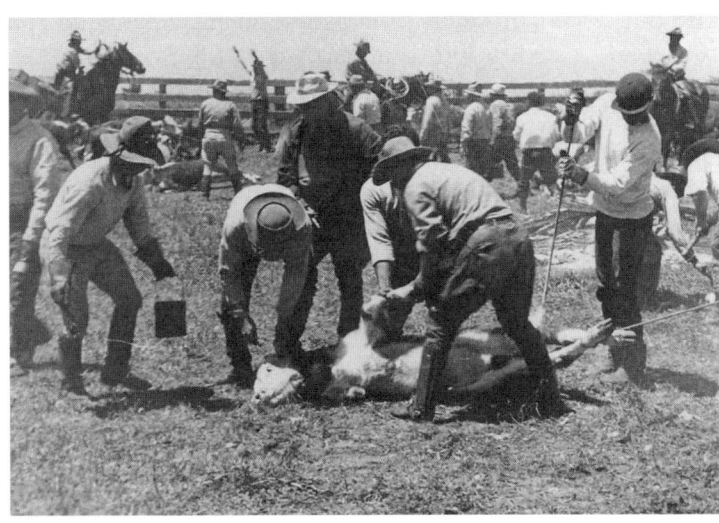

Dr. Leonard N. Case (center) at a branding, providing direct oversight. PPS.

narian (Hawai'i's first!) who had established an office in Hilo, was called upon by Carter to provide a second opinion.

Affable, competent, and anxious to serve a good purpose, Les Weight ventured to Waimea and was joined by Hartwell Carter, who hosted the young doctor on a tour of the affected paddocks in which hefty 400-pound Hereford calves were dying at a rate of several head per day. Courteous to his colleague Case, Weight had alerted him to Carter's request for a second opinion.

Blackleg is a common disease of young cattle caused by a spore-encapsulated bacterium, *Clostridium chauvoei*, that readily finds a permanent home in the soils of livestock country. The protective spore in which the bacterium is encapsulated makes the organism impervious to heat, freezing, and sunlight, resulting in an endemic presence. The resultant disease has postmortem signs that are described as pathognomonic, meaning that lesions—by their appearance, feel, smell, and so on—are specifically characteristic of a certain condition, setting it clearly apart from other diseases by these unique features. Blackleg is so nicknamed because of the unique lesions that cause severe hemorrhaging into the major muscle groups of the extremities. Such intramuscular hemorrhaging quickly darkens from red to black. In its progression, this dispersal of blood throughout the limbs brings on a characteristic stilted gait in calves described by the *paniolo* as *likelike*. On firm palpation of these limbs, a definite crackling effect can be felt and heard (crepitation), and again the Hawaiian cowboy described this unique sign as *nakeke ka 'ili*. This is caused by accelerated gas production in the process of tissue degeneration.

Upon dissection, the examiner notes the profuse subcutaneous gas pocketing accompanied by another pathognomonic sign—the distinct smell of rancid butter caused by fatty degeneration. The appearance of severe bruising of the muscles due to hemorrhage, coupled with the crepitation and rancid butter aroma, gave Dr. Weight an immediate confirmation of his colleague's diagnosis of blackleg.

Dr. Weight composed a considerate but firm memo of affirmation to A. W. Carter, fully apprising him of the specific points of confirmation of the disease, hitherto undescribed on the lands of Parker Ranch. Vaccine was ordered posthaste from the West Coast, and within ten days the outbreak of blackleg was quelled. While A. W. never became accustomed to the laid-back demeanor of Case, he nonetheless never questioned a diagnosis provided by the highly competent veterinarian again.

While the Case brothers in Honolulu practice were known to enjoy a good stiff drink or two, A. W. Carter was well entrenched in his prohibitionist posture. Aware of Dr. Case's occasional enjoyment of his favorite libation—a Ramos Fizz, a frothy combination of rum and soda, blended with lime—Carter became increasingly tolerant of Case's moderate use of libation just as he accommodated, even under these temperate times, the habit of his dear and close confidant, James Palaika Brighter, who was known to produce a fine *panini* (cactus fruit) swipe (moonshine) for his private use. Case by no means was a great user of alcoholic beverages. In fact, he was rather prudent in its use when compared to his Kapiʻolani Park days of Honolulu society.

My first memory of Dr. Case was in 1949 when I stayed with Holi Maʻe at ʻUmikoa village at Kūkaʻiau Ranch. Case came to cattle brandings to vaccinate heifer calves for Bang's disease (brucellosis) that had earlier decimated the exceptionally fine dairy herd of Kūkaʻiau Ranch and threatened adjacent beef herds. I remember him stepping out of his Jeepster in very distinguished management-level attire: starched khaki long-sleeved shirt, jodhpurs (riding pants) with suspenders, and laced-up riding boots that were nearly knee-high. His head was capped with a shock of well-groomed white hair. His large belly in combination with the above brought Santa to mind—but no beard and certainly no "Ho! Ho! Ho!" Instead, Case was his usual quiet but courteous self, his professional countenance notwithstanding. Uncle Holi, as usual, had me approach the kind doctor with outstretched hand for an introduction.

Later, when Holi moved to Kūhiō Village in Waimea, Dr. Case came by to attend to Holi's *ponoʻi* (owned) horses as well as the ranch horses we dealt with at Pukalani Stables. He came to lance a large chest abscess on Holi's young *hapa laka* (half-trained) horse. With no sedation or local anesthetic, he effectively drained the abscess and cleansed the wound—impressed, I could tell, by the stoic discipline of Holi's mount. Purple lotion, the age-old remedy for moist and weepy wounds, was copiously applied and healing was uneventful. Ten years later, I found myself in veterinary classes with equine clinical professors speaking at length about pigeon breast or bastard strangles, which Holi's colt likely had. When they described the abscess causing a rather pointed and expansive swelling to the chest, developing the appearance of a pigeon's chest, little did I know that a decade later I would be treating many such cases on Parker Ranch and surrounding communities. Caused by a bacterium named *Corynebacterium pseudotuberculosis*, these abscesses appear in epidemic form in certain years, usually spread by flies. Except for the modern-day advantages of excellent sedatives and analgesics, very little has changed in how these abscesses are treated in the fifty years

that have transpired since first observing the skillful Dr. Case relieve the affected horse of its infirmity.

Many old-timers have described Dr. Case's inclination—and, to a degree, Dr. Nagao's—to put down rather than treat badly injured ranch horses, and I remain considerate of those times and circumstances as being quite different than those of today. In those early times, Parker Ranch had an abundance of horses, many of which were not gentle and none of which were routinely shod. Modern-day sedatives were lacking and restraint chutes were either nonexistent or so enclosed that examination and repair of limb wounds rendered general anesthesia as the necessary recourse. Intravenous administration of such drugs was risky, dangerous, and difficult in ungentled and head-shy ranch mounts, and follow-up care such as rebandaging was a genuine challenge to both animal and man. With such large horse numbers, scarred or blemished horses were clearly expendable, leaving euthanasia as a logical solution for severely hurt horses. Despite my comfort around broncky horses, it is likely that I would have matched my predecessors' predilection for euthanasia in these cases.

Because his practice was located in a remote area, Case by sheer necessity established an extensive pharmacy of basic veterinary compounds to formulate specific remedies. Using available formulations described in veterinarian pharmacopoeia, he was able to concoct many a remedy, but he always gave deference to the Native Hawaiian herbalist/healers such as Holi and Palaika, who by sheer experience and handed-down knowledge had a significant medical and veterinary armamentarium of their own. Blue Lotion, nicknamed "purple medicine," was by then a clear favorite of the horsemen, with scarlet oil—a eucalyptus-scented healing salve—a close second. These skilled caregivers still commonly used aloe, and Case readily acknowledged the value of the Native Hawaiian *la'au lio* (horse medicine).

In the field of veterinary medicine, it is likely that Case's most significant contribution was the development of a simple, easily read field test for bovine tuberculosis. Like the human intradermal skin test, a measured response (a swelling or lack thereof) to an injection of 0.1 milliliters of tuberculin antigen, measured after a seventy-two-hour period, can signal the presence or absence of clinical tuberculosis. Historically such injections are given in the soft tissue around the tail head of cattle, either in the caudal (tail) fold or vulvar lip. Each cow is restrained (in a squeeze chute) for injection and again restrained for the seventy-two-hour reading that is done manually. While time consuming and doubly restraining of the subject animal, the procedure was the only one accepted by territorial and federal veterinary officials of those times.

Considering the thousands of cattle spread from 'O'ōkala across Kohala and Kona to South Point that were scheduled for aggressive testing to eradicate tuberculosis, Case developed through extensive experimentation an easily administered and read tuberculin test using the sensitive soft tissue of the lower eyelid of cattle. The subject cow would be restrained only once—at the time of tuberculin injection. He effectively duplicated the caudal fold tubercular response in cattle, meaning that any significant reaction could be noted as a swollen pouch on the lower eye-

lid of a reacting cow. Reading the test could be done visually, even from 6–10 feet away as the cow looked toward you. At the time of reading, cattle were gradually walked down an alley toward the attending doctor without the need for head restraint. The attending cowboys would part off any cow with a swollen lower eyelid for further testing or culling for slaughter. With all regulatory blessings, the palpebral (eyelid) test for tuberculosis was officially adopted by the Territory of Hawai'i. While the test was rescinded by federal officials in 1986, Case developed an accelerated and effective test method that allowed the Big Island to be classified free of tuberculosis by 1968, fully forty years after he had launched the palpebral test.

Over an extensive span of nine years, I conducted full herd tests of the cow herds of Hāna Ranch, which numbered 9,000 at the time (the 1970s), scattered over three ranches that included the home ranch as well as the Koali and Kīpahulu outfits. I duplicated the required complete herd tests every three years for three consecutive negative sessions before the federal government lifted its long-standing (twenty-five-year) quarantine of the entire Hāna Ranch, then the second largest in the state after Parker Ranch, which had 18,000 head of mother cows. While I rarely detected suspicious palpebral swellings, subsequent postmortem/slaughter examinations yielded uniformly negative results. The speed and efficiency of Case's palpebral tests allowed me to effectively reverse the quarantine order in a manner that under different procedures would have likely consumed another two decades of the strict regulatory restraints that come with quarantine law. Since these times, nearly thirty-five years have passed during which Hāna Ranch slaughter performance has yielded uniformly tuberculosis-free cattle.

While the U.S. Department of Agriculture and Animal and Plant Health Inspection Services U.S. experts on this disease rescinded the use of this test for a variety of reasons, mostly dealing with uniformity of reading responses, Case nevertheless provided heroic service in his lifelong career to rid Hawai'i of this dreaded disease.

Case, nicknamed Kauka (doctor) early on by the cowboys, made an enduring contribution to the history of Parker Ranch far beyond animal health. His siring of a dozen children would stand out in any community. Case had three sons who had significant ties to Parker Ranch: Richard, who served as Case's veterinary assistant; Leonard, who rose to become trucking foreman; and William, who attained superintendent status over the sprawling high-volume (and pressure!) water department.

With Mabel K. Hussey, Case fathered two girls and six boys. The girls Keala and Lani did not develop ties to the ranch, but the younger daughter grew to become a statuesque beauty whose *hapa haole* (Caucasian/Hawaiian) background blended in a most striking manner. The bulk of her adult life was spent on O'ahu after graduating from the Kamehameha School for Girls.

Other Case boys included Donald and Lloyd (Hawaiian) Case. Lloyd became a respected activist in hunting and Hawaiian movements. Richard grew up at his father's side, as did Leonard to some degree. Many people expected Richard to go on to become a veterinarian given his intense field experience working alongside his father. Happily

married with a growing family, Richard went on to develop a career with the Territorial and State Highway Division when the senior Case retired as a veterinarian.

After fulfilling military service obligations as a young man, Leonard was employed by the State Division of Animal Industry at the Quarantine Station on O'ahu, where he did intensive testing of livestock, especially in the dairy, beef, and hog industries. Upon returning to his home land of Waimea, Leonard took on several utility roles on the ranch before being assigned to the motor pool under foreman Bob Lincoln. The ranch had a limited cattle truck fleet that included a pair of ten-wheel White trucks that readily handled a dozen butcher cows each, requiring several trips to Kawaihae Harbor on shipping day.

By this time, fat cattle were no longer walked to Kawaihae for loading out on a variety of ships or Young Brothers' barges. Major trucking chores were outsourced to Hiroshi Ryusaki under the management of Penhallow and Greenwell, but freight hauling and day-to-day cattle transport was done by the White trucks operated by Leonard Case and Alex Bell Jr. These trucks were heavy and slow moving, but they were well powered and dependable in service. The White trucks delivered posts, wire, fertilizer, minerals, lumber, and general merchandise in and out of the ranch warehouse, which was ably manned by Masao Yoshimatsu and his assistants, Sam Kimura and Sueo Yamasaki. Leonard and Alex worked well together in developing the trucking component of the motor pool, which was eventually transformed into a stand-alone department.

Under the regimes of Greenwell, Lent, and Hanson, the trucking fleet was gradually expanded and converted to diesel truck-tractors using single- and double-decker cattle trailers to accommodate the changes in shipping by Young Brothers. By this time the ranch had gained about a decade of experience with the Big Red Peterbilt cab over semi with an attached cattle body and trailer. While Alex Bell manned this rig, Leonard readily learned the ropes. When the new rigs came in during the 1970s and 1980s, he operated a powerful Ford truck tractor, pulling a wide variety of trailers that included cattle containers, flatbeds, dumpers, low-boys, and so on. Upon the retirement of Alex Bell Jr., Leonard Case moved up to become foreman, a post he held until his retirement in 1987.

William N. Case was born with an industrious and inquisitive nature. Growing up in old Waimea, his interests were far and wide, but they did not include the realm of veterinary medicine. Still, in his adulthood some people called him "Doc," but he was more commonly called "Bill" or "Casey." After a stint in the armed forces, Bill returned to Waimea and married Delma Begas, started a family, and looked intensively for any kind of a job. Then manager Rally Greenwell assigned him to the blacksmith shop under the tutorship of Duke Karimoto, the respected senior "smithy." Blacksmith responsibilities included the forge and anvil production of gate hinges, hooks, tie rings, branding irons, and the like. An allied function was the cutting and threading of galvanized pipe of all sizes. Seeking knowledge and experience, Bill was anxious to become adept in all areas of blacksmithing and plumbing materials, paving his way for a lifetime career on the Parker Ranch.

While farrier work was a minor func-

tion of the blacksmith, given the Cowboy Gang's need for shod horses only when the arid ranges were driven, Bill became highly skilled at producing fine branding irons from tapered bar stock iron, a skill and service he continued to provide even through his eventual water department years. Adaptable in attitude, Bill quickly accommodated Walter Slater's mandate that the ranch block "P" be combined with the year brand number on a single iron handle. Hence both brands could be applied to the hip of calves in a single pass by one man armed with one branding iron instead of two. As sire brands were designed in the ensuing years, it was Bill who set aside his water duties to spend an evening or weekend producing the desired irons.

Bill's true passion for Parker Ranch soon focused on the complicated but resourceful water department. He embraced the system with gusto, working truly from the ground up. This meant packing 21-foot lengths of galvanized pipe high into the Kohala Mountains, where key water heads were tapped. Eventually becoming foreman and later superintendent of the ranch's water department, Bill had a small crew of workers that included Kalani Lewi, Francis (Kole) Perreira, Bob Scott, and Charles (Blackhawk) Kainoa, who was often accompanied by his daughter Tammy. Bill's forty years of service on the Parker Ranch's water resources were truly exemplary. Because of his own and his brothers' years of dedicated service to the ranch, the Case name is still used with reverence—a credit to the progeny of the senior Dr. Case, who left an enduring legacy of combined and honorable service in the Parker name.

On June 26, 1958, Dr. Case retired at age seventy-seven from government service with a golden anniversary plaque honoring him for his dedicated years of service to the Territory of Hawai'i's livestock communities. He also passed the torch of Parker Ranch veterinary consultant to Dr. Wallace T. Nagao, who eventually assumed Case's regulatory duties. Dr. Case, however, continued his private practice out of his little office on Kawaihae Road—the same building presently occupied by ReMax Realty broker "Mike" Kerr. Over the ensuing eight years, Case continued to care for livestock and pet animals, retiring at age eighty-five, capping a fifty-eight-year span of veterinary service to Hawai'i's animals. He enjoyed a brief four-year span of full retirement, dying quietly at his Waimea home on September 30, 1970, surrounded by his children, grandchildren, and great-grandchildren.

Upon his death, the New York State Veterinary Alumni Association created a golden bookplate honoring Dr. Case's lifetime contribution to the advancement of veterinary medicine in America. The plaque was placed in the Great Hall of the New York State Veterinary College at Cornell University in Ithaca, New York, a full eighty years after he graduated with honors from this hallowed institution. On September 30, 1981, a hundred years after his birth, Case Memorial Veterinary Hospital was dedicated on Mānā Road in Waimea in the name of this fine member of the veterinary profession. It was Hawai'i's first full-service large and small animal veterinary hospital. This honor to Case remains today. Hawai'i has been a better place because of Leonard N. Case, the kind doctor.

Aware that the kindly Dr. Case was well into his twilight years of clinical practice, Hartwell was quietly monitoring a young Kohala native, Dr. Wallace T. Nagao, who had settled in Kona as a practicing deputy territorial veterinarian. Envisioning a promising

Case Memorial Veterinary Hospital on Mānā Road, built in 1981 as the state's first combined large and small animal hospital. WCBC.

successor to Dr. Case, Hartwell approached Nagao in his typically quiet and private manner. Dr. Nagao's story is a fascinating one and reinforces Hartwell's wisdom in making this choice.

Wallace Takeshi Nagao, DVM

Wallace Takeshi Nagao was born near Union Mill in North Kohala on August 2, 1918, to Jindo and Fuji (Tsuruda) Nagao, who emigrated from Japan. The family included a brother and two sisters, all of whom entered elementary school in Honomaka'u and continued their education at Kohala High School.

As the second child and eldest son, Wally went to work immediately after high school as a scale boy for Kohala Sugar Company, riding on horseback to various job sites. In 1939 he enrolled in the General Agriculture program at the University of Hawai'i at Mānoa.

With the bombing of Pearl Harbor on December 7, 1941, overwhelming changes occurred for Wally and all of his nisei classmates at the university. The ROTC was called to active duty that morning to form the nucleus of the hastily formed Hawai'i Territorial Guards, but when this unit became federalized two months later, Wally and his nisei cohorts were discharged on orders of higher-ups in Washington. But rather than passively accept their status, they quickly formed the Triple Vs (Varsity Victory Volunteers) and offered to serve in whatever capacity the local commanding general saw fit to use them. They were taken in and attached to a combat engineer regiment in Schofield Barracks.

A year later, when the 442nd Regimental Combat Team was formed, Wally and the rest of the Triple Vs joined a group of 2,000 volunteers who were sent to Camp Shelby, Mississippi. After basic training, Wally was one of 250 men transferred to the Military Intelligence Service School in Camp Savage, Minnesota. On completion of training there, he was sent to the Southeast Asia Translation and Interrogation Center in New Delhi, India, where his duties mainly involved prisoner of war interrogation. For six months he served with a British intelligence unit in the

Central Burma Campaign. He received a direct commission shortly after his return to New Delhi and was then sent to Burma again to be a part of a large British force in Rangoon that was preparing for the invasion of Singapore and the rest of Malaya. With the sudden end of the war, Wally was next assigned to the U.S. War Crimes Investigation Division in Bangkok and Singapore. He was finally discharged from active service after a four-month tour of duty in Washington, D.C.

Returning home to Kohala, Wally relaxed with his family and friends for a brief three weeks before leaving for Michigan State University, where he enrolled in preveterinary medicine. Combined with his credits transferred from the University of Hawai'i and funded by the GI Bill, Wally completed requirements within a year to be admitted to the veterinary school. Continuing his military relationship, Wally joined the Army Reserves Counterintelligence Corps. While in the Triple Vs and the army, Wally had taken up boxing, and he was offered a boxing scholarship from Michigan State. But collegiate boxing had to be set aside due to the pressures of veterinary school.

On one of his military duty trips to the West Coast, Wally met and later married Priscilla Yasuda, a native of Utah. Priscilla worked for the State of Michigan while Wally completed his DVM degree in 1951.

While in veterinary school, Wally developed a keen interest in orthopedic surgery under the mentorship of pioneer veterinary surgeon Dr. Wade O. Brinker. Equipped with a DVM and extra-intensive training in orthopedic surgery in small animals, Wally returned to Hawai'i and entered the prestigious Honolulu practice of Dr. Paul Nomura, where he applied his professional skills with gusto.

Anxious to return to the Big Island, Wally accepted an offer to do meat inspection, then a function of the Territorial Department of Health and headed by a prominent public health veterinarian, Dr. John Gooch. Shortly thereafter, Wally was appointed deputy territorial veterinarian for the districts of North and South Kona, where he became immersed in ranch practice along with his regulatory duties. Enjoying the special ranching clientele of the Henriques, Hinds, Greenwell, Paris, Gomes, Wall, Freitas, Glover, Magoon, Gouveia, Ackerman, Stillman, and Wodehouse outfits, Wally was still being courted by public health professionals—this time by Dr. James Steele of the National Communicable Disease Center in Atlanta, Georgia. However, happily at home in Hawai'i, with three fine Kona-born children, the Nagao family had firmly set its roots.

An opportunity did arise, however, when Hartwell Carter beckoned Wally to move to Waimea to be groomed as Parker Ranch veterinarian because Dr. Leonard Case, already in his mid-eighties, quietly viewed retirement. Aware that Dr. Case was a couple of years away from rounding out a fifty-year career with the territory as a deputy veterinarian, Wally asked that Hartwell defer his offer for a few years. Carter did one better, offering Wally a fellowship to return to the academic world to study under Dr. O. R. Adams, a world-renowned expert in large animal medicine—especially in the equine species. Leaving Priscilla and their three children with her Salt Lake City family, Wally ventured to Colorado State University in scenic Fort Collins, where in-depth training bolstered his skills in large animal medicine and surgery.

On July 1, 1958, the Nagao family returned home, where Wally became the dep-

Dr. Wallace T. Nagao. PRC.

uty territorial veterinarian for North and South Kohala on Dr. Case's retirement. Hartwell Carter continued to foster and nurture the Nagao family in every regard, assuring them a comfortable place in the community of Waimea, in which they readily fit.

Assuming the rudimentary but adequate animal health program from Dr. Case, Wally shifted emphasis to prevention of disease in livestock, a forte of his well-rounded veterinary armamentarium. With management and field personnel well tuned to the importance of animal health on Parker Ranch, Wally developed a booster program for the clostridial diseases such as blackleg and malignant edema as well as the respiratory disease of Pasteurellosis, commonly referred to as shipping fever. "Boostering" to field personnel meant repeating the same vaccines given at calfhood (branding) and again at weaning. To the calves, it provided anamnesis, a known immune phenomenon in which repeated doses of antigens (vaccines) generates a more heightened and longer lasting immunity. His logic was clearly based on the true endemic nature of these diseases that were embedded in the meadows of Waimea over the past 150 years of cattle ranching. He also added deworming and began mineral supplementation on a selective basis. Early on, Wally indicated concerns for copper deficiency in ranch calves in certain areas.

Off of Parker Ranch, Wally served the surrounding livestock communities with regulatory as well as livestock health consultation. With vigor, he eradicated the final remnants of bovine brucellosis in the Mud Lane homestead area of Waimea.

The Nagaos became active members in the community, with school functions and church activities. Wally reached prominence among his veterinary peers, chairing the Territorial Board of Examiners and serving more than once as president of the Hawai'i Veterinary Medical Association. His regulatory expertise and livestock disease control experiences readily poised him for succeeding Dr. Ernest Willers as the Hawai'i state veterinarian and head of the Division of Animal Industry in the State Department of Agriculture in Honolulu. It was under his stewardship that the State of Hawai'i became certified free of brucellosis and tuberculosis, capping off a stellar career in veterinary medicine and in service to his home and country.

Leadership Development Initiatives

Just as they were well aware of the importance of a strong veterinary program to the

health and welfare of a cattle operation, A. W. and Hartwell knew that a strong agronomy program was also essential to the success of cattle ranching. Seeking to surround himself with a highly qualified management team, Hartwell followed up on A. W.'s initiative and brought Harold Baybrook on board to serve both in a management capacity and later to take the lead in implementing significant agronomy regimes.

Harold Baybrook

Agriculturist Harold Baybrook came to Parker Ranch in 1943 from Kona, where he had managed the W. H. Greenwell Ranch for more than a dozen years. Baybrook's earlier career involved teaching vocational agriculture in both Hilo and Kona.

Born July 25, 1896, Baybrook was farm raised near Linton, Oregon. Graduating in agriculture from Oregon State University in 1924, he was drawn to the Islands by the teaching profession. Prior to graduation he was offered a teaching position at Hilo Intermediate School, where he started the first vocational agriculture curriculum. He later was transferred to Konawaena High School to serve in the same capacity. He likely would have stayed in education had the untimely death of W. H. Greenwell not occurred, leaving his widow Maud and several young children to continue the Kona ranch operations. Prophetically, prior to his death Greenwell had already approached Baybrook to manage the ranch, and the educator was mulling over the offer. He was hired by Maud shortly thereafter to manage the operation of W. H. Greenwell, Ltd.

After fifteen years of managing the outfit, Baybrook was invited to come to Parker

Harold Baybrook working with dung beetles. Photo courtesy of George W. Baybrook.

Ranch by the Carters (A. W. and Hartwell), who saw promise in the former Oregonian's potential in management. By this time, Hartwell was essentially running the ranch and sought to encircle himself with a sound crew of dependable middle managers. Moving to Waimea in 1943, Edith and Harold Baybrook brought their two Kona-born sons with them: seventeen-year-old Seymour and fifteen-year-old George.

Baybrook, however, was found to be much more of a hands-on guy than supervisory, and a logical slot that needed filling was in the continued agronomy endeavors of the ranch. Still, for a period of two to three years Baybrook served as assistant manager when

Rally Greenwell went to Kahuā Ranch. Concentrating on weed control and pasture improvement, Baybrook was more comfortable in the field.

During his tenure on the ranch, he worked closely with University of Hawai'i soil and plant scientists, concentrating on biological control of noxious plants such as cactus, lantana, and emex. On several ranch sites, he conducted experiments in culturing a variety of organisms and plant parasites. In this role, his work brought little glory and credit, but modern-day weed control experts describe his contribution as quietly heroic. The same can be said of his propagation of new species of grasses and legumes.

Maligned by some for his pioneering work in Kikuyu grass distribution, I am convinced after more than half a century of observing range management under extended drought that without the presence of this tenacious drought-resistant grass, thousands more cattle would have perished. Furthermore, the interwoven matrix of Kikuyu grass that carpets barren soils and its deep rooting prevented soil erosion that would be measured in thousands of tons lost over the plains and meadows of the Big Island. Pangola grass distribution is also credited to Baybrook—efforts that continued long after his retirement. Baybrook found enthusiastic support for grassland improvement from John Kawamoto of the Kohala section of the ranch.

Seymour went on to be educated at Oregon State University and received a BS in agriculture. After a career teaching high school in San Jose, California, he retired in Newberg, Oregon, to be near his elderly parents.

George grew up in Waimea, attended Honoka'a High School, and graduated from Mid-Pacific Academy. After training in theology he returned to the Islands, where he served in several ministries and congregations, including 'Imiola Church in Waimea, and finally as associate conference minister for the Congregational Churches of the Big Island, where he retired.

After a twenty-one-year career on the ranch, Harold Baybrook handed the agronomy reins over to Charles Christensen, who had moved to Waimea as the field auditor for the Hawaiian Homes Commission after a short career as assistant county extension specialist for the University of Hawai'i.

Harold Baybrook was a humble but diligent agronomist who drew little attention to his successes. His legacy, however, lies in the rangelands of North and South Kohala and Hāmākua, where green grass is rolled forth like an emerald carpet. He would have been greatly challenged yet charged with much enthusiasm at the sight of the pastoral scourges of gorse and fireweed, pondering as he always did a science-based, methodical, and frontal attack. He would be in his element.

With an eye to the future, Hartwell had been watching the early career of a young O'ahu cattleman who was employed at neighboring Pu'uwa'awa'a Ranch, owned by the Hind family. Hartwell viewed the young man as a promising candidate for management of the purebred Hereford herd at Makahālau. His decision to bring Edwin (Bull) Johnston to Parker Ranch reaped rewards for the ranch over his decade of service to Parker Ranch.

Edwin (Bull) Johnston

Edwin Milne Johnston was a Hawai'i-born product of old Scotland who developed a colorful and progressive career in Island ranch-

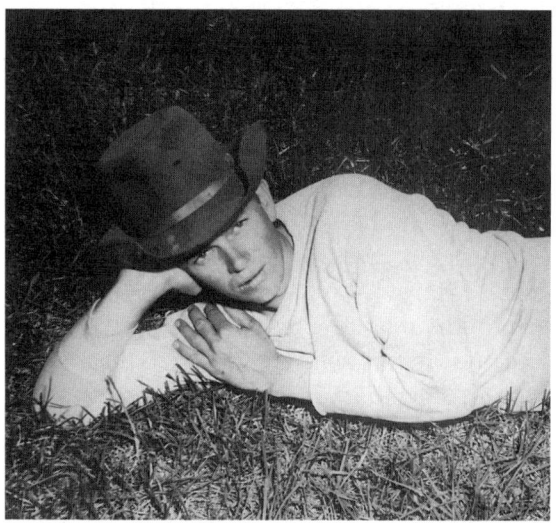

Edwin "Bull" Johnston taking a lunch break on a bed of Kikuyu grass. Courtesy of Edwin "Bull" Johnston.

ing, a great deal of which occurred on Parker Ranch.

Bull Johnston, as he was more commonly known, was born to James and Jean Johnston, who both emigrated from Aberdeen, Scotland, to Hawai'i's burgeoning sugar industry. Bull was born on March 22, 1917, on the "Scotch Coast" of the Big Island. A few years later, younger brother Harvey was born. When Edwin was seven, the elder Johnstons shipped the boys off to Scotland for schooling for three years, reinforcing little Edwin's pride in his family's motherland.

Returning to Hawai'i, Edwin attended Punahou School, where he earned the nickname "Bull," which stayed with him throughout his rich and colorful life. He got the name from his boarding school reputation for finishing the many fights that he never started. The name was so well engrained that even in adulthood few people knew that his real name was Edwin.

During his early boyhood, a deeply rooted competitive spirit began to surface—a quality that served him well through life on the athletic field, in beef production, and in horse racing.

Bull's love for horses was born in the place of his birth, 'O'ōkala, where the horses and mules of plantation life beckoned to his inner sense of aloha for the noble steed. Exposure to the meadows of 'Umikoa where Kūka'iau Ranch was headquartered reinforced his love for livestock. Riding the hills and valleys of Keanakolu under the shadow of Big Joe Ignacio sealed his fate: He was made for ranch life.

Bull's success on the track fields of both Punahou and Sacramento State Junior College, notably the low hurdles, yielded record-setting performances while earning a strong education, despite having good times.

Returning home, Bull went to work for Mutual Telephone Company, still yearning for the life of a cattleman. After six years in the phone business, Bull was offered an opportunity to go to work at Pu'uwa'awa'a Ranch alongside his good friend R. L. "Bobby" Hind II, a Punahou School classmate of his younger brother Harvey.

Life at Pu'uwa'awa'a was in many ways idyllic—stunning scenery, balmy weather, and working with some of the finest men Bull would ever know, notably Robert Ke'akealani Sr. However, ranch life there was frustrating at times, given the rascal nature of people like Kamaki Lindsey, formerly of Parker Ranch, and the laid-back management style of Leighton Hind, coupled with periodic interference by Hind sisters Mona and Irma and the antics of younger brother Robson. But Bull was loyal to his colleague and friend Bobby, with whom a lot of hard work and good times were had.

Having peaked in his ability to contribute to the Hind operations, Bull was in the process of moving on when Leighton confided in him that Hartwell Carter wanted to talk to him. Hartwell likely followed Bull's career at Puʻuwaʻawaʻa, noting leadership potential in this Scottish local-boy *haole*. Hartwell knew, however, that in bringing on an off-ranch leadership candidate, the ability to "earn his spurs" was up to the young man.

Bull joined the Parker Ranch ranks in 1950 and spent a progressive and colorful decade on the huge spread. His first assignment was to the esteemed Cowboy Gang, led by the hard-driving John Samoa Lekelesa.

While the newcomer might view this assignment as a rigid boot camp test of one's mettle, in my opinion placing Bull on the ranch's most prominent and hard-driving crew was a compliment to his ability and demonstrated Hartwell's enhanced view of the young man. History will show that the same process enhanced the early career of Rally Greenwell, who was viewed by A. W. Carter as a leadership candidate of genuine potential. Surviving the heavy-duty peer pressure and downright harassment that comes with the Cowboy Gang territory is definitely a "cowboy boot camp," not unlike the severe preparation of Quantico, Virginia, for the Marine Corps. The responsibilities of the rank and file as well as of the Cowboy Gang were immense, and surviving the ordeal of a few years on this elite crew was an accurate measure of one's constitution. Bull passed muster.

His next assignment was nearly the opposite in both pace and pressure. He now reported to Baybrook, the ranch agronomist, for exposure to another aspect of Parker Ranch operations. While the bulk of this assignment centered on the eradication of cactus via parasitic organisms, it was a boring but necessary rite of passage in Hartwell's manner of developing leadership personnel. While other candidates such as the young Peter L'Orange and Alex Penovaroff were spared such tedium in ensuing years, Bull accepted these assignments with a begrudging but competitive spirit, just as his nickname always implied.

Before long, foremanship of Makahālau and the purebred cattle breeding operation became Bull's assignment, one that brought immense responsibility, parallel stature, and a great opportunity to showcase his management abilities. All this he did with great enthusiasm.

Bull fondly recalls the great men of that station, such as Bob Hasegawa, Tadao Nakata, and Charlie Kimura, who was given his first permanent assignment caring for Parker Ranch livestock. Bringing Charlie Kimura back from the Fence Gang into the livestock realm of Makahālau launched a career opportunity for the young man who, three decades later, would become livestock manager of Parker Ranch. Other men of note during Bull's tenure were Saichi Morifuji of Hanaipoe and Iwataro Ishii of the Old Dairy at Palihoʻoʻukapapa.

Challenges kept coming for Bull, however, usually in the form of broncky "reject" mounts from Cowboy Gang strings and/or the Breaking Pen. This was quite a departure from his stint on the Cowboy Gang, where his string of horses had all come from Frank Vierra who was out on an extended injury furlough. In typical Bull fashion, he took on these rejects with special vigor and dedication, turning them into productive cow horses. Bull loved to meet any challenge head on.

Even more challenging was the mission

Edwin "Bull" Johnston (right) herding registered heifers with Charlie Kimura. Courtesy of Kamuela Museum.

of developing a respectable relay racing team out of Makahālau, where station horses were utility quality and were rarely given the opportunity to be conditioned for the July 4 races in Waimea. By tradition, the nine stations on the ranch entered horses in relay matches and straight match races as well as half-mile distance heats, and Makahālau was rarely a leading contender in most of these matches. Mustering his own track experiences, coupled with his innate desire to win, Bull set out to change the image of the Makahālau Station—which included Hanaipoe, manned by the noted but often underrated horseman Saichi Morifuji, nicknamed "Mori." He had other fine horsemen to call upon, such as Mickey Perreira and some of the men who were dutiful and well-versed herdsmen in the eminent bull stud of the Parker Ranch. Bull provided intensive conditioning and feeding of these mounts. He cajoled the ranch surveyor, amiable Stanley Wright, into measuring off an exact quarter-mile distance on the pancake flat *pahuʻa* (flat) between Puʻu Iʻo and Puʻu Kaʻaliʻali, giving the relay team as well as the mounts ample opportunity to practice the swiftly coordinated passing of the relay baton. Over the next few years, the Makahālau relay team became consistent victors at the Independence Day races at the Parker Ranch racetrack. No longer were they the target of the derisive kidding that came with their former substandard performances.

It was with comparable pride that Bull fine-tuned the purebred Hereford breeding program that continued to produce superior seed stock for the ranch as well as neighboring ranches such as Kahuā, which sought to improve its herds. Not long after this purchase, he was offered an opportunity to go to work at Kahuā, but he declined. A general management position had quietly been offered to him by the owners of Huʻehuʻe Ranch, just south of his former stomping grounds, Puʻuwaʻawaʻa.

Off to Kona he went, to work alongside Theodore Vredenburg of old Parker Ranch, who was poised for retirement. In the process of assuming the full reins of the outfit,

Bull made another stellar selection in Willy Gomes as his foreman at Huʻehuʻe, taking a rough-and-tumble but smart and capable cowboy out of the former ranks of the Chow Ranch of Hanaipoe. Bull effectively developed Willy into a highly respected foreman for the Huʻehuʻe outfit, working in tandem with him on the aggressive and productive master plan to bring the Kona ranch into the modern ages. They were effective in executing a variety of major ranch projects.

Before long a new road was built from the old belt road near Hōlualoa town to the upper reaches of this section of the ranch. This encouraged progressive pasture management practices as well as the building of modern pipe gates and corrals that became the template for many Big Island ranch facilities, including Hualālai, Parker, Kahuā, and many others.

When his ranching career came to an end, Bull returned to Oʻahu to remain in land management for the Ward Estate. Bull left an imprint—a legacy of excellence in ranch management at every ranch he rode for—and Parker Ranch was no exception.

Another horseman who made his mark on Parker Ranch was young James Dowsett, who had a yen for every aspect of cowboy life. Proving his worthiness, he enthusiastically tackled all assignments, working toward his goal to become a member of the prestigious Cowboy Gang. Unbeknownst to him, Dowsett was placed in a variety of situations by Hartwell Carter as a test of his leadership potential.

James (Jamie) Dowsett

James (Jamie) Alexander Dowsett was born on Oʻahu on December 20, 1924, and reared by his mother Marian (Babe) Dowsett, whose father was the noted Alexander (Alika) Cartwright Dowsett. The Dowsett name is historic in Hawaiʻi's ranching heritage. Jamie Dowsett's great-grandfather, J. I. Dowsett, brought Shorthorn cattle from Oregon to Hawaiʻi about 1878, crossbreeding the imported bulls on locally bred cows.

In 1881, J. I. Dowsett imported four Angus bulls along with four cows from Aberdeen, Scotland. His Scottish agent, Hugh Fergusson, was commissioned to select, pay for, and ship to Honolulu these early importations of the Angus breed, which in modern-day Hawaiʻi has become the leading breed of beef cattle. Dowsett spent $11,000 on this successful venture.

Jamie grew up in Hawaiʻi's ranching circles with an enduring attraction to horses. He sought every opportunity to be on horseback. Alika took Jamie under his wing when he was an infant and taught him about the ranching business. Given this bond to the noble steed, coupled with a family heritage steeped in ranching tradition, Jamie envisioned a life with ranching.

After graduating from Punahou in 1944, he enrolled in the U.S. Army Officer Candidate School at Fort Lewis, Washington. After the military, Jamie moved directly to Corvallis, Oregon, enrolling in the animal science course at Oregon State University, from which he later graduated.

Returning to Hawaiʻi in 1949, he was encouraged by notable mentors Archie Kaʻauʻa, Ronald von Holt, and Percy Sanborn to follow his heritage pathway to the Parker Ranch. It was a logical course for him to follow, given that Elizabeth (Tootsie) Dowsett Parker was his grandaunt as well as Richard Smart's grandmother.

That same year, about six months after the death of A. W. Carter, Jamie applied for a position with Parker Ranch and was hired. His appeal for a job was well received by his cousin Richard Smart. Hartwell Carter, then manager of Parker Ranch, immediately assigned him to the Utility Gang under Theodore (Akeni) Akau Sr., a noted taskmaster. After a few months, the anxious cowboy inched closer to the range management aspect of the ranch in an assignment to the fountain grass control crew. Remaining there for only three months, Jamie dug fountain grass by the roots along the western flank of the ranch bordering on territorial lands that abutted Puʻuwaʻawaʻa Ranch, where the pesky grass had made a home. From above ʻĀnaehoʻomalu Bay, going *mauka* beyond Puʻu Hīnaʻi, Keʻāmuku House Camp, flanking Puʻu Heʻewai, and ending at Puʻukeʻekeʻe near the present-day Pōhakuloa Training Area, Jamie trekked the arid plains afoot in the crew's collective effort to follow Hartwell's noble but futile mandate to rid the ranch of this forage of low palatability and nutrient content.

Again exposing Jamie to different aspects of ranching, Hartwell sent him to the Parker Ranch slaughterhouse manned by Shunji Yoshimura. After a few months of slaughtering, deboning, and processing beef, mutton, and pork, Jamie was assigned to the cactus control crew that was managed at different intervals by Harold Baybrook and Bull Johnston.

Finally, Jamie was beckoned to the livestock department, becoming a member of the Cowboy Gang. He was finally back on a horse.

In retrospect, it becomes readily apparent that while his early assignments were mundane and in some cases demeaning, one must remember that most other management trainees were subjected to the same "boot camp" exposure. It was Hartwell's way to test their mettle while developing patience, practical knowledge, and leadership skills. Hartwell wanted to observe in these youthful candidates the ability and willingness to learn while waiting their turn for upward mobility to occur.

Now part of the Cowboy Gang, Jamie found comfort among the legion of elite *paniolo*. Reporting to the stern John (Samoa) Lekelesa, who cut no slack for the young and restless, Jamie was willing to do what it took to fit in among his peers. He fondly recalls his horse string by names and their sires, reflecting on the great progeny of Querido, the prominent remount Morgan stallion. Jamie readily credits horse breakers such as Walter Stevens and Daniel Pai with putting out well-started, gentle colts for the Cowboy Gang. Aside from Lekelesa, Jamie credits Henry Ah Fong with providing splendid leadership qualities, quietly mentoring the young cowboys in the Parker Ranch standard of livestock handling. Bob Sakado, as Dowsett recalls, also helped him learn the ropes.

While on the subject of ropes, few knowledgeable stockmen of the era would disagree that Jamie was quickly emerging as one of Hawaiʻi's better ropers in or out of the rodeo arena, which was the venue of many of his championships. He was as good a horseman also and took pride in his mounts. Between the Parker Ranch Fourth of July rodeo/racing festivities and the Hawaiʻi Saddle Club Rodeo of Honokaʻa, the name Jamie Dowsett was invoked with respect. Jamie was appropriately

James Dowsett at Second Gate on one of his first ranch Quarter Horses, a son of Sappho. Courtesy of James Dowsett.

James Dowsett with Peter Baldwin at a horse show (Maui fairgrounds, Kahului, Hawai'i). Courtesy of James Dowsett.

recognized in 2005 as the Hawai'i Saddle Club Honoree at the Memorial Day festivities in Honoka'a.

Things changed drastically when the Korean War broke out and Jamie was drafted. Upon resolution of that conflict, he returned home, now married to his longtime sweetheart, Queenie Ventura Dowsett, and ready to start a family. Delighted to return to the Cowboy Gang and back on his fine mounts, Jamie saw an opportunity for advancement in an assignment to the First Gate, Second Gate, and Pā'auhau sections of the ranch under the amiable Joe Pacheco and Walter Rycroft. While in this verdant section of the ranch, he befriended a station cowboy named Sanshiro Yano. Upon Rycroft's retirement, Jamie became foreman of those sections of the ranch.

With a management opportunity beckoning at Pu'uwa'awa'a Ranch under the new Dillingham/Carlsmith owners, Jamie (along with Yano) left the Parker Ranch, taking with him great memories of cowboys of great magnitude.

While only there for a short while, the inclusion of his name in the history of the Parker Ranch is only fitting given the unique combination of innate cowboy skills, good looks, and congenial nature that Jamie Dowsett possessed.

Hartwell's Avocations and Sunset Years

Hartwell developed two avocations, one major and one minor, but neither was less dear to his heart than the other. One dealt

with purebred cattle and the other was his horticultural endeavor.

Over the years, especially those spent with his wife Becky, Hartwell engaged in a hobby of breeding purebred cattle, as did his successor Dick Penhallow. Hartwell was a consummate Hereford man, and in a smaller sense he replicated—with modified lines—the purebred breeding operation at Makahālau.

While under his management, the ranch was breeding herd and range sires out of the Makahālau unit to a satisfactory degree in quality and quantity. Little in the way of new lines of Hereford cattle was imported. In establishing the Homestead Farm on 87 acres in Puʻukapu in 1952, a venue was provided to look toward limited importation of breeding stock of modified lineage. As he built his small seed herd, he established a market venue of prominence, at least by local standards, in the Hawaiʻi Bull and Horse Sale.

Hawaiʻi Bull and Horse Sale

As producers of well-bred bulls and horses, it naturally followed that Parker Ranch as well as Hartwell Carter would promote a public livestock sale. The concept provided access for the general ranching community of the state to long sought after bloodlines of cattle and horses. Prior to the birth of such a public sale, private purchase of blooded stock was by private treaty, and Parker Ranch was not readily accessible to all ranchers for this purpose. No ranch-sponsored dispersal sales of livestock occurred before 1972, when the Rubel and Lent team hosted a "fire sale" of polled Hereford and Angus bulls and a plethora of horses that varied from registered mounts to grade stock of mixed breeding.

Homestead Farm bull named KB None Such 100. PPS.

The idea of a local bull and horse sale was born when Sherwood Greenwell and R. L. (Bobby) Hind Jr. of Kona noticed the repetitive success and aura of the traditional Red Bluff Bull and Gelding Sale in northern California, likely hosted by their good friend and colleague Bill Verdugo.

The concept soon grew into reality, with much organizational support from the University of Hawaiʻi County Extension Agent, Norman Nichols. The Hawaiʻi Cattlemen's Association, with Bobby Hind at the helm, became the sponsoring agency. Hartwell Carter served as a very supportive vice president of the organization and provided significant support for launching a venue by which many of his better bulls could be sold.

A sifting and grading committee was

formed to provide an acceptable level of health, soundness, and uniformity. Serving on this committee was Dr. Wallace T. Nagao, Charles Koontz (Hawaii Meat Company feedlot manager), Dr. Estel Cobb, and Norman Nichols, both from the University of Hawai'i.

The first Hawai'i Bull and Horse Sale was held on November 18 and 19, 1965, with Howard Brown of Denver, Colorado, as auctioneer. The top-selling bull was Parker Ranch's Hereford bull, PR Beau President 2, which was purchased by Kona rancher Joe Gomes for $1,800. The nine Hereford bulls consigned, including Daleico Ranch and Homestead Farm, as well as Parker bulls, averaged $1,243, while four Angus bulls from Randolph Crossley's Koa Ridge Farm were sold to Carl Meyer for an average of $912. The fifteen Santa Gertrudis bulls consigned by Hualālai Ranch, W. H. Shipman, Ltd., and Semloh Farms (Mrs. Mona Holmes) averaged $608. All told, the twenty-nine bulls offered at this first sale brought an average of $855, more than satisfying the sale committee's expectations.

As for the horse sale, nine horses were consigned to this history-making sale and sold for an average of $475. The sale committee viewed the average as satisfactory since they were mostly yearlings, except for a couple of cow horse offerings from Freddy and Sally Rice's FR Quarter Horse Ranch.

The annual Bull and Horse Sale grew to be the livestock industry's flagship event, becoming increasingly popular since the consignors' offerings grew in number and quality. From 1970 to 1980, I served as sale veterinarian, which I considered a privilege. After a decade of doing the sale, I passed the torch to Dr. Alan Kaufman.

The sale eventually died for lack of in-

Program cover: First Annual Bull and Horse Sale, 1965.

Becky Carter with shorthorn bull at Homestead Farm. PPS.

Shiro Fujitani with son Dean and daughter Gail. Dean appears to be anxious for the maki sushi. *Courtesy of Dean Fujitani.*

terest. Unfortunately, this was shortly after Parker Ranch built a special sale ring attached to the south wall of Pukalani Stables.

Beyond the annual bull and horse sale, other buyers for Hartwell's bulls were engaged by private treaty, including Parker Ranch to a limited degree. As a service to interested ranchers, Hartwell also dabbled in the registered Shorthorn breed of cattle often sought after by grass-fat operators for their inclination to apply body fat readily.

Looking forward to his retirement years, Hartwell continued to develop Homestead Farm, including a spacious home occupied by one of his herdsmen, Shiro Fujitani, a former Parker Ranch cowboy. Several outbuildings were built, maintaining an appearance much like those of Makahālau. Hartwell was delighted to develop as a full-time herdsman Yutaka Kimura, who had retired from the ranch in 1967. Yutaka over the years had been working in a part-time capacity. Besides Fujitani, Hartwell brought in other former Parker Ranch hands of note, including retired assistant cowboy foreman Bob Sakado, retired cattle superintendent Joe Pacheco, and retired Breaking Pen foreman George Purdy. All men were noted for their gentle, caregiving nature.

Hartwell and Becky developed their home place on 25 acres about a mile out of town toward Honoka'a. This colonial style executive home had become their new domain several years earlier as Hartwell was leaving the ranch after vacating the great White House built for his father and expanded upon later for him. Some of the gardening staff reflected on the sadness they felt on that day, not only for the parting of the Carter family forever from this fine estate, but also they mourned the destruction of Hartwell's exten-

Bob Sakado enjoying his retirement years with horned Hereford bull at Homestead Farm. PPS.

Joe Pacheco, Shiro Fujitani, and Yutaka Kimura each holding proud offerings of Hartwell Carter's efforts to advance the Hereford breed in Hawai'i. PPS.

Right: Hartwell Carter in retirement years with his signature lei hulu pāpale *and fine-weave* pāpale lauhala *(pandanus hat). PPS.*

sive collection of plants and flowers. Entire greenhouses were destroyed over a point of discomfort with the ranch owner and Hartwell's inability or failing to plan for their evacuation to his home estate. Hartwell, on a much smaller scale, was able to rekindle his horticultural avocation, but it was the cattle that brought him joy. He also received pleasure from being surrounded by his most loyal circle of men—Fujitani, Kimura, Pacheco, Purdy, and Sakado.

The premises of both the Homestead Farm and his home estate were graced by immaculate landscaping, largely due to the dedication of another former ranch employee, Isami Ishihara, and his wife Matsuyo, who worked as the Carters' housekeeper.

Hartwell and Becky truly enjoyed their golden years, surrounded by fine cattle, a dignified social circle, and loyal, endeared employees. Hartwell passed away in 1985 and Becky in 2000, leaving most of their holdings to charity.

The community of Waimea, the ranching industry of the entire state, the private hospital and educational institutions of Kamuela, and most notably the Hawaiian homesteaders owe an enduring debt of gratitude to the Carters, Hartwell and Becky. Aloha, Hakuwela!

2

THE DICK PENHALLOW MANAGEMENT ERA

Though beaches and game, horses and business sites are in many other places, there is only one famous Parker Ranch with its history, traditions, and people. Without its success all else becomes harder to accomplish.

These words, extracted from an article by Dick Penhallow in the June 1962 issue of the ranch newsletter, *Paka Paniolo*, succinctly describes why Parker Ranch is held dear in the hearts of all who have been part of its history. Dick Penhallow was no exception. He was loyal to the land.

In 1948 Richard "Dick" Penhallow came to Parker Ranch as Hartwell Carter's assistant. Hartwell later hired Roger Williams as a parallel assistant manager. Well-situated at neighboring Kūkaʻiau Ranch, Williams was a consummate Hereford man closely aligned with the Carter family. Nevertheless, Penhallow arrived on Parker Ranch and reported for work.

Penhallow's Background

Born in 1906 in Wailuku, Maui, Dick Penhallow was the son of Henry B. Penhallow, manager of Wailuku Sugar Company. The family hailed from Portsmouth, New Hampshire. A New England seagoing family, Dick Penhallow's grandfather and great-grandfather were ship captains. It was his grandfather, DeBlair Pearce Penhallow, who made the Hawaiʻi connections with his ownership of the barque *Hope* and the ships *Robert Lewis* and *Alice Cook*.

As a boy of fourteen, Penhallow worked for Harold Waterhouse Rice at Kaʻonoʻulu Ranch (formerly Cornwell Ranch) on Maui, aspiring to be a cowboy. His father, however, guided him into a career of sugar instead of ranching. Young Penhallow earned a degree in agriculture-sugar technology from the University of Hawaiʻi, where he also starred in football and track. His first job was as an agriculture research specialist with the Honolulu Plantation Company in ʻAiea, on Oʻahu. By 1944 he was plantation manager, a post he held until the company folded in 1946. For a short period he worked for Hawaiian Commercial and Sugar Company before moving to the Big Island with his wife Olive and two sons, Christopher and John (Jack). He spent a final two years in the sugar industry at Onomea Sugar Company before joining Parker Ranch, where he remained for the next

Richard Penhallow at his desk. PRC.

twenty-four years. He was ranch manager for the last two years, during which time he made significant managerial changes—some perhaps planned during the previous two decades.

At Parker Ranch, Penhallow focused on agronomic improvements. An advocate of soil conservation, he saw to it that Parker Ranch was first to sign on when the Mauna Kea Soil and Water Conservation District (MKSWCD) —now called the National Resource Conservation Service—opened its Honokaʻa office in 1955. Penhallow not only provided excellent representation of the ranch's needs, he also brought his strength in organizational leadership to the group. He served on the organization's board for seventeen years, seven of them as chairman and four years as state vice president.

Residents of the Waimea community owe Penhallow a debt of gratitude for his foresight, planning, and execution of a flood control plan. It not only conserved water for truck farmers but also provided protection against flooding of the Lanimaumau stream during torrential rains. Penhallow, through MKSWCD, is credited with building the long levee that runs parallel to Mānā Road across from Case Memorial Veterinary Hospital, the expansion of adjacent Pāʻiakuli Reservoir within the Mānā levee, and the pillbox drains scattered throughout the western flat of the Kalani Schutte Ranch homestead.

During his tenure as assistant manager of the ranch, Penhallow also became a director of the Hawaii Cattlemen's Association, a group with territory-wide influence.
In this role, he was active on the tax and rainmaking committees.

At the time, Albert Waterhouse proposed a tax formula developed by C. Brewer Ranches of Kaʻaluʻalu and Kapāpala that reflected a credit on cattle-carrying capacity for weaner to yearling animals, which meant a substantial discount to all ranchers. This action came from placing the land tax treatment of ranchers on a more equal footing with pineapple and sugar producers. The territorial tax commissioner approved the tax committee's work. Penhallow's role was significant.

The rainmaking committee was headed by prominent neighboring rancher Ronald von Holt, and it captured Penhallow's attention. It was a joint venture with the Pineapple Research Institute and totally experimental. A collection campaign headed by von Holt was not well supported in the broader ranch community, and Kahuā and Parker Ranch were the only primary contributors, with the latter outfit providing $10,000. The paucity of progress reports on the experiment probably reflected the nature of the results. Still, the effort showed that both von Holt and Penhallow were willing to take risks and explore the unknown.

Waimea flooding: main intersection looking south toward Mauna Kea with the old ranch office and Hayashi Store to the left. Penhallow collection, Arch McCabe photo.

Waimea flooding: liquor store view—the overflowing of Lanimaumau Stream (near Mānā Road) led to this flooding. Penhallow collection, Arch McCabe photo.

Above: Waimea flooding: streams from the Kohala Mountains meandering down Laelae paddock during a 1979 storm. Pat Greenwell collection.

Right: Waimea flooding: truck farm damage—gully erosion of the Whitehead truck farm cabbage crop. Penhallow collection, Arch McCabe photo.

Penhallow's Role in Hawaiian Homes Commission Matters

At the time that Parker Ranch employed Penhallow, the Hawaiian Homes Commission (HHC) began planning the development of homesteads on the Waimea parcels that the ranch had under lease. The generous response of Hartwell, Richard Smart, and Penhallow, as noted earlier, was underscored by a couple of years of intense background efforts. With Richard Smart's concurrence, Hartwell worked out the cooperative proposals, while Penhallow negotiated the details for the ranch with the commissioners of the Territorial Land Office and the HHC. (These were Republican times, and Penhallow was an active player behind the scenes in the political arena.)

In 1949 the HHC notified the Land Office of the decision to homestead their lands. HHC was concerned that the Land Board would attempt to return the land to general territorial use. Rumors circulated that the HHC would subdivide the ranch lots in the Waimea area, giving rise to hopes for an award of land to such deserving people as John Holi Ma-e at Kūka'iau Ranch, Johnny Kainoa at Kahuā Ranch, and a number of Parker Ranch foremen, including respected ranch superintendent, Harry Kawai and general employees. But despite the raised hopes, it took a few years before the first lots were drawn and awarded. The HHC prevailed in its efforts, effectively blocking the Land Office and small rancher initiatives to revert the subject lands to general territorial use.

A related issue was how and when Parker Ranch would vacate the HHC lands. In an effort to retain the lands, Parker Ranch attorney Garner Anthony approached the attorney general with the suggestion of a continued custodial approach—a plan to "stay and take care." The attorney general immediately dismissed this idea. A second line of appeal came in the form of a tenant-at-sufferance, a scheme that also failed. A tenant-at-sufferance is a holdover tenant beyond the lease term who acknowledges no legal right to remain but desires to continue using the land for an indefinite period of time. It is likely that the indefinite time frame caused alarm with the attorney general. The final plan adopted was the release of the lands in an allocation of step-by-step fencing of individual ranch lots, an approach that gave the ranch more time to evacuate. Garner Anthony was notable in assuming the legal role, wisdom, and strength of A. W. Carter. A young attorney in Garner Anthony's office, William F. Quinn, brokered the agreement; Quinn went on to become governor of Hawai'i.

Quinn's deal overcame intense antagonism from commissioners Norman Maguire, David Furtado, William Heen, and the chairman, Victor Houston, head of Kamehameha Schools. Evacuation and fencing was to begin at Nienie, followed by work at HHC lands at Pu'ukapu.

Another related issue was the reacquisition of Hanaipoe lease lands by Parker Ranch, held at the time by several small ranchers—Choi Leong Chow, Texeira, DeLuz, Ramos, and Nobriga. These ranchers were in the same predicament as Parker Ranch, facing the loss of grazing lands and nowhere to go with current cow herds. Parker Ranch wanted the Hanaipoe lease back to accommodate the cows grazing on lands to be returned to the HHC. The Hanaipoe consortium was well connected to the Land Office and Land Board, which held jurisdiction over

the Hanaipoe land lease. To be reckoned with was the antagonism of the commissioner of Public Lands, Norman D. Godbold, and board members A. D. Castro and G. N. Serrao. So Anthony, Quinn, and Penhallow worked at convincing the governor, the attorney general, and the Land Office that the ranch was willing to give the Hanaipoe consortium more time if the HHC would in turn give Parker Ranch more time. This created a mutually satisfactory time frame. This understanding with the Land Office helped make possible the phased withdrawal from the Nienie and Pu'ukapu Hawaiian Homestead lands. On October 27, 1951, Penhallow sent Hartwell Carter the following memo regarding the Ranch's position:

> I want you to know that a great deal has been going on under the surface and behind the scenes. In a discussion last Saturday, the matter of building up friendly support from Castro, Serrao and others was considered with Mr. Anthony and Mr. Quinn. In view of open hostility which had been shown by these two, which was also obviously affecting less active commissioners and the personnel of the Land Office itself, we thought it in our best interest to try to overcome this, preferably before our antagonists could spoil our case before the Homes Commissioners, and if somehow the Governor, Attorney General and Land Commissioner could be convinced of the inter-relationship of the homes land withdrawal and the dispossession of the small ranchers whom Serrao and the Governor had been trying to protect, then the participation of these other government officials would also have an influence upon the allowance of time by the Homes Commission.
>
> This plan was for Anthony to see if Castro could not start as his own development some plans to allow the Hanaipoe group more time.
>
> This has proved very much to appeal to Castro, Serrao and Godbold and through them to the lawyers of our opposition. Very friendly relations have been re-established with the Governor's office.

Another land issue was the Land Board's inclination to subdivide the Humu'ula land into three parcels when the Parker Ranch lease expired. The ranch had a friend on the Land Board in Archibald Spencer (Archie) Ka'au'a, son of the man who was a champion roper at the Cheyenne Frontier Days in 1908. Archie alerted Penhallow to the plans for subdividing and leasing Humu'ula plus the 11,400-acre 'Āinahou *kīpuka* (an open oasis-like area surrounded by lava) across the highway from the Humu'ula Sheep Station. The *kīpuka* covered an expanse from that approximately 6,000-foot elevation downward 6 miles to the Pu'u'ō'ō-'Āinahou-Keawewai trail to Keauhou Ranch and was under a lease nearing expiration to W. H. Shipman for growing stocker cattle. The second and third parcels were to be created by splitting the Humu'ula lease into two parcels; one would extend from the sheep station to Laumai'a House, the second from that point on to Hopuwai House. The Kalai'eha-Humu'ula Sheep Station would become a sheep ranch and the Laumai'a-Hopuwai section would be leased as a cattle ranch. The question for Parker Ranch was what to do with 5,000 sheep ready to shear and another 15,000 scattered across the 50,000-acre lease. This three-

parcel approach died a quiet death, but not without the close monitoring of Penhallow and Archie Kaʻauʻa. On May 20, 1952, Hartwell wrote Godbold offering a continued annual payment of $22,232 for the Humuʻula lease on a revocable permit from January l, 1952—the lease extension expired on December 31, l951—as long as Parker Ranch occupied the land. The offer was accepted.

In 1956, Shipman cattle were removed from the ʻĀinahou *kīpuka,* and the land was placed in conservation. I worked as a summer cowhand for neighboring Puʻuʻōʻō Ranch during these times and at age fifteen was rather naive as to the long-range significance of this changeover. Herbert Shipman, President of W. H. Shipman, Ltd., despite the loss of grazing lands, welcomed the move; he was an early advocate of wildlife conservation. The area was the early home of the *nēnē,* Hawaiʻi's State Bird, which was saved from extinction by Shipman. It is still an important sanctuary for this endemic Hawaiian goose.

As for the splitting up of Humuʻula at the Laumaiʻa point, little support came from the Land Board members. Undoubtedly, Archie Kaʻauʻa supported the practicality of one intact lease. Parker Ranch subsequently rebid the entire lease successfully in l953 for an annual fee of $24,000. The Humuʻula lands later fell under the jurisdiction of the Department of Hawaiian Homelands.

Perhaps the thorniest challenge to the HHC homesteading program came from Anna Lindsey Perry-Fiske, who smoldered under the proposed termination of approximately 500 acres in an HHC lease along the slopes of Puʻu Haloa and Puʻu Kaʻala in Puʻukapu. Not one to take a setback lightly, she appealed unsuccessfully to Hartwell to sublease l,000 acres at Kawaihae Uka next to her Keawewai mountain retreat and ranch, *mauka* of the scenic lookout on the Kohala Mountain Road, to accommodate her Puʻukapu cow herd. Unknown to Parker Ranch, Anna had begun a quiet campaign to become the supplier of foundation heifers and cows to the newly awarded HHC lessees. For the Aunty Anna I knew well, loved, and respected, this was vintage "Anna the Rancher" combat by intimidation, as Parker Ranch was deep in negotiations for more time with HHC, while concurrently offering more time to the Hanaipoe consortium through the Land Board. Anna thus placed the ranch, already concerned with the risk of losing the Humuʻula lease, in an even more vulnerable position. Her effort to provide the new lessees a supposedly better deal on foundation stock alone created community unrest and disruption.

Anna's brother, Sheriff Bill Lindsey, and one Charles Sylva effectively confused the new homesteaders. I remember Holi and his wife Esther in soft *ʻōlelo kanaka* dialogue reflecting their disdain for what was happening to the ranch. As Holi described the conduct of Lindsey and Sylva, it was *namu namu* (back biting) of a low type. Holi was pleased and anxious for the Parker Ranch proposal for foundation stock, perimeter fencing, and water resources to achieve reality and questioned why anyone would go against this fine opportunity.

By late August 1952, Penhallow was attempting to broker an agreement with Anna Perry-Fiske in which she would receive not only her l,000 acres at Kawaihae Uka but garner a twenty-year lease term. This was clearly an effort by Penhallow to mollify Anna on a smaller issue for the greater good of the whole ranch. It was not to be. In a memo of Septem-

Richard Penhallow honored at Anna Perry Fiske party. Left to right: Julia Rodenhurst, Rally Greenwell, Richard Penhallow, Stanley Wright, Anna Perry Fiske. PPS.

ber 17, 1952, Penhallow wrote to Hartwell: "It would seem that Anna has chosen to interpret a neighborly act as an effrontery. In so doing she had gone farther along the road of no return. In her actions and talk she is her own worst enemy. My approach to her was to try to get her back to the area of friendly dealing, but has resulted in just the opposite."

In the end, Anna failed to supply breeding cattle to more than a couple of homesteaders, but she retained her 500-acre lease in Puʻukapu for a period of twenty-five more years. Dick Penhallow and Anna Lindsey Perry-Fiske eventually restored their close social relationship.

In his role as assistant manager, Penhallow worked on other land matters, including water easements and land exchanges. One water easement issue was the disposition of the Kaʻala 4-inch line coming out of the low-pressure water head *(keʻahawa)* that crossed several Hawaiian Homestead lots, including those of Davis, Flores, Kealamakia, Kauahi, Chong, and Lindsey (Oscar); it was the kind of detail work in which Penhallow excelled. Penhallow also worked on rights of entry agreements, including a Hawaiʻi County Board of Water Supply agreement regarding the Hāmākua (Āhualoa-Honokaʻa) Water System and another with the Federal Aeronautics Commission for work on the Waimea-Kohala Airport at Kamuela.

Enter Roger Williams

Penhallow's tenure as assistant manager was marked by his diligence and his abilities in a broad array of duties, much of them behind the scenes. He remained loyal to and respectful of Hartwell's closely held decision-making style, despite describing his role as being a

Hartwell Carter with Roger Williams at Wailea Beach. PPS.

"spectator." For reasons unknown, Hartwell did not seem to warm up to this relationship and in 1957 brought in Roger Williams as his assistant manager, leaving Penhallow somewhat in limbo. It is not known whether Richard Smart encouraged Hartwell's decision or whether Hartwell moved in the direction of a protégé in whom he had greater trust. My inclination is that Hartwell found Williams to be more closely aligned with his stoic, conservative management style.

Roger Williams had considerable ranching experience from his previous position at neighboring Kūka'iau Ranch, which ran Hereford cattle exclusively. Noted cattleman Joseph (Joe) Correia was the foreman there. Williams came with the respect of the men of Kūka'iau Ranch, even bringing one cowboy with him. John Holi Ma-e returned to Parker Ranch in 1957, having started his career as a cowboy in Humu'ula in 1918, then moving to Kūka'iau until he was fifty-five; he retired at sixty-two from Pukalani Stables, where he rode a small band of five colts for the Breaking Pen—and where I worked in 1959 before heading off to college.

Roger Williams' wife, Gwen, was a charming woman who settled easily into the new surroundings, including a newly remodeled home on Hoku'ula Road. But Williams and Penhallow found little common ground. Wrote Jimmy Greenwell (in *One to Eighty-One*):

> Around 1959, it became clear that friction was fast developing at Parker Ranch between A. Hartwell Carter and Richard Penhallow. Richard Smart was in residence and taking some part or positions in management that tended to be sympathetic to Penhallow. In frustration, Hartwell succeeded in persuading Roger Williams, then at Kūka'iau, to accept the position of Assistant Manager of Parker Ranch but failed to make clear to Williams and Penhallow who exactly in fact was IT. The Penhallow/Williams discord ultimately led to Hartwell's resignation. Williams and Penhallow faced off and Penhallow survived, apparently with Smart's blessing.

By the end of 1959 Hartwell ended his term as trustee/manager and, apparently with Smart's counsel, retired from the ranch.

On January 1, 1960, Penhallow was named manager of Parker Ranch, the culmination of the last dozen years spent preparing for the moment. Williams went off to Huʻehuʻe Ranch, where he became manager following the tenure of Edwin "Bull" Johnston, who had succeeded Theodore Vredenburg. James Armitage moved to Kamuela from ʻUlupalakua Ranch on Maui to become Penhallow's assistant, as Penhallow shifted his focus from land, water, and agricultural concerns to livestock production and property development. A pall of silence enshrouded the ranch and community as to the exact details of Alfred Hartwell Carter's departure from the ranch. This code of silence lasted through the passing of both Carter and Richard Smart.

Penhallow's Early Vision

In the dawn of his tenure as ranch manager, Penhallow set forth bold but thoughtful proposals that reflected his wholehearted acceptance of his new responsibilities. He wrote frankly, "Parker Ranch is synonymous in every detail with the personal fortune of Richard Smart. In his absence it is dominated by the personality of a manager who is his attorney-in-fact."

Penhallow distanced his management style from that of Hartwell Carter, whose close-knit and somewhat mysterious organizational posture often defied clear horizontal or vertical lines of authority. But it worked. Penhallow sought progressive development of the ranch using initiative potential found among informed and educated personnel, both present and future. Designating authority and responsibility under a system of budgetary controls and operating policies that were made known to all concerned achieved this development.

Penhallow carefully reviewed the existing organizational structure of the ranch and set out to author a relatively bold plan for reorganization that had previously been used successfully in the sugar industry from which he came. He considered the time to be right for a graceful transition to a plan of action, as many key operating personnel were approaching retirement. Penhallow expected the help of these senior employees "in the training of competent replacements with broader educational backgrounds." Obviously, he was looking to college-trained men or—in the case of Charlie Kimura (cattle breeding) and Teddy Bell (horse breeding)—men with extensive field experience. Penhallow declared, "When young college-trained men are introduced to the organization their possible destiny should be made clear to them, but the importance of their intermediate satisfactory service with patience should be made patent."

There were four premises to the Penhallow vision:

1. Clear understanding and recognition by the executive employees of the prerogatives of the owner and his family.
2. Absolute need for policies and procedures under which the ranch organization operates. These policies and procedures would provide for operational continuity regardless of who those executives may be.
3. Provision for the adoption of smaller operational units (divisions) rather than a single unwieldy framework.
4. Effective efforts that must be exerted by the full employee base providing that these ef-

forts are dignified by being made and considered significant.

The first and second premises were to be served by executive personnel governed by a code that omits special privileges or any semblance of feudalism or paternalism toward subordinates. Clearly, Penhallow desired to separate himself from the Hartwellian style of operating the ranch.

The third premise harkened to "plantation style" management, with more than subtle references to trade unionization and defense thereof. The Penhallow vision called for the option of detaching any at-risk division into an operating subsidiary. This would allow the property, both real and personal, to continue to be the holdings of the parent entity—Richard Smart dba Parker Ranch—or dispersed to the operating subsidiary by corporate manipulation. The example provided involved departments in which labor unionization would seek influence: the shops and trades such as motor pool (mechanics, pump men) and the carpenter crews. It was in his vision to consider separating these departments from ranching operations, even to the point of subsidizing independent enterprises of employees who chose to open up private businesses upon leaving Parker employment.

Penhallow described the fourth premise to be "the key to the permanence of [a] happy and successful operation. It can be achieved by management through subtle attention to human rights and personal pride."

Heavy on Penhallow's mind was the recent (summer of 1959) strike activity on Maui that indicated the desire of the International Longshoremen and Warehouse Workers Union (ILWU) to seek membership growth in nonunion agricultural groups. He stated that "the number of employees on Parker Ranch makes it a prime target for future attention; I would like to have corporation papers prepared for immediate filing if organization should even be attempted." It was Penhallow's immediately operable counteroffensive strategy. His logic was that by breaking the corporate ranch down into smaller subsidiaries, only some of these groups would succumb to unionization or perceived to be so small that organizers would lose interest. He stated, "In all cases, a parent entity (Parker Ranch, Inc.) can be maintained as the controlling agency prescribing policy and advising and servicing the subsidiaries as is done in some of the sugar agencies."

Penhallow's Ranch Management Structure

The surest way to reduce a man to nothingness is to attach no significance to his work.

All work on Parker Ranch is significant and all its men are important. If any man were not important to the ranch he would not be on its rolls.—Richard Penhallow, January 1, 1960

As the Carters' tenure came to a close and Penhallow assumed the leadership, the management structure on Parker Ranch was destined for change, but a historical perspective is in order. The business side, for example, always had a key player. In the early years, Olaf Sorenson, an accountant by trade and brother-in-law of A. W., reported to A. W., functioning somewhat as an assistant man-

John Kawananakoa Lindsey. Note his riding breeches and laced-up, knee-high riding boots. Courtesy of Larry Wight.

Theodore Vredenburg with Willie Kaniho and Olaf Sorenson at the 1935 lava flow. PPS.

Willie Kaniho at Old Hawai'i on Horseback festival at Anna Ranch. PPS.

ager. A. W. and his successors functioned as general manager of all ranch resources, including land, livestock, and water. Norman Brand followed Sorenson and served as office manager.

A. W. Carter groomed Hartwell as his administrative assistant, to run on-ranch operations on a day-to-day basis. In the early years, John Kawananakoa Lindsey, an effective leader, led the actual field operations, functioning as a field superintendent. During the terms of both Carters, other key field bosses included Theodore Vredenburg, Willie Kaniho, Yutaka Kimura, Rally Greenwell, and Harry Kawai. Section and crew foremen reported to one of these men for orders. Closer foremen reported directly each day, while remote operations such as Humu'ula and Kohala relied on telephone reports.

Some individuals had direct access to A. W., including the trusted James Brighter (Palaika), who ran the Breaking Pen and in effect the breeding horse program in his prime years. Hartwell, during his tenure as general manager, developed Yutaka Kimura as a direct confidante, but Harry Kawai was overall field superintendent. On assuming management of the ranch, Penhallow kept Kawai in this role but also enjoyed a close and personal relationship with John Kuakini Lindsey. Penhallow's long-range management plan never fully materialized—he ran out of time before he could implement it. The plan would have divided the ranch into several divisions, each managed by a superintendent. It was a managerial structure adopted only in part, and it was not until 1971, in the early days of the Rubel and Lent era, that the ranch was divisionalized. In 2002, the divisional management of Parker Ranch was dissolved, reverting back to the administrative structure of pre-1971.

Penhallow's Plans for Ranch Reorganization

Reorganizing the operational framework of the ranch could be accomplished in three ways: (1) divestiture of specific business functions such as milk, meat, and general merchandizing; (2) outsourcing trade services such as the motor pool, carpentry, and so on; and (3) divisionalizing ranch in-house operations.

Penhallow wisely moved to end the era of paternalism in both the plantation and, eventually, the ranching communities such as Parker, Pu'uwa'awa'a, Kūka'iau, and Kahuā. In the early days in Waimea, a remote and isolated village, employee benefits such as meat, milk, and poi (pastelike food staple from cooked taro corms), in addition to medical, educational, and housing services, were part and parcel of ranch life. At the end of World War II, services such as electricity, telephone, hospital and clinic services, and merchandise via the company store were routine. Improved transportation was reflected in better roads and affordable vehicles.

Seeking to develop his own administrative style and wanting to remove all evidence of previous management practices, he attempted to remove the food benefits for the cowboys. Meat, milk, and poi were holdover paternalistic practices of the Carter and Parker eras. While he stated that "under retiring management there have developed some disparities," I can fondly recall the months of 1959 when Holi Ma-e and I, on our way

Left: Palaika in his senior years. PRC.

Above: Yutaka Kimura with Masa Kawamoto at Fourth of July Races honoring the senior stewards of Parker Ranch. PRC.

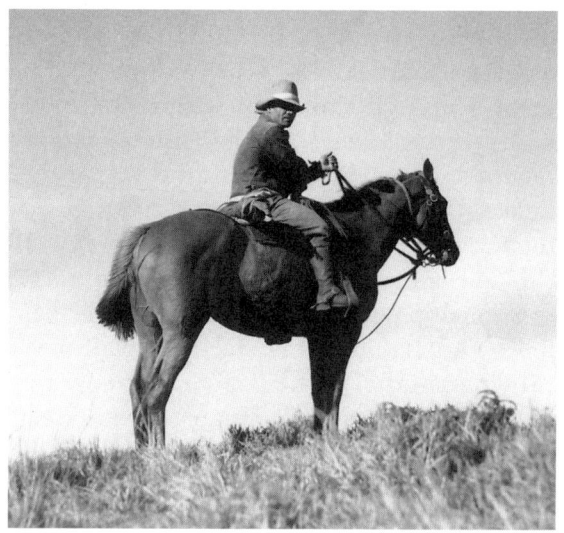

Left: Harry Kawai—a classic glimpse of a classic paniolo. PPS.

Above: Kuakini Lindsey mounted on a sorrel Quarter Horse/Thoroughbred mare. PPS.

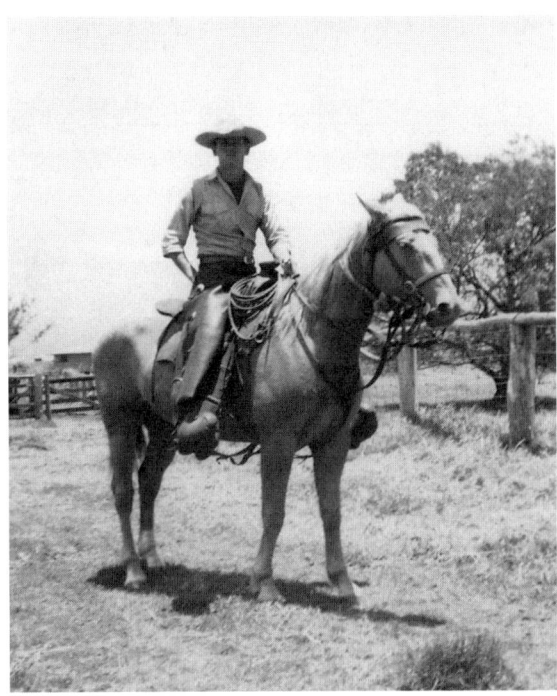

A young Billy Bergin on palomino mare Leiala, a daughter of Naniloa. Photographed in 1958 at John Holi Ma-e's residence in Kūhiō Village. WCBC.

home *pau hana* (after work) from riding *hapa laka* (partly tamed or broken) colts at Pukalani Stables would ride by the Meat Market to pick up our allotment of meat and poi. The poi bag was draped over the saddle horn until we reached home in Kūhiō Village to *wali* (to mix until smooth) the poi in the kitchen sink. Most mounted employees followed this same routine, stopping by the Meat Market as they took their *lio ahiahi* (night horse) home for the next day's work. The meat, milk, and poi benefits prevailed, although their production was eventually outsourced.

Penhallow did not succeed in outsourcing the motor pool and carpentry services, ably managed respectively by Bob Lincoln and Jimmy Kurokawa. He moved forward, however, with the sale of the ranch dairy to Norman Greenwell, the meat processing facility (slaughterhouse and butcher shop) to Yaroku Dochin, who developed it into the Kamuela Meat Company, and the company store to the Hayashi family, who previously worked as employee clerks in the Parker Ranch facility. Outsourcing of the motor pool and carpentry services did not come to fruition until the Voluntary Separation Program of 2002, which occurred several years after his death.

The third element of reorganization was divisionalizing in-house ranch operations. To a degree, Penhallow's model plan broke the ranch down into divisions according to specific defined functions or geographic locations, each with its own budget and cost center. Through his assistant manager Rally Greenwell, Penhallow sought oversight of six distinct entities that became subsidiary livestock divisions: agriculture, cow/calf, growing stock, market stock, Kohala, and Humuʻula.

The Agriculture Division included the Cowboy Gang and pasture crews (weeding, planting, poisoning, etc.), while the Engineering Division headed by James Armitage included the fence gangs, water system personnel, motor pool services, and general construction. It was his intent that this division would also perform off-ranch contracting services to generate outside revenue, with cost experience gauging job pricing.

Kohala Ranch Division

Penhallow was not comfortable with the productivity and management of the Puʻuhue and Puakea sections that made up this divi-

sion of Parker Ranch. He was naive to the fact that the Kawamoto men were industrious and fastidious in the care of these sections. He was inclined to appoint college-trained personnel to take over this outfit, which was supervised by John Kawamoto and his foremen sons, Masa and Yoshi. In his own words, the Kohala Division "requires progressive and intelligent management full time." I remain perplexed by Penhallow's failure to realize the full value of the Kawamoto clan. As with the other livestock divisions, Penhallow planned that Kohala "be operated as a cost center to develop costs of animals per days grazed." The Kawamoto clan outlasted Penhallow.

The plan for Kohala was to crossbreed Angus bulls on market Hereford heifers (or use artificial insemination) that were long yearlings (one and a half years old). After calving, these heifers would be fattened for butcher after weaning of calves that would return to the Growing Stock Division in Waimea. His logic was that overall calf production would rise without extra investment in breeding stock. Kohala would also receive all culled cows from the Cow/Calf Division, where they would be fattened after weaning their final calf in bull-secure paddocks. These calves upon weaning would also return to the Growing Stock Division in Waimea. The Kawamoto clan remained clearly in charge of Kohala far beyond Penhallow's era, with Yoshi as superintendent through the 1980s. In my judgment, the contribution of the Kawamoto clan is nothing short of epic.

Humu'ula Division

Penhallow described the Humu'ula operation, which was also to be treated as a subsidiary, "to have been well exploited, but not with scientific or orderly control."

One thought was to expand production by reducing lamb losses via the housing of shepherds in house trailers near the lambing flocks, akin to the effective sheep husbandry of the Basques in the Pacific Northwest. While Penhallow also counted on improved sheep production via genetics and thus improved breeds, he sought resolution of the tedious annual shearing that involved a crew of a dozen men, who were growing weary of the assignment. He proposed shearing over a month with only two shearers using shearing tables that provided animal restraint similar to those of branding tables for calves. Working in an upright posture, significant physical relief could be afforded. While there are no records that the trailer-housed shepherds ever materialized, the shearing table experiment was a dismal failure. Penhallow did, however, affect improved sheep genetics and production. He was acutely aware of the availability of a USDA–backed wool subsidy, providing $65 for every 100 pounds of wool the sheep ranch sold.

He proposed changes in how Humu'ula's heifer-growing function was to be managed. He suggested the use of antibiotics, minerals, and protein supplementation to hasten the growth and maturity of weaner heifers into long yearlings for shipment to the Kohala Division for breeding and market heiferette (young heifer, preadolescent) production. This would open up more pasturage for the addition of weaned heifer calf crops in ensuing production years. Pete L'Orange was assigned to run the Humu'ula operation. Under L'Orange's management, the goal of reaching a 15,000-head sheep flock was paralleled by the carrying of 8,000 replacement heifers.

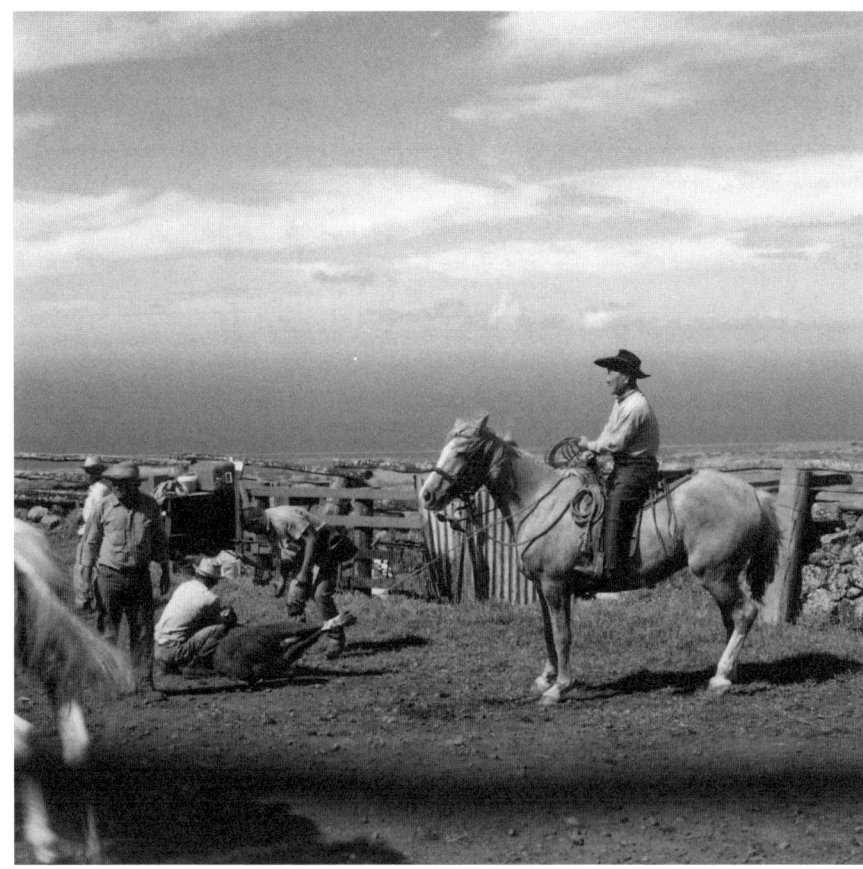

John Kawamoto in his retirement years enjoying a Puʻuhue branding. Photo courtesy of Frank Turek.

Penhallow was concerned that the entire 50,000-acre Humuʻula Division could be turned over to the Hawaiian Homes Commission for subdivision into homestead ranches. If such a crisis arose, his plan was to acquire Shipman's Puʻuʻōʻō lease for the sheep operation and spread the heifer-growing program across the rest of Parker Ranch, accommodated by improved pasture management. Developing the fattening operation at Puakō was also considered a relief for market heifers.

The Kohala and Humuʻula operations had clear geographic boundaries and were in a sense isolated from what was traditionally termed the "Main Ranch." The Main Ranch, simply put, was all of the lands within the 360-degree vision of a Waimea observer. It included the slopes of the Kohala and Mauna Kea mountains facing Waimea and the plateaus that join them. Extension of these views continued eastward to the low rolling hills of the Mānā area, including the verdant meadows of Mahiki and Pāʻauhau, the arid plains of Keʻāmuku to the west, extending from the *mauka* meadows of Waikiʻi and Puʻukeʻekeʻe seaward to the coastal ranges below Puʻuhīnaʻi, where Waikoloa Village

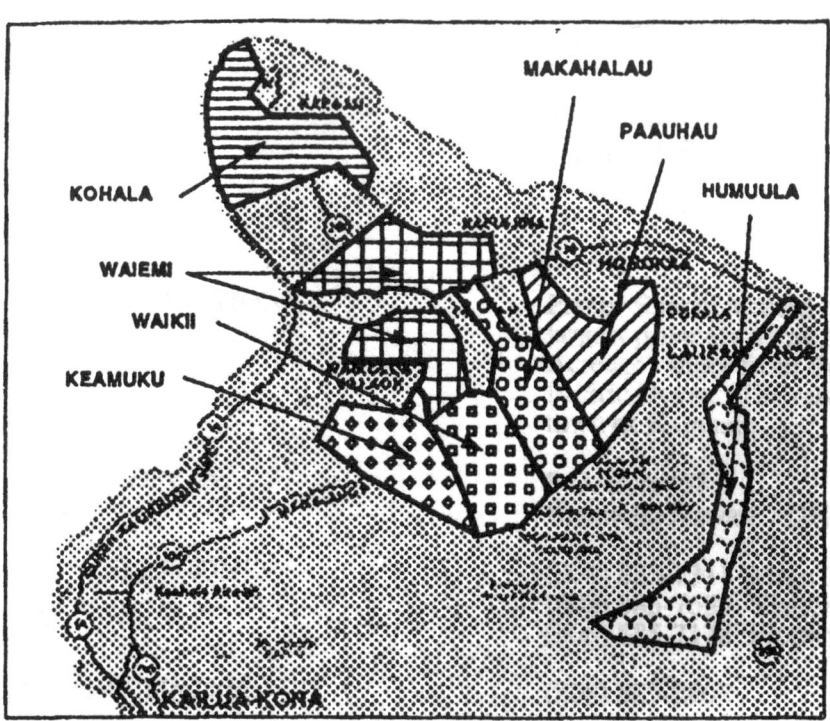

Ranch map by sections.

was later developed. The Kawaihae Uka paddocks I through IV were *mauka* of Kawaihae village. This alone formed a huge ranch, with a variety of ecological and managerial challenges that had been dealt with over the previous half century of the Carter era.

Penhallow took a different approach in proposing to staff the leadership of the three divisions of the Main Ranch—the Feeder, Marketing, and Cow/Calf components. He sought improved results of the different operations via individual managements, each specializing in its own field. However, he included a caveat: "In order to avoid the three deadly hazards of boredom, entrenchment and stagnation, rotation of one type of operation to another after several years of service will be kept in mind." By this time, his grand plan was sounding increasingly complex and progress in its execution became bogged down in the details and, in some cases, the impracticality.

Just as he proposed artificial insemination as a possibility in the Kohala long yearling heifer operation, Penhallow in theory extended this management concept to the main cow herds. His approach to wide-scale artificial breeding of the commercial herds was centered on the use of Dinol, a hormonal preparation to induce estrus heat and ovulation. Dr. Wallace T. Nagao introduced the product Dinol to the ranch and managed its application. Penhallow opined: "When this is perfected, it will be possible to induce ovula-

tion by injection and insemination according to pre-determined schedules with semen from proven producers (sires). This eventuality will eliminate any local responsibility for bull raising either in the registered or commercial herd. Our efforts in breed development can then be concentrated in the selection of superior females." Penhallow's ideas were decades ahead of their time, as estrus synchronization with products for advanced technology did not surface for nearly two more decades, along with dependable heat detection devices. Ironically, the Hawaii Meat Company traditionally was highly dependent on a constant supply of sausage bulls (culled commercial herd sires). A wholesale switch to artificial insemination would likely have had a catastrophic financial impact on the ranch's marketing outlet on O'ahu. In summary, it can be said of his plans for artificial insemination on the Parker Ranch that he was the first to introduce its use on the Big Island—albeit only in ten select heifers, with semen donated from Wye Plantation Farm in Pennsylvania. There were no offspring from this venture, and artificial insemination did not make a true entry into the Parker Ranch management scheme until the era of Gordon Lent in 1971. Kahuā Ranch, in the interim, developed a leadership role in using artificial insemination of cattle on a large-scale basis. This highly productive program lasted into the new millennium for both outfits.

The Cow/Calf operation was commonly referred to as the Breeding Herd Division and did not include the purebred component, which Penhallow dubbed the "stud herd."

Penhallow logically reasoned that the most productive paddocks should be reserved for the feeder (weaners, yearlings) and market stock (fattened butcher cattle). The breeding herds, therefore, were assigned to marginal grasslands. He wrote, "It has been my observation that by breeding in some of the best lands, a part of the weaners and feeders have been denied good growth conditions, even though they were weaned in top shape. I believe calves can better tolerate rough conditions when still with their mothers and therefore propose reserving the all-season reliable good lands for improvement to carry many growing animals." Penhallow's logic was quite sound.

The breeding herds were assigned the following paddocks:

Waiki'i in entirety	Pu'ukawaiwai
Ke'āmuku in entirety	Kawaihae Uka II, III and IV
Range I, II and III	Holoholokū I
Kemole I mauka and makai	Hanaipoe section
Kemole II	Pu'uka'ali'ali
Pu'u'io	Big Makahālau
Pu'ukīkoni I	Pu'u Pueo I and II

As these paddocks became permanent annual pastures for assigned herds, Penhallow delayed all cattle movements until after additional water service, fencing, alleys, and gateways were installed. Further, he planned brush control, grass and legume planting, and periodic resting of paddocks to generate more forage production. University of Hawai'i agronomist Edward Y. Hosaka was instrumental in the planning process for progressive agronomic proposals and the execution thereof. Feeder and market paddocks were also scheduled for similar improvements, including fertilization.

The Feeder Division had the following paddocks assigned to it:

Kawaihae Uka I	Vierra
Laelae Mauka	Ramos
Poʻo Kanaka II	Waikoloa Grass Field
Mahiki	Kaʻala
Baker	Kaʻala Grass Field
Waikoloa	Pāʻauhau I through V
Kawela	Lower Kalōpā
Kawela Grass Field	

As for the market cattle accommodations, Penhallow planned on feeding 6,000 cattle yearly at the Oʻahu feedlot while finishing 3,250 steers and heifers on grass at the home ranch. His plans for Puakō called for finishing 3,000-plus head annually once it was up and running. This was his "relief valve" for the risk of losing the HHC lands (homesteaders) and other governmental lands acquired at auction. Besides a feedlot, plans called for irrigating the coastal plains of Puakō via horizontal drilling in directions radiating from existing wells within the horizon of known water tables. This would determine limits of water availability and, in turn, mandate the amount of acreage to be irrigated.

Penhallow had significant Oʻahu experience in irrigation that he put to considerable use in areas beyond Puakō. Using the Keanuʻiʻomanō Stream meandering through Waimea, he built a productive *auwai* (irrigation ditch) that gracefully zigzagged several miles through the ranch lands of Lālāmilo, ʻŌuli, and Kanehoa paralleling Kawaihae Road. Remnants remain intact to the present, and the subdivisions of Kamuela Plantations and Kanehoa reestablished the Penhallow *auwai*, which keeps those residential areas green nearly year-round. Another irrigation plan of Penhallow's was development of a field of alfalfa in Kaomoloa, located behind the present-day Waimea Middle School, by reactivating the seasonally dependable Lyon's Ditch that meandered from a waterway near ʻImiola Church. The waterway followed a course from ʻImiola Church across to the Breaking Pen, flanking Puʻu Kaomoloa to the south and disappearing in a *pohā* (sinkhole) near the Parker Ranch racetrack. The alfalfa field was to serve the relocated stud herds of registered cattle—one of Penhallow's least popular moves, in which he brought the blooded bulls from the verdant meadows of Makahālau to sunny but arid Waiemi Stables near Puʻuʻōpelu. Penhallow stated that "the core of these operations will be moved to central headquarters for convenience of operation and control."

The stud herd paddocks included accommodations for not only the registered Hereford cattle but also the Thoroughbred breeding operation, which was headed by Teddy Bell headquartered at the Racetrack Stables. Stud herd paddocks assigned to these cattle and horses included the following:

Līhuʻe	Range Holding Pen	Puʻuloa
Race Track	Puʻuʻōpelu	Church
Holoholokū II	Stonewall	Nakanishi
Puʻuhihale	Lālāmilo	Ishihara
Pelekuai	Makahikilua	Ahumoa
Kaomoloa	Baker Cornfield	Waimea Dairy
Manager's Horse Pen	Puʻuneʻeneʻe	Puʻu Kakanihia
	Holoholokū I	

At the time, Holoholokū I as a paddock was nearly 16,000 acres and Ahumoa and Puʻukeʻekeʻe were vast rangelands. Their mention here is in the context of using these fields as large turnout paddocks for the Thoroughbred operation.

Penhallow's style was that of an open and direct manager with clearly defined goals. He was not interested in popularity but in effec-

tive execution of those goals. He wanted to make improvements in water resources, land (pasture and commercial development), cattle, sheep, horses, economics, and personnel.

Penhallow's Water Resource Development

Penhallow's top priority was water development. He initiated studies to improve existing water heads and pipelines while researching superior pumping systems. The current system included more than 160 miles of pipelines and more than 400 water tanks and troughs. Due largely to Willie Kaniho's diligence, there were more than 175 ground tanks (dirt reservoirs)—thirty of them in Humu'ula alone. Comparable progress was made in Waiki'i and to a lesser degree in Kawaihae Uka. Penhallow's background in water conservation meant that appropriate ground tanks were rubber lined. His actions often were a follow-up to Hartwell's own initiatives, and Willie Kaniho provided the continuity.

Pasture Development

Penhallow had a close relationship with Edward Y. Hosaka, an agricultural extension specialist with the University of Hawai'i, with whom he enjoyed a common interest in agriculture, primarily range management. Penhallow's practical observations and Hosaka's scientific methods meant positive results in grass/legume introduction, pasture fertilization, and grazing methods. High priorities were forest clearing, brush and weed control, and extensive pasture rest. There was empha-

Edward Y. Hosaka, industrious agronomist who trekked the entire Parker Ranch on foot, identifying more than 300 species of grasses and legumes. PPS.

sis on biological control of noxious plants, using insects for cactus and emex.

Lantana was controlled by the heavy concentration of cows, especially in forage areas such as Kawaihae Uka after heavy grubbing with chains drawn by tractors. Kikuyu and Guinea grass planting showed promise as a means of choking out the emex and lantana respectively. The use of fertilizer via helicopters on improved pastures (Baker and Vierra

Puakō irrigated pasture where Bermuda grass was seasonally supplemented by kīawe beans, making excellent forage. Penhallow collection.

Fertilizing Baker paddock by tractor: Isami Nishie pulling a fertilizer spreader with a D-6 Caterpillar. Penhallow collection.

Fertilizing via biplane: Murray Air dusting pangola/Kikuyu and clover paddocks near Puʻuhue. PRC.

in the Kaʻala area, Fertilizer Field in Kohala) brought rapid results and intensified grazing. Over the next decade, fertilizer became prohibitively expensive to use, but Penhallow used it with enthusiasm during his tenure, for it was more affordable then.

The relationship between Penhallow and Hosaka was mutually rewarding and spanned many years on the ranch. Sadly, Hosaka died in 1961 at a fairly young age, leaving a vacuum for a period of years until University of Hawaiʻi extension agent Clarence Garcia came aboard during Rally Greenwell's management.

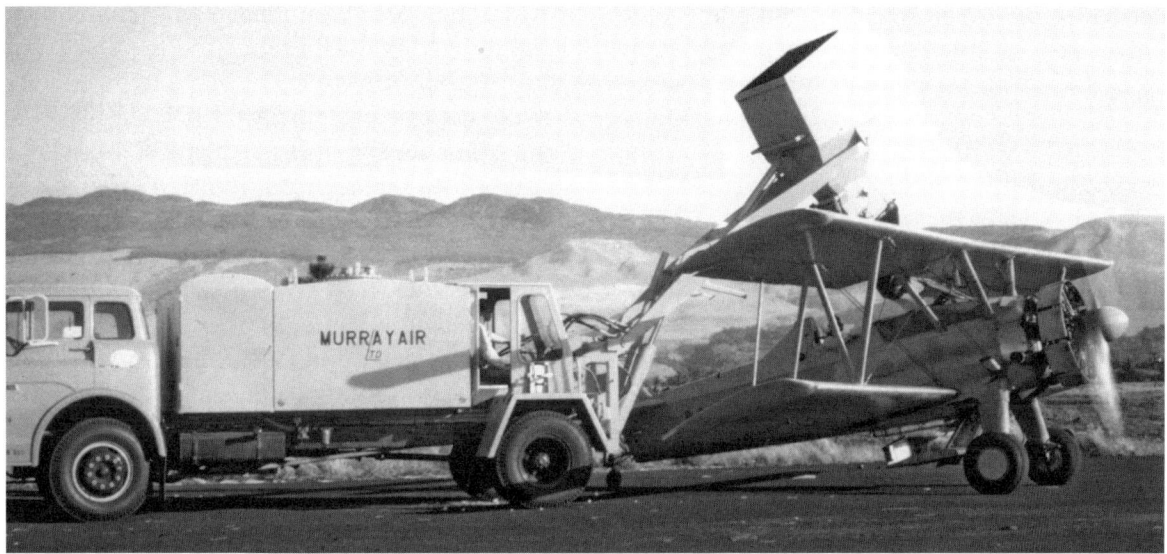

Murray Air servicing a biplane with fertilizer. Baker and Vierra paddocks were prime grasslands for such treatement. PRC.

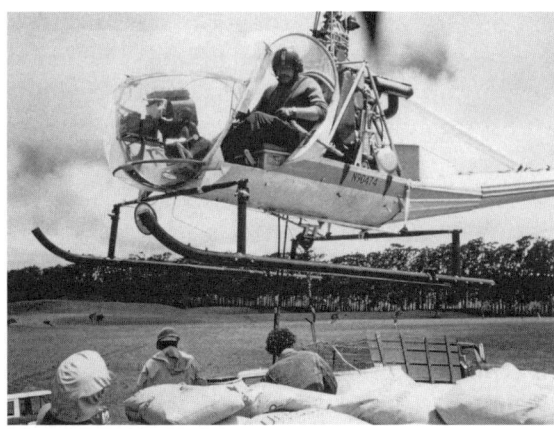

Murray Air servicing a helicopter used for fertilizing the hilly terrain of North Kohala. Bill Case photo.

In extending due credit to these pioneers in range management, the following section describes the significant grasses and legumes, followed by a section on weeds and shrubs.

Grasses and Legumes

While this section on common forages may seem boring to some, I feel it is appropriate reading for the genuine "grass farmers" (ranchers) who may appreciate the century-long process by which Parker Ranch rose to international prominence in range management. It also provides the general reader with a perspective for understanding the important relationship between the rancher and researcher—particularly the dependency of the former on the latter in securing critical information to improve ranching operations and thus ranchers' economic base. More importantly, it sheds some light on how research,

especially in ranching, plays an important part. It also serves the purpose of giving credit to the historic ranch pioneers of grassland development—notably A. W. Carter, Harold Baybrook, and Hisa Kimura. Special credit is given to University of Hawai'i agronomist Edward Y. Hosaka, who in 1936 trekked across the entire ranch afoot, cataloging all available forage.

This treatise on forage is not a complete inventory of all ranch grasses and legumes but a selective overview of those salient forages that graced the sprawling plains, ridges, and valleys of 'Āina Paka. The first volume of *Loyal to the Land* described some of the native endemic and earlier introduced grasses and legumes. Predominant grasses of more recent times are described below. Fertilization became obsolete by 1985 due to prohibitive costs.

Rattail Grass

Rattail grass *(Sporobolus elongates)* is a wiry erect perennial forage that was first found in Hawai'i in 1903. A native of Africa, rattail became well entrenched in Australia and New Zealand and likely reached Hawai'i within the bowels of imported bloodstock, for which the latter country was a well-known resource. Rattail is of low to moderate nutritional value, especially when in neglected later stages, but it is noted as a saver of livestock through lengthy droughts that affected Waimea and its surrounding meadows. Surviving well at ranges as high as 4,000 feet from Hanaipoe to the upper reaches of Ke'āmuku, this forage was more than adequate feed for the cow herds, particularly when it was kept moderately grazed. When the ranch increased its herd size from 12,000 to 18,000 mother cows in the 1960s and 1970s, the added grazing pressure actually enhanced the palatability and nutrient value of rattail.

Agronomic efforts of that same time actively disked and harrowed tillable fields of the Mānā and to a degree Waiki'i areas in a program to replace rattail with a progressive mixture of new grass and legume species, and to a large degree they were successful in suppressing rattail proliferation. Two factors were problematic: (1) the persistent opportunist Kikuyu grass quickly entered in, and (2) of those desired forages that did succeed as replacement grasses, none, including Kikuyu, were as drought resistant as rattail.

Over the past half century, rattail went from the predominant forage of the upper reaches of Waimea to the pathway carpetlike grass limited to roadways of Parker Ranch pastures, a phenomenon of this grass that remains a mystery. As fountain grass invaded the ranch over this same period, the ranch went from moderate to substandard mainstay forage.

Buffelgrass

Buffelgrass *(Pennisetum ciliare)*, which is common to the range, Holoholokū, and the Kohala coastal ranges, takes special management. The management of buffelgrass depends upon the rainfall cycle. A rotational deferred system of grazing, in which a different pasture is used first each time, is ideal for improving or maintaining pastures in buffelgrass. The grass makes rapid regrowth if soil moisture is available, and it can be rotationally grazed on a thirty-day cycle. Regardless of rainfall conditions, buffelgrass should not be grazed closer than 2 to 3 inches from the ground. Buffelgrass pastures should be allowed to reseed every four to five years.

In one season, established buffelgrass has

yielded from 4 to 6 tons of green forage per acre under a low level of fertility and from 8 to 10 tons of green forage per acre under a high level of fertility.

Green Panic Grass

Green panic grass *(Panicum maximum* var. *trichoglume),* found scattered in moist parts of the ranch, is a grass that needs lots of moisture and even fertilization to be a significant forage force. Green panic grass has a thirty-day regrowth cycle after rains or irrigation during the warmer months and a forty-five-day regrowth cycle during the cooler months of December, January, February, and March. This grass was rotationally grazed when soil moisture was available to provide sufficient regrowth. In drier areas, deferred rotational grazing was practiced to provide forage during the dry season or to allow the grass to set a seed crop for stand improvement.

Guinea Grass

Guinea grass *(Panicum maximum),* common to the Puakea section, is a grass that has been traditionally underutilized as a dependable forage resource, especially for growing stock. Common guinea grass pastures are adapted to a sixty-day regrowth cycle during the hotter months and a ninety-day period during the cooler months of December, January, February, and March. For maximum production, this grass would be rotationally grazed when soil moisture was adequate. In areas where moisture was limiting, a deferred rotational system was used. Use of the pasture was occasionally deferred to provide feed during the dry season or to produce seed to improve the grass stand. Ninety days were usually necessary to produce a seed crop. To maintain maximum vigor and stand, the lower-growing type was not grazed closer than 6 to 8 inches, and the colonial types not closer than 10 to 12 inches. Guinea grass alone, or with *koa haole* under irrigation, produced heavy annual forage yields—upward of 100 tons of green forage per acre. Without irrigation, the annual yield varied with the climate and ranges from 5 to 35 tons of green forage per acre. By 2004 guinea grass was found to have volunteered in the lower-elevation paddocks of Range I, II, and III, as well as in the Boise parcels and Puʻupāpapa.

Kikuyu Grass

Kikuyu grass *(Pennisetum clandestinum)* is a ubiquitous and tenacious drought-resistant grass found in all sections, including Humuʻula. Kikuyu, along with fountain grass, plays a heroic role during drought times. Kikuyu grass or Kikuyu grass-legume mixtures are adapted to a thirty-day grazing rotation during the warm season and require up to a forty-day regrowth cycle during the cool season at elevations below 4,000 feet. Longer regrowth periods may be needed as elevation increases. Under certain conditions, this grass can precipitate magnesium and calcium deficiencies. In cattle, hypomagnesemia causes grass tetany and in horses, chronic hypocalcemia causes "big head disease," a form of osteomalacia.

Kikuyu grass and its associated legumes will withstand grazing down to 2 to 3 inches in a rotational pasture system. Periodic close grazing is desirable to maintain the legume in the pasture and prevent the development of woody, short-leafed stems. Kikuyu grass will produce from 40 to 100 tons of green forage per acre, depending upon the climatic conditions and the amount of fertilizer applied.

Pangola Grass

Pangola grass *(Digitaria decumbens)* is common only to the most improved pastures of the Mānā and Kohala Divisions and is highly seasonal. Pangola grass or pangola-big trefoil mixtures are adapted to a thirty-day pasture regrowth cycle during the warm season and up to a sixty-day regrowth cycle during the cool wet season. Under good management, these pastures will produce up to 80 tons of green forage per acre annually. Pangola grass and big trefoil both withstand close grazing under a rotational grazing system. To help maintain the proper grass-legume balance, a desirable stubble height is 2 to 3 inches. Pangola responds exceptionally well to fertilizing. Harold Baybrook is credited with oversight of the intensive pangola grass planting program on Parker Ranch.

The pangola grass–greenleaf desmodium pasture needs a longer regrowth period and should be managed to maintain a grass-legume balance of 40 percent legume and 60 percent grass. During the warm wet season when greenleaf desmodium is growing rapidly, it can be pastured on a forty-day cycle. During the cooler season, this pasture cycle will need to be increased to more than sixty days. The legume stems are the guides for pasturing a pangola grass–greenleaf desmodium mixture. Animals should be removed from these pastures before the legume stems are eaten to the ground. The best pangola meadows were given up in the loss of the Baker/Vierra leases and the sales of Lālākea and Mahiki and numerous Kohala paddocks in recent years.

Para Grass

Para grass *(Panicum purpurascens),* also known as California grass, was once common to the Keʻāmuku Division and came with the attendant problems described below. If heavily fertilized in areas with sufficient moisture or under irrigation, Para grass may be cut at thirty-five- to forty-five-day intervals for high yields of superior quality. Yields of 60 tons per acre per year have been obtained in Hawaiʻi, with moderate levels of fertility. Under most conditions, a sixty- to ninety-day regrowth cycle is allowed for green-chop feeding. The sixty-day period is needed during the cooler months or at a higher elevation. Under grazing, where considerable stubble is left, thirty- to fifty-day regrowth periods appear to be satisfactory. If this grass is used for pasture, overgrazing should be avoided. Para grass cannot withstand prolonged close grazing and heavy trampling. With the heavy grazing of the "superherding" program in the new millennium, Para grass all but disappeared on the ranch.

Rhodes Grass

Rhodes grass *(Chloris gayana),* is an upright, vigorous perennial 2 to 4 feet tall, a native of Africa that became naturalized through tropical America. Rhodes grass is well valued as a cattle feed on Parker Ranch, lending itself well to rotational grazing under modest management. Under heavy grazing it recedes to a dormant state but readily survives drought conditions if grazing pressure is held to a considerate level. Much Rhodes grass is seen around Waimea in holding paddocks or horse pastures. Its predilection for roadside growth reflects its need for moisture as well as rest.

Star Grass

Star Grass *(Chloris divaricata)* is a creeping perennial with upright flower stalks that enjoys drier surroundings, such as the whole of upper Keʻāmuku, where it complements Natal redtop and Bermuda grasses as a moderately nutritious forage. Somewhat resistant to drought, star grass is sensitive to overgrazing that accrued in the dawn of the new millennium with the superherding regime, leaving the grass overwhelmed by fireweed coverage and near extinction.

Sweet Vernal

Sweet vernal *(Anthoxanthum odoratum)* is a fragrant annual bunch grass that has been found in Hawaiʻi since 1906, especially in the cooler, moist meadows of medium to high altitude.

A. W. Carter's first impression of the grass was a negative one, relying heavily on published reports of its "unpalatable" nature with a tendency to "crowd out more valuable grasses." By the 1930s, sweet vernal had established itself well in the Mānā area, given its persistence for reseeding readily. Not until Willie Kaniho reported the highly positive observations on cattle and sheep in the Laumaiʻa and Hopuwai paddocks of Humuʻula did Carter give the forage its due credit as a significant part of the ranch's forage mixture. In the late 1950s, Rally Greenwell introduced sweet vernal to the higher paddocks of his family's Palani Ranch in North Kona, and the grass grew in profusion there by the new millennium. Sweet vernal can still be found as a dependable forage resource in parts of the Mānā region of Parker Ranch.

Bermuda Grass

Bermuda grass *(Cynodon dactylon)*, called in Hawaiian *mānienie,* is common to lower elevations and coastal ranges. As forage, Bermuda grass is adapted to a twenty-one- to thirty-day regrowth cycle, with the shorter intervals occurring during the warm, sunny periods. When soil moisture is sufficient to provide good continuous growth, it should be pastured under a rotational system. Bermuda grasses, especially the "giant" forms, should not be allowed to mature if used for young animals because they become tough and difficult to graze when they approach maturity. They lose their feed value with age. Yields of the forage types of Bermuda grass vary according to the climate regions where they are grown, as well as availability of soil moisture. In dry, shallow soils, yields of green forage may be as low as 2.5 tons per acre. Where a high water table is present or under adequate rainfall or irrigation, annual yields of 40 tons of green forage per acre have been obtained in Hawaiʻi.

Annual and Perennial Ryegrass

Annual and perennial ryegrass *(Lolium perenne)* is a historic grass common to the Mānā Division. Ryegrass fits a thirty-day grazing cycle during its best period of growth. It may be necessary to lengthen this cycle to forty-five days during cool weather. Grazing of ryegrass was deferred during dry periods. Under good management, this grass produced annually from 10 to 20 tons of green forage per acre.

A rotational pasture system produced the best forage yields. Such a system was used where continuous pasture growth was possible. A deferred rotational pasture system

Italian rye with white Dutch clover in Big Pakila paddock of Waiki'i. Bill Case photo.

Orchard grass, Big Pakila. Bill Case photo.

was used to increase the stand by producing a seed crop. About 90–120 days are required to produce a crop of perennial ryegrass seed.

Ideally a rotationally grazed ryegrass-legume pasture was managed to maintain approximately 60 percent grass and 40 percent clover. Turning cattle into the pasture when the grass reached an 8- to 10-inch height and moving them when the grass was grazed down to a 2-inch stubble accomplished this. Like brome grass, ryegrass adapts naturally to the temperate zone and is notable as one of Hawai'i's finest forages.

Orchard Grass

Orchard grass *(Dactylis glomerata)* is another grass of historic use common to higher elevations of the Mānā and Mauna Kea Divisions. In most locations during the warmer season, orchard grass (also called cocksfoot) is adapted to a thirty-day regrowth cycle. When the temperature and incoming radiation decrease during the colder months, it is necessary to lengthen the regrowth cycle. Winter-grazing cycles may be as long as sixty days. In drier locations, a deferred rotational grazing system was used to increase the stand by producing a seed crop.

Cocksfoot-clover pastures were managed to maintain a 60 percent grass and 40 percent clover mixture. This is accomplished by turning the cattle into the pasture when the grass reaches a 10- to 12-inch height and pasturing it down to a 2- to 4-inch stubble height. With good management, this grass yielded annually from 5 to 8 tons of green forage per acre.

Wild Oats

Wild oats *(Avena fatua)*, as its name implies, is an erect annual 2 to 4 feet tall that was an escapee from intentional cultivation on major islands as early as 1888. Attracted to medium altitudes of the ranch, this forage blended well with other grasses and legumes in complementary fashion, its nutritional value enhanced by its grained head. It was key forage in the grass-fat marketing program.

A native of Europe and a popular forage of the U.S. West Coast, where it was often harvested as a grass hay, wild oats does not fend well under heavy grazing or extended drought and may become dormant for long periods before rain and rest brings the versatile forage back to the forefront of ranch pastureland.

Yorkshire fog in Puʻu Puʻeo. Bill Case photo.

Yorkshire Fog

Yorkshire fog *(Holcus lanatus)*, sometimes referred to as velvet grass due to its velvety hairs on the foliage, has a usually silvery head that gives the grass a misty, grayish appearance—hence the English name of Yorkshire fog.

Native to Europe, this erect perennial became widespread in the meadows of the United States. In Australia it is considered a pest, while Hawaiian ranchers consider it a good pasture grass. When it was introduced in 1903, largely through the efforts in the early days of A. W. Carter, this grass became the mainstay—along with sweet vernal and a variety of clovers—for the fattening paddocks of Mānā, Nienie, Pāʻauhau, and Poʻo Kanaka. Yorkshire fog prefers moist, medium- to high-elevation country but remains a hardy survivor even under difficult climatic conditions.

Koa Haole

Koa haole (Leucaena glauca) is a legume common to the Puakea section. *Koa haole* used as a pasture with either guinea grass or green panic grass was kept well cropped and not out of reach of the grazing animals. The stumps of *koa haole* should be less than 4 feet high in a well-managed pasture. Livestock were moved out of *koa haole* pastures as soon as possible after the companion grass was grazed to its proper height. A sixty- to ninety-day regrowth period was allowed when adequate moisture was available.

If harvested as green-chop forage, *koa haole* was cut to ground level or a height favorable to the companion grass.

Under good management, *koa haole* will annually yield 35 tons of green chop per acre. An irrigated *koa haole*–guinea grass mixture will annually yield up to 100 tons of green forage per acre. Without irrigation, the annual yield depends on climatic conditions and varies from 5 to 35 tons of green forage per acre. The best of the *koa haole* fields of the Kohala section were lost in the wholesale dispersal of these fee simple lands in the early years of the new millennium.

White Dutch Clover

White Dutch clover *(Trifolium repens)* is a legume ubiquitous in the warmer, wetter areas of the ranch. Management of white clover grass pasture must consider the growth characteristics of the clover as well as the grass.

The pasture was managed to maintain 20 to 40 percent clover in the mixture. To maintain a pasture of 40 percent clover and 60 percent grass, the grass was not allowed to shade the clover. This required pasturing the grass often enough to control its growth at a height compatible with the growth of clover. A thirty-day cycle normally provides this kind of growth. Livestock were usually turned into a white clover–grass pasture when the grass was 10 to 12 inches high and removed when the white clover–grass mixture had been grazed to 2- to 3-inch stubble.

Under good management, white clover–grass pasture yields ranged from 8 tons of green forage in areas with low rainfall to 60 tons of green forage in areas with a higher and better-distributed rainfall. With the epidemic spread of fireweed *(Senecio madagascariensis)*, both white Dutch and yellow Dutch clovers are effective biological control agents by smothering the weed's progress physically as well as nutritionally. In their nitrogen-fixing capacity, the clovers encourage the desirable forages to compete against the fireweed.

If bunchgrass such as ryegrass or cocksfoot were used, it was necessary, however, to allow the grasses to reseed periodically to maintain the grass stand. Using a deferred rotational grazing system did this. The superherding program of the early new millennium caused these grasses to disappear, and it was replaced by Kikuyu at best and fireweed at the worst.

Yellow Dutch Clover

Yellow Dutch clover *(Mellilotus officinalis)*, nicknamed sweet clover, is readily recognized by its bright yellow flower, as opposed to the circular while crownlike flower adorning white Dutch clover. All other comments under white clover apply to sweet clover, particularly in terms of pasture management. Both clovers are notorious for causing frothy bloat in adult cattle due to the plants' ability to induce suspension of the belching reflex, a vital part of the rumination process, in which gas buildup requires frequent relief. Holoholokū is a pasture notorious for seasonal clover bloat, requiring the cowboys to vigorously "ride" the bloating cow by chasing her on horseback until flatulence allowed gas release. In severe cases where the cow was unable to be moved into a trot or run, the cowboy would deftly trocar (puncture) the rumen (the largest of four stomach compartments), allowing the release of gas. It is remarkable that these cows never died of peritonitis (infection of the abdominal lining). Typically it was the nānāʻāina man (ranch land observer) that alerted management at the outset of clover season, and the herds were moved at the optimal time of grass/clover admixture, thus averting clover bloat. Under the ranch's superherding regime and rotational grazing, management of clover bloat has become much easier.

Greenleaf Desmodium

Greenleaf desmodium *(Desmodium intortum)*, found irregularly today on Parker Ranch, is another legume that provides excellent forage but is not a hardy survivor. The management of a greenleaf desmodium–grass mixture is governed by the growth of the legume, and rotational grazing must be carefully practiced. This legume must be given an opportunity to make enough top growth for good root development. Care must be taken to prevent excessive stem damage because the new growth comes from buds in the leaf axils on the stems as well as from the crowns. Ideally, all livestock should be removed from the pasture as soon as possible after the leaves have been stripped from the stems. Greenleaf desmodium has a sixty- to ninety-day regrowth cycle. Early indications of established desmodium in Kalawamauna paddock of Keʻāmuku are encouraging.

Big Trefoil

Big trefoil *(Lotus uliginosus)* is another legume with much potential found irregularly on Parker Ranch. It has a thirty-day regrowth cycle during the warm season and may re-

quire up to sixty days regrowth during the cool rainy season or at higher elevations. Big trefoil can withstand close grazing on a rotational basis. When grown in association with bunchgrasses such as cocksfoot or perennial ryegrass, a rotational deferred system of grazing was advocated by Hisa Kimura to permit reseeding the grasses.

Kaimi Clover

Kaimi clover *(Desmodium canum)*, also called Spanish clover, is a ubiquitous, hardy legume. Continuous grazing, because its prostrate, creeping growth makes it possible for the plant to reproduce foliage that cannot be removed completely by livestock, cannot harm *kaimi* clover. The best management for *kaimi* clover pastures, therefore, is that which is most beneficial to the companion grasses and the other legumes, if present. Ideally, a thirty- to forty-day regrowth period should normally be satisfactory.

Excellent results have been observed where the grasses and legumes, including *kaimi* clover, were allowed to grow to heights of 10 to 12 inches, then heavily grazed to heights of 2 to 4 inches during periods of four weeks or less. Where preferential grazing of the *kaimi* clover results in patches of ungrazed, tough, unpalatable grasses, annual mowing is necessary to promote uniform pasturing. Puakea is noted for this grazing scenario. By 2004, the excellent grazing meadows were sold after being identified by trustee/management as "marginal properties."

Fountain Grass

Fountain grass *(Pennisetum setaceum)* is appropriate to bridge discussion from grasses to weeds and noxious plants of Parker Ranch since this forage straddles both disciplines. Nicknamed pampas grass in Kona, this bunchy, erect perennial, 2 to 4 feet tall, has woody stems, long, stiff, narrow, harsh leaves, and a flowering head made of pink to purple spikelike awns. Its sheer description is one of unpalatability, but in times of severe drought or, better yet, appropriate management, this forage can be converted to good use.

A native of Africa, fountain grass was a deliberately introduced ornamental at Hu'ehu'e Ranch by a resident judge named Mathewman. Readily spread by wind, the grass quickly established in a *kīpuka* called 'Aina Hou that bisected Hu'ehu'e from Pu'uwa'awa'a Ranch, the latter of which is dubiously credited as the place of origin.

In *Noxious Weeds of Hawaii*, published in 1945, it is justified as a pest: "Fountain Grass tends to form dense stands and if it becomes established in good pasturelands it greatly reduces their grazing value. The harsh wiry leaves are rarely eaten by cattle."

Parker Ranch recognized this northeastern-creeping scourge and kept it at bay by periodic digging and disposal by utility crews, as well as the cowboys during slack seasons between branding, weaning, and shipping. With the military occupation of the vast ranch lands during World War II, these efforts at control were logically set aside, and the noxious grass flourished as it entered through Pu'uhīna'i and Kalawamauna on the western border of Ke'āmuku. By this time, this grass had consumed Pu'uwa'awa'a Ranch lands, save for some of the high-elevation paddocks of Nishiyama, Hale Piula, and Poho'ō'ō.

The spread of fountain grass onto Parker Ranch was effectively reduced by routine digging up of sprouts by 'Ōpae Gangs and utility crews. This process was intensified after World War II when the Waikoloa and

Above: Holoholokū before fountain grass, 1940. Note sparse foliage. PPS.

Right: Holoholokū with fountain grass. Photo by John Russell.

Fountain grass in Puʻuhīnaʻi, 1960, with Leroy Lindsey and Alex Penovaroff heading out on a hunt. Note interspersal of **koa haole** *legume. PPS.*

Fountain grass in full bloom in Range I below Waimea Airport. Courtesy of Phillip Motooka.

Lālāmilo lands were returned to the ranch, already heavily reinfested with this noxious bunchgrass.

Maintenance programs controlling both gorse and fountain grass were gradually terminated, and the outcome has been a gradual degradation of ranch lands. Eventually the ranch was overwhelmed by the wholesale invasion of this grass, which was flanked by cactus overgrowths.

By late 1950, fountain grass could be found in the upper reaches of Holoholokū and Puʻu Keʻekeʻe paddocks in its frontal siege of Parker Ranch lands. By the late 1960s, early stands of this tassled scourge could be spotted in the area of Humuʻula Sheep Station.

With all this said, some positive as well as philosophical points need to be made. First, imagine for a moment that Judge Mathewman instead sowed the seeds of an equally tenacious but nutritious and palatable plant such as guinea grass. This point is not so far fetched, as ranchers in Kona watched over the past three decades as profuse stands of guinea grass spread from Puʻuanahulu to Nāpōʻopoʻo and beyond.

Second, in hundreds of photos of ranch lands taken since the birth of modern photography through the end of World War II, the lands of Waikoloa during droughts are revealed as vast plains of barren soil, save for occasional stands of ōwī weeds. In my lifetime, I observed hundreds upon hundreds of cows between Huʻehuʻe and Parker Ranch being kept alive by rustling forage among the stands of solitary fountain grass, which at times were ground down to their roots. As minimally nutritious as it is, it provided fiber, carbohydrates, and a smidgen of protein, keeping mother cows alive as we waited for rain. If it was possible, then, to periodically regraze the early succulent regrowth of the stands of fountain grass in a rest/rotate/recuperate fashion, Parker can likely match the moderate to good grass management results by Puʻuwaʻawaʻa master graziers Kuakini Cummins, Johnny Medeiros Sr., and Miki Kato, who over the past four decades gleaned every bit of nutritional fiber out of this substandard feed.

Weeds and Shrubs

"A pound of weeds equals a pound of forage." This opening statement, taken from *Weeds of Hawaiʻi's Pastures and Natural Areas*, produced by the College of Tropical Agriculture and Human Resources of the University of Hawaiʻi at Mānoa, clearly identifies the importance of addressing weed control in successful ranch operation. Published in 2003 with Dr. Phillip Motooka as senior author, this identification and management guide includes in its contents five scenes representative of severe weed infestations—four of which were on Parker Ranch lands.

Dr. Motooka, an extension specialist in weed science at the University of Hawaiʻi, is a veteran scientist, highly respected by his peers and agricultural and conservation personnel in Hawaiʻi. In many ways, he has become the "weed" counterpart to University of Hawaiʻi agronomist Edward Y. Hosaka's "grass" expertise in the ranching industry. Motooka's work, developed in the realm of modern-day science and time, contains voluminous knowledge and information on weed control under a variety of regimes.

Hosaka authored the early seminal publication already mentioned—*Noxious Weeds of Hawaii*—published in 1945 by the Territorial Board of Commissioners of Agriculture

and Forestry in cooperation with the University of Hawai'i Agricultural Experiment Station. It was a rudimentary guide of just twenty-eight pages. Appearing in September of that year, the report was limited to the following weeds: barbwire grass *(Cymbopogon refractus)*, cat's claw *(Caesalpinia sepiaria)*, elephantopus *(Elephantopus scaber)*, emex *(Emex spinosa)*, firebush *(Morella faya)* (not firewced), fountain grass *(Pennisetum setaceum)*, gorse *(Ulex europaeus)*, melastoma *(Melastom melabathricum)*, pāmakani *(Eupatorium adenophorum)*, rhodomyrtus *(Rhodomyrtus tomentosa)*, sacramento bur *(Trirumfetta semitridoba)*, and sour grass *(Trichacne insularis)*. With public awareness, the twelve weeds identified in the 1945 publication grew in number to include 386 noxious plants of importance to Hawai'i's agriculture and conservation lands in the 2003 work of Dr. Motooka and his colleagues.

Collin G. Lennox, president of the Board of Commissioners of the Bureau of Agriculture and Forestry (BAF), articulated an early alarm in the foreword of the 1945 publication: "It is difficult to predict which exotic plants may become noxious if introduced into Hawaii, but it is possible through careful observation and surveys to note the plants that tend to become noxious." In the introduction to the same report, he reaffirms the broad responsibility for such observation: "Obviously this is a community enterprise. Infestation on one farm threatens and endangers all land owners and the whole community." His words were prophetic, his advice sage. Today, six decades later, Hawai'i's efforts to withstand the onslaught of alien species, despite its good intentions and scientific and regulatory protocols, have failed to stem this frontal tide.

An example of the myriad pathways through which noxious plants enter Hawai'i is the infestation of fireweed on Kaua'i in recent years. In the late 1980s, a fireweed infestation was noted at the Halfway Bridge near Kīpū Ranch on Kaua'i on a road cut that had been hydromulched with contaminated grass seed. How do we guarantee in this fast-moving global economy that each pound of imported grass seed, hay, and grain is purified of nearly microscopic contaminants? Truly, the "needle in the haystack" adage applies.

The Hawai'i Department of Agriculture provides a firewall of sorts against noxious weed seed contaminants. The Chemical/Mechanical Control Section of the Plant Pest Control Branch of the Department of Agriculture manages a seed laboratory for this purpose. Aware that commercial hydromulch products have been responsible for inadvertent importation of seeds of fireweed, the Department of Transportation has been alerted, since many of the early invasions have occurred along highway improvements that were hydromulched.

The early history of Parker Ranch's defense of its lands against weed infestation is detailed in volume 1 of this text and deals mainly in cactus eradication and control. A. W. Carter took an active role in forcing the government and livestock industry to muster its forces against the scourge of the *pānini (Opuntia* sp.) (cactus). Harold Baybrook ably kept up the vigilance against weed infestation in general in the interim period between the Carters, in times that rendered little concern beyond cactus, emex, and ōwī (seashore vervain). In the 1945 BAF report on noxious weeds, gorse was described to exist only on Maui in the area of Olinda, although much earlier reports of its minimal presence came

from the Humu'ula area. Emex, on the other hand, was described as being profusely abundant in the Waimea area. There are legitimate concerns regarding the status of Hawai'i's countryside that alien species invasions, by whatever means, are beyond effective control. Specific concerns among the livestock industry provide a litany.

First, the surface area of pasturelands is a finite medium for forage growth and harvesting (i.e., green chop, hay, silage, and grazing). If, in fact, a pound of produced weeds replaces the production of a pound of forage, loss of productive soil surface resources occurs at a ratio of 1:1. For example, paddock A of a thousand acres normally carries 250 cows on an annual basis through drought and good times; if it becomes 50 percent infested with fireweed, can the ranch still carry the same number of cattle? If forced to do so, the same-sized cow herd may survive—but not indefinitely—with the inadvertent consumption of fireweed along with the available grass that is now in limited supply. However, cutting the herd by 50 percent is not a viable alternative for the struggling rancher.

Second, a livestock owner must be aware of the health hazards to the animals via the inadvertent or forced consumption of toxic plants that commingle with good forage.

Third, weeds compete with desirable forages for soil nutrients, water, sunlight, and nitrogen sources from fecal and urine deposits, as well as atmospheric-fixing qualities of certain legumes. Worse, some of the most invasive weeds such as firebush have nitrogen-fixing qualities like some clovers, which provide an advantage to the weeds that are more effective in using soil nitrogen than most grass species. Such differential utilization compounds the pasture degradation created by these noxious plants.

Fourth, during dry times, wilting of forage is accelerated where brush and shrubs are present.

Fifth, fuel for wildfires is far more abundant in pastureland infested with unpalatable shrubbery than in well-grazed, weed-free meadows.

Sixth, thorny and gnarly brush such as gorse makes livestock handling more difficult for lack of visual or physical access for observation, processing, movement, and so on. Thorns, spines, and burrs make life hard for the ranch cow, the cow horse, the cow dog, and the cowboy.

Finally, invasive plant life threatens the very integrity of the unique and cherished ecosystems of ranch lands and specifically Parker Ranch, which in times past worked fervently to defend its meadows from such invasive weeds and shrubs. These scourges of the range are described next.

Emex

Nicknamed "noxious" by Parker Ranch personnel, emex *(Emex spinosa)* is an annual herb that rarely grows more than a foot high and produces a small (1 cm) spiny head nicknamed "goat's head" because of its sharp triangular points. Its broad and tenacious matting effect displaces surface area needed for grass.

Originally from the Mediterranean, emex found its way to Moloka'i, where it was first identified in 1928. Readily spread due to the thorny head's attachment to shoes, hoof clefts, equipment, and vehicle tires, this plant easily leaped to the Big Island, where it found comfortable quarters on the range, in Waiki'i, and in the Ke'āmuku drylands.

Emex in full infestation in Department of Hawaiian Home Lands pastoral lots in Puʻukapu. Courtesy of Phillip Motooka.

While there is no toxic effect, the spiny heads accumulate occasionally in the cleft between cattle hooves, causing lameness. Cow dogs are also affected, while horses are free of the nuisance. In cattle as in dogs, physical restraint is required to remove the clusters of pesky goat's head, which if left untreated can result in abscesses of the feet. Some control programs were of significant success. The Department of Agriculture (Territorial/State) studied biocontrol methods that pointed to a weevil that devoured the emex plant, which by this time had extended its invasion toward Makahālau from the drier plains of Waikiʻi and Holoholokū. At Makahālau, ranch agronomist Harold Baybrook successfully reared and released the weevils by the thousands and effectively controlled further spreading of this menace. However, Baybrook was enthusiastic in his theory that the introduction of Kikuyu grass would "choke out" the emex. Much like the bane of the mongoose introduction to control rats, the Kikuyu grass was found to choke out the better grasses such as sweet vernal, Yorkshire fog, and wild oats while peacefully coexisting with the emex plant.

Lantana

Occurring on all major Hawaiian Islands, where it is said to infest more than 400,000 acres, this escaped ornamental is native to the West Indies. Its route to Hawaiʻi is not described. A consistent pest in the drier fields of Kohala and South Point, lantana *(Lantana camara)* has been the subject of more control studies than any other noxious plant of Hawaiʻi to date.

Biocontrol efforts regarding lantana began over a century ago. Beginning in 1902, myriad organisms were reviewed as candidates for controlling this bramble. In recent

Lantana control via chain-dragging in Kawaihae Uka II paddock. PRC.

Cactus prevalence, Lālāmilo. PRC.

Isami Nishie, bulldozer operator. While his career on Parker Ranch began as a top-notch sheep shearsman, Isami grew to become an excellent bulldozer operator. PRC.

years, twenty-six insects were released, fifteen of which became established. Credit again needs to be given to the State Department of Agriculture, notably Drs. Ernest Yoshioka and Patrick Conant. Without their efforts, lantana would likely have covered the lowlands of Hawaiian ranges.

From chain dragging with tandem bulldozers and through a myriad of biological control methods, topical application of pesticides was the persistent method of choice for Yoshi Kawamoto, longtime foreman and later superintendent of the Kohala Division of the ranch. Symbiotically, the forage Tinaroo glycine, when left ungrazed for sufficient periods, completely cloaks lantana, creating regression but not death of the lantana bush.

With the wholesale disposal of the Kohala pasturelands in the early years of the new millennium, so went the lantana frustration. Some of the new owners of these parcels have shown excellent stewardship, and

finding lantana in Maliu, Nunulu, and Irvine paddocks no longer is common.

A'ali'i

A'ali'i (Dodonaea viscose) is considered a native plant and therefore generates no control efforts by the State Department of Agriculture despite its wide distribution over the grasslands of Waiki'i and Ke'āmuku and other parts of the island of Hawai'i. Found on all islands except Kaho'olawe, *a'ali'i* is a member of the soapberry family and produces two to four angled fruits that come in various shades from reddish brown to purple brown. Lei makers prize the colorful fruit and leaves. In old Hawai'i, the fruits were used to prepare a red dye.

While there are no known reports of toxicity from *a'ali'i*, cattle in times of drought reluctantly browse on the leaves. Rogue steers are also found to crouch beneath the *a'ali'i* canopy to hide from *paniolo* in hot pursuit. The dried woody trunks and branches make excellent firewood for the barbecue, burning a hot flame followed by sustaining charcoal of moderate duration.

Control efforts by ranch agronomist Hisa Kimura included strip clearing followed by planting Tinaroo glycine in hopes that the legume would establish a stand that would encroach on adjacent *a'ali'i*, forming a dense umbrella much as it does over lantana.

In clusters of cactus in Holoholokū, remnant stands of Tinaroo glycine can still be found. However, its intended effect on controlling *a'ali'i* never came to pass.

Wild Olive

Although described as a pest, the scattered groves of wild olive *(Olea europaea)* in the Ke'āmuku Division of Parker Ranch have spread throughout these dryland plains, with its dense canopies providing needed shade for livestock.

Cultivated in the Old World for more than 4,000 years, olive trees are said by elders to have been planted by the MacFarlane sheep ranch operators in Hawai'i during the mid-1800s before Parker Ranch expanded its horizons westward. Developed for food, oil, ornamental, and hedge purposes, it is likely that the early plantings, once secured, were profuse in seeding and fruit production, spread by bird and hog movement. The oldest stands of olive trees surround Old Ke'āmuku Camp, and clusters of olive trees profusely dot the mauka paddocks of Pu'uhe'ewai and Pu'uke'ke'e, touching on the flank of the military's Pōhakuloa Training Area.

In my opinion, the olive trees of Ke'āmuku are a complementary feature, given their pleasant shady characteristics and minimal invasion. Such shading was also provided at Āina Hou Ranch of W. H. Shipman, Ltd., where the subspecies *Olea africanus* existed.

Guava

This ubiquitous shrub was brought to Hawai'i in the early nineteenth century by Francisco de Paula Marin and spread rapidly to all major islands. Few people have grown up in the Islands without the memory of browsing on guava fruit along the roadsides of Hawai'i.

For Parker Ranch, guava *(Psidium guajava)* became a nuisance in both the Kohala meadows and the lower-elevation paddocks of Mahiki, Kawela, Pā'auhau, and Lālākea. The Kawamoto clan—John and his two sons Masa and Yoshi—organized consistent chemical control measures using utility workers or summer employees to keep the weeds at

bay in the northern reaches of Parker Ranch. Using similar help in the eastern area, the efforts of Charlie Lindsey, George Rycroft, Jamie Dowsett, Rally Greenwell, Goichi Fujii, and Joe Pacheco were relentless in keeping guava from becoming well established. Guava creates dense stands with a broadly shaded understory in which no forage grows, and without persistent control efforts, grazing surface area and carrying capacities are sharply reduced.

Castor Bean

The castor bean *(Ricinus communis)* is called *pā'aila* or *kahape'a* in Hawaiian. Like Christmas berry, it has an opportunist nature, with the difference being that the former plant occurs in abundance only after heavy traffic has disturbed the ground. Corral pens are often infested on an intermittent basis. Granted the castor plant can be an aggressive and invasive shrub with an expansive canopy rendering a barren understory, older cattle plunder the treelike plant and control it by sheer physical damage. As it is highly sensitive to popular pesticides, property can be cleared of its presence effectively. Its toxic nature is significant due to the presence of ricin in its seed coat that can create severe digestive episodes in livestock. The plant is so unpalatable, however, that consumption occurs only if cattle are left in a dry lot with nothing else on which to forage. Its presence is more a nuisance than a plague.

Christmas Berry

Christmas berry *(Schinus terebinthifolius)* was nicknamed *wililaiki* (Willie Rice) by ranch folks in the earlier days of colorful politics. Willie Rice is incorrectly blamed for the introduction of this noxious plant. Rice merely wore the colorful red berries as a *lei papale* (hat lei) for his *lauhala* (pandanus) hat while campaigning for political office. "Christmas" is part of its field name because of the winter appearance of its bright red berries against forest green leaves, the colors of yuletide, and many wreaths are woven from its products.

Far more invasive and tenacious than castor bean, Christmas berry can overwhelm a whole paddock if left unchecked, leaving an impenetrable, gnarly, and dense forest of no productive value. Although it is common to Kohala and Ka'ū, ranch personnel have managed to keep this menace at bay with pesticides after bulldozers in the 1960s and 1970s reclaimed some of the excellent grazing lands of Parker Ranch.

Berries

Thimbleberry *(Rubus rosifolius)*, blackberry *(Rubus argutus)*, and raspberry *(Rubus niveu)* are collectively described as nuisance weeds largely for the reason that Parker Ranch never allowed them to get a foothold, as in the case of other ranchers who, after land clearing in forested country, failed to nip these plants in the bud. This was especially true with blackberry. The blackberry infestation of newly created pasturelands of Kahuku Ranch in the 1960s nearly defeated the pasture expansion and development efforts of this progressive ranch.

The yellow Himalayan raspberry *(Rubus ellipticus)* has emerged as a serious threat to rangelands since the turn of the new millennium. Keauhou Ranch at the volcano and neighboring rancher Mary Ellen Wong, in particular, have valiantly challenged the spread of this bramble, which now has spread north—likely by birds—to be established

Joe weed in pastures, 1940. Today, joe weed is confined to horse paddocks, dry lots, and runs. PPS.

Hisa Kimura, ranch agronomist, 1975. Photo by Parker Ranch business manager, James Whitman.

along the Saddle Road. By 2004, the upper reaches of Hāmākua rangelands were already infested.

While these brambles, endemic in wetter meadows, are unpalatable and replace surface area vital to grass growth and beef production, Parker Ranch in years past limited their damage by patient and persistent chemical control measures.

Seashore Vervain

Referred to frequently by A. W. Carter as a noxious and persistent pest of the Parker ranges, seashore vervain *(Verbena litoralis)*, or *ōwī (ōī)* in Hawaiian, is commonly called joe weed or *ha'uōwī* today and is rarely found under conventional grazing conditions.

Over the past half century, in fact, joe weed has limited its presence to heavily trafficked horse pens, pastures, and dry lots. Having no toxic feature, its ground-up leaves and stems when combined with Hawaiian salt forms an effective poultice for reduction of localized fever, swellings, boils, and abscesses. In local circles, its common availability wherever horses are kept, coupled with its medicinal value, renders its reputation more as incidental than as a nuisance.

Cocklebur

Commonly called *kīkānia*, a term also used to describe certain prickly spur rowels, cocklebur *(Xanthium strumarium)* is an opportunist found only in areas that have been disturbed by vehicular, bulldozer, or animal traffic, relegating it to the category of a nuisance plant. Its name comes from the burr that is covered with hooked prickles topped by two beaks. Having no toxic elements, the burr created a nuisance for the sheep industry of earlier times. It is usually controlled by pesticide treatment.

Spiny Amaranth

Called *pa'akai* grass by some ranchers, spiny amaranth *(Amaranthus spinosus)* is an opportunist that is attracted to horse and cattle traffic areas. Its red stems and branches that support very thorny spines are sufficient to cause blockage of pathways for animals.

Also called pigweed, the plant is grazed only accidentally or in dry lot situations where feed fiber is totally lacking. In horses, profuse drooling manifests severe ulceration of the tongue and interior cheeks. Eliciting pain when being bitted and bridled, horses respond well to extensive rest (two months) on succulent forage such as Kikuyu or pangola. This weed responds well to pesticide control.

Cheeseweed

A common opportunist weed of the rangelands of Hawai'i, cheeseweed *(Marva parviflora)*, or *pohe* in Hawaiian, is attracted to loafing and trafficked areas along trails, around watering and mineral troughs, and within corrals.

Spiny amaranth—a pest of highly trafficked or overgrazed horse pens. Bill Case photo.

A succulent leafy and stemmy plant, *pohe* evokes a cheeselike aroma when crushed in one's hands. *Paniolo* would occasionally add the stems to a corned beef and mayonnaise spread, giving it a crunchy watercress texture but a milder taste.

Cattle, sheep, and hogs are attracted to *pohe*. Cattle quickly devour verdant stands of pohe when they are moved back into a rested paddock. An innocuous weed, *pohe* provides some forage value, a degree of erosion control, and with its emerald-green shade, some natural beauty.

Rattlebean

Rattlebean *(Crotalaria incana)*, or *kūkaehoki* in Hawaiian, is an erect shrub reaching 2 to 3 feet in height with leafy branches and a seed pod. The seed pod contains the highly poisonous pyrolizidine factor, which is severely heptotoxic in horses and swine. When the pod is mature, it becomes a hard plastic-like capsule in which the loose seeds rattle when held to one's ear. The pod also shares a strong resemblance to the fecal cluster of mule dung—hence the name *kūkaehoki*. It is found throughout the ranch in areas subjected to recent bulldozer activity and is easily controlled by the 2,4,5-T herbicide.

Human Resource Development

Penhallow had a deep regard for the people of the ranch, while being a taskmaster and expecting a high level of loyalty and productivity in return. He wrote the following in his 1961 handbook:

> Only through patient skill and faithful good-natured devotion that animal handling requires can an operation like Parker Ranch persist. . . .
>
> The Parker Ranch is a Hawaiian Ranch with long tradition. The largest numbers of employees are descended from Hawaiians. The other ethnic groups emulate their habits and methods. Some of the present-day members of the staff are third and fourth generation descendants of men who associated themselves with Parker Ranch years ago.

Penhallow turned to Rally Greenwell as the logical assistant ranch manager, ensuring solid field support for his livestock initiatives, while James Armitage, an acquaintance from the sugar industry, was groomed as a protégé concentrating on land matters. In effect, Armitage operated as Penhallow's administrative assistant.

Penhallow was also interested in developing a new generation of young leaders. To this end, he sought college-trained personnel and men with strong field experience who became integral to his plans. Individuals such as Peter L'Orange, Stephen Bowles, Alex Penovaroff Jr., and Charlie Kimura were prime candidates. Short biographical sketches of each of these men are provided in the following pages within the context of the appropriate sections to illustrate ongoing Penhallow progress in personnel development. L'Orange and Bowles follow, with Penovaroff and Kimura later.

Peter L'Orange

Groomed by Hartwell for eventual ranch management, Peter L'Orange enjoyed a close relationship with Richard Penhallow. Born in Waipahu, O'ahu, in 1933, the only child of Hans L'Orange and Mele L'Orange, Pete—as he was commonly known—graduated from Punahou School in 1951.

Hans L'Orange ran the Waipahu Sugar Company over a long span and endeared himself to the rank and file of the sugar industry and the community alike. Much like my own childhood, Pete was likely exposed to the extensive stabling care and use of draft and pack mules as well as the well-trained Ken-

Hartwell Carter with L'Oranges at Marine Rodeo. Left to right: Ernest Podmore, Hans L'Orange, Edith Carter Podmore, Mrs. Mele L'Orange, and Hartwell Carter; young Peter L'Orange kneeling in front. Carter collection.

tucky Saddlebred and Thoroughbred mounts used by the plantation *luna* and managers.

Pete's bond to the ranching industry, however, grew out of the long-standing and close relationship of his parents with Hartwell Carter and later his wife Becky. Summers were spent with Hartwell as early as Pete's eighth year, often riding the range with his mentor. His first summer on the ranch was 1941, and this continued consecutively through 1946. Tony Vierra, a ranch hand who took special interest in young Pete L'Orange, often was assigned as stableman for the Carter compound that later became Hale Kea Farms under the ownership of Bill White. Today, the former Carter compound serves as a bed-and-breakfast under the name of Jacaranda Inn.

These were formative and fortunate years for Pete, who from an early age desired a career in ranch management. Much more than being exposed routinely under field con-

ditions to the leadership skills of such men as Willie Kaniho, Yutaka Kimura, Rally Greenwell, Henry Ah Fong, and Joe Pacheco, Pete had the counsel of Hartwell—a noted judge of fine horses and cattle who at the same time ran Parker Ranch with a high level of stewardship of the land, livestock, and people. During his high school years, Pete lived in his parents' cottage on Laelae Road while working for the ranch.

As Pete worked his way through high school, he was also exposed to Dick Penhallow, who brought a plantation philosophy of organization to the ranch, a theme of management much like his own father, Hans. Undoubtedly, Hartwell and Dick Penhallow saw leadership potential in Pete, who was "paying his dues" in the field as he eyed a college career at Cornell University in New York. During his college summers of 1951–1954, he worked on a variety of assignments on Parker Ranch.

Off to Ithaca, New York, Pete majored in animal husbandry with a minor in animal nutrition. Again fortunately, Pete was trained in the Department of Animal Science, headed by L. L. Morrison, PhD, author of the text *Feeds and Feeding*. Pete was likely aware at the time that the U.S. livestock industry, including the Territory of Hawai'i, was gearing toward intensive grain finishing of livestock, hence the feedlot theme of market cattle production.

While in college, Pete met and married Joan Stevens and began a family of three sons—Hans, John, and Eric. Upon his return home in 1955, he began his full-time tenure with Parker Ranch.

As a college trainee, Pete worked closely with Harold Baybrook, the ranch agronomist, before moving on to work under Yutaka Kimura in the Ke'āmuku and Waiki'i sections. After an intensive two-year stint with Yutaka, Pete was transferred to Makahālau under the supervision of Rally Greenwell. He reported to foreman Charlie Kimura, working exclusively with purebred Hereford cattle. Pete's first foreman assignment was the First and Second Gate sections in 1959.

When Dick Penhallow gathered the management reins of Parker Ranch, Pete was assigned as foreman of the sprawling Humu'ula section. Pete had a challenging assignment: rebuild the total sheep flock from 3,000 to 15,000 while developing improved fleece and lamb production. Under the direction of Dr. Wallace T. Nagao, Pete developed an estrus synchronization program for the ewe flock with two goals in mind: first, to deliver three lamb crops within a two-year period, and second, to shorten the lambing season significantly. The latter goal was realized by allowing more intensive shepherding of the lambing ewes, thereby increasing the survival rate and reducing depredation by wild hogs and dogs. The existing rotational herds of more than 8,000 Hereford heifers were also part of his assignment. The two species never really competed for grazing since the sheep preferred the high, drier elevations while the heifers savored the lowland meadows abundant with earthen water tanks.

Pete inherited a sheep flock of predominant merino breeding. In a period of only six years, sheep numbers reached the prescribed goal of 15,000 after significant crossbreeding with Suffolk rams. These "meat" type rams were used on the lowest third of select merino females to cater to the lamb market. The best two-thirds of the select ewes were bred back to improved merino rams to enhance wool production. Pete eyed the Pend-

leton, Oregon, wool market as the standard for wool production and was headed in the direction of those goals when he was called back to ranch headquarters. Alex Penovaroff was sent to Humu'ula as foreman.

In the interim, management had changed from Penhallow to Rally Greenwell, who called Pete back to headquarters to be groomed as business manager of the ranch. Norman Brand, the long-standing office manager, was in waning health, and Pete's strong educational background made him a logical choice.

It was during this period that the ranch chose to close down the sheep operation, much to Pete's lament, particularly in light of his heroic efforts to restore the program. As the ranch made more high-level management changes, it appeared that Pete's historic perspective and experience was not appreciated and may in fact have been bypassed.

Pete made a difficult but practical decision to move on from his beloved Parker Ranch. Shortly thereafter he began a successful second career in ranch management at McCandless Ranch in South Kona.

Peter L'Orange with wife Joan on a field trip around Mauna Kea. They stopped for a break in Keanakolu, his old stomping grounds. Courtesy of Peter L'Orange.

Stephen P. Bowles

A bright and promising candidate for a potential leadership role in Penhallow's plans was Stephen Bowles. Born and raised on O'ahu, Steve attended Punahou School, graduating in 1956. During his teenage years he found work in the Hawaii Sugar Planters Association doing soil moisture research. He became interested in the water development aspect of the sugar industry, involving drilling, tunneling, and irrigation of O'ahu's plantation resources. These formative years were instrumental in his career choice.

Bowles left Hawai'i for college in Indiana, acquiring an AB degree in geology with a minor in soil science. It was there that Bowles met Kathy, whom he married, a union that produced two children.

In seeking work back in the Islands, Bowles was not attracted to the sugar industry, desiring to be involved in more of a pioneering aspect of agricultural water development. While an opportunity to join the Hawaii Sugar Planters Association as a sugar trainee was tempting, Bowles chose to respond to an offer from Penhallow to come to

Steve Bowles and son Dan on a fine Waiki'i horse, 1960. Courtesy of Steve Bowles.

the ranch as a management trainee assigned to the Puakō water development project.

Arriving in Kamuela in August 1960, the young Bowles family moved into ranch housing at Waiki'i, where the stunning panoramic view of Parker Ranch was awesome. As the Puakō project was preparing for launching, Bowles' interim work was with the Waiki'i livestock personnel under the leadership of Willie Kaniho and Kale Stevens. Other coworkers included the Lewi brothers, Hiram and Albert, Abraham Kihe, and Tomo Fujii.

Once underway, the Puakō water exploration called for the budding hydrologist to oversee horizontal tunneling of the old well shaft of the Hind Plantation era. Developing the flat plains of Puakō into irrigated pasture was also the plan as Bowles worked closely with Kepā Bell and their superior, the respected Harry Kawai. At about this time, cornfields were planted with the milk stage crop experiments. The potential for three annual crops of such forage was realized, although in the long term this project was shelved and irrigated pasture became the norm.

Both vertical and horizontal drilling efforts had merit far beyond the Puakō project. The Mauna Lani Beach Hotel golf course operation eventually sought the water tunnel, and Bowles launched his career as a noted hydrologist.

With the passing of Penhallow's management period, so passed Steve Bowles' tenure on the ranch. He left for O'ahu and later Kaua'i, further developing his expertise in water resource exploration, transport, and development. Two decades later, the Bowles' family returned to the Big Island, where Steve established a consultative practice in hydrology. Going full circle, Bowles has become Parker Ranch's top consultant in hydrology—he was "back in the saddle again."

The Penhallow horse program

Penhallow paralleled cow horse production with racing prospects. The annual goal for foal production was 150, which meant carrying a total broodmare band of nearly 300 females, since production was steady at around 60 percent. There were two types of broodmares: the registered band of Thoroughbred and Quarter Horses and the grade herd of mares that often were of the same breeding but more likely to include Morgan, palomino, and Standardbred crosses. A registration program for purebred Thoroughbreds and Quarter Horses was already started in their breed organizations. James Merseberg, a former cowboy from the Carter eras, continued to

Teddy Bell with Hauli, a six-year-old stallion by Alicane out of Kauhane. Alicane was by Alibhai out of Belle Cane by Beau Pere. Kauhane was by Ormesby by Sir Galahad III. PPS.

be the ranch's equine genealogist. I worked with him in 1959 at Pukalani Stables and enjoyed hearing him rattle off the pedigree of a weanling that Hartwell would randomly point out. Merseberg's nickname was "Dictionary" because of his phenomenal recall of pedigrees—but also of other relevant and sometimes irrelevant facts.

Traditional breeding season began the first half of the year during foaling. Foaling at the beginning of the year or soon after was appropriate for the registered mares, especially for their offspring to be formally documented with the proper breed organization.

Penhallow named Teddy Bell Sr. horse foreman and instituted several progressive changes to the horse program—notably repetitive handling after weaning and presenting the Breaking Pen crew, headed by George Purdy Sr., with three-year-olds to begin training for the cowboy strings. Earlier ranch tradition had put these horses into the Breaking Pen as late as five and six years old, which was hard on the Breaking Pen crew. Some former horse management practices remained, including the late castration of colts. Grade colts (unregistered with a breed association) were gelded as long yearlings, and the registered ones were two and a half years old before they were gelded. Further, the casting or knocking down of these robust colts took place without benefit of sedation or anesthesia—hard on the horses as well as the handlers.

Teddy was a popular figure on Parker Ranch, and his background reflects a broad array of experiences that support Penhallow's wisdom in selecting this native son to manage the horse program.

Theodore "Teddy" Bell

Born on August 14, 1923, Teddy was the third child of Alexander Bell Sr. and his wife Antonia. Brother Alex Jr., and sister Violet preceded Teddy in the family. Younger brother Stanley and sister Dorothy soon joined the three older siblings. Teddy was the namesake of Theodore Vredenburg, Parker Ranch superintendent.

At the time of Teddy's birth, the family was living in a spacious residence built for them by A. W. Carter. Carter held Alex Sr. as well as Teddy's grandfather, George Bell, in high regard. George was a blacksmith for Parker Ranch. The family's house later became the residence of Theodore (Sonny Akeni) Akau and is now the home of his surviving family, located adjacent to the Quonset hut along Māmalahoa Highway in Waiemi, bordering the Ahuli subdivision.

Until 1934 Teddy attended Waimea School. At age eleven he moved with his family to Waiki'i village when Alex Sr. followed Donald MacAlister as foreman of Waiki'i.

MacAlister had moved to Kūkaʻiau Ranch to become its manager. Teddy entered the one-room Waikiʻi schoolhouse and came under the watchful tutelage of Betsy Lindsey. Miss Lindsey later became Mrs. Johnny Pieper.

Teddy's strong interest in horses, cattle, hunting, and the outdoor life kept him from pursuing further education. In 1936, when he was only thirteen years old, Teddy began work cutting *keiki* corn (corn suckers) at Waikiʻi for Parker Ranch.

But Teddy was anxious to become a cowboy. His idols at this time were *paniolo* Harry Kawai, Hogan Kauwe, and Kaliko Maʻinaʻaupō. These were men after whom Teddy aspired to fashion his life. Gradually Teddy's work drew him closer to the cowboy life. His father began to assign him to more serious "boot camp" chores: fixing fences, cutting posts, and checking water levels. When the prestigious Cowboy Gang worked the Waikiʻi section, Teddy was allowed to saddle up and work with them. The ranch soon recognized his natural ability as a cowboy, and as a young bachelor he was assigned to the Keʻāmuku section. He worked and camped at Keʻāmuku with several other young *paniolo*, including Charles (Kale) Stevens and Henry Ah Sam.

The excitement of wild cattle drew Teddy to Puʻuʻōʻō Ranch, a W. H. Shipman operation on the slopes of Mauna Kea, *makai* (oceanside) of Humuʻula Sheep Station. His boss was his cousin and noted cowboy foreman Tom Bell. Teddy had other young cowboys as peers on this ranch as well. Hideo Imoto and Masa Takaoka were cowboys there, as was Hideo's father Muranaka, a quiet legend in his own right. Much of the cattle work involved *pipi ʻāhiu* (wild cattle), and Teddy sharpened his roping skills to perfection. Of course, roping a fat hog or sheep was the only recreation the young *paniolo* had in those times, regardless of where the ranch lands were located.

The reclusive mountain life became arduous, so Teddy moved to Hilo where he became a fireman. At this time he became attracted to Piʻilani Matsu of Keaukaha. With World War II raging, however, Teddy felt a strong duty to his country and volunteered for the U.S. Army in 1944. He was shipped to Fort Hood, Texas, for basic training. Despite having an asthmatic condition since childhood, Teddy was in excellent physical condition as a result of his previous employment as a fireman prior to enlistment. His basic training was extended, and at the end he qualified as a ranger/scout with the armed forces and was assigned to the Philippines. In the Philippines he worked to rid the jungles of Japanese soldiers and rebel forces. The cowboy from Waikiʻi kept busy working with Igorot tribesmen in the dense jungles, where he continued to refine his stalking skills learned in the hills of Waikiʻi. While his Igorot counterparts were armed with bows and arrows, Teddy had his trusty .30-06 army issue that made him a respected marksman in the field. Back at the home ranch where Teddy returned to hunt the bountiful game on Mauna Kea, a .300 magnum Savage rifle replaced his military issue.

Teddy was honorably discharged from the U.S. Army in 1947. Despite his chronic asthma and contracting malaria in the Philippines, Teddy felt a deep sense of urgency to return to the cowboy life. With the robust mountains, fresh air, great horses, and cattle as his therapy, he quickly returned to the comfort of life back home. He and Piʻilani were married and moved to Waikiʻi. Teddy worked as a cowboy and Piʻilani taught school

in the same one-room schoolhouse that he attended in his boyhood.

Teddy's cowboy skills were refined further through years of experience and—perhaps more importantly—by exposure to long hours in the saddle alongside noted cattleman Yutaka Kimura. Here was a man Teddy longed to emulate.

While at Waiki'i village, Teddy and Pi'ilani started their family. Firstborn daughter Theolani (Lani) was soon followed by other children: Theodora (Tootsie), Theodore Jr. (Teddy Boy), Rodney (Butchie), and Keith (Miki). In 1949, the Bells moved to the racetrack house in Waimea. Teddy had been promoted to the prestigious Cowboy Gang and worked under Willie Kaniho. Shortly thereafter he was offered an opportunity to work directly under Yutaka Kimura and his father Alex Sr., so the Bell family moved back to Waiki'i.

The year 1957 was a momentous one for the family. Waiki'i School was closed, Alex Sr. retired as section foreman, and Teddy was called back to work with the Cowboy Gang in Waimea. The family moved into a cottage along Wai'aka Stream. This cottage eventually became home to the Walter Stevens family.

Shortly thereafter, Dick Penhallow became the manager of Parker Ranch. Penhallow had great confidence in Teddy's knowledge of horses and promoted him to horse foreman. Penhallow had very progressive plans for the horse program and charged Teddy with responsibility for carrying out the new mandate.

Teddy was featured in *Western Horseman Magazine* in an article heralding the new direction of Penhallow's Parker Ranch horse program. Shortly thereafter, Teddy was awarded a ranch of his own, a 300-acre pas-

Teddy Bell with Son of Hessian, a direct son of the famous King Ranch foundation Quarter Horse sire, Hired Hand. PPS.

toral lease near Pu'uka'ali'ali in Mānā, at the heart of Parker Ranch. With Penhallow's departure from ranch operations, Teddy set out to tend his own *kuleana* (property) as well as work as foreman for Morrison Knudsen's projects in Waikoloa and on construction of the Queen Ka'ahumanu Highway.

However, the cowboy life still had strong appeal, and Teddy soon headed back to Waiki'i. Putting his construction career behind him and feeling his own ranch was in good order, Teddy returned to the Parker Ranch payroll as a Waiki'i cowboy once again. This time he was working under Dan Kaniho. These men shared deep and mutual respect. Teddy's twilight years on the ranch were happy ones. His final ride on the Parker range was in 1981. He then retired and spent his remaining years tending to his family, grandchildren, and the Bell ranch.

One of Teddy's pet projects in his retirement was the formation of a Hawaiian Home Lands riding club. With his good humor and welcome smile, the club grew to be a testimonial to Teddy's popularity, sincerity, and good-hearted nature.

Theodore Bell Sr. passed away in Waimea in July 2002.

Under Teddy Bell's leadership, Penhallow made improvements in the program, both in training methods and in the acquisition of such stallions as Peppy DeeDee, brought to Parker Ranch by noted veterinarian/horse trainer Dr. Billy Linfoot of California. Linfoot also introduced progressive horse training methods. Charles O. Williams was another consulting horse trainer used by Penhallow. He also retained the Thoroughbred as the breed of choice for its special qualities—especially racing.

The following article, in which Penhallow eloquently describes his overall plans for the Parker Ranch cow horse program, appeared in the August 1962 issue of the ranch newspaper, *Paka Paniolo*:

> The stock horse is a ranch man's principal working tool. The quality of that tool depends on two things:
> 1. what it is made of.
> 2. how it is finished for use.
>
> Horses are made of conformation (which means "build"); disposition; courage; speed; intelligence and stamina. These qualities result from the bloodlines and selections that the breeder chooses.
>
> Every horseman knows that some families of horses are easier to train than others. Likewise some are faster and some "stay" longer. Some are more willing and some are afraid to try. Some are predominantly well built and some turn out disproportionate numbers of swaybacks, narrow chests, sloped rumps or other defective animals.
>
> The present horse-breeding program at Parker Ranch is emphasizing pure breeding. In this the thoroughbred is still the key because of speed, courage, intelligence and stamina. For pure breeding we have also chosen the Quarter Horse, because that breed is essentially a Thoroughbred with a cow-pony build.
>
> It is axiomatic that Parker Ranch horsemen are presently mounted both well and copiously. Nevertheless, replacements must inevitably be resumed, hence bloodlines need to be sustained and screened by selection. In the meantime, our reputation for sales will improve by careful attention to the purebreds. Later crossing will make new "grades."
>
> There are still over a hundred "grade" broodmares. By selection the ill tempered were eliminated. Good cow horses result from mating "grades" to pure Morgan, Thoroughbred or Quarter Horse sires. In addition "local fancy" is indulged with good results. I am referring to the Humu'ula stud and also some projected crossing of "part heavy" mares with Dr. Fronk's Arabian. The offspring of one are noted for sound feet and the hope of other is for fine bone, better heads and good conformation improving the size and weight of the part heavies.
>
> While ranch policy determines the breeding and training program, individual riders can help a lot in achieving results if they will adopt the training methods and spirit which the program requires.
>
> Even the best bred cow horse requires proper finishing for use. In the breaking stable the method taught us by Dr. Billy Linfoot is being used with excellent results.

For the information of those of our readers who do not know, the Linfoot method is designed to instill in foals from an early age, confidence in men. Frequent handling, strict but not cruel or harsh discipline, and consistent rewards all meted out with even temper are the secrets of success.

After weaning, every foal is taught to lead by halter and to stand tethered. In addition each is taught to allow any of its four feet to be picked up and handled. Further, the foals through quiet performance are subjected to carrying a rider bareback, mounting and dismounting from any side repeatedly, as well as to becoming used to ropes, raincoats, etc.

The result is that when the two-year-old returns to the stable for training, instead of fearing men he has learned to trust them.

It goes without saying that it would be the greatest of mistakes to betray that trust. Having once shown a foal that with even temper, proper responses earn rewards while improper responses reap punishment, how confusing it would be to that foal if a new teacher suddenly became harsh and intemperate in his handling. For example, if a horse has already ridden and rough broken without "pani maka" or blindfold, how can he be expected to understand if his new teacher suddenly blindfolds him? I have heard of this happening recently when a cowboy received a new horse.

Now the important thing to assure progress is that anyone to whom Ranch horses are assigned will follow through with the method, which is being applied at the weaning and early breaking stages of training. It was very noticeable at the last issue that the new horses were by far the gentlest at that particular stage that have ever been assembled here. They were the first lot to have been exposed to Dr. Linfoot's teaching when they were foals, and they only had the benefit of it in the last stages of their handling.

It is extremely important that all trainers familiarize themselves with what is going on in the breaking stables and follow the pattern that is being set by the "Rough Riders." Every horseman must visit training sessions and see how they do. Some things to consider and heed are:

1. Teach your horse in frequent short lessons rather than for long stretches any one time.

2. Spend a lot of time on the ground with a halter and an even temper and patience before trying to work mounted. This is to get your horse to know you well and can be done with and without bits.

3. During ground training use disciplinary methods that will not make the horse flinch. Dr Linfoot demonstrated the "war bridle" or "jerk cord." Hobbles and forms of leg ties like the "running W" etc. are Okay but avoid hitting or striking, though it may be necessary to whirl a rope in self defense.

4. Pick up all feet often, mount and dismount bareback from all sides, handle all over and accustom the horse to the passage of ropes around legs, under tail, etc.

5. Accustom the horse to saddling and carrying the saddle with patience for a time before the first ride in the saddle.

6. Avoid the use of the "pani maka" or blindfold and also do not tie stirrups but mount carefully and move deliberately with patience and even temper.

7. The rest is a matter of time, consistence, patience, confidence. If the horse is any good you will then succeed. You cannot make him better by losing patience and breaking confidence. If he will not come around by the patient method, you had better turn him in.

I have heard it said that it takes too much time this way. Maybe each horse takes longer but several horses can be trained at once with a series of short sessions for each, day after day, and in the end the horses will not flinch. They will be more useful and trustworthy.

The proof of the system is that several two-year-olds in the hands of "Rough Riders" are already used for roping in the branding pen and have passed the inspection committee. Among these are the two stallions "Lucky Tom, Jr." and "Coconut Island." If the "Rough Riders" can do it, so can you.

Dick Penhallow accepted rodeo as an avenue for public showing of the fine ranch mounts. He endorsed on-ranch events as well as rodeos around the Big Island as a progressive means not only of showing but of further training for ranch mounts, enhancing their value and image. A brief history of rodeo in a Parker Ranch historical context will help illuminate Penhallow's plans to return the image of the ranch cow horse to first-order status.

Ranch Rodeo History

Rodeo in America is loosely defined as a recreation for sporting purposes to showcase the various chores of the working cowboy that require timing, skill, and athleticism. To the *vaquero* it meant a roundup—a cattle gathering for branding, weaning, or shipment. It is easy to understand how such gatherings created a stage for competition among the Mexican cowboys, as crowds usually gathered to enjoy the festivities and marvel at the graceful techniques used to ensnare and cast cattle with a deft rawhide loop.

It is no wonder that when Kamehameha III attended one of these festive roundups in Alta California in 1831–1832, he came away convinced that such deft *vaquero* skills could in fact be transposed to the Native Hawaiian cattle tender, who during those times worked afoot with less effective control over the hordes of wild beeves. Trapping and gunshot were the only means of apprehending such *pipi ʻāhiu*, and Kamehameha III's action appropriately changed that. By bringing the *vaquero* and his *montura* (horse gear) to the Islands as mentors to his *makaʻāinana* (common people) brethren, he forever changed the history of the Hawaiian Islands, which still celebrate the *paniolo* 175 years later.

Some romanticists argue that Hawaiʻi had working cowboys before the American West. Noted cowboy historian Richard Slatta further asserts in the *Montana Journal of Western History* that the district of Kona was the cradle of *paniolo* life in the Islands, as cattle were landed there first before moving on to Waimea, the historically accepted heart of Hawaiʻi's cattle industry.

While documentation has been provided in support of this assertion, it begs the follow-

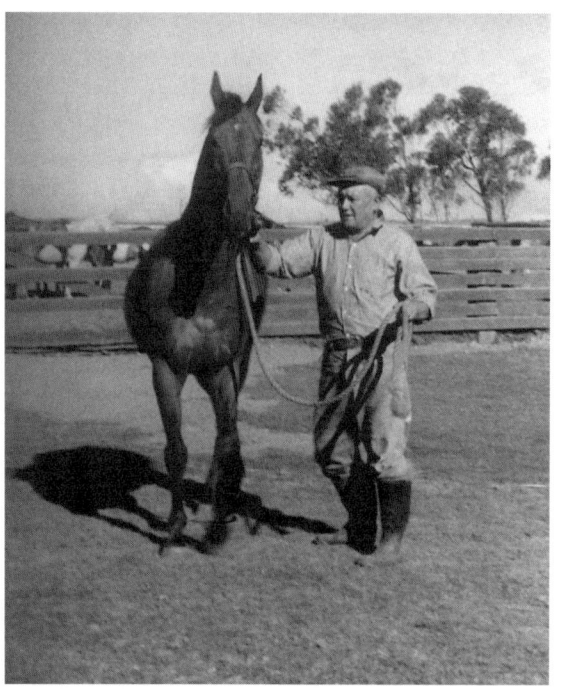

Skip Khal with George Lindsey at Pukalani Stables. PPS.

Sun God III, a California Thoroughbred sire that added significantly to the ranch horse program. PPS.

Dr. Fronk's Arabian with Kanakanui Iokepa. Penhallow's introduction of Arabian bloodlines into Parker Ranch was not successful. PPS.

Billy Maina'aupō with Coconut Island, a stallion sired by Sappho Jr. and out of a Thoroughbred mare Mokoli'i by Bannerman out of War Banner, a daughter of Man o' War. PPS.

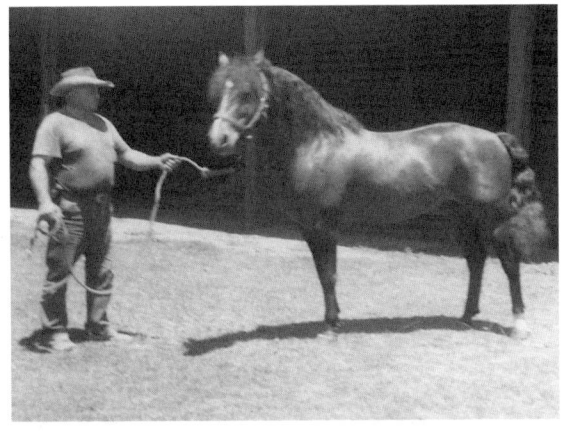

Left: Billy Maina'aupo with Junior, a popular Morgan sire of great cow horses. PPS.

Below: Aerial view of the racetrack stables. Note roping arena within the racetrack; the Parker Ranch motor pool and warehouse presently sit in the center of the tree plot. The racetrack stables and stud barn remain intact today. PRC.

Above: Horse corral with alley; broodmares in background. Rear stud barn was replaced by the Parker Ranch motor pool in the early 1990s. PRC.

Right: Round pen and horse stock. The round pen sported a 2-foot depth of sand. To the left of the round pen is a horse chute for restraining brood mares. PRC.

Above: Cutting gate and loading chute. PRC.

Right: My Man Min, a Thoroughbred stallion noted for producing heavily muscled offspring of the Quarter Horse type. PPS.

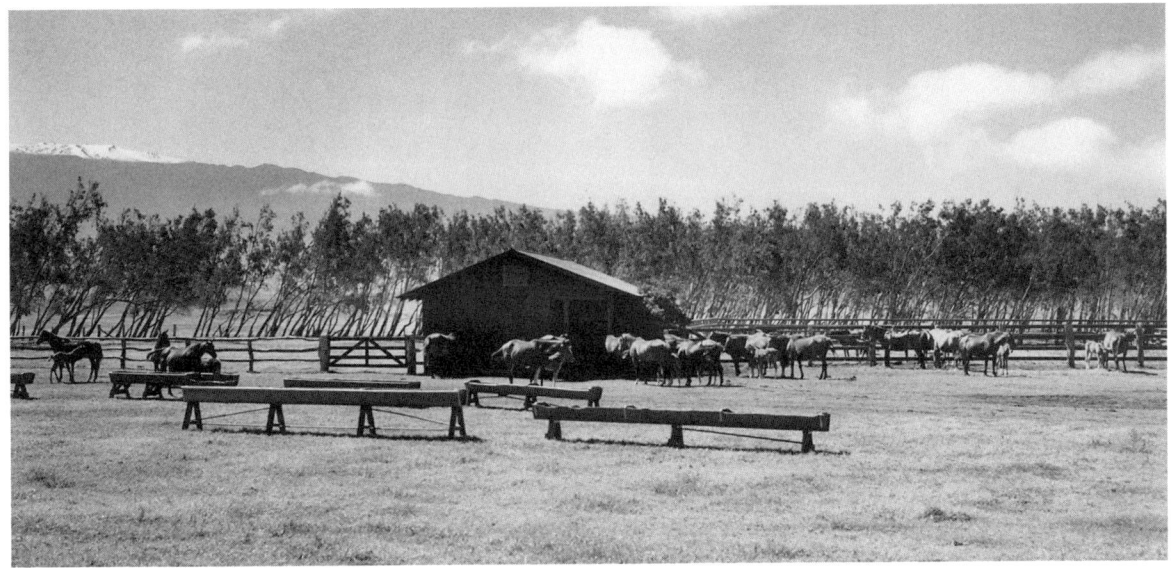

Thoroughbred mares and foals browsing in a paddock during breeding season. PRC.

Left: Texts such as Jackson's reflect the long-standing history of ranching on the North American continent preceding the arrival of cattle in the Hawaiian Islands in 1792 and the vaquero in 1833.

Above: A young Billy Bergin with Bel Canto at Pukalani Stables in 1958 when each of the fourteen stalls boarded stallions between breeding seasons. WCBC.

ing question: If Hawai'i had working cowboys before what became known as the American West, then why did Kamehameha III need to bring *los vaqueros* in 1833 to instruct the Native Hawaiian in the use of horse and lariat to gather cattle? The argument put forth that Alta California was not part of the United States at the time raises similar questions regarding Hawai'i's status as well. At the time, Hawai'i was not an American territory but part of the Kingdom of Hawai'i. The parallels clearly speak for themselves. No doubt this issue will be a topic of debate for years to come.

The influence of the vast system of Catholic missions is worthy of mention and one that I truly appreciate. Established in the sixteenth century, the missionary foundation of Hispanic tradition stemming from old Castile spread in linear fashion from central Mexico up into central California like beads on a rosary. Native American Indians were converted from agrarian nomads to mounted men of great skill. Furthermore, the blending of the Spaniard and Native American formed the bronze race with an attachment to the horse that was secure for eternity. The following quote from Jerald Underwood's *Vaqueros, Cowboys and Buckaroos* is eloquent on the topic:

Imagine if you will, a situation in which a Spanish conquistador takes as his wife an Indian woman. To this couple is born a little boy. He rides on a horse in a cradle strapped to his mother's back. Later he rides in front of her, clinging to the horse's mane with his little hands. His mother holds him to keep him from falling off. This little boy absorbs the feel and smell of the horse. As he grows larger, the boy rides with his father and later gets his own horse. By the age of ten the boy becomes an accomplished rider. He is part of the horse; the horse is part of him. The boy is neither Spanish nor Indian. He is a member of a new bronze race: he is Mexican. This young man can ride as no one in North America has ever ridden before: he is the true centaur of the New World.

While the profound missionary thrust over the far western landscape marked the beginning of the *vaquero* tradition, this method of horsemanship and cattle handling had also spread inland. Large estate *rancherias* from which cattle drives were commonly occurring, with thousands of beeves being moved to and from remote frontiers of Kansas in the north and Louisiana in the south, were well established in what is known today as New Mexico, Arizona, and Texas. These confirmed *vaquero* activities were well-developed in the late 1500s through the 1700s. This timing is well ahead of the advent of cattle to Hawaiian shores in 1793.

While historians may continue to argue positions one way or the other, I am convinced that the true *paniolo* is disinclined to join in the discussion regarding who is credited for being the first to bring them their lifestyle and skills. Whether the birth of their profession was before or after these great men of the bronze race is unimportant. That they are brothers beneath the skin of the *vaquero* of old Mexico is of far greater importance. That's just the cowboy way. Buster McLaury states the case for the cowboy way in *The Texas Cowboys:* "A cowboy lives an unwritten code of ethics that involves integrity, morality and honesty. Does he set himself up as some kind of icon he thinks the rest of the world should follow or look up to? Certainly not. He figures that every man must decide how he wants to live. In that respect, maybe he's the living cornerstone of America's concept of itself."

The learning curve of *vaquero* skills for the Native Hawaiian was a steep one in the first decade after the arrival of King Kamehameha III's *caballero* (mounted gentlemen) guests in 1833. The *vaquero* had especially willing and naturally capable students given their grace, athleticism, and nimbleness of hand and body. In addition, Native Hawaiians of long ago were skilled craftsmen adept at canoe carving and weaving mats and sails. Mimicking the Mexican saddletree, they readily hewed a prototype from a variety of cured woods—likely including sumach (*neneleau*). The weaving and splicing of the *'awe'awe* rigging or *kaula 'ili* (skin rope) required abilities that were embedded in the Native Hawaiian man from centuries prior. However, no other *vaquero* skill was more endearing to the Native Hawaiian than roping—*ho'ohei kaula*. This lasting attribute led to the inadvertent birth of rodeo in the Hawaiian Islands.

Actual competition in roping in a public

Mexican saddletree. Note the low-lying, bulky dally horn. Photo by Nancy Erger Gmirkin.

Hawaiian saddletree. Note the slick fork, tall, prominent dally horn, and comfortable cantle. Photo by Nancy Erger Gmirkin.

forum came to pass in the very late 1800s in the form of steer roping, which remained the main event until after World War II. A single mounted roper rode up behind a released running steer and roped it around its sturdy horns, which usually spanned about 3 feet. The roper had previously tied the end of his rope hard and fast to the saddle horn *(nākiʻi)*. While riding past the left side of the steer, the roper deftly pitched the slack of his lariat behind the mid-hind legs of the steer and rode off to the left with enough force and speed to trip the steer from behind. The downed steer was hog-tied by three feet, while the rope horse held the lariat taut. Once tied, the roper signaled for time by raising his hands above his head. Average times were well over a minute—often two minutes or more.

In the early 1900s, Hoʻolulu Park was the venue for matched ropings, and cowboys came from Maui, Oʻahu, and even Kahoʻolawe, with the bulk of the competition being Big Island ropers. In a 1905 event, the winning roper was a pure Japanese cowhand named Okada from Horner Ranch (later Kūkaʻiau Ranch, Ltd.). Other winners included James Stevens of Parker Ranch and Maikaʻi Keliʻilike of Kahoʻolawe Ranch.

In the Parker Ranch community of Waimea, jackpot ropings became commonplace, with the likes of Ikua Purdy, Keoni Liʻiliʻi (John Kawananakoa Lindsey), and a young lad named William Paul Mahinauli Akau competing. William Akau, at age fifteen, more often than not out-roped both Purdy and Lindsey, but he never reached their level of fame. In 1908, Purdy was declared world champion steer roper in Cheyenne, Wyoming. Archie Kaʻauʻa and Jack Low, both noted ranch ropers, placed third and sixth in the same world competition.

The Parker Ranch roping arena of those times was a stone wall enclosure about 200 feet wide and 300 feet long. Dubbed the Slaughterhouse Pen due to its routine use as a corral for butcher cattle, the arena acquired a historic name of its own thanks to the skill of Keoni Liʻiliʻi, who won a matched roping

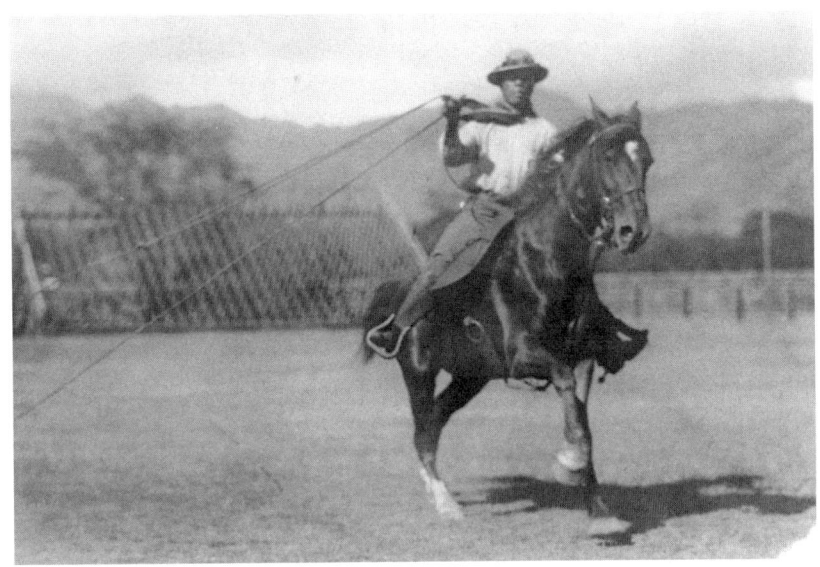

Ikua Purdy on O'ahu. Note the size of his big loop. PPS.

against twenty-seven other cowboys, including those mentioned above. Keoni roped and tied his steer in less than a minute, establishing a Big Island record. The pen became known as Minukiole (less than a minute) in his honor. In recent years, the Parker Ranch Foundation Trust leased the site to the YMCA, which, with the Rotary Club of North Hawai'i, proposed developing it into a community park—Minukiole Park—in memory of Johnny Lindsey, complete with an open-air pavilion. As a result of miscommunication, the YMCA instead dedicated the park in the name of William Akau and dubbed it 'Āole Minuke. But no harm was done; both Akau and Lindsey were great ropers.

Some of the Waimea matched ropings were limited to Ranch employees, and one such jackpot brought out fifty-six ropers.

Credit needs to be given to Eben Low, who saw great merit in the roping skills of the Waimea cowboys. Through A. W. Carter, he managed to send to O'ahu, horses and all, several Parker Ranch cowboys, including Purdy, Lindsey, and Akau, as well as Bell. Ikua Purdy won the steer roping with a thirty-eight-second run that became a long-standing territorial record. The O'ahu Fair at Kapi'olani Park, described by Low as the largest rodeo to date in Hawai'i's history, had promoted the event with Robert Witt Shingle, an O'ahu businessman. Based on the roping successes of the Waimea cowboys on O'ahu, Low was inspired to muster the funds to sponsor Purdy, Archie Ka'au'a, and Jack Low (his half brother) to travel to Wyoming to compete on a national level. This was just the beginning of such challenges in which local cowhands competed against the nation's best.

The rodeo activities continued on Parker Ranch at a moderate, somewhat subdued pace through the Great Depression years, when many luxuries and recreational activities were held to a minimum. The outbreak

Eben Low on the right greeting Will Rogers at Honolulu Wharf. Ever the promoter, Eben Low hosted Will Rogers' attendance at an Oʻahu rodeo in 1905. PPS.

"The Ropers Return." Left to right: Eben Low at the wheel, Archie Kaaua, Ikua Purdy, and Billy Spencer, who all trekked to Cheyenne (1908). PPS.

of World War II and the bombing of Pearl Harbor at first seemed to further suppress activities, but Parker Ranch at least maintained the Fourth of July and New Year's horse races and related activities, always capped off with a community *lūʻau*. The advent of the Third and Fifth Divisions of the U.S. Marine Corps to Waimea generated an enduring presence of rodeo to Parker Ranch, the Big Island, and the Territory—and later State—of Hawaiʻi.

Undoubtedly, many of those young and battle-weary marines came from ranching

February 18, 1944 No. 7, Vol.1

Rodeo Smash Hit For 10,000

Headline: "Tarawa Boom De-Ay." The Camp Tarawa newspaper covered the rodeo in fine fashion.

backgrounds, and some had rodeo prowess. Senior *paniolo* reminisced about how mainland cowboys in uniform vied for opportunities to get up close and personal with the local cowboys, just to stroke the necks of their fine mounts or wonder out loud about the braided *'awe'awe* rigging of the saddle and rub their war-torn hands over the slick *lala* (seat lining) that they appropriately called a "mother hubbard" back home in Idaho. For the farm boy away from Iowa, the sight of quality Hereford cattle meant as much as did the view of the black and white Holsteins to the Minnesota marine. The latter provided the milk, cream, and cheese for the mess halls of Camp Tarawa, the base camp through which 40,000 marines passed by war's end. For those of us who love animals, the sight, feel, smell, and sound of them arouses quiet but deep emotions of companionship. To the tattered twenty-year-old marine, the rekindling of contact with animal companions meant much more—it expressed gratitude for life. The following excerpt from Marine Corps combat correspondent Sergeant Hy Hurwitz describes the plight of the young marines as they approached Camp Tarawa for rest and recuperation:

> Battle-weary, hungry, unshaven and clad in weird combinations, Marines and Navy Corpsmen just in from the bloody skirmishes on Tarawa Atoll joined with an Army Band at a U.S.O. building for their first musical entertainment in two months here, this evening.
>
> The Leathernecks and Gobs who had battled the Japs for 76 hours on the well fortified Bettio Beach reached this spot this morning after a slow trip on an evacuation transport. After a quick breakfast, they started a six hour climb over bumpy, dusty mountain roads to reach their new camp.
>
> The camp was far from ready and the men had to satisfy themselves on canned rations, the only thing available. The horrible holocaust on Tarawa was fresh in their minds and they were looking for an outlet to give off steam and forget.

SECOND DIVISION
BAR-B-Q and RODEO
FEB. 12th
PARKER RANCH, KAMUELA
WIAMIA, HAWAII, T.H., U.S.A.
PROGRAMME

THE FOLLOWING EVENTS AND BAR-B-Q HAVE BEEN ARRANGED AND PREPARED FOR THE MUTUAL ENTERTAINMENT OF THE MEN OF THE SECOND MARINE DIVISION AND MEMBERS OF THE ALLIED FORCES TOGETHER WITH THEIR NUMEROUS FRIENDS AND GUESTS OF THE TERRITORY OF HAWAII.

SCHEDULE

1000-1045 SECOND MARINE DIVISION BAND PLAYING IN AND AROUND KAMUELA.
1100- BAR-B-Q FOR EVERYONE AT THE RODEO GROUNDS.
1230-1255 GRAND MARCH WITH THE SECOND MARINE DIVISION BAND.
 (a) GENERAL EDSON AND CHIEF OF STAFF.
 (b) COLOR BEARERS.
 (c) QUEEN OF THE RODEO, MRS. MARJORIE WILSON.
 (d) MRS. COOKE AND MR. CARTER.
 (e) MISS LEWIS AND COWBOY CONTESTANTS.
 (f) SECOND REGIMENT CONTESTANTS.
 (g) SIXTH REGIMENT CONTESTANTS.
 (h) EIGHTH REGIMENT CONTESTANTS.
 (i) TENTH REGIMENT CONTESTANTS.
 (j) EIGHTEENTH REGIMENT CONTESTANTS.
 (k) SPECIAL TROOPS.
 (l) SERVICE TROOPS AND AMPHIBIOUS TRACTORS.
1300- COLORS - - NATIONAL ANTHEM.
1305-1325 PONY EXPRESS RACE, HAWAIIAN COWBOYS ONLY.
ENTRANTS:-
No. 1. W. PALAIKA No. 4. S. FUJITANI
No. 2. F. MAERTENS No. 5. A. QUINTAL
No. 3. H. LINDSEY No. 6. K. SAKADO
 No. 7. W. KAWAI
1325-1330 General Smith Presenting Prizes to winners.
1330-1355 STEER RIDING, MARINES ONLY.
ENTRANTS:-
No. 1. E. D. WESTBROOK, 18th. No. 4. E. D. PETERSON, 6th.
No. 2. DALTON, SerTrps. No. 5. LAUDENSLAGER, 8th.
No. 3. J. B. PRESTON, 2nd. No. 6. R. WEBBER, SplTrps.
 No. 7. WORTMAN, 10th.
1355-1400 General Smith presenting prizes to winners.
1400-1415 GROUP ROPING EXHIBITION BY HAWAIIAN COWBOYS ONLY.
ENTRANTS:-
No. 1. G. PURDY No. 9. A. QUINTAL.
No. 2. Y. KAWAMOTO No.10. F. SPENCER.
No. 3. S. KAEHALIO No.11. J. HERSEBERG.
No. 4. H. LINDSEY No.12. F. MAERTENS
No. 5. A. BELL No.13. S. LIANA
No. 6. K. SAKADO No.14. S. HOKAMA
No. 7. S. FUJITANI No.15. J. LINDSEY JR.
No. 8. A. KIMSEU No.16. J. LINDSEY SR.
General Smith presenting prizes to winners.

Actual rodeo program. It is interesting to note the alternating soldier/ paniolo *format.*

Rodeo cartoon. Even in the midst of World War II, the marines sought and enjoyed humor.

The word passed that there was a U.S.O. House a half a mile from camp and early in the evening the "joint" was jammed.

An Army Band, who had heard what these Marines and their corpsmen buddies had been through, was on hand to greet them and one of the most unique jam sessions ever seen followed.

These Marines didn't need any girls for dancing partners. They were thankful that they were alive and they sang and danced and gyrated for hours in celebration. This was a bunch of raggedy-pantsed leathernecks, some in clothes that sailors had given them aboard transports. Some even wore pieces of Jap uniforms that they had picked up as souvenirs at Tarawa. Some were in dungarees. For these men had lost most of their belongings on that bloody beach that was Bettio.

These men were overflowing with joy and a desire to wipe out the memories of the buddies they had left behind. This was their avenue to escape and their first taste of civilization in weeks, following tiresome maneuvers and the bitter battle that ensued on Tarawa Atoll.

Parker Ranch went further in making all marines feel at home. In 1944, a military rodeo was planned on Parker Ranch lands

Jiro Yamaguchi and Teddy Bell at Honoka'a rodeo. Note the size of Jiro's head loop as Teddy prepares for a heel shot. Jiro's paint was a pono'i *(privately owned) horse of Adam Quintal. Courtesy of Donald and Paula DeSilva.*

across the main road from Camp Tarawa. The area is called Pu'uhihale, with an almost *heiau*-like (pre-Christian stone platform place of worship) stone corral as its centerpiece. With guidance and expertise provided by the Marine Corps, typical bucking chutes were erected to accommodate the Big Island's first true rodeo where rough stock events such as bronc riding were combined with steer roping and bulldogging (steer wrestling) events. Convoys of jeeps and trucks in lieu of fences formed the boundaries of the arena. The first marine rodeo was well touted by the news media, especially due to the patriotism of the times and the fact that Parker Ranch cowboys were featured in competition with the leathernecks. The rodeo program describes a rodeo queen, the grand entry, which included a marine color guard, and a list of events and entries.

The marine rodeo left a lasting impression on the Big Island and the Waimea community. The interest in true rodeo never waned, as the community of Nā'ālehu in Ka'ū staged their first Fourth of July invitational ranch rodeo in 1949. Shortly thereafter, the community of Honoka'a hosted its first rodeo in 1952, sponsored by the Hawai'i Sad-

Masa Kawamoto on Icing, after winning a ribbon and trophy at an Oʻahu Quarter Horse show. PPS.

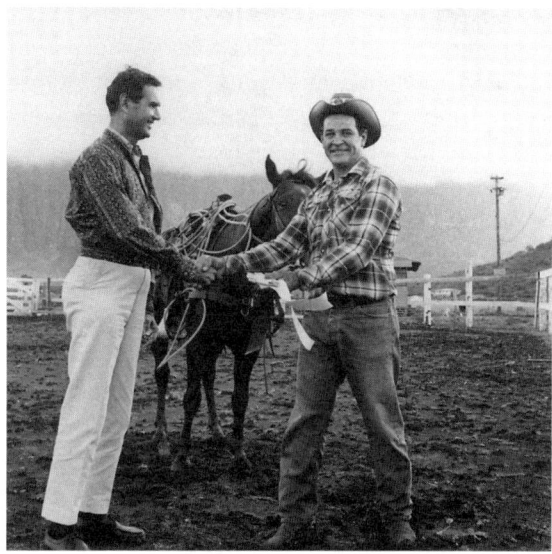

Richard Smart presenting awards to Joe Cambra, who won the calf roping on a Parker Ranch–bred gelding at an Oʻahu Quarter Horse show. PPS.

dle Club on Memorial Day. Both rodeos have continued to the present day.

Dr. Edwin (Buzz) Willett, Maui horse enthusiast who practiced as a physician and surgeon in Honokaʻa, and several other men were largely involved in organizing the Hawaiʻi Saddle Club in its early formative years. But as a whole, the Memorial Day event was a function and organization of the people of Āhualoa, Honokaʻa, Paʻauilo, and Kūkaʻiau.

Contestant winners in the roping events were men such as Jiro Yamaguchi, Masa and Yoshi Kawamoto, and Teddy Bell. By the mid-1950s, the Hilo Paniolo Club was organized by Joe Serrao, with racing events featured along with rodeo events. Parker Ranch was a frequent competitor. By this juncture, a younger generation of ranch hands could be found in competition, including Charlie Kimura and Alex Penovaroff. Soon, Parker Ranch built a roping arena in the racetrack infield with hog wire, *kiawe* posts, and black gum rails.

The birth of the Quarter Horse industry in Hawaiʻi brought related forms of rodeo horsemanship into the mix, and the Kawamoto brothers were exemplary in showing off Parker Ranch horses, particularly in the calf-roping event. Dick Penhallow actively supported the advent of Quarter Horse shows. In early 1962, a statewide Quarter Horse show was held in the Parker Ranch arena, and Masa Kawamoto went on to qualify for an Oʻahu Quarter Horse show under Parker Ranch sponsorship. In 1963, Parker Ranch's relay team placed second after Kahuku Ranch at horse races in Hilo sponsored by the Hilo Paniolo Club.

The level of rodeo, racing, and horse showing stimulated enough interest among the ranch hands to form a club called the Paka Paniolo Horsemen's Association (PPHA),

with Alex Penovaroff elected as its first president. A series of four "play days" were held in 1964, with team roping and calf roping as main events. The PPHA gave ranch boys a forum in which they could compete for ranch-sponsored entries into Hilo, Honoka'a, and Kona rodeos, as well as to qualify relay teams for the annual Fourth of July races at the ranch racetrack.

In 1966, three ranch men—Louie Akuna, Hiram Lewi (team roping), and Chucky Waiau (bronc riding)—won big in the first annual Kona Stampede. Traditionally, the ranch discouraged rough-stock participation such as bull and bronc riding, but times were changing. Shortly thereafter, Charles Kimura was elected PPHA president, and play days and roping series continued in full swing.

By the end of 1969, interest in the PPHA was waning and the club entered a dormant state. A new generation of younger cowboys was on the horizon and it took their maturing into positions of leadership before a formal ranch rodeo/roping organization surfaced. By 1970, with ranch management under Rally Greenwell—who admittedly saw little value in rodeo—the PPHA was soon to end. Part of its demise can be attributed to the decision to exclude nonranch personnel from the jackpots and roping clinics. Cowhands were divided on the issue of whether guests should participate or not.

Incentive Program

To reinforce the progress of the cow horse training program, Penhallow developed a system of incentive awards, largely geared to the American Quarter Horse Association (AQHA) rules, with some additional standards specific to ranch cowboy needs. The following standards were set forth:

1. The program applies only to trainers of registered Quarter Horses.
2. Entering and placing in AQHA shows merits a $30 incentive fee.
3. Achieving Register of Merit standing for such a mount earns the trainer a $50 bonus.
4. A sales commission incentive offered the following-
 a. In trained horses sold at 12 years of age or less, the trainer is entitled to 1/2 of the sale price in excess of $250.
 b. In trained horses sold over 12 years of age, the trainer is entitled to 1/4 of the sale price or 1/2 of the sale price in excess of $250, whichever is greater.

The first qualifiers for the incentive program were Teddy Bell, George Purdy, and Masa Kawamoto. Kawamoto went on to a highly successful AQHA show and rodeo career.

Shortly after the onset of the program, noted horsemen who joined in included Joe Hui, Larry Ho'okahi, Allen Lindsey, Walter Stevens, Joe Cordeiro, and Leroy Lindsey and his brother, Paul "Cookie" Lindsey.

The most notable of these incentive awardees was Masa Kawamoto, foreman of the Pu'uhue section, who took top honors at the Parker Ranch 125th Anniversary Rodeo and AQHA Horse Show. Kawamoto and his mount, Icing, sired by Sappho and out of a mare named Palama, won the All-Around award as well as the Dr. Billy Linfoot trophy and an all-expenses-paid trip for him and his horse to the March 10 AQHA show at Saddle City on O'ahu.

As part of Penhallow's enhancement of the horse program, he formalized a policy of saddle and tack care out of concerns that repair and maintenance of cowboy gear was inconsistent, with the result that a significant number of workhorses suffered from saddle and cinch sores. He also had legitimate concern for the safety of both the horse and rider. Traditionally, Parker Ranch had availed itself of quality saddle and tack makers, excellent leather, and a standard for production of all horse equipment, but aside from the saddletree all else came out of the pocket of the workingman. This new policy was extended only to the Cowboy and Rough Rider Gangs. Penhallow went a step further by expanding the policy to include all leather and hardware, including bits, buckles, and rings. With John Kauwe as the able saddle maker, Penhallow's goal was to further elevate the standard of horse equipment to one that was uniform throughout the ranch. He stipulated that all horse equipment and gear belonged to the outfit whether the cowboy left or stayed for life. This policy continued through Rally Greenwell's tenure and was refined further under Gordon Lent so that a five-year tenured cowboy earned ownership of the ranch saddle he rode and the tack he used.

Penhallow enthusiastically endorsed the sale of Parker Ranch horses and was especially pleased with the positive media attention that came with it.

With the effect of royal interest, the ranch was pleased to sell five outstanding mounts to the Imperial Palace Riding Club of Tokyo. Represented by Colonel Kiyoshi Innami, the riding club purchased four Thoroughbreds sired by either Alicane or Hauli and a Quarter Horse gelding sired by Sappho Jr. The horses were destined for careers on the polo fields and hunting clubs of the Tokyo facility. This sale was followed shortly by the export of four Thoroughbreds to a Philippine polo club.

Penhallow's enthusiasm for the horse program was further fueled by his continued success stories, such as that of a four-year-old ranch gelding named Hoanani. A son of Alicane and out of a mare named Kīholo, the daughter of one of the ranch's finest modern Thoroughbred sires, Bel Canto Hoanani, owned by R. S. Dixon of Los Angeles, Hoanani won in convincing fashion the bulk of the $3,000 Anniversary Purse at the Caliente, Mexico, races in June 1962.

Local buyers were always welcome, some often buying in numbers that same June. Gordon Cran and Manuel Soares of Hilo each bought six horses, five went to John Kahaikupuna of Waimea, and James Cushnie of the Honoka'a Sugar Company took home three.

Other notable sales included a Skip Khal Thoroughbred colt to Joseph J. Cambra, a noted O'ahu horse trainer and exhibitor. From Moloka'i Ranch came its assistant manager, Henry Rice, who took back ten young horses as cow horse prospects.

Noted O'ahu horse enthusiasts, including Mrs. Tom Singlehurst, Clark Reynolds, and Roger James, acquired top show and polo prospects from Parker Ranch in the early 1960s. Penhallow viewed horse sales as the best advertisement available.

By this time, Penhallow's focus on the reincarnation of the Parker Ranch Thoroughbred horses as marketable (West Coast) racing prospects caught Richard Smart's attention and support. While Penhallow laid the pathway for renewed vigor in racehorse production, his efforts did not bear fruit until the middle to late 1960s under the direction of

Alex Penovaroff, who succeeded Teddy Bell as horse foreman. While not directly part of his horse management plans, Penhallow nevertheless saw promise in the leadership potential of a young college-trained Alexander Penovaroff.

The following biographical sketch reflects Alex's fundamental values, experience, and education, which placed him in a position for upward mobility.

Alex Penovaroff

First child and only son of Alexander (Sr.) and Leilani Penovaroff, Alex was born on December 2, 1935. Alex's paternal grandparents were Russian immigrants, Timofei and Pasha, who settled in the small Puna hamlet of Happy Valley, near ʻŌlaʻa town, in the 1800s.

In the old country, Timofei served as a sheriff. Having left the war strife of his homeland, Timofei turned to his woodworking trade of cabinetry, producing finely crafted guitars, mandolins, and ukuleles. His son Alexander became a Hilo businessman.

Alex's maternal family is equally colorful and historic, from both an English and Native Hawaiian perspective. His great-grandfather, Jack Payne, left Plymouth, England, on a British man-o'-war in the mid-1800s and landed in Kawaihae on the Big Island, leaving the life of a sailor behind. In a few years, Jack prospered as a pub owner in Hilo on the corner of Kamehameha Avenue and Haili Street, where Standard Drug Company was later located. Sailors and locals alike enjoyed the popular grog shoppe—Jack's Pub.

One of Jack's sons, William J. Payne, developed a career in land surveying and settled in the Hāmākua and Waimea communities. In Pāʻauhau, Willie Payne married the daughter of Reverend Charles Kamakawiwoole, Agnes Kalanikapu, and they bore a large family that became noted in the engineering and construction industries of the Territory of Hawaiʻi. One of two very attractive daughters, Violet Leilani married Alexander Penovaroff Sr. in 1934, and young Alex was born the following year.

As a young boy, Alex was sent to live with his grandfather Willie at his ranch in Puʻukapu, where the present-day Lakeland subdivision is located. Young Alex readily embraced the crisp mountain air and the scent of eucalyptus in a countryside laced with cattle and horses among the foggy mist. As a nine-year-old boy, he made a firm covenant that Waimea would be his home.

After a short stint at Kamehameha School for Boys on Oʻahu, Alex transferred to the budding Hawaiʻi Preparatory Academy (HPA) in Waimea. It was during his years there that he met his future bride, Jane Kaniho, eldest daughter of Willie Kaniho Sr., the legendary Parker Ranch figure.

During his high school years, Alex worked summers for Puʻuʻōʻō Ranch under the firm tutelage of Thomas Weston Lindsey; wild cattle and broncky "Gold Oak" horses were daily fare. After graduation from HPA he went back to work at Puʻuʻōʻō before leaving for college on a boxing scholarship. From 1953 to 1959, Alex studied animal science and competed in intercollegiate boxing at California Polytechnic College in San Luis Obispo. During those years he became enamored with *vaquero* tradition, particularly with the attendant horse training methods. Young and upcoming horsemen and cattlemen—including Jack Roddy, Greg Ward, and Les Vogt—surrounded him. For an interim period of over a year, Alex returned to

Alex Penovaroff at the reins preparing to breeze a Parker Ranch Thoroughbred. Photo by Alex Burso.

Alex Penovaroff, in vaquero *garb, chats with Morgan Brown at Old Hawai'i on Horseback festival. Mounted in the background are Kale Stevens, Richard Smart, and Anna Perry Fiske. PPS.*

Waimea with his wife and family, where he worked at the Humu'ula Sheep Station under his father-in-law, Willie Kaniho. Then he and his family returned to San Luis Obispo, where he completed a BS degree in farm management with a minor degree in animal husbandry. Alex returned to Waimea in 1959 with his family, which had grown to include four children.

The first assignment for Alex was the Makahālau section, where he remained for a few years, working under Rally Greenwell as foreman and with Charlie Kimura, who was head herdsman. While this opportunity gave him intensive purebred cattle management exposure, Alex consumed much of his energy training and racing horses. It was a time when the fine lines of ranch Thoroughbreds were coming to an end, and Penovaroff seized the moment to study these pedigrees both from a genetic and performance perspective.

Alex gained from both a cattle and horse aspect when he became a student of Yutaka Kimura, who was considered an undisputed livestock authority in the broad sense. This relationship with Yutaka spanned from 1959 to the passing of the iconic cattleman in 2003. Others shared this same deep respect for Yutaka during these years, including budding management prospects such as Pete L'Orange and young Charlie Kimura. Alex credits other great but quiet men of his Makahālau years—notably Tadao Nakata and Saichi Morifuji, who is described as never having been unseated from a bucking horse.

When Willie Kaniho became general supervisor responsible for the breeding herds of Parker Ranch, Alex was assigned the responsibility of the eastern portion of Parker Ranch, including all mother cows in Hanaipoe, Pu'u Noho, Kemole, Pu'upueo, and Makahālau.

As management of the ranch shifted from Hartwell Carter to Dick Penhallow, Alex was elevated to the broad function of foreman for Humu'ula, the vast 50,000-acre section that stretches from Kalaieha across to Keanakolu, ending in the lower forested meadows of Waipunalei above Laupāhoehoe Sugar Company. During this eight-year span, Alex

```
                    PARKER RANCH
                    KAMUELA, HAWAII

                                September 13, 1961

    Mr. Donald de Silva
    Makahalau
    Kamuela, Hawaii

    Dear Donald:

         Alex Penovaroff has reported that you are doing satisfactory
    and necessary service for Parker Ranch additional to your regular
    duties by shoeing horses which are used in the Makahalau section.

         I wish to recognize this interest which you have displayed
    by increasing your salary in the amount of $10.00 monthly commencing
    September 1, 1961.

         Congratulations on your efforts!  You have my best wishes
    for continued success.

         With cordial regards,

                                Yours sincerely,

                                Richard Penhallow
                                Manager

    RP:ky

    cc:  Mr. N. Brand
```

Penhallow letter to Donald DeSilva reflecting the manager's progressive stance on personnel development.

continued to hone his horsemanship skills and knowledge while developing early relationships with prominent California racing horsemen such as Rollin Baugh, J. T. Elmore, and Rex Ellsworth. Penhallow was diligent in fostering these relationships as a means of reincarnating Parker Ranch as a resource for foundation lines of Thoroughbred horses. Although his management career was a brief two years, Penhallow's vision was carried through by Penovaroff as he was moved back to the ranch headquarters as foreman of horse operations when his predecessor Teddy Bell left for a stint in the construction industry.

In a sense, Alex's dreams came true when he became head of the horse program. Despite his enthusiasm, there were some genuine challenges that included a large band of broodmares with mixed registry, grade Thoroughbred, Standardbred, Morgan, and Quarter Horse breeding. He was striving to carry out a supportive mandate of Richard

Sun God III, a stallion with a kind expression and disposition. PPS.

Smart, who—together with the leadership of his son Tony—demanded that the ranch return to its racing greatness so prevalent on the mainland in the 1920s, 1930s, and 1940s, when Parker Ranch horses dominated the West Coast tracks prior to pari-mutuel wagering. Elective culling of the horse numbers was difficult on a large scale since so many cowboys and foremen had favorite mounts that had been retired to the breeding bands. Horse sales were erratic and divided among local horse enthusiasts and O'ahu and mainland buyers, the latter of which were searching for the offspring of notable stallions such as Sun God III, Hauli, and Bel Canto.

Richard Smart gave Penovaroff significant autonomy in his efforts to salvage the Thoroughbred program especially during the period from 1962 to 1971. Penovaroff drew on his mainland contacts to bring the ranch Thoroughbreds back into the limelight of West Coast racing circles, and some of these successes are worthy of discussion in terms of importation of "speed horses" to cross on the foundation lines. Exportation of ranch Thoroughbreds to mainland tracks was moderately successful.

By 1965, Penovaroff's efforts began to produce results. Hauli, the handsome dark-brown stallion sired by Alicane (by Alibhai) and out of Kauhane (by Ormesby, the remount stud son of Sir Gallahad III), had multiple progeny running on mainland racetracks.

Bel Canto, the 17-hand brown bay son of Beau Pere out of Sengida by Cinna, had produced eight winners. Bel Canto's daughter Piholo nicked well with Hauli in producing Hey Sam, who won more than $10,000 at Bay Meadows in 1965.

Sun God III, a direct son of Migoli, was a half brother to Gallant Man, who was an English-bred stallion. Migoli was a winner of multiple stakes races in England and he was prepotent, producing thirteen starters,

The Dick Penhallow Management Era

seven of which won twenty races totaling nearly $30,000 in cash. Sun God III passed on his racing heritage to his progeny. Apollo's Promise, his bay two-year-old daughter, won stakes races in California, while the average sales price of his foals was $2,700. Standing for a stud fee of $500 at Parker Ranch in 1965 and 1966, he was leased from the Loma Rica Ranch in Grass Valley, California.

Penovaroff's early acquaintances within racing circles were beginning to pay off also in terms of broodmare power. Rollin Baugh arranged for Parker Ranch to receive significant broodmare power in the likes of Min, a daughter of Blenheim II out of Ma Minnie by Man o' War, and Rising by County Clare, who also produced County Maid, a stakes winner.

Crossed on Hauli, Bel Canto, or Sun God III, both Min and Rising brought speed lineage of a modern nature. Min's father Blenheim II was a noted broodmare sire, his daughters having produced over $6 million in stakes winnings. Min arrived in Waimea with a foal at her side as well as in foal. John Winslow by Nashua, sire of eighteen stakes winners, sired the colt at her side, named My Man Min. Before leaving for Hawai'i, Min was bred to Nagea, another son of Nasrullah, England's leading sire of the times and five times leading sire of the U.S. stakes winners. Min gave birth in Hawai'i to a stud colt that was lost to an intestinal twist prior to weaning. My Man Min—who interestingly produced a heavy-set cow horse type of offspring that made very serviceable ranch horses—was also a noted sire of hunter and jumper mounts.

Leaving California, Rising was bred to Rideabout, owned by Kjell Qvale of Green Oaks Stud Farm in Napa Valley. Rideabout in his career won nearly $62,000, starting thirty-two times and coming in the money eighteen times. Rising arrived in September 1965 with a filly foal at her side sired by Octopus. She foaled a colt named Rising's Ride, who later became a Parker Ranch sire noted as a great producer of broncky colts. Rising herself had won over $5,000 in three races before leaving California in foal to Rideabout.

Octopus, despite his name, had a significant history in winners' circles. He was sired by John's Joy, who often led the sires list in the number of winners produced. Bargain Counter, an Octopus-sired California allowance winner, was a noted son. His Hawaiian filly daughter out of Rising also fared favorably on California tracks.

A note of significance is that the breeding of John Winslow, Rideabout, and Nagea all traced to the lineage of Nearco, which has been regarded as among the best in the world at the time. Current statistics of those times reveal that of the 560 winners of significant races and derbies in the United States, 102 (18 percent) carried Nearco blood.

While the ranch seemed headed in the right genetic direction, other problems arose that pointed to nutritional problems in the raising of yearling prospects for the West Coast tracks. Penovaroff observed that too many of the yearlings would arrive on the coast lacking in size and bone density. While these became two-year-olds under top feeding and training regimes, breakdowns (arthritic changes) often cost these horses their careers on the track.

In 1965, a supplemental feeding program was instituted on the ranch to develop growth and bone density. While this helped somewhat, the mineral component of the ration was left unattended and breakdown

continued at a higher than acceptable rate. Sound mineral nutritional attention was not provided for Parker Ranch livestock until 1972, just as Alex was leaving for a career on the California tracks. At this point the Thoroughbred program had lost significant interest and funding, and the new management team of Rubel and Lent was moving toward a purely Quarter Horse operation. This change in direction solidified Alex's decision to leave the ranch to pursue his interest of heart—horse racing.

The Sheep Operation

Beginning in 1914, Humu'ula was a Parker Ranch sheep operation, with merino the predominant breed. The cold climate of Humu'ula, with occasional snow and frost between December and April, was conducive to sheep production. Traditionally, annual shearing took place in April before lambing time. Dipping for external parasites occurred in summer, while drenching for internal parasites took place as needed. On an average, 5,000 sheep were shorn at the annual Humu'ula sheep shearing. In the war years of the 1940s, wool continued to bring a good return, but by the late 1950s the value of the wool was equal only to the value of the mutton from culled sheep sales. Lamb sales were extra, but the Honolulu market for lamb dwindled despite an increasing population.

In his early tenure, Penhallow adopted a program of improving breeding stock and expanding the general flock. Under Hartwell's management, mass selection of breeding rams occurred and the flocks were divided into several smaller ones to avoid inbreeding. Penhallow's thrust was toward mating young native rams with ewes of equal quality. This also took place in other ewe flocks using Targhee and Suffolk rams on selected native ewe flocks, with an eye to increasing body weights and thus poundage of fleece. Targhee, a sheep breed noted for tenacious dams and excellent wool and fleece characteristics, was developed and made popular in Idaho. Parker Ranch purchased two rams from the Charles Cooke flock on Maui, while importing thirty rams from California. These were Suffolk sheep, which are noted especially for their large size and excellent carcass characteristics.

The crossbreeding program yielded higher-grade lambs when half-bred ewes were bred back to merino rams. The ratio of rams to ewes in the breeding herds was a steady 4 percent.

The 1961 production, referred to as the "wool clip," was 25,814 pounds. The 1962 wool clip increased to 27,425 pounds and, as in the past, was sold through the Blue Mountain Hide, Wool and Fur Company of Portland, Oregon. Through his tenure as Humu'ula foreman, Peter L'Orange individually graded the fleece of each shorn sheep, constantly upgrading the standard of wool production.

Still striving for a higher production rate, Penhallow described the 1962 wool clip as average since he expected the genetic improvements already under way to step up the quality and quantity of Parker Ranch wool.

Penhallow's enthusiasm resulted in marketing Humu'ula "spring lamb" through the Kamuela Meat Market, which was by then owned and operated by Yaroku Dochin. This operation utilized the old Parker Ranch slaughterhouse, which was built to accommodate the military activities of World War II.

Gathering the sheep flock at Puʻuʻōʻō. Note the lone rider coming over the hill. PPS, Arch McCabe photo.

Holding the sheep flocks together. A lone cowboy serves as kīʻai (guardian), awaiting the signal to move the flock to the Humuʻula Sheep Station corral. PPS.

Above: Approaching Kalaieha, the headquarters of the Humuʻula Sheep Station, with a large flock of sheep for shearing and dipping. PPS.

Left: Flocks in the Humuʻula Sheep Station main corral awaiting shearing and dipping. PPS.

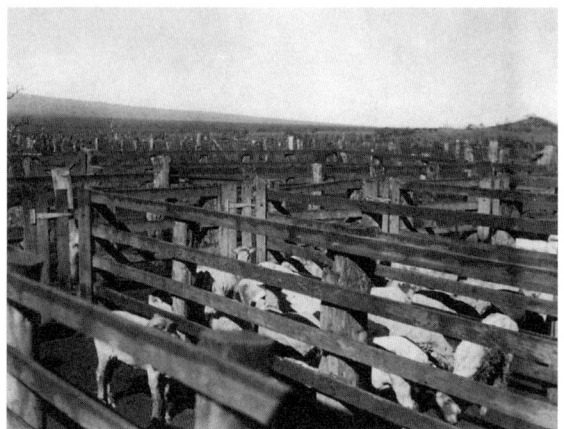

Above, left: Corralling sheep. Younger lambs were separated for market from the ewe flock. PPS.

Above, right: Corralling sheep in smaller pens for the shearing and dipping process. PPS.

Right, top: Shearing barn in excellent working condition. PRC.

Right, bottom: Water boys serving the shearsmen. Note the robust workhorses. PPS.

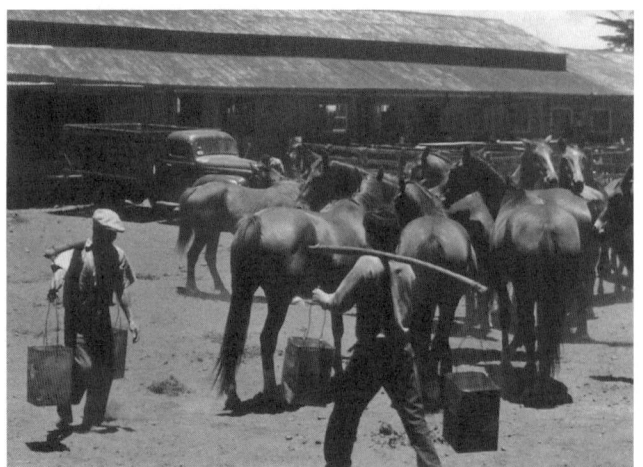

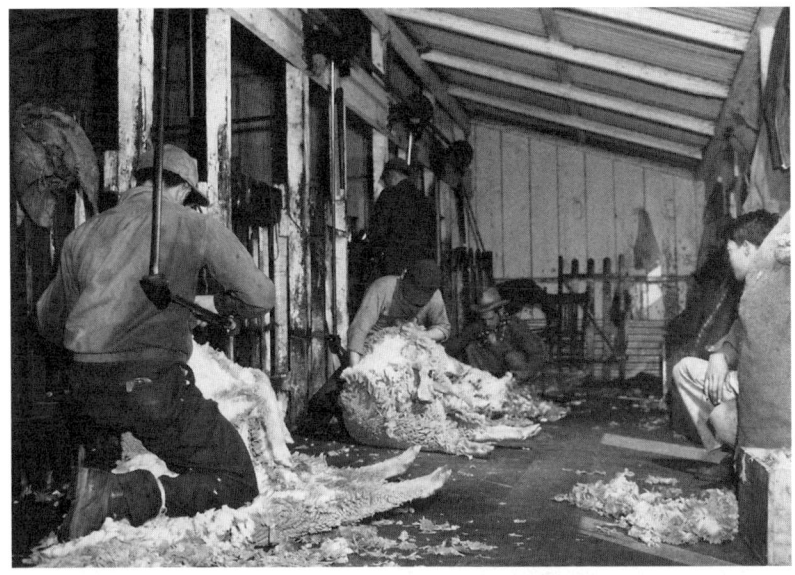

Sheep shearing. The cowboy in the background with the **lauhala** *hat is Jordan Quintal, on loan from the Breaking Pen. PRC.*

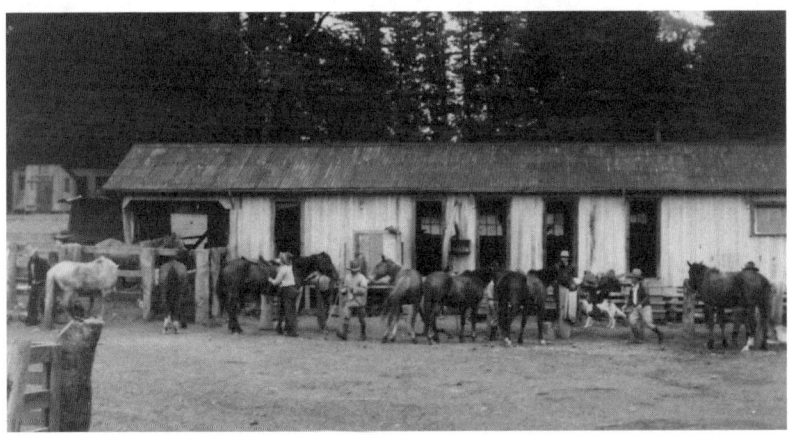

Cowboys unsaddling at Humuʻula Sheep Station. Saddle rooms were elevated from the ground. PPS.

Present-day saddle house (2005) with Sonny Keakealani standing by. WCBC.

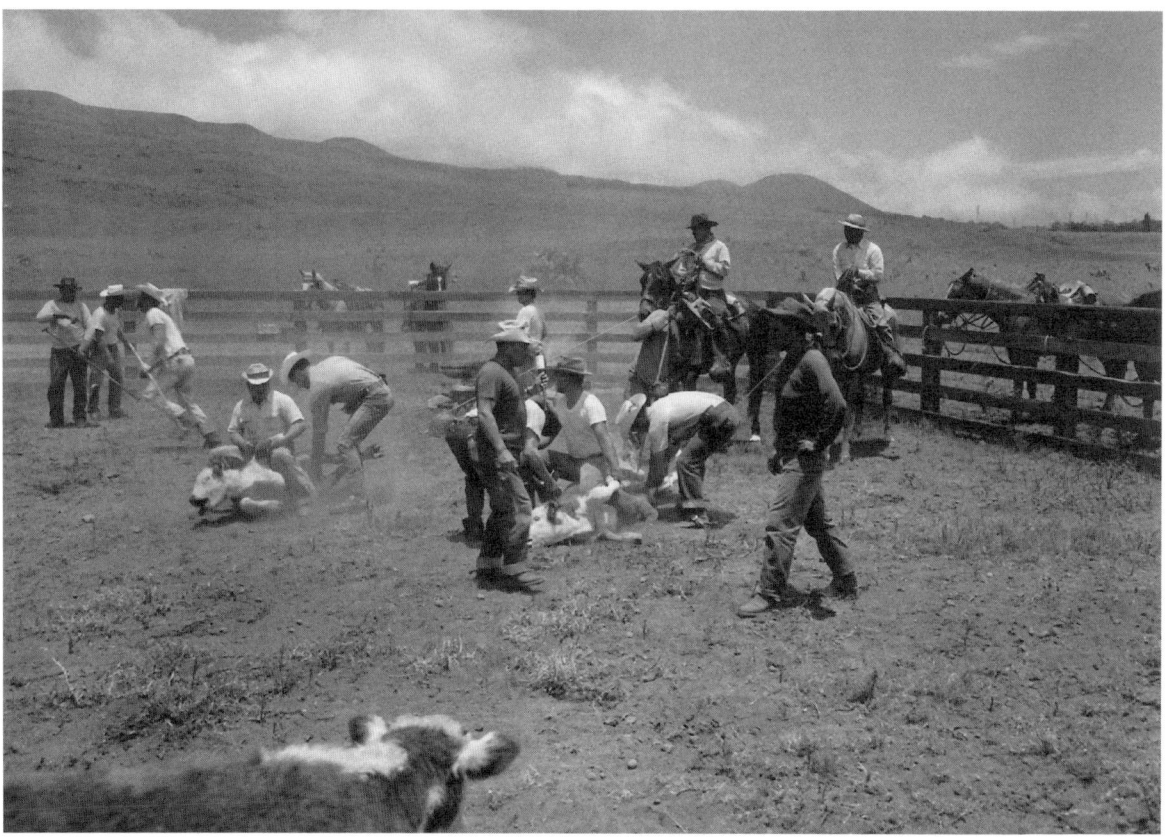

Puʻu īki branding. Roper on the left is Frank Vierra, flanked by Henry Ah Fong on a stout palomino. The calf on the left is held by Gilbert "Shinko" Hokama, while Joe Hui prepares to castrate it. PPS.

L'Orange supplied 100-pound market lambs using a minimum of supplementation at the rate of twenty-five head per week. Times Supermarket of Oʻahu called for even greater marketing demand, seeking a hundred head per week of the Humuʻula "spring lamb."

Penhallow set a higher goal for lamb crop percentages by devising a second lamb crop in a single year, using hormones to induce estrus. He wanted to double the flock size. Despite the estrus synchronization efforts, lamb crop percentage increased only 75 percent due to depredation by wild dogs, whose impact on the flock was serious. On the mainland, sheep producers routinely produced better than 100 percent lamb crops due to twinning. This was not possible in Penhallow's flocks. During 1952–1956, I worked next door at Shipman's Puʻuʻōʻō Ranch, where the wild dog packs came after lambing season was over. Both outfits were relentless in destroying the packs, but the females raised large litters—plus the numbers increased by abandonment or loss of dogs by hunters. Humuʻula cowboys proudly displayed wild dog scalps above the saddle room doors. In

a given year, dogs claimed the lives of 2,000 or more lambs on an average. Wild dogs were also a threat to cattle and pigs around the entire circumference of Mauna Kea, and they still pose a nuisance today.

As ranch management passed from Richard Penhallow to Rally Greenwell, the end game for Parker Ranch sheep operations had already begun.

The Cattle Program

Part of Penhallow's management goal was to raise the number of cows from 12,000 to 14,000 and increase the number of bulls to 700 range sires. He called for a minimum 85 percent calf crop and targeted the greatest weight per age at weaning. Penhallow was ahead of his time in defining a final market product—a 600-pound carcass of high yield and grade in an industry that had not yet developed the broad uniform standards seen today. Although his aggressive plan for wholesale artificial breeding of the cow herds never materialized, Penhallow is credited with developing crossbreeding as a significant means of improving beef cattle production.

Aware that a crossbred (Angus sire) calf out of a straightbred dam (Hereford) has a higher survival rate, a larger appetite (inducing more milk production by mother cows), and gains faster than a purebred of either breed, Penhallow forged a new direction in ranching efficiency. Later the Santa Gertrudis sires were introduced, used in terminal crosses (all progeny marketed) to ensure higher feeder weights going into the Oʻahu feedlot. The purebred Hereford herd, however, was still the heart of Parker Ranch's beef cattle progress, and he sought and found the right person.

About that time, Charlie Kimura—a rising star on the ranch—was appropriately

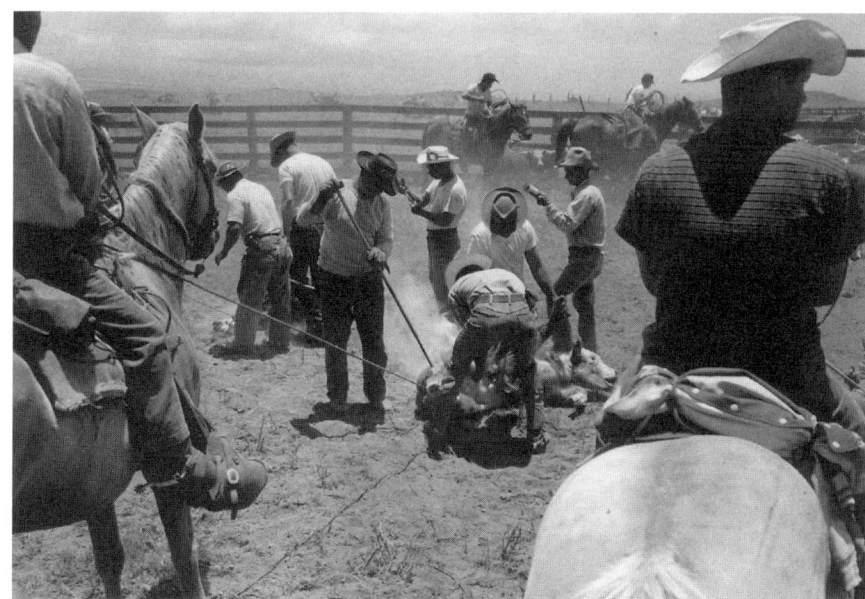

Puʻu īki branding. Tony Smart is on the right and Henry Ah Fong is on the left. PRC.

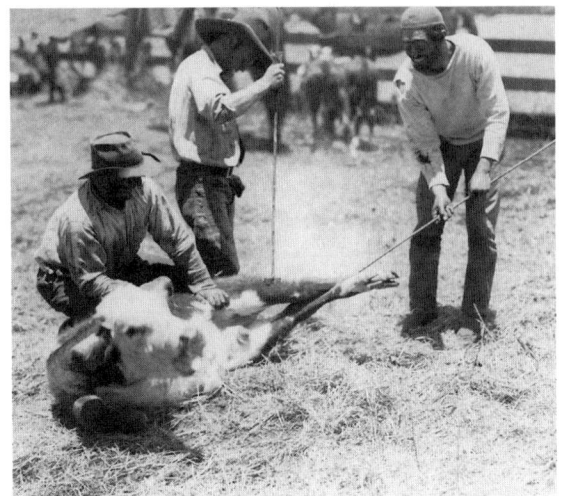

Left: Puʻukīkoni branding. John "Samoa" Lekelesa is holding the rope, Joe Maertens is holding the calf, and Jordan Quintal is doing the branding. PPS.

Below: Puʻu Mahaelua branding with Willie Kaniho in charge. Ropers are Hogan Kauwe on the left, flanked by John "Samoa" Lekelesa. The calf on the left is held by Jiro Yamaguchi, while Gilbert "Shinko" Hokama applies the brand. Ropers on the far left are Henry Ah Fong and Willie Kawai. PPS.

viewed by Penhallow as a viable leadership candidate in the field of purebred herd management. The profile of his career that follows attests to Penhallow's excellent judge of character.

Charlie Kimura

Charles Kimura was born on July 21, 1931, at Pu'ukīkoni Dairy in Mānā, Parker Ranch, to Yutaka and Haruyo Kimura. Charlie was the second youngest of five children and at age six moved with his family to Kamuela to attend school. His love for cattle and horses was already ingrained, and the ensuing summers found Charlie back up at Pu'ukīkoni Dairy helping care for the cows and riding the horses. During these years, he closely observed his father's work in managing the dairy, which included the breeding program, calving procedures, milk production, and butter and cheese processing. These early impressions of intensive management of livestock gave Charlie true insight into the responsibilities of animal husbandry. These observations would play an important role in his career in ranch administration.

Charlie's first job on Parker Ranch came at age twelve when he was part of the 'Ōpae Gang, made up of summer student employees who were given the task of repair and maintenance of various facilities, including water catchment care and cleaning. Other tasks included noxious plant control, picking *kiawe* beans for ranch hogs, harvesting corn and putting up hay in Waiki'i, dipping sheep at Humu'ula, and working on the carpenter and fence gangs. In 1949 Charlie became a full-time ranch employee upon completing high school, and although cattle and horses were his first love, the only available job was on the fence gang. Again, this very basic experience in ranch work would be beneficial as Charlie gradually rose to administrative ranks.

When an opening in the area of livestock became available at Makahālau, Charlie went to work under Bull Johnston, who oversaw the purebred operation of Parker Ranch. After an enjoyable six-month stay, Charlie was drafted into the Marine Corps during the Korean conflict and went off to war. His military experience further reinforced his family traits of discipline, chain of command, and working through channels to reach one's goals. These values would be useful in his later years of ranch management.

Returning to Makahālau in 1953, Charlie quickly rose to the level of assistant foreman, heeding the advice of his father that Parker was a cattle ranch, not a horse ranch. Although Charlie focused diligently on purebred herd management, he never lost sight of horses and the importance of this companion to successful ranch operation.

When Yutaka retired with forty-nine years of service, the torch was passed to Charlie as he was promoted under the management of Rally Greenwell to become the marketing foreman of a ranch whose cow herd had grown from 12,000 to 18,000 mother cows. As Charlie approached his retirement year, Parker Ranch mother cow numbers grew to exceed 21,000. During his tenure as manager of the Ka'ū Division, total Parker Ranch cow numbers exceeded 23,000.

Charlie's role as marketing foreman gave him the opportunity to demonstrate his talent for logistics. His responsibilities included coordination of biweekly shipments of feeders, cows, and bulls to O'ahu markets via the Hawaii Meat Company, as well as filling the

needs of the grass-fat market of the Kamuela Meat Company. Charlie further applied considerable experience to the logistics of the mainland shipment of feeder cattle via air. His keen judgment on uniformity of size, weight, and frame of the feeders was critical to the success of these shipments. It was at this point in Charlie's career that his name became a familiar one in Western livestock circles, short courses, and symposiums. He was frequently called upon to purchase herd sires for the ranch from various livestock shows and prominently placed breeding farms. Some of the well-known outfits that Charlie frequented were King Ranch, Mitchell Ranch, Spade Ranch, Victoria Land and Cattle Company, and Carnation Farms.

In 1971, Richard Smart made the decision to retain the mainland firm of Rubel and Lent to manage the ranch, and with this change came a reorganization of the company in a geographic and regimented fashion. Clear lines of authority were drawn, coupled with goal-oriented performance. Charlie fit very well into such an organization and was looked upon as a person that could effect some strong changes in how the ranch would be run. Instead of a single roving Cowboy Gang, each division had its own superintendent, foreman, and cowboy crew. Charlie was named to head the Eastern Division, later known as the Mānā Division. There would be no mass movement of cowboy horses; stock trailers (bumper pulled) and gooseneck trailers (fifth-wheel pulled) assigned to each division came into play. No longer would there be strings of twenty-odd horses per cowboy. Instead, each man was limited to eight mounts. These horses were now shod not by assembly line fashion preparing for a drive of Holoholokū but by the master, who took formal training in shoeing from a robust, red-faced, and stout farrier named Bob Jastram.

Included among the changes were feeders requiring preconditioning before shipment, bulls needing vaccinating before breeding, and minerals being delivered at a rate of 2 ounces per cow per day, which converted to a distribution rate of 40 tons per month. Through this logistical nightmare marched Charlie, quietly achieving the goals set out before him by a mainland consulting group that could rarely pronounce the place names correctly. Charlie knew that change was coming, and while he viewed the "overhauling" of the ranch with some apprehension, he carried out his mission in an exemplary way. This restructuring effort of thirty-four years ago left a lasting impact on Parker Ranch and, despite subsequent management and trusteeship changes through this period, the basic structure remained operational with few adjustments.

Charlie's image on the ranch was favorably enhanced during these formative years of progress, and it came as no surprise when top management enlisted his help and assigned him another "mountain to climb." The acquisition of Seamountain Ranch—formerly Hawaiian Ranch properties that ranged from South Point to Volcanoes National Park—brought a massive logistical challenge that Charlie met with gusto. The nearly 100,000-acre expansion to the south meant the movement of nearly twenty men and their families to the communities of Nāʻālehu, Pāhala, and Volcano. This was in addition to the horses, an equipment inventory of tractors and compressors, and a large fleet of rolling stock. Charlie was nonetheless determined to take on this challenging task. The cattle operation had been severely neglected to the point

of being a commingled herd of semiwild to truly feral animals. The horse strings consisted of either old horses suitable for light use or retirement or four-year-olds that were not halter broken and in some cases uncastrated. The working facilities were in disrepair and no drive could be complete without a trailer load of metal Powder River corral panels. Charlie roped his share of the big, bad horned bulls that seemed to emerge from the *wili laiki* (Christmas berry) in unlimited number. As a southpaw, Charlie was a great roper, but to see him manhandle the *pipi 'āhiu* across the lava fields and effectively snub big horned bulls into submission to the closest solid *kiawe* tree was testimony to his reputation as a "cowboy's cowboy." Charlie was an all-around hand with cattle, whether it was a show sire in Makahālau or a wooly brindle *laho* (bull) in 'Ōhaikea.

Weather conditions were an added challenge for the men assigned to the Ka'ū ranching project. Water supply was feast or famine. They were either dealing with flooding or extended droughts, necessitating water hauling to supplement an obsolete and neglected distribution system. Charlie's philosophical approach to ranching was based first on water—its quality, availability, and distribution—as a priority far above genetics and other aspects of livestock management. It was truly put into practice when the Kapāpala water system suffered severe damage from the great earthquake of 1975. Men had to scale the cliffs by rope and restore water flow by replacing 4-inch, 21-foot pipe lengths that carried water from the underground tunnels above Wood Valley across to Kapāpala Ranch. It was a mission of high risk considering after-quake tremors that could generate landslides at any given moment. Comparable damage had occurred when the same quake badly impaired water flow on the Nā'ālehu side of the ranch, putting the cow herds in the Ka'alu'alu area at risk.

Through all these hardships, Charlie diligently shipped out thousands of feeders, uniform in size but of very mixed breeding. In the beginning these feeders were wild and snorty and slow to go on feed at the Hawaiian Milling Feedlot, but they finished with good carcass quality.

Other highlights of Charlie's management career will be noted on subsequent pages. Suffice it to say that Charlie rose to the pinnacle of his management career—the livestock manager of Parker Ranch—having begun truly from the "ground up." Men such as Dick Penhallow recognized developmental potential when they saw it in Charlie Kimura.

Early on, Charles Kimura was promoted to foreman of the purebred program, and in helping to develop Kimura's skills, Penhallow brought in Richard Clark, U.S. Department of Agriculture beef cattle scientist. Dr. Clark tutored Kimura extensively on improving cattle quality via genetics and selective breeding. In effect, Clark helped chart the course for the future ranch-registered beef cattle program, and Kimura played an enduring role in its progress.

Penhallow moved the purebred registered breeding herd from its traditional home at Makahālau to Waiemi Stables, next to Richard Smart's home at Pu'u'ōpelu. In spite of improved buildings, the move was unpopular and eventually was reversed. The dismantling and transport of a 40 x 80-foot bull barn from Makahālau to be reassembled at Waiemi was a huge undertaking for the able carpenter crew of Jimmy Kurokawa. Be-

Richard Penhallow and Charlie Kimura with Plutonium 80, grand champion at the 1961 Maui County Fair. Penhallow collection.

sides Makahālau, other fine meadows were used for this program; paddocks such as Old Waikiʻi Mauka and Makai served the larger purebred cow herds during gestation.

Penhallow came up with a formula for effective range bull calf production. It began with a single superior herd sire mating with twenty-five registered cows of select quality, which would produce about a dozen half-brother bull calves to be grown to sexual maturity. Then they were exposed to 250 select-grade cows. Of the 120-odd bull calves from these select cows, the top fifty selected were grown to maturity for range use. They would meet strict weight-for-age standards, be polled, and have appropriate conformation and color.

Penhallow demanded the annual production of about 200 replacement bulls to maintain a 700-head battery. Pressure for the production of replacements was tied to a mandate to cull range bulls by the time they were six years old.

Penhallow was enthusiastic about crossbreeding. He used a 400-cow Santa Gertrudis herd in the ranch area on the arid range at Puʻu Pā and Angus bulls for a long-yearling heifer program at Kohala. His logic regarding the Angus bulls had two bases: first, the Angus bull tends to throw a smaller and more deliverable calf; second, by exposing select market heifers to the easy-calving black bulls, Parker Ranch could realize an additional calf crop from those heifers that could wean a crossbred calf and still be fattened for a three-year-old grass-fat market. In the interim, those heifers failing to conceive would reach grass market finish anyway as

Angus bull at Waiemi named Upland Eileenmere. Penhallow collection.

two-year-olds. The yearling-heifer breeding program was logical but was less than effective economically. Early in the 1970s this program resurfaced under Don Hanson and Walter Slater's management, with the same end result. In 2002–2003, ranch management made a third run at trying to make such a program work, again repeating the substandard results of the 1961 and 1972 episodes.

There is a place for breeding yearling heifers, but there are fundamental steps that must be taken to avoid disaster. A producer must place his candidate weaner heifers on excellent feed and minerals to achieve a 600- or 700-pound yearling with a stout frame and a wide birth canal. This nutrition must continue at a high level to ensure active ovulation and subsequent conception. Leveling off this nutrition plane is acceptable by the last trimester of pregnancy. Overly fat calving heifers must be avoided because of birthing problems that come with a fat-lined birth canal. Once delivered, the young dams again demand high nutrition for lactation and daily maintenance. As the calf approaches the third month and becomes more of a ruminant, a common error in management is to reduce nutritional support, and about this time the long-yearling heifer becomes "shelly" (*lahilahi*, or skinny) and her calf begins to show a reduced state of nutrition. By weaning at six months, you have a "shell" of a heifer with a substandard frame and a calf with unsatisfactory weight for its age. Often these nutritionally challenged heifers are lost, along with their calves, as was the case in the 2003 Keʻāmuku episode. Breeding yearling heifers works for operators who make a serious commitment to good nutrition to make up for a rather early biological expectation from one of God's noble creatures.

The livestock industry of Hawaiʻi is uniquely challenged by the logistics of interisland transport, interranch politics, and the bureaucracy inherent to the packinghouse aspect of marketing cattle, hogs, and sheep. The interrelationships between the different meat packers made not only for greater competition but for rivalry that added much color and interest to the ranching industry's history as a whole. Dick Penhallow played a brief but colorful role in this history.

Beef Marketing in Hawaiʻi

Penhallow's role in the meat industry was short but epic. To better understand his logic in planning an overhaul of Hawaiʻi's cattle marketing system, a review of this rich history is helpful.

The Territory and State of Hawaiʻi have enjoyed access to several beef processing plants over the last 125 years. While each island had small slaughtering facilities that butchered five to ten head per day, Oʻahu—

where 80 percent of Hawai'i's beef is consumed—developed major kill plants that processed fifty to eighty head daily. These facilities also served neighbor island producers via steamship and railway transport. Eventually, conventional barging and trucking systems were used.

In the late 1800s, prominent O'ahu ranchers and businessmen formed the Metropolitan Meat Company. Gilbert Waller and his nephew of the same name managed this operation, which provided slaughtering and processed carcasses for wholesale distribution among O'ahu's meat purveyors. Parker Ranch was the primary client by a wide margin. Other neighbor island ranchers used the Metropolitan Meat Company beyond their local slaughter plants. By 1900 the company had become very successful, acquiring a somewhat arrogant regard for the supplying ranchers in terms of prices and scheduling shipments. To a degree, this posture served to strengthen the local kill plants. Hilo Market Company, Ltd., for example, established a facility of significance for Big Island ranchers in 1900. At this juncture, it was a partnership owned by W. H. Shipman, the prominent rancher and landowner, R. L. Hind Sr., S. Low, and A. Horner. In 1908 A. W. Carter joined in. In 1911 Carter was instrumental in transforming Hilo Market Company, Ltd., into Hilo Meat Company Ltd., with the same partners, plus the inclusion of Hawaiian Agriculture Company, Ltd., which solely owned Kapāpala Ranch. Shipman became its first president, with A. W. Carter serving as vice president and Albert Horner of Kūka'iau Plantation Ltd. as secretary. Still, the marketing needs of Parker Ranch necessitated shipments to O'ahu of large numbers of steers, heifers, cows, bulls, hogs, and sheep.

Concurrent with the turn of the century was the appointment of A. W. Carter as trustee of the holdings of the youthful Thelma K. Parker. While developing detailed oversight of ranch operations, Carter became deeply concerned with the marketing process and pricing posture of the Metropolitan Meat Company. On the ranch end of the process, Carter vastly improved the finish (fat cover) of the market cattle by setting aside superior pastures for such animals. Via imported bulls, Carter greatly enhanced growth and fattening performance within the first decade of his tenure.

During this decade, Carter exhausted all efforts to affect improved relations with the Metropolitan Meat Company in regard to poor pricing, slow payments, and erratic shipping schedules that often left fat cattle at Kawaihae Harbor because of canceled steamship services without any forewarning. In late 1908, Carter notified Waller that in six months, all Parker Ranch consignments to Metropolitan Meat Company would end as he was planning to build a Parker slaughter plant on O'ahu, with significant participation of the major neighbor island cattle ranchers. The board of directors of Metropolitan Meat Company responded quickly, offering to sell their kill plant to the Carter consortium, retaining only the processing and marketing arm of the operation. In 1909, the Hawaii Meat Company (HMCo) was born, with major partners including Robert L. Hind Sr., Albert Horner, J. A. Maguire, W. H. Greenwell, J. D. Paris, J. F. Woods, and R. A. Cooke, the capitalization being $100,000. Founded as an agricultural cooperative with related advantages, the purpose of HMCo was to process and market all cattle from member ranches.

Carter secured most improvements in shipping and scheduling of livestock transport and processing. Maritime law in the Islands mandated a six-hour maximum time period that livestock could be held at wharves, and Carter used this standard diligently in demanding coordination between cattle delivery to and from the ports with shipping schedules. Hawaii Meat Company in the early 1920s rendered even greater shipping services to neighbor island ranchers when the SS *Bee*, a cattle steamer, was launched. This vessel was later joined by its sister ship SS *Hornet* and eventually the well-known and frequently photographed SS *Humuʻula*. SS *Hawaiʻi*, in the interim, was an HMCo–designed vessel that transported cattle interisland. This ship was built in 1924. A. W. Carter himself directed the design and construction/renovation of these vessels. Hawaii Meat Company lost its status as an agricultural cooperative when it entered the shipping business. Eventually the company divested itself of its shipping arm, with Inter-Island Steam Navigation Company assuming control, retaining A. W. Carter on their board of directors. Over the 150 years of Hawaiʻi's ranching history, more than thirty-two vessels serviced the Big Island's many and varied harbors, ports, landings, and coves.

In 1927 the Hawaii Meat Company bought several acres of barren land on Slaughter House Road from a pork merchant, C. Q. Yee Hop. By 1929, the company built the territory's first modern packing plant on the property that eventually became Middle Street. Shortly thereafter, the plant received federal certification from the Bureau of Animal Industry, receiving stamp #970 certifying federal carcass inspection. The plant thrived on Oʻahu and neighbor island cattle consignments. Rail service brought cattle to the kill plant from the wharf and transported chilled carcasses to various meat retailers in Honolulu. Hawaii Meat Company returned to its function as a cooperative marketing arm of the member ranchers, with Parker being the predominant component.

Enter Competition

In 1928, a parallel rancher/meat packer entered the industry when Atherton Richards and Ronald von Holt purchased Kahuā Ranch in North Kohala from Frank Woods. Herbert Montague Richards Sr. moved to Kahuā Ranch as manager shortly thereafter. The sale included 3,000 head of cattle, 150 horses, several dozen mules, and a smattering of pigs, turkeys, and chickens. The bull battery included twenty purebred Herefords. In 1929, the Richards family was blessed with the birth of a son, Herbert Montague Richards Jr. By 1931, Kahuā Ranch cattle had grown to 5,000, including cows, replacement heifers, and yearlings, as well as grass-fat market cattle. In that year, Kahuā Ranch branded nearly 1,500 calves. This was the nucleus of what would become a major component in the livestock industry of Hawaiʻi in terms of marketing and genetic improvement of cattle over the ensuing seventy years. By this time, the two-and-a-half-year-old child, H. M. Richards Jr., moved with his family to Oʻahu and Ronald von Holt became the manager of the ranch.

The market cattle of Kahuā Ranch were divided between local markets serving the burgeoning plantation communities of North Kohala. Union Market (Higa) was a solely owned store, while the Kohala Sugar Company (Castle and Cooke) owned the Hāwī and

Kohala Meat Markets. The ranch established a kill plant that was paralleled by a similar slaughterhouse at Puakea Ranch owned by the Wight family. Beyond its market outlets in North Kohala, Kahuā shipped fifty head a month to the Hawaii Meat Company out of Kawaihae Harbor, swimming the steers out through the surf to the waiting longboats. From its headquarters, Kahuā's fat cattle were walked in the cool of the midnights and early dawns more than a dozen miles down toward Kawaihae, where they rested overnight in a holding and watering pā'eke (corral) nestled alongside Pu'u Hanai, a gentle knoll just above the bay of Kawaihae. On the actual morning of shipment, the cattle had a short two-hour walk to the shoreside holding corral.

One of Carter's issues with Metropolitan Meat Company was price per pound of only 9 cents. Over the years, the pricing gradually improved to about 15 cents in the late 1920s. Also seeking better prices, Kahuā consigned their market cattle to the O'ahu Railway and Land Company (OR&L)—an outfit that entered the slaughtering business to service their own ranch needs as well as those of others. OR&L was paying 17 cents a pound and by 1933 received all of the Kahuā cattle, while Hawaii Meat Company was kept busy with Parker Ranch and other consignors' market animals.

In 1935, Kahuā Ranch formed a partnership with OR&L in the slaughterhouse business at the Honouliuli facility in 'Ewa, O'ahu. In 1939, a protégé of A. W. Carter, James M. (Jimmy) Greenwell, was transferred from Parker Ranch's Kohala operation at Pu'uhue to become the manager of Hawaii Meat Company. He was all of twenty-three years of age.

Ranch-raised in Kona, Greenwell brought field experience as well as good business sense to HMCo, making significant improvements in facilities, service, and marketing. A local boy with both ranch and business savvy, Greenwell fit well into the O'ahu meat scene. He knew that Kahuā Ranch's meat operation was a keen competitor, further underscoring Greenwell's drive to prove A. W. Carter's wisdom in selecting him to head the company. With both offices and the packing plant on Middle Street, Hawaii Meat Company had grown into a processing and marketing organization handling more than half of the territory's beef and mutton. With Parker Ranch holding a majority of the stock, it was structured as a cooperative.

By 1940, OR&L was getting out of the cattle business, selling the packinghouse to Kahuā Ranch and its Honouliuli Ranch to Parker Ranch, giving that outfit an O'ahu venue for breeding, growing, and finishing animals. This became a vital component as World War II broke out and interisland cattle transport became complicated when the military commandeered most vessels. Later, Honouliuli Ranch became the property of Richard Smart, apart from the meat company.

The acquisition of Honouliuli Ranch by Hawaii Meat Company was an exciting venture for Greenwell, who always yearned to be back in the saddle working livestock. He even brought two former Pu'uhue Ranch hands—Solomon Lincoln and Koichi Tomei—to set the ranch up the way he wanted it to be. Shortly thereafter, Awili Lanakila of the Parker Ranch Cowboy Gang became an employee of Honouliuli Ranch.

Honouliuli Ranch totaled 22,000 acres of leased Campbell Estate land and was made up of three sections: 'Ewa, Kahuku,

and Honouliuli proper. The Kahuku section was pastureland below the forest reserve but above the sugarcane fields, stretching from Paumalū to Mālaekahana. The 'Ewa section spanned below the Honouliuli Forest Reserve from Kunia to Nānākuli, bordering above the sugarcane and pineapple fields. It included several thousand acres of coastal plateaus that were enhanced by dense *kiawe* trees and stands of *mānienie* (Bermuda grass). The ranch headquarters abutted West Loch. Land improvements included aerial seeding with guinea grass and buffelgrass, followed by fertilization.

Kahuā in the meantime secured 40 acres of Campbell Estate land from 'Ewa Plantation Company across the road from the OR&L packinghouse they operated, virtually next door to Hawaii Meat Company's plant. The attractive lease, secured through the wisdom of Atherton Richards, was priced at $20 per acre per year. Shortly thereafter, Kahuā built a new plant at a cost of $15,000 that averaged more than a ten-head-per-day kill rate, considerably below the Hawaii Meat Company's sixty-head-per-day average at the Middle Street operation. Both packinghouses sold half carcasses (sides) to meat purveyors throughout O'ahu via trucks, which at first were open decked with canvas covers; enclosed, refrigerated vans became the vogue in the early 1960s. By this time, both HMCo and Kahuā Ranch were dependent on significant in-shipment of beef sides from the U.S. mainland, Australia, and New Zealand. Both chilled and frozen meat were received, the latter causing logistical problems. Such importation was necessary, as Hawai'i's beef industry at the time rarely supplied more than 40 percent of the meat consumed in the Islands. This figure dwindled to about 30 percent in the 1970s and 1980s. As we entered the new millennium, Hawai'i's share of meat consumption dwindled to 5 percent as calves were exported to Canada and the continental United States.

It was during this era that other notable figures in the Hawai'i beef industry arrived at Kahuā's meat company. One was Percy Sanborn, a local fellow with strong Parker Ranch roots via the Lindsey lineage (Emma Lindsey was his grandmother). Percy was a Kaua'i boy who went to work at Kahuā Ranch in North Kohala, eventually becoming assistant manager. Shortly thereafter he was transferred to the O'ahu facility to become manager of the meat-marketing component of Kahuā Ranch. In 1947, Peter Kama, a distinguished Native Hawaiian of bright and industrious character, joined Sanborn. Kama was also a skilled saddle maker in the true Hawaiian tradition. In 1951 a young Alexander Napier joined the Kahuā outfit. Coming also with strong roots in Parker Ranch history, Alex was the son of Alexander (Sandy) Napier, a lead herdsman for the purebred Hereford operation at Makahālau. Fresh out of college, H. M. (Monty) Richards Jr. joined the firm in 1953 as an office boy in the meat company. A nephew of Atherton Richards, Monty started his field experience truly from the ground up, eventually becoming prominent in leadership circles in a variety of capacities.

In 1952, a third meat purveyor entered the market. Pālama Meat Company was established by Donald Lau and developed the Hawaiian Warrior brand of beef. With appeal to the "Mom and Pop" corner grocers, Pālama Meat Company grew to a peak of supplying more than 3.6 million pounds of beef by the new millennium. Bankrupt by 2003, the firm outlasted both Hawaii Meat Company

and Kahuā Beef Sales, eventually owning the Pa'auilo kill plant on the Big Island—Hawai'i Beef Packers, Inc.

Jimmy Greenwell was diligent in retaining HMCo's fair share of the beef market needs. At this time, they were butchering 300 head of cattle per week. In the early 1950s beef prices were up to 40 cents per pound, but both beef brokers were feeling the effects of the increasing influx of imported beef that by 1954 reached a million pounds annually, often distributed by other meat purveyors. In the interim, Jimmy Greenwell's brother Rally had left Parker Ranch for Kahuā Ranch to become assistant manager under Ronald von Holt. Rally became the manager of Kahuā Ranch with the sudden tragic death of von Holt.

On the Kahuā Meat Company side, another major loss occurred in 1955 with the sudden passing of Percy Sanborn, who was known as a taskmaster. Rough and ready for any challenge, Sanborn had a "can-do" approach, solving problems rather than deferring them. Finding huge shoes to fill, Sanborn's replacement fortunately had significant tutelage: Alex Napier was up for the challenge. Napier elevated the business to a new and higher level, largely out of his enthusiasm, wisdom, political acumen, and congenial local-boy style. By this time, Kahuā acquired Waialua Ranch, which also was placed under Napier's management. Added to this task were the slaughtering, processing, and sales responsibilities, and he surrounded himself with capable individuals, including Peter Kama and Eddie Okasaki. Okasaki was well experienced, coming from a family operation in Wailupe, O'ahu. In Kohala, Morgan Brown had become assistant manager at Kahuā Ranch.

Jimmy Greenwell was equally multi-tasked, covering the packinghouse and sales operations while managing the Honouliuli Ranch. Although fiercely competitive, he and Napier were truly local boys, maintaining mutual respect while striving to garner their fair share of a consumer market that demanded tender, tasteful, and marbled beef. Kahuā in 1956 trademarked their top-quality meat as Kahuā Ono Beef shortly after Greenwell initiated marketing of the Hawaii Meat Company's branded, premium product as Maile Beef. Colorfully labeled, refrigerated vans scrambled about O'ahu filling the market needs.

In 1956 Rally returned to Parker Ranch to become assistant manager under Hartwell Carter. Morgan Brown had left Kahuā Ranch to become an independent rancher and horse breeder of note. Monty Richards became the manager at Kahuā Ranch.

In 1957, mainland meat merchant A. H. Hansen, already supplying the Honolulu markets, joined forces with Kahuā in a beef-fabricating (breaking down sides and quarters of beef to counter-ready products) plant in the old Tuna Packers warehouse near Fisherman's Wharf. This was a short-lived relationship. Within five years, Kahuā bought out Hansen and moved its processing equipment to United Meat Company, adjacent to Hawaii Meat Company on Middle Street. HMCo became a meat supplier for both the army and navy commissaries. Later, a bidding process allowed Kahuā access to the military beef market scene.

Over at Hawaii Meat Company, Greenwell had been breaking carcasses (processing bulk beef into retail portions) routinely while upgrading the original brick and mortar plant, which by then was thirty years old.

Maintenance costs were already high, but beef prices were up to 44 cents a pound and hides were valued at $8.00.

The mainland trend of pen-feeding cattle for superior finish was reaching the Islands, and Greenwell successfully launched the process in Hawai'i after a small-scale experimental project at Honouliuli. Hawai'i's first feedlot site was a 181-acre coral flat owned by Campbell Estate, which typically expressed no interest in selling the parcel to Hawaii Meat Company. But Greenwell had a plan. He was aware that HMCo, in the process of buying out the Metropolitan Meat Company, had acquired a fee simple property on King Street that Campbell's tenant, Liberty House, traversed with its delivery trucks. Realizing that Greenwell and Hawaii Meat Company had Campbell Estate literally "over a barrel," its directors agreed to an exchange: 181 acres in 'Ewa for 30,000 square feet on the corner of King and Bethel streets. Charles Koontz was brought in as feedlot manager in 'Ewa in 1958. Imported grains were supplemented with locally produced molasses mixed with alfalfa and green panic grass hay, and consignors of feeder cattle were welcomed, including the clientele of Kahuā. Haleakalā, Kaupō, and Parker Ranch were the first consignors. This revolutionized ranching in the Islands over the ensuing thirty years, as ranchers moved away from grass finishing of market cattle and adopted grain feeding, resulting in a much younger butcher animal and yielding the more tender and marbled product (fat interspersed among muscle) demanded by the modern consumer. Ranchers were relieved of pastures dedicated to the grass finishing of steers that might be three or four years old before butchering, as opposed to their two-and-a-half-year-old counterparts that entered the feedlot as 600-pound yearlings. While the Hawaiian feedlot industry faded out of the picture in the early 1990s, Greenwell's pioneering venture certainly added to the success and history of Island ranching.

Kahuā completely rebuilt its slaughtering plant in 1959 at the same location, with significant upgrades in processing and inspections. Costing about $100,000, the new facility aged well, relieving the need for any major renovations until the mid-1980s. The processing component of Kahuā moved into a new cutting room on United Meat Company property on Middle Street, adjacent to the Hawaii Meat Company. This was a short-lived venture. By 1961, the cutting room at Wigwam Store became the next home for a newly christened entity, Kahuā Meat Company, Ltd., a wholly owned subsidiary of Kahuā Ranch, Ltd.

Hawaii Meat Company remained unchanged in structure, owned 83 percent by Parker Ranch (Richard Smart) and the balance of 17 percent by 229 other neighbor island ranches that included Haleakalā, Moloka'i, and others. Jimmy Greenwell became aware that feeding cattle for a variety of neighbor island ranchers often left him the subject of complaints, but like his eventual successor, Leonard Bennett, such griping was shouldered as "coming with the territory."

There were rumblings however, among ranching circles, that Hawaii Meat Company was shutting down the packinghouse and feedlot and moving the entire operation to Kawaihae. This was a brainchild of Dick Penhallow. The Kawaihae plan was adamantly opposed by Greenwell, and in an August 18, 1961, letter to Richard Smart, he expressed concerns that such a decision would not be that of Parker Ranch alone since other major

livestock entities had a genuine stake as to where their cattle would be fed, butchered, processed, and marketed. In the same memo, Greenwell expressed concern that Kahuā Meat Company's marketing efforts were seriously encroaching upon HMCo territory as it was. A move to Kawaihae would cost Hawaii Meat Company a major portion of the Oʻahu beef market and a significant reduction in feeder cattle going into the ʻEwa feedlot, which had become a successful component. By this time, Kahuā Feed Company had been incorporated as a joint venture of Kahuā Ranch, Ltd., and Beckley Commercial Feed Company of Linden, California, with feeding pens at Waialua Ranch. In a 1961 memo to Hawaiian ranchers, Atherton Richards noted that with Kahuā Meat's four years and Beckley's ten years of experience in cattle feeding, a viable feeding operation was in place that had the logistics, knowledge, and resources to satisfy most ranchers' needs.

With the advent in 1960 of Penhallow as the new manager of the Parker Ranch, some significant marketing scenarios surfaced that confirmed the rumors that changes were on the horizon. These marketing proposals appeared sensible to some producers such as Parker Ranch, but to others the changes were seen as drastic.

The Hawaiian beef industry faced the stark realities of the 1960s era, which brought a constant risk of maritime labor strikes and a growing presence of foreign beef in the marketplace.

Penhallow's Marketing Plan

Penhallow was on the right track, perhaps even ahead of his time, when it came to marketing. He was comfortable with easing away from the grass fat to feedlot finishing of ranch market heifers and steers, although during his management time the ratio was about fifty-fifty between grass and grain. A grass-fat butcher animal is one that has been finished on pastoral forage, with no grain supplements. Cattle are usually at least three years old when finished on grass. On any ranch, a grass-fat program uses up the better pasture for a longer period, as opposed to shipping yearling calves to a feedlot for grain finishing, thereby making more range pastures available for mother cows. Finishing butcher cattle on grain normally takes four to six months because of the confined feeding of a high-energy carbohydrate diet, which makes marbled beef much faster than succulent saladlike grasses found in pastures. The rancher has a marketable animal at half the age and has freed up pasture for a larger cow herd.

At the feedlot/slaughterhouse on Oʻahu, Penhallow had to deal with Jimmy Greenwell of Hawaii Meat Company; it was a contentious relationship. The fact that Penhallow was president of the meat company's board of directors was not a comfort to Greenwell. It did not help that both men were alike in their determined positions, which were often intractable. Jimmy Greenwell had tremendous admiration for A. W. Carter, whom he saw as the great leader responsible for the ranch and the meat company attaining their deserved place in Hawaiʻi's history and in the eyes of the national cattle industry. But A. W. had passed on a dozen years earlier, and the ranch owner had emerged as a dominant force. Richard Smart was poised between these two strong-willed men—a strong-minded man himself, who retained his checks and balances between entities.

In reviewing correspondence between

the two parties, I am reminded of the rancorous dialogue and correspondence between Leonard Bennett of Hawaii Meat Company and Bob Johnson of Hawaiian Milling at the Barber's Point feedlot and that of several Parker Ranch managers, including Rally Greenwell, Gordon Lent, Walter Slater, Don Hanson, Charlie Kimura, and Robbie Hind. The ranch seemed to do nothing right, and complaints were never ending. It was evident that wrangling was to be the norm.

Central to Penhallow's marketing strategy was to convert Hawaii Meat Company and the attendant feedlot to a pure cooperative, in which the members would share proportionately the cost of operation as well as the receipt of profits. Clearly, Penhallow was concerned that it was always Richard Smart—dba Parker Ranch—that had to capitalize the construction of the marketing facilities, as well as any major overhaul and repairs. In seeking to alleviate the ranch owner of such personal outlay, the co-op approach seemed quite logical, and the transferring of the butcher plant and feedlot was in fact only a proposed component of the overall plan. Penhallow had early engendered the full support of Richard Smart. Smart's support was tragically withdrawn very late in the process, leaving the ranch manager in a most awkward position.

Penhallow was an exacting person simply because of his regimental nature, but it appeared that as far as Jimmy Greenwell was concerned, cattle shipments could never be done right. Usually it was a matter of numbers, weights, and timing, and if Dick Penhallow couldn't do it, it's unlikely that anyone else could have. Jimmy Greenwell worked under severe pressure and the demands of a fickle beef market against inadequate carcass numbers, weights, grades, and yields. Kahuā Meat Company provided formidable competition. He was also committed to serve other market cattle suppliers on the neighbor islands as well as O'ahu, and he protected their positions and resources while trying to serve the largest stockholder—Richard Smart and Parker Ranch.

On October 7, 1959, Penhallow fired a volley in a memo to Jimmy Greenwell; it mandated reduced cow shipments because Penhallow wanted to build up his herd. Furthermore, Penhallow questioned the desirability of the Hawaii Meat Company staying in the ranching business. This latter issue struck home, for Jimmy's pet project was Honouliuli Ranch. Under A. W. in 1928, these 22,000 acres were acquired from the previous lessees, Henry von Holt and later O'ahu Railway and Land Company. Shortly thereafter, Jimmy Greenwell was sent from his foremanship position at the Kohala sections of Parker Ranch to manage the Hawaii Meat Company. During World War II, Honouliuli Ranch was important as a depot for butcher cattle when interisland shipping was erratic, but in the first decade after the war there was reasonable doubt as to the ranch's necessity. Also, there were suggestions that HMCo was competing with the ranchers' supply of cattle for the marketplace. Nevertheless, Honouliuli was dear to Greenwell's heart, and Penhallow's suggestion to part with it was not well received, to say the least. Eventually, the Honouliuli Ranch ownership was transferred directly and personally to Richard Smart and later sold to Rudy Tongg, a Honoka'a native who had moved to Honolulu and developed a prominent role in publishing and real estate. He purchased the ranch, less the marketable cattle, on October 1, 1962, for $300,000.

Penhallow's second memo, on January 18, 1960, apprised Greenwell of two upcoming studies concerned with developing a statewide cooperative approach to centralize the packinghouse industry. Penhallow described a meeting he had with Herbert Shipman of Hilo Meat Company, Atherton Richards of Kahuā Meat Company, Manduke Baldwin of Haleakalā Ranch, and Francis (Franny) Morgan of Kualoa Ranch. Penhallow wrote: "Such a cooperative would replace and absorb the sales departments of all contributing entities (Hilo Meat, Kahuā Meat and HMCo) utilizing most if not all of the present personnel. ... It is hard to find fault with the premise and faults in the details can be avoided by careful organization." This put Greenwell on the defensive. Meanwhile, Penhallow received the first comprehensive marketing feasibility study from Richard Keigley, a well-qualified CPA with Haskins and Sells.

The Hawai'i Meat Producer's Cooperative

By mid-July 1962, the articles of incorporation of the Hawaii Meat Producer's Cooperative were filed in Honolulu, offering a program for all meat producers in the state.

The original subscribers to the organization were Francis Morgan, vice president of Theo H. Davies (Kūka'iau Ranch); Sherwood R. H. Greenwell, vice president of Kealakekua Ranch; David (Dai) Frazier of Dillingham Investment (Pu'uwa'awa'a Ranch), and Richard Smart, owner of Parker Ranch. President of the new cooperative was Francis (Franny) Morgan. Sherwood Greenwell served as vice president and Dai Frazier was elected secretary/treasurer.

Other Big Island ranchers that were party to the new co-op included W. H. Greenwell, Palani Ranch, and Hawaiian Ranch, rounding out 70 percent ownership of all Island cattle.

The co-op was incorporated with a capital of a million dollars and the number of shares issued was fifty, which could be expanded upon if required. Participation was limited to one share per producer, and each of them carried only one vote—Parker Ranch included. Nonshareholding producers were invited to participate as well. In a July 15, 1962, article Penhallow stated that there would be "no distribution between cattle of shareholders and other producer contractors." While stating that the new holding company (co-op) would give all shareholders an equal voice in decisions and policy, he went on to affirm that "this change should result in a gradual evaluation of improved service and economy in marketing Island beef."

In a May 27, 1962, *Star Bulletin* article, Penhallow noted two advantages of the co-op approach. First, it offered a tax advantage not available under the old integrated system. The second advantage, one that had great initial appeal to Richard Smart, was that the co-op approach would spread the cost of finishing and slaughtering of cattle proportionately among participating meat producers rather than the principal number of Hawaii Meat Company stockholders.

By this point in time, Hawaii Meat Company had twenty-nine stockholders, serving about 130 producers—the larger of which in some cases were not stockholders. Penhallow hoped to attract HMCo's largest competitor, Kahuā Ranch, Ltd., as well as other independent ranchers throughout the state.

As for facilities, there was a plan. Once underway, the co-op would then operate the facilities and pay expenses out of a withhold-

ing assessment levied proportionately among the participating producers.

Penhallow had included Janss Investment Corporation, which came with feedlot as well as land development expertise. Janss early on agreed to form an organization to operate the custom feeding operation at 'Ewa, hoping to lease or purchase the facility. This aspect further appealed to Penhallow and Smart as it would get the ranch owner out of owning and maintaining a feedlot operation. Janss' management responsibilities would be extended to include the Hawaii Meat Company slaughterhouse on Middle Street, a facility that was also considered to be on the sale block.

In the minds of many people in the ranching business at the time, a sense of bewilderment was present due to conflicting proposals coming from Richard Penhallow and Parker Ranch. While advocating for a cooperative takeover of the O'ahu packinghouse and feedlot facilities, Penhallow was proposing that duplicate operations be built on the Big Island. More feasibility studies were forthcoming.

The second study launched by Penhallow left Jimmy Greenwell threatened. It was "A Study of a Beef Slaughtering Facility in West Hawai'i," conducted by Law and Wilson, Ltd., a firm with extensive experience in the slaughtering and processing business. Keigley's study had been limited to marketing. Both studies came at a time when Greenwell was approaching the meat company's board of directors, requesting a change in the bylaws to elevate him to a new position of senior vice president. The studies placed the feedlot in a tenuous position because it would meld HMCo with two other packinghouses into a cooperative, but it would also close the slaughterhouse on Middle Street on O'ahu and reopen it at Kawaihae on the Big Island. The Law and Wilson report began as follows:

> The objective of this report on a beef slaughterhouse operation at Kawaihae, Hawaii is to indicate, in a preliminary way, what such an operation might entail in the way of costs, capital investment, etc. The final design of the plant as well as more finalized costs of equipment and operation can better be determined when the type of operation desired and needed is finally decided upon. The plant would have to be designed and engineered in detail to suit a particular location.
>
> It has been assumed that the slaughterhouse operation, as indicated by Mr. Richard Penhallow, would have a volume of 15,000 head per year. In addition, it was assumed that the plant could expand to a slaughter of some 19,000 head per year.
>
> Since the contemplated plant is expected to sell beef to the Armed Services, it was presumed that the plant would have to meet the specifications of a U.S. Inspected Meat Packing plant.

Penhallow, in proceeding with the studies, had the early backing of Richard Smart. In addition, tentative support came from the armed forces as a major market. This summary describes the thrust of the study:

1. A two-level structure is envisioned for the contemplated slaughterhouse facility at West Hawai'i, the first level to be as close to sea level as is permissible in order to have as much of a basement type structure as the site will allow. This type of arrange-

ment will permit a more efficient production arrangement than a one-story operation. Some five acres of land have been set aside by consultants to the Department of Transportation for a livestock processing facility at Kawaihae. The location appears well suited for a slaughterhouse operation of the type contemplated, being close to the pier and facilitating the movement of containerized beef carcasses.

2. Much of the equipment at the Middle Street slaughterhouse plant of Hawaii Meat Co. can be utilized in the contemplated West Hawaii slaughtering facility. The most expensive new equipment needed will be refrigeration equipment for chilling, holding and offal rooms. A maximum three to four-week shutdown was allowed in determining what equipment might be utilized from the Middle Street plant.

3. Investment necessary for the plant structure including site preparation, loading docks, electrical work, plumbing and ventilation, exterior utilities including sewage treatment plant, roads, paving and drainage and a holding pen with a capacity of 200 head is estimated at some $282,000.

4. Direct labor requirements are estimated at 29 men with an annual cost of $124,654.40. Minimum indirect labor includes a manager, bookkeeper and clerk at an estimated annual salary cost of $23,600. Total annual wages and salaries excluding fringe benefits are estimated at $148,254.40. Total annual operating costs (excluding taxes, insurance, interest, auditing and legal expenses) for the contemplated operation are estimated at $217,536.40.

5. There is little demand for tallow and grease in Hilo and Honolulu. One of the biggest markets for U.S. meat processing plants is in Japan. Initial inquiries with Japanese firms indicated an interest in purchasing tallow and grease from Hawaii.

6. The proposed feed yard at Puako can be equipped to handle 4,000 head with the feed yard equipment at the Holualoa Ranch, Captain Cook, together with certain equipment from the feed yard equipment of Hawaii Meat Co. at Ewa. The feed mill equipment at Captain Cook is leased, and permission must be obtained from the lessor to move the equipment and transfer the lease to Parker Ranch.

Jimmy Greenwell saw little or no merit in either approach. While it is true that he was acting at least in part out of self-preservation, there were some common sense questions that needed to be answered. For example, considering that Greenwell opened the first Hawaii Meat Company feedlot on 181 acres of Campbell Estate land, a convenient location, why move it to a neighbor island? Additionally, it would require neighbor island ranchers to double-ship their cattle, first to O'ahu, then to the Big Island at Kawaihae. Some questioned if this were a subtle plan to take care only of Parker Ranch needs. Adding to this intrigue were rumors of a grain facility and a feedlot being planned for the Kawaihae area. Greenwell summarized his feelings in his autobiography, *One to Eighty-One*:

> For some months Penhallow, by now Manager of Parker Ranch (majority stockholder of Hawaii Meat Co.), had been secretly eying a plan which involved the entire liquidation of Hawaii Meat Company's Oahu facility—packing house, feed yard and all—and moving the operation to somewhere in the vicin-

ity of Kawaihae. To me, he seemed not to care at all about the ranchers served by the company on the other islands. Parker Ranch was to come first! Oahu, Niihau, Kauai, Molokai, Maui and others could fend for themselves.

Since this was a policy I could not condone, the relationship between Penhallow and myself became strained to the point where we were communicating in writing rather than speaking. In truth, he was the most autocratic man I ever had to deal with.

Penhallow, who wrote frankly and frequently to Greenwell, laid out his views:

> I read with interest your views on my ideas for an alternate marketing system.
>
> While I appreciate your blowing off steam to me, I would not advise you to circulate the report. It could be misunderstood as conflict between management and the owners, having the flavor of absence of respect and loyalty. I know you do not mean it that way.
>
> You will recall that in discussing my inquiries into alternatives, I told some of the stockholders informally that before any plan is presented it will be discussed fully with the manager. I would consider it one of my problems to convince him.
>
> When the time comes we will have to analyze comparisons, feature by feature. If I cannot satisfy myself that scheme will stand comparison, I will not advance it. No point can be achieved now by tilting with hypotheticals.
>
> In the mean time it is not only right but also my duty to investigate other avenues to marketing our beef. One of my principal concerns is providing an ample opportunity for all to cooperate and prevent a falling apart. That is threatening in spite of your feeling that "there is general if not unanimous agreement that the Company has done a good job."

Meanwhile, Penhallow had conversations about market animals with the C. Brewer ranches (Ka'alu'alu, Kapāpala, and Keauhou, which eventually merged into Hawaiian Ranch Company). In this regard, Penhallow was acting in a dual capacity: that of Parker Ranch manager and president of the HMCo board. Greenwell viewed Penhallow's activities as undermining his role as manager of HMCo and went to work with other neighbor island ranchers and stockholders to resist Penhallow's initiatives. Greenwell had supporting and sympathetic members on the Hawaii Meat Company board, including Oskie Rice of Ka'ono'ulu Ranch, Manduke Baldwin of Haleakalā Ranch, and Harry Cooke.

Rumors continued to fly. Finally Harry Cooke, then president of Moloka'i Ranch, Inc., and a director of HMCo, expressed concern in a memo to Penhallow on December 26, 1961:

> Dear Dick:
>
> As a director of Hawaii Meat Company, Ltd., I am very much concerned about the manner in which the policies of the Company, or lack of them, are being determined, and particularly with the lack of information being furnished to the Board of Directors.
>
> You will recall that in the latter part of 1960, you informed the directors (in an informal manner which, at your request,

was not recorded in the minutes) that a study was being undertaken to determine the policies of the Company with respect to location of slaughterhouse facilities, distribution of its products, and marketing in general. A part of this study was to relate to the operation of the Hawaii Meat Company feed lot and ranch on Oahu.

Although this announcement was made over a year ago, the directors have been furnished no information on the results of these studies, either by way of an interim report or a final report.

Many disturbing rumors have been current during the past several months concerning the plans of Hawaii Meat Company giving up its Honolulu slaughter house and re-locating it at the Kawaihae area in Hawaii, of shipping carcass beef from the slaughter house to the Honolulu market, of abandoning the feed lot and ranch on Oahu.

Cooke's letter came shortly after an August meeting of beef industry leaders. On August 16, a Cattlemen's Association meeting was held in Waimea. Jimmy Greenwell used his clout as a member of the board of Hawaiian Airlines to charter a DC-3 for Maui, Moloka'i, and O'ahu ranchers to commute to the Big Island for the meeting.

After a brief excursion to a Ke'āmuku branding, the group of about fifty ranchers met at Pu'u'ōpelu, Smart's home, for luncheon. Smart gave a brief welcome, then introduced Penhallow, who gave an overview of the preliminary findings of the studies nearing completion and offered to share the final recommendations. It was obviously his attempt to quell rumors and quiet the discomfort. Jimmy Greenwell, however, felt the cooperative and the Kawaihae plant were foregone conclusions.

Other factors gave the Kawaihae location some support. A mainland grain dealer, W. E. Payton, began building grain elevators at the Kawaihae pier and a small feedlot on Parker

Hawaiian Airlines arriving at Waimea Airport with Dick Devine of Hilo Meat Company followed by James Armitage. PPS.

Ranch land in Puakō. Penhallow described these activities in a November 26, 1961, memo to Greenwell:

Dear Jimmie:

An advertisement for tenders to reserve under lease premises for the construction of a grain storage facility at Kawaihae was published. I read it in the paper a couple of weeks ago. No doubt this is at the request of Mr. W.E. Payton who plans to ship to Oahu bulk grain at reasonable prices.

Mr. Payton will stop at Kawaihae each trip and skim off enough of the load to fill the local storage.

Regarding the agreement between Parker Ranch and Mr. Payton, it is as yet only a letter of intent. He will build a feed yard on land belonging to Parker Ranch and we will pledge him a number of cattle in weekly deliveries to conduct his trial feedings. He will buy the cattle outright.

Regarding any decisions affecting the future slaughtering plans of Parker Ranch, you know what I am doing. All studies indicate that a change to local slaughtering will benefit Parker Ranch.

However, no decision has been made. Two important matters to be resolved before such a decision can be considered are the marketing structure in Honolulu and the return of stockholders' equities if Hawaii Meat Company should disappear. I am working on both of these matters now.

I hope this will answer your questions.

At the 1962 annual meeting of the HMCo stockholders on Oʻahu, Penhallow unveiled his plan to move HMCo to Kawaihae and convert the company to a cooperative. By this juncture, Richard Smart had replaced certain HMCo board members that were positioned contrary to the new marketing plan. The new board was stacked in favor of the cooperative proposal. Greenwell made an impassioned plea to maintain the status quo, but his earlier suspicions were realized. By 2 p.m. that day, Smart and Penhallow went by the HMCo office to accept Greenwell's immediate resignation. Named interim manger of HMCo was Norman Brand, longtime office manager of Parker Ranch.

The Payton Plans

Payton in the meantime forged ahead with plans for a food pantry at Kawaihae serving the State of Hawaiʻi, ready to feed man and animals in the event of an emergency. His bold statements drew attention, mostly from skeptics. In Dick Penhallow, however, he found an avid supporter who could help more than anyone to make the dream a reality. Payton at this point had already secured a lease on Puakō acreage for a small feedlot.

Payton used Washington consultant Frank R. MacGregor, who came with eminent credentials, one of which was serving as a former vice president of the Commodity Credit Corporation. The plan was for construction of mammoth storage bins—actually grain elevators like those common to the Midwestern countryside along rail service routes. By availing these granaries to the federal government, Payton envisioned storage of rice and wheat in the event of famine in the

Pacific Rim and Orient as a whole. Ironically, Leonard Bennett in the next decade capitalized on attractive grain prices preceding such a famine in the Orient. The deep-draft harbor of Kawaihae offered clear advantages with its proximity to the livestock industry as well as O'ahu's burgeoning population. Feedstuff for livestock, including the proposed new Puakō feedlot, could be stored in volumes that could likely outlast a shipping strike.

Budgeting more than $250,000 to build the feedlot and storage facilities, Payton projected a 30 percent increase in beef production on the Big Island. Besides the Puakō lease, he secured dockside land from the State Department of Transportation at Kawaihae Harbor for the twin storage tanks, each 63 x 80 feet, providing a 4,000-ton grain capacity. Three more storage units (elevators) were added later.

The feedlot at Puakō was to be built by Allied Construction Company of Bristow, Oklahoma, a firm 90 percent owned by Payton. The pens were built with prefabricated steel panels and secured with steel gates. Watering and feeding devices were automatic, but oversight of the feedlot was under Omar Hurst. In a February 18, 1962, *Tribune-Herald* article, Payton stated: "Forty years of practical experience is banked in Hurst. His father and grandfather were successful 'finishing men'."

In March 1962, the first twenty steers entered the Puakō feedlot, weighing in at an average of 800 pounds live weight. Heifers followed shortly thereafter, scaling an average of 700 pounds. Payton planned a 100-day feeding period with 3 to 3.5 pounds per day weight gains, bringing the steers up to 1,100 pounds and finished for slaughter.

In the process of constructing the steel

Payton elevators at Kawaihae Harbor, August 9, 1962. PPS.

storage bins, Payton took on a partner, Richard Lee Stanton, manager of the Rockport Grain Company in Rockport, Missouri. By completion, Payton had laid out $300,000 for the project.

Struggling to get a foothold in the cattle feeding industry, Payton's feedlot program was shipping seventy-five head of finished Parker Ranch steers to Hawaii Meat Company's slaughter plant in Honolulu by the end of its first year. Parallel to these shipments were direct loads of grass-fat steers to the same kill plant. There was no reporting of yield returns comparing the grass-finished, Payton Feedlot, or HMCo's 'Ewa feedlot butcher cattle. Later, Kūka'iau Ranch manager Penhallow developed significant performance data on feeders finished at the refurbished Puakō feedlot under Theo H. Davies' leadership.

Despite the commonsense cooperative approach of the granary and start-up feedlot,

Unloading grain at Kawaihae Harbor: Alcoa Planter *unloading the first 1,200 tons of grain for the Payton program. PPS.*

a myriad of problems kept the project from gaining the momentum and support to succeed. Somehow, someone got to Richard Smart, who quietly withdrew his support of Penhallow's marketing plan. The skeptics, Greenwell included, rested on their laurels, but the Payton people were optimistic.

The partnership between Robert L. Stanton and W. Edward Payton that was established in 1962 was formally incorporated two years later as Kawaihae Elevator, Inc., with Theo H. Davies and Company, Ltd., combining forces to expand cattle feeding and marketing services throughout the Big Island.

The officers of the company were Harold Weidig, president; Francis S. (Franny) Morgan, W. Edward Payton, and Robert L. Stanton, vice presidents; and Charles H. Holt, secretary. Weidig was president of both Theo H. Davies and Kawaihae Elevator. Morgan and

Holt were also Davies executives, while Payton and Stanton continued their oversight of day-to-day operations of Kawaihae Elevators.

Payton and Stanton had historic relationships with the grain industry in the mainland Midwestern heartlands. Stanton hailed from Atchison County, Missouri, which was then one of the largest corn-producing counties in the nation. Ironically, Stanton Grain Company, established in 1946, was in direct competition with Payton's neighboring grain company, while their Hawai'i operation appeared to be a complementary joint venture. At that point in time, the Big Island had 70 percent of the state's cattle, many of which were owned by smaller ranchers who had no established marketing avenue. While Parker Ranch offered its alliance with its marketing arm, the Hawaii Meat Company, the Theo H. Davies connection brought in all of Kūka'iau Ranch feeders, which came with a history of good feed conversion.

Bulk loads of corn seed from Missouri were shipped down the Mississippi River, through the Gulf of Mexico and the Panama Canal, and were received directly into five large elevators in Kawaihae Harbor that had a combined capacity of 12,000 tons of feed.

The 30-acre Puakō Feedlot was built with twenty-two pens that received feeders ranging from eighteen to twenty-two months old and between 550 and 700 pounds in weight. While some ranchers chose to custom feed their cattle for direct sale on O'ahu, Kawaihae Elevator actively bought feeders for direct ownership, finishing, and marketing. Marketing outlets were all on O'ahu, requiring weekly shipments of live fat cattle for the HMCo or Kahuā Meat Company packinghouses for butchering and processing. GEM Stores and Big Way Supermarkets sold the beef under the Kawaihae Certified Corn Fed label, Kawaihae Elevator's private trademark.

It could be argued that Penhallow's handling of the meatpacking situation was not the best. In any case, the slaughter plant remained in operation on Middle Street until it closed on December 31, 1990. The grain elevators were never productive, and the Puakō feedlot folded as HMCo moved its feedlot from 'Ewa to the Campbell Industrial Park at Barber's Point in the mid-1960s. This facility closed in 1993 and the property reverted back to Campbell Estate.

Early on, as already noted, Penhallow enjoyed the support of Richard Smart, but it seems that the unsatisfactory conclusion of these initiatives and the rancor surrounding them took a toll on that relationship. Richard Smart during those times also became increasingly aware that relocating the feeding and meat packing industry entirely to the Big Island was self-serving as far as the ranch was concerned. He was very conscientious in recalling that HMCo and the feedlot were built to serve the entire territory, and his sensitivity to the needs of O'ahu, Maui, Moloka'i, Lāna'i, Ni'ihau, and Kaua'i ranchers was real. A. W. Carter's early mentorship still had an impact on the ranch owner. Certainly these factors also took a toll on Jimmy Greenwell's career.

Ironically, the Penhallow cooperative plan for relocating the feeding, slaughtering, and processing to Kawaihae in the final analysis might have been the solution to avoiding the severe marketing crisis facing the Hawaiian cattle industry in the new millennium. Richard Smart's last-minute withdrawal of support for Penhallow's cooperative proposal,

Richard Smart portrait taken in 1970. PPS.

one that ironically was designed to protect the ranch owner's interest, left Penhallow in an untenable state. In the end, after a two-year pitched battle, the only changes were in the careers of the two powerful men, Greenwell and Penhallow, who tendered their resignations by 1962.

There was a basis for a smooth managerial transition following the departure of Jimmy Greenwell in Don Devine, Hawaii Meat Company head bookkeeper who was functioning as assistant manager. Don's brother Richard (Dick) Devine managed Hilo Meat Company over a period of nearly thirty-five years.

Other factors affected the Smart-Penhallow relationship. Property development was one of them.

Land Development

Parker Ranch's approach to land development had several components. First, it would create available leasehold properties for commercial development: hotels, motels, banks, retail stores, and offices; on the agricultural side, it would make leasehold parcels available for the Puakō Feedlot and lease the ranch dairy facility to an interested party. Penhallow's supermarket plans were certainly visionary given his overtures to O'ahu-based grocery chains such as Foodland.

One of Penhallow's several commercial property thrusts included a serious overture regarding Foodland Supermarket, Ltd. This effort culminated in a joint announcement in May 1962 by Maurice J. Sullivan, Foodland president, and ranch owner Richard Smart.

In keeping with Smart's monarchy motif, architects Kenneth F. Brown and Ernest Hara designed a single-story structure of steel and cement served by a parking lot accommodating 150 vehicles. It was to be Foodland's first neighbor island venture.

There were two natural ties binding the proposal. At the time, Sullivan's O'ahu market chain of twelve locations was the major purveyor of Parker Ranch beef from Hawaii Meat Company; secondly, the Waimea supermarket had an active interest in marketing Waimea produce, given Kamuela's reputation as the state's veritable breadbasket of fine vegetables.

Building costs were estimated at

Proposed Hāpuna Beach subdivision. Imagine what Kawaihae/Puakō would look like today.

$250,000, with a matching outlay for stocking the shelves; it was to be operated by thirty-five employees and management from the Waimea area.

Although Sullivan's venture never came to fruition during this period, Foodland's anchor position in 2002 in the Parker Ranch Center reminded *kama'āina* of the early vision of Richard Penhallow and Richard Smart.

Another vision encouraged development of a ranch community that would do business with the improvements. Finally, Penhallow discontinued any ranch operation that was not productive. The ranch dairy of Mānā Road was among the units closed. Richard Smart played an active role in these efforts. He was a leading player in the hotel development aspect, especially in Laurence Rockefeller's precedent-setting and highly successful Mauna Kea Beach Hotel. Dick Penhallow initiated much of the groundwork for these projects. One project that never got beyond the drafting stage was an intensive subdivision of ranch lands between Hapuna Bay and Wailea Bay.

Penhallow's Plans: Two Years Later

Responding to numerous inquiries, local and otherwise, Penhallow, although near the twi-

light of his management career, opted to review fully his leadership philosophy with the employees of the ranch and the local community. In the seventh issue of the June 1962 *Paka Paniolo*, Penhallow issued a thoughtful review of his two-year tenure as manager in an article entitled, "How Are We Doing?"

Two years have passed since the change in Parker Ranch management. New things have transpired. It is reasonable that Parker Ranch people may wonder why and what have been the results.

First, why? The answer, major costs of running and maintaining a property like Parker Ranch do not decrease. Taxes, rentals, purchases, wages and fringe benefits, marketing costs, move only one way —up. Therefore, more income must be sought to cover the costs, and justify the maintaining of the investment by earning some net interest on it.

Obviously, larger use of the property is the only solution.

Before considering results let's look for a minute at what opportunities for larger use are available. Here they are:

1. Offering recreational, resort and residential land for development.
2. Leasing facilities for business development.
3. Developing services, which a ranch can supply to 1 or 2.
4. Producing more beef.
5. Increasing the efficiency of factors serving 4.

Now what has been done and how are we doing? Obviously, any report of this nature can only be preliminary. This can only be a progress report subject to later reviews when things are farther along.

Initial phases of opportunity number one are underway. The plans for Waimea properties and Mr. Laurence Rockefeller have been facilitated by Mr. Smart's foresight. Likewise, different and expanding plans for others are in advanced states of preparation. The exploitation of the recreational aspects of this opportunity will follow later but do require simultaneous planning. They involve horseback sports, outings and hunting in addition to the obvious provision for golf which developers themselves are making.

Opportunity number 2 is progressing. You can already see evidence of this in the expansion of the dairy; the meat market; the service station; the bank and post office; the feed yard; the grain storage. Many other ventures are just around the corner, already on the planning board.

The thoughts that make Opportunity Number 3 a consideration are these: In preparing for hunting privileges and their exercise, control needs to be consigned. Artificial lakes, game raising, dog training, are in the cards with some beginnings already noticeable. Horses and horse training are being re-emphasized, not only to provide for the need, but also to establish again our valued reputation for horses and horsemanship. More of this will continually develop.

Producing more beef is the unavoidable Opportunity Number 4. The nucleus around which all the other opportunity satellites will revolve around Parker Ranch. Though beaches and game, horses and business sites are in many other places, there is only one famous

Parker Ranch with its history, traditions and people. Without its success all else becomes harder to accomplish.

Achieving greater production must be with one eye on the market. Can we sell many more beeves in the way, which developed the Hawaiian Cattle business? The answer is "no". The additional business seems to be (1) in providing a dependable supply of graded carcasses, and (2) in competing price-wise with the imports which now supply the other end of the quality change, for boning, dicing and grinding. We can hold the "in between" market for grass finished steers, heifers and cows with difficulty, and perhaps only temporarily.

More graded carcasses means more calf production. To produce each additional calf yearly, not less than one additional cow is needed. Additional cows can be bought or they can be withheld from marketing, and bred. The first alternative requires money, the second causes a rancher to receive less money.

Parker Ranch has always marketed its less desirable heifers for beef as two-year-olds. These have numbered one half of the total heifer calf production year after year. In order to produce more calves quickly without either buying more cows or withholding market females, the following course had been adopted.

The less desirable one half of the yearling heifers were planned to be bred in the fall. This decision did not affect the numbers, which would be available for market because yearlings are never marketed. To minimize the calving loss hazard from young age breeding, and to offset with cross-breeding vigor the lowering of calf quality, which would normally be expected from breeding lower quality females, it was decided to cross these yearlings with Angus bulls.

The black-white face calves you have seen are the results. By color they are permanently identified as unsuitable breeding herd replacements, and by cross-breeding influence they are uniform, thrifty and vigorous.

How are we doing? By pure Hereford fall breeding of a herd of far-advanced top selected heifers (in addition to the above), and by increasing the cross-breeding herd through holding for second and third calves the top part of that herd, we aim to produce over 12,000 calves per year. Compare this with a normal previous calf crop of 8,000 calves per year. In the transition year of 1961: 11,019 calves were branded. In 1962: we expect the same with further increases in 1963 and 1964. When this production is coupled with calf purchases, our sales plateau each year becomes 12,000 carcasses instead of 9,000. The increase is one-third.

Kohala has been chosen for cross-breeding in order to confine the mixing of breeds to that area. Humuula continues to be the growing ground for young heifers because there is less opportunity for "catch calves" in that comparative isolation. The Puukapu, Paauhau, Keamuku and Pookanaka paddocks with Kawaihae-Uka are reserved for growing weanlings, because they're the autumn and spring weaners and have greatest assurance of feed regardless of drought.

Not to admit Opportunity Number 5, the increased efficiency from spreading the overhead over higher numbers of

sale animals is obvious. Pen feeding will make this possible. Further opportunity to assure sales is available through offering under-finished cows to compete with imports of lean beef. This practice will release cull cow fattening pastures for use by more young stock.

Experimental routines for increasing efficiency are not being neglected. Mineral and feed supplementation on pastures is under observation and study. Breed improvement by the selection of sire material from performance tests is standard practice now in both cattle and sheep herds.

The well at Puako has been enlarged. More irrigated fields are being laid out scientifically to use the water in the most efficient way.

Studies of cost reveal that it will pay to slaughter cattle here, rather than in Honolulu. This can be done only after re-modeling transportation and sales to accommodate change.

Even the horse training methods, safety programming, medical insurance, and sick leaves are the results of thinking about Opportunity Number 5. They didn't "just happen."

And if you wonder about publicity, if you marvel at the bright and tasteful redecoration of ranch buildings and homes, remember too that these touches serve both the development and the efficiency of the venture. They are designed to attract comment and interest. They are attempts to surround you with glamour and proud tradition and to brighten the outlook.

This presentation is a bit long. The important thing to remember is that all schemes for betterment are inter-related to shape a pattern for our own individual, personal, economic improvement. Each of us must keep informed about all phases. Only thus can we kokua and avoid obstructing any one phase unwittingly.

The year 1963 will be the first to reflect increased cattle output. New jobs for our ohana and our youngsters have already begun to appear; new projects soon to be started promise to add more. Waimea will be the fastest expanding part of Hawaii Nei. It will remain a good place to live. Heads up, be proud. How are we doing? Just fine!

Penhallow's Visionary Legacy

The Big Island, and especially Waimea, owes a debt of gratitude to a true visionary who—unlike the great builder A. W. Carter—had his bright and aggressive management career prematurely shortened. Briefly, we have the following gifts for which we can thank that crusty gentleman, Dick Penhallow:

1. He implemented comprehensive flood control improvements, with federal funding.
2. He implemented federally funded, comprehensive water resource development.
3. He was instrumental in the development and success of two fine educational institutions: Hawai'i Preparatory Academy and Parker School.
4. He was instrumental in recreational and resort development of the "Gold Coast," in concert with Richard Smart and Laurence Rockefeller.
5. He elevated livestock production to newer

and higher levels as an industry goal and successfully increased the ranch cow herd from 12,000 to 14,000 mother cows.
6. He brought the role of the Thoroughbred racehorse back to a point of pride.
7. He envisioned the advent of Foodland Supermarket to Waimea, although it happened forty years later.
8. He demonstrated vision and wisdom in proposing the cooperative marketing master plan, and—despite its failure to mature for moving the packinghouse, granary, and feedlot to the Big Island—in a four-decade retrospective analysis, it was nothing short of heroic. The potential of this contribution was evident when the Big Island beef industry entered 2005 with the major slaughtering facility (Pa'auilo) in near collapse.

Penhallow's Departure

Given the stormy relationship that developed between Richard Smart and Dick Penhallow, coupled with the furor over HMCo and property development issues, it is likely that the two men had a meeting of the minds to determine that Penhallow would step down. While happenings behind closed doors can only be surmised, Penhallow's departure remains the subject of much conjecture. The Richard Smart I knew had no hesitation in firing anybody he felt should go. On the other hand, the Dick Penhallow I knew was an honorable man, not likely to want to stay in a position where his views were not accepted. He was somewhat frustrated by the failure to execute many of his initiatives. With Smart's blessing, Penhallow went on to other opportunities—notably management of Kūka'iau Ranch and a highly successful real estate and sales business that received a large share of ranch property listings and contracts.

Penhallow could be gruff; Jimmy Greenwell described him as "autocratic," a term that others might have used on more than one occasion to describe Jimmy as well. Penhallow, however, had a basis for positions he took that was usually grounded in facts. My dealings with him were in the areas of property and private schools. The founding of Parker School brought us into closer contact. While Penhallow and I both were fervent supporters of Hawai'i Preparatory Academy, we saw the need for an alternative private school in the community, and he became chairman of the Parker School board on which I served. In the first two years, the relationship among parents, faculty, students, and administration was discordant. Parent/Teacher/Student Association (PTSA) meetings were often unruly and nearly unmanageable. The administration tried vainly to stop the spreading disharmony.

Penhallow decided he'd had enough. To the board of directors he presented a regimented course of action to be imposed at PTSA meetings, a plan that had no room for disorderly conduct. Every single director backed the plan, but none agreed to accompany Penhallow to a meeting scheduled that evening. Concerned about his solo presentation to the Parker Association, I telephoned him that afternoon and offered to accompany him; he was very appreciative. We met at the old Kahilu Town Hall campus and went into a meeting where the anger was palpable. We joined the lone administrator at the front of the room, and the association president opened the meeting.

Dick Penhallow giving Mauna Kea Soil and Water Conservation District awards, 1960. Left to right: Y. Kitagawa, Theodore Sparrow, Les Wishard (behind Penhallow), Charles Maruyama, John Smithhisler, Arch McCabe, Sam Lujan, awardee Leon Thevenin, Albert Akana, Thomas Lindsey, Herbert Horner. Penhallow collection.

Dick Penhallow as Western Livestock Journal *tour director, 1960. Left to right: Penhallow, Nelson Crow, Roger Williams, Hartwell Carter, and John Cholis. Penhallow collection.*

Right: Dick Penhallow with 4-H champion steer, flanked by Richard Smart, who bought the Parker Ranch blue ribbon show steer from Lois Kawabata. William Wong from the Hilo Meat Company is on the far right. Penhallow collection.

Below: Dog trials fostered by Penhallow, typical of his efforts to diversify ranch operations. Penhallow collection.

Penhallow in his twilight years. Still active in the community in retirement, Penhallow cochaired a fund drive with Richard Smart for a private hospital in north Hawai'i. Standing left to right: Fred Nonaka, Frank Correia, Henry Ah Sam, Ernest Martinson, Albert Ozaki, Frank Fuchino, Emrich Nicholson, Herbert Ishizu, Steve Morifuji, Sam Kimura. Seated: Wally Iwamasa, Masato Doi, Yutaka Kimura, Richard Smart, Richard Penhallow, Mel Martinson. Photo courtesy of Roy Ishizu.

What followed was, for me, an example of Penhallow's courage and conviction that in the meetings there would be only honor, decency, maturity, courtesy, and mutual respect. He detailed his expectations calmly and clearly. In the space of five minutes, he pulled the hushed group together into a single purpose, and I came away inspired by his strength. In later years trustee Warren Gunderson, in an effort to close down Parker School, was subjected to rancorous, discomforted students, parents, and faculty—a scene that could well have used the firm demeanor and leadership skills of Dick Penhallow.

Unlike his white Jeep Wagoneer that always slowed traffic through Kamuela, his career in community service never waned, and Richard Smart was gracious in honoring Penhallow at the July 4, 1980, races in Waimea.

Penhallow died in 1998. His wife Olive preceded him in death in 1995.

3
THE RALLY GREENWELL ERA

Richard Smart alone made the decision to select Rally Greenwell as new manager of Parker Ranch, a position sought by several men, including Greenwell's brother Jimmy and Yutaka Kimura. Rally's appointment was a popular one, for Rally was a local boy who came up through the ranks. He was, in fact, the first Parker Ranch cowboy to become general manager. The move occasioned a celebration on September 27, 1962, as cowboys and livestock personnel gathered at Rally's house.

If management changes were frequent, it certainly seemed so to ranch staff and cowboys. In less than three years the top job went from Hartwell Carter to Dick Penhallow to Rally Greenwell, changes that brought about considerable upheaval and set the trend for later management and trusteeship changes involving some strong personalities. Always in the equation was the presence of Richard Smart, beginning with the imposed departure of Hartwell Carter. Rally himself served as ranch manager for nearly a decade, but his leaving removed a stabilizing factor. It is difficult to appreciate the emotional trauma and the loss of productivity inherent in these frequent management changes, and until he died in 1992, Richard Smart was pivotal in these decisions.

Simultaneous with Rally's appointment was that of Norman Brand, head of the business office, to the newly created post of Parker Ranch business manager. Brand had served in his previous capacity since 1944, when he came to Parker Ranch from Onomea Plantation. He was a native of Dundee, Scotland, and enjoyed a good relationship with Rally. Each of them now reported to Richard Smart.

In a reassuring inaugural message, Rally stated that while changes come with new management, "they will be done with the welfare of the Ranch and the Ranch families at heart."

Radcliffe L. Greenwell came to Parker Ranch in 1934, when he was twenty. That was a year after his brother Jimmy moved to Kohala from the Carter home in which Rally continued to live during his first decade on the ranch. The Greenwell brothers—Rally, Jimmy, and Robert—were raised on Palani Ranch at Honokōhau in North Kona. Their father Frank was one of ten children of Henry Nicholas Greenwell, who built the Kona ranching dynasty. Frank was heir to Palani Ranch, northernmost of the three Greenwell ranches and the only one extant today as an intact working outfit.

The eldest of the sons, Robert, remained at home with his father to help run the Green-

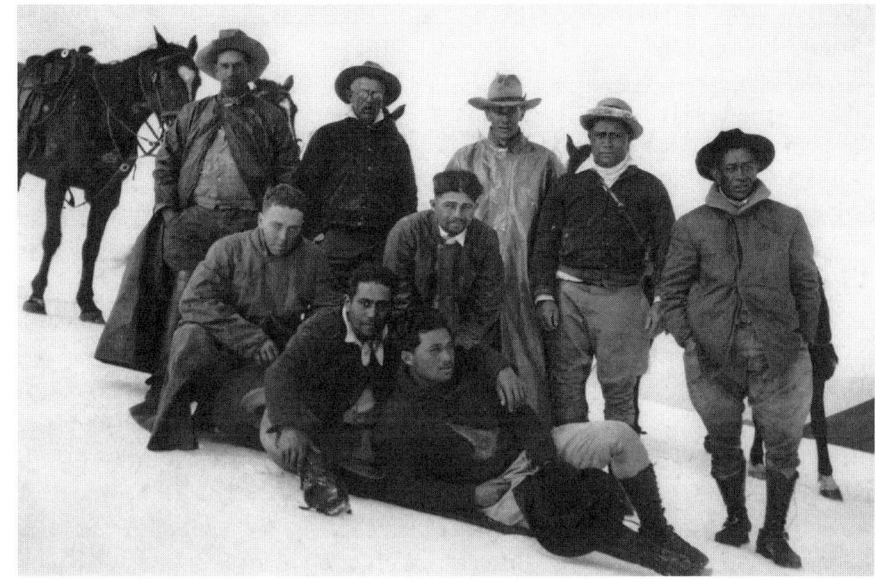

The Snows of Mauna Kea. Left to right, back row: Frank Vierra, Martin Martinson Sr., James M. Greenwell, Martin Martinson Jr., Harry Koa. Middle pair: Rally Greenwell, Willie Kawai. Front pair: Sam Liana, George Purdy. Photo by Willie Kaniho. PPS.

Jim Murray (surveyor), Norman Brand (business manager), Richard Smart, Rally Greenwell, and Ralph King (surveyor assistant) at Puakō. Pump house in rear provided irrigation for Puakō finishing paddocks, where kiawe beans provided an excellent protein source. Pat Greenwell collection.

well Ranch. As an eleven- or twelve-year-old boy, I spent summers on that ranch since Robert's sons, Peter and Kelly, were my good friends. We did cattle work, during which old Frank would sternly (but kiddingly) lecture us on cowboy techniques. "Go easy, go easy," he would demand, or "Get out of the way if you don't know what you're doing." He was an imposing figure, as was his son Robert, a kind, hardworking ranch manager. I was not

The Rally Greenwell Era

acquainted with Rally until the mid-1950s, when I accompanied Holi Ma-e with his calf crop to Wahinekea Corral near Makahālau for the annual payment in weaned calves on his chattel mortgage with Parker Ranch. Holi enjoyed the *ōlelo kanaka* (Hawaiian language) with Rally, whom he described as *kanaka makua* (a young person with a mature attitude).

It wasn't until I returned home in 1968 as a veterinarian that I got to know Jimmy. All three of the Greenwell brothers bring to mind that my father, Dr. W. N. "Bill" Bergin, was their family doctor in the mid-1930s, after he completed his medical residency at Queen's Hospital on Oʻahu and began practicing in North Kona. In the early years of my own practice I came to know the South Kona clan of Greenwells socially and professionally. There was Jack, Henry, and Norman of W. H. Greenwell Ranch and Sherwood of Kealakekua Ranch. I have always remembered my father's comments on the Greenwells regarding the clan's chief characteristic: loyalty—they never let you languish when there was trouble. Such qualities my father aptly described as "Greenwellian." I think about that, although more than fifty years have passed since I first stepped into a saddle on a gentle horse on Palani Ranch, and I appreciate my father's judgment.

After a year's experience on the Cowboy Gang, Rally's first assignment as foreman with Parker Ranch was Keʻāmuku, a large part of the *ahupuaʻa* (land division extending from upland to the sea) of Waikoloa. It took in the entire western boundary of Parker Ranch with territorial lands that separated it from Puʻuanahulu and Puʻuwaʻawaʻa. The *makai* (seaward) boundary was a stone wall below Puʻuhīnaʻi near present-day Waikoloa Village and its uppermost reaches included Puʻukeʻekeʻe and Kaʻohe, which, after World War II, became part of the Pōhakuloa Training Area. This section of the ranch had a camp called Keʻāmuku House, where Rally and the men headquartered. Although arid, Keʻāmuku under proper management is good cow country and until recent years was known for producing champion 4-H calves from a stout Hereford herd.

From the camp, which still showed traces of the MacFarlane Sheep Ranch days, the men covered the *mauka* (above the location of Kona Road) and *makai* country. Often the Keʻāmuku men rode daily to Waikiʻi for cattle work, returning to the camp in the evenings. Having already worked with the central Cowboy Gang out of Waimea, Rally became immersed in the functions of the entire home ranch, including Kahuku Ranch to the south.

Over the decade he lived with Hartwell Carter at the ranch manager's home built by A. W. Carter, Rally and Hartwell became well acquainted and shared common ideas of animal husbandry. Jimmy, however, felt that Hartwell was not the man A. W. had been and never developed the closeness and mutual respect shared by Hartwell and Rally. Rally recognized the strong and traditional values of stewardship in Hartwell.

In the latter years of World War II, Rally left the ranch to work as assistant manager to Ronald von Holt at Kahuā Ranch, where he stayed until 1956. During that period he married Patricia Gilman of Oʻahu, and they had two children, David and Joan (Fluffy). The years at Kahuā Ranch broadened Rally's experience, not only because of new country and new challenges but also because of the opportunity of working with von Holt, a

Rally Greenwell unloading Parker Ranch feeders from a Kahuā Ranch truck at Kawaihae Harbor. This photo was taken when Greenwell served as president of the Hawai'i Cattlemen's Association. Pat Greenwell collection.

highly respected cattleman in the Territory of Hawai'i.

Returning to Parker Ranch, Rally was assigned the Pā'auhau section, a rather self-contained ecosystem with plenty of rainfall and lush pastures. His position allowed him to interact with all sections of the ranch, including Kohala and Humu'ula. Prior to Hartwell Carter's retirement, Rally was promoted to assistant manager, a well-placed post that readied him for rising to full management duties on the departure of Dick Penhallow as general manager.

Rally took the helm of a ranch that had grown to 262,000 acres, made up of 612 paddocks surrounded by 600 miles of fence lines and serviced with fifty working corrals. A vast 160 miles of pipelines filling 400 water tanks and 212 water troughs delivered water that came primarily from the Kohala Mountains to these lands; 170 ground tanks had been built, and many more were under way via the skilled design of Willie Kaniho as Rally's master plan for water unfolded.

Rally's Management Structure

Rally had serious misgivings about Penhallow's plan to divisionalize the ranch. This

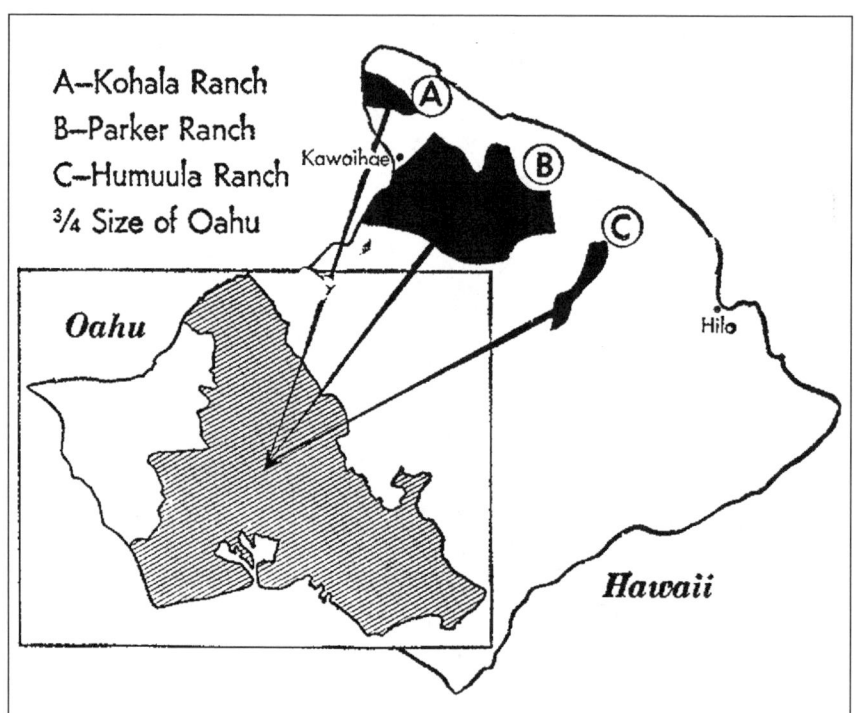

Map comparing Parker Ranch to the Island of O'ahu illustrates the magnitude of Parker Ranch holdings. HTH February 10, 1951.

same discomfort surfaced as the Rubel/Lent group proceeded to divide up Parker Ranch a decade later. Rally had his reasons, the main one being the imposition of a competitive and territorialized attitude among the leaders of the different sections. Other reasoning was based on his comfortable grasp of the remote sections and complete trust in the men who ran them.

One must remember that Rally was only twenty when he came to the ranch in 1934, and he was placed directly in the prestigious yet most demanding assignment—the Cowboy Gang. As he matured into leadership roles on all sections of the ranch, his day-to-day field observations of the land, water, weather, and animals equipped him to be a competent judge of the men around him.

"Parker Ranch is one ranch" was his management theme, and the inspiration for his confidence was born out of the many years in the saddle, carefully observing the work habits, knowledge, and skills of the men around him who worked the total ranch in unison. He could not envision turning these men on each other when divisional boundaries were imposed on a ranch owned by one man. So in the early days of assuming general ranch management, Rally readily dismantled the organizational management structure of his predecessor and returned the ranch to the control of Richard Smart through a single manager—himself.

Rally had an excellent administrative support team that included the accounting and business support of the able Scotsman

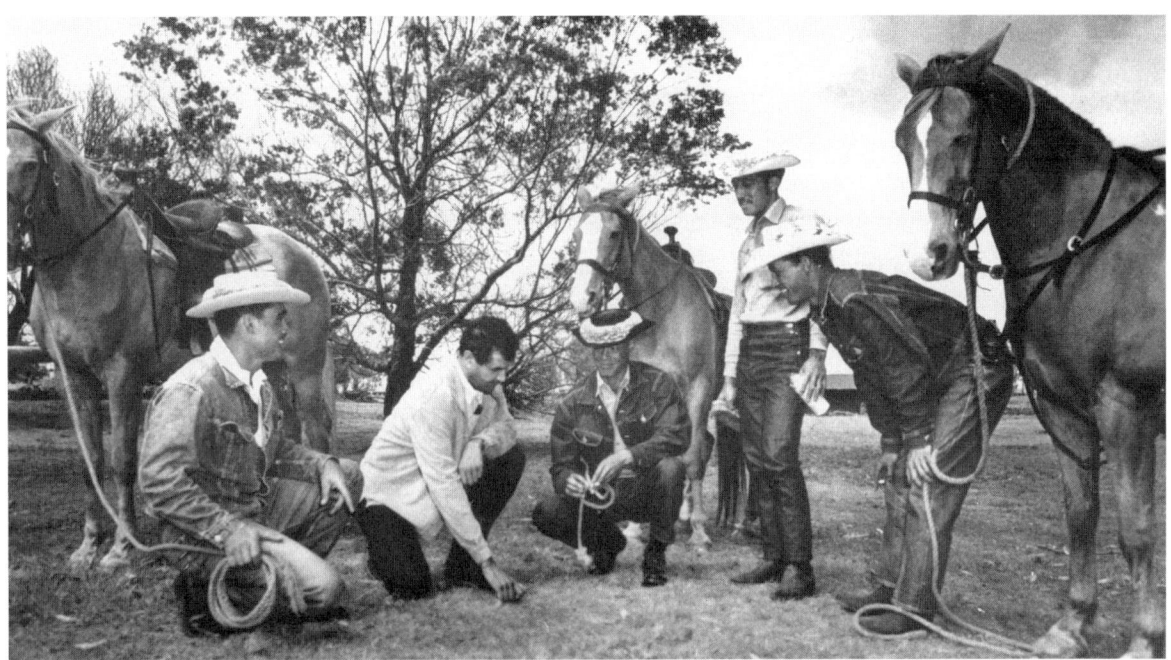

Richard Smart with cowboys at Puʻuōpelu planning for an Aloha Week parade in which Richard Smart served as grand marshall. Left to right: Dan Kaniho, Richard Smart, Kale Stevens, Joe Hui, Walter Slater. PRC collection.

Norman Brand and sound secretarial support from experienced secretary and bookkeeper Kiyome Yoshimatsu. He turned to Dr. Wallace T. Nagao for veterinary consultation and a close friend, Harry Kawai, to continue as a general superintendent of all ranch operations. In effect, Harry Kawai operated as assistant manager of the whole outfit, as well as direct overseer of the Main Ranch, which included the paddocks Range I and II, Kawaihae Uka I–IV, Holoholokū, Kamoa, Laelae, and Hōkūʻula. Harry also provided oversight on the Puakō section manned by Kepā Bell and his crew, where irrigated pasture grazed cattle and hogs.

Beyond managing the Main Ranch, twelve section foremen and six utility crews —three of which were fence gangs—reported to Harry Kawai on a daily basis at 5:30 a.m. Rally Greenwell was also present in the office on these mornings to accommodate any section foreman or crew chief who needed his advice or counsel. This was routed through Harry Kawai to ensure that communications remained open from top to bottom. In the more remote stations of Humuʻula, Kohala, Kalōpā, Pāʻauhau, and Puakō, morning consults and rain gauge reports were handled by telephone.

Also reporting directly to Rally was the foreman of the Cowboy Gang, John "Samoa" Lekelesa, as all cattle movements, with the knowledge and comfort of Harry Kawai, were controlled by Greenwell.

A good deal of Rally's management day was spent in the field, usually in a ranch Jeep-

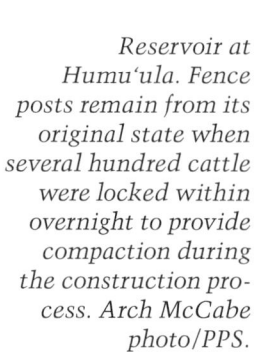

Greenwell Organizational Plan. Note the horizontal breadth that provided a basis for far-reaching authority.

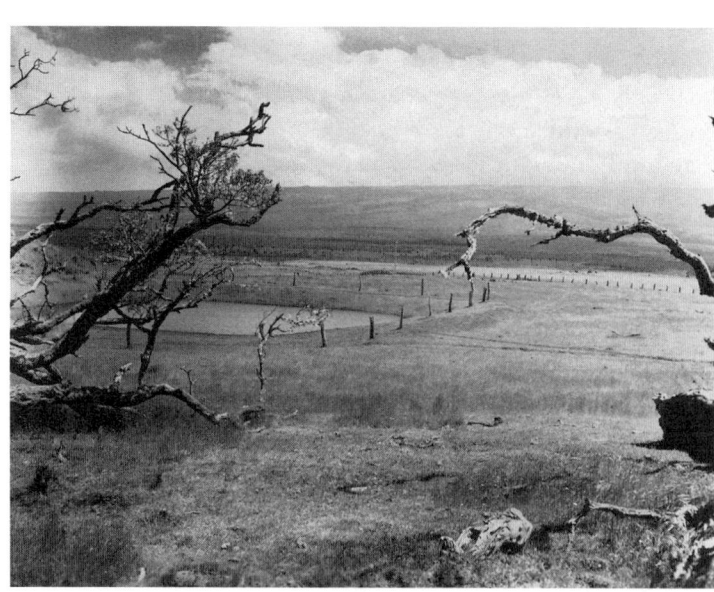

Reservoir at Humu'ula. Fence posts remain from its original state when several hundred cattle were locked within overnight to provide compaction during the construction process. Arch McCabe photo/PPS.

ster but sometimes astride a good horse. On weekends, Rally, accompanied by his wife Pat, rode through different parts of the ranch checking on cattle, water, grass, and so on. Very little occurred on the ranch of which he was not aware. His knowledge came from his direct observations and contacts, avoiding dependence on the word of others, no matter how trustworthy.

Always present in the ranch office, keeping Rally duly informed of in-house activities, was ranch secretary Kiyome Yoshimatsu, whose integral role in Parker Ranch history encompassed several management eras. A tireless, behind-the-scenes worker, Kiyome was a significant contributor toward ensuring that ranch operations ran smoothly. Additionally, her close professional relationship with owner Richard Smart is one that she can be proud of. A profile of her career on the ranch is illustrative of the depth of her loyalty and vast experience.

Kiyome Yoshimatsu

The second daughter of Masao and Kii Yoshimatsu, Kiyome was born at their Waimea home, where her childhood was spent. From a very tender age, she and her siblings enjoyed watching the cowboys return from work on their mounts, tying them to the long hitching post adjacent to the ranch office.

The family lived in several ranch homes. After living in the secretary's cottage near Waimea School, the family home became a ranch cottage immediately behind the ranch office in the area where the Purdy Statue stands today. From that vantage point, it was daily routine to see the cowboys come and go from the headquarters where Masao had an office. His daily routine began at 3:30 a.m. by recording the rain gauge reading at the ranch office. By 5:30 a.m. he would collect, by telephone, the rainfall measurements from all sections of the ranch, from Humu'ula to

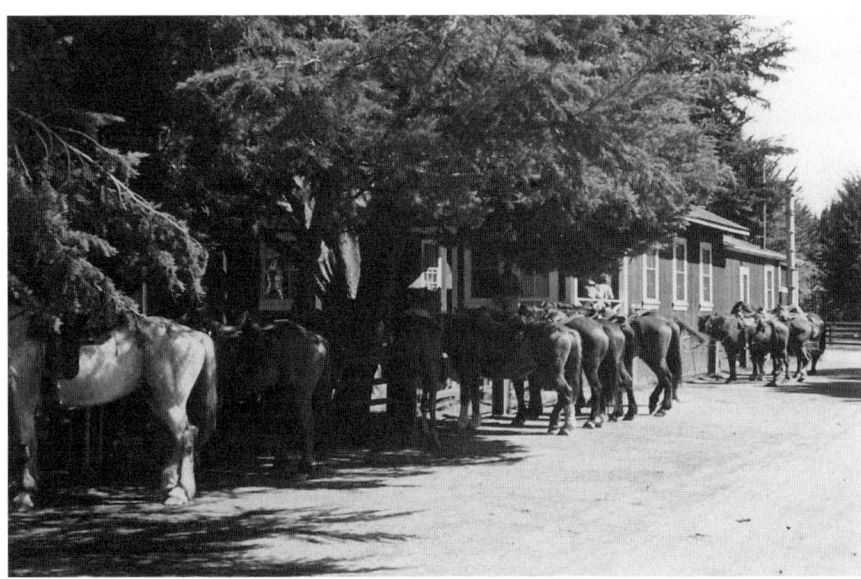

Parker Ranch office pau hana. *The row of mounts represents the cowboys'* lio ahiahi *(evening horses) that provided transportation to and from work. PPS.*

Puakea, Keʻāmuku to Hanaipoe, and Kemole to Lālākea along the valley rim of Waipiʻo. Once gathered, this data was forwarded to A. W. Carter the same morning. Masao was consistent, loyal, and dependable, and his role on Parker Ranch deserves mention.

Kohala was the birthplace of Masao Yoshimatsu on August 12, 1899. Entering employment on Parker Ranch at age eighteen, his first assignment was chauffeur for A. W. Carter, which gave him genuine exposure to general ranch operations. His brother Tokohiro later served as chauffeur for Hartwell Carter. Given his natural ability and knowledge of ranch merchandizing, Masao was stationed at the Parker Ranch Store for seventeen years, gaining valuable experience with inventory and warehousing responsibilities.

In 1941, Masao was made warehouse boss at the original Parker Ranch facility located on the Hilo side of the store, where he remained in exacting control of the inventory. His strict control of the ranch's material assets enhanced his reputation as a deeply loyal employee who held the best interest of the ranch as first and foremost. Masao's sister, Hatsu Nakano, operated a thriving restaurant—the Do Drive Inn—during the war years of 1942–1945, and it served as a gathering place for marines to enjoy a home-cooked steak dinner. Hatsu's husband, Ernest Nakano, was a ninth grade teacher and principal of Waimea School at the time. He divided his time between those responsibilities and regular early morning runs, first to Nakahara Store in Kohala to load ice into the trunk of his Chrysler, then on to Kona for the beef pickup and preparation before reporting to school to begin his workday. Meanwhile, Hatsu and their only child, Dorothy, busied themselves preparing the evening meal for 500 marines, which included baking forty to sixty apple pies each day!

During her childhood, Kiyome was a student at Waimea School and continued to enjoy her upbringing in the heart of Parker Ranch at a time when the cowboy was king. After graduating from Waimea School, she went on to complete high school at Honokaʻa before enrolling at the University of Hawaiʻi, where she majored in social work.

Kiyome returned to Waimea after two years of college and went to work in the Parker Ranch office in April 1951. After a short hiatus to care for her ailing mother, Kiyome returned for good to Parker Ranch employment in January 1952. Father Masao moved into a larger facility around 1955, at which time the warehousing buildings included three Quonset huts and one long military barracks building that became the headquarters. His prudent warehousing practices were passed on to Sam (Sonny) Kimura and Sueo Yamasaki, the former of whom succeeded Masao when he retired in 1962 after forty-four years of dedicated service to ʻĀina Paka.

Kiyome's first assignment was in the Engineering Department under Stanley Wright, surveyor, taking dictation and typing metes and bounds descriptions of all Parker Ranch lands. Her sister Akiko was already in the main office, where she had begun working after graduating from Honokaʻa High School in 1945; she stayed until her marriage to Richard Hanano in 1953. Because Richard worked for Hawaiian Airlines in Honolulu, Akiko left her job at the ranch and moved to Oʻahu. Kiyome credits Akiko with much of what she learned, because Parker Ranch kept accurate records of everything, including cattle, horses, pigs, and sheep.

Kiyome's next assignment was in the business office under Norman Brand, who instilled in her the exacting detail of appropriate bookkeeping for a livestock operation. Cattle inventories were logged on a daily basis, with trial balances mandated at month's end. If even the slightest discrepancy was noted by the taskmaster Brand, Kiyome dutifully reexamined all entries, often thirty days retrospectively, to locate an error involving only one head of cattle. Such exacting reconciliation of cattle books was the Parker Ranch standard, one that remained intact as the new millennium approached. By the mid-1990s, management manipulation of an "adjustment column" became sort of a catch-all, indeterminate place to accommodate cattle count discrepancies and unclassified cattle deaths.

This strict attention to detail reinforced Kiyome's lifetime commitment to quality performance for the ranch and devotion to its owner Richard Smart. Within ten years of her hiring, Kiyome became the general secretary for the entire ranch, a position she held for another ten-year period, focusing her attention on the needs of both the ranch manager (Richard Penhallow at the time) and Richard Smart at the Parker Ranch office. Her office was centrally located, with Richard Penhallow on one side and Richard Smart on the other. She capably served both leaders, handling all secretarial responsibilities and bookkeeping tasks of the ranch. After Penhallow, Rally Greenwell became manager and Kiyome's boss.

When I arrived on the ranch in mid-1970, Kiyome was already at her desk in her office situated immediately adjacent to Mr. Smart's. These small, single-walled offices were located at the Kona end of the Parker Ranch office, a modest redwood building painted red with white trim that included a moderate degree of "gingerbread" decor. Gordon Lent, arriving in 1971, occupied Rally Greenwell's former office, while livestock manager Walter Slater worked out of Richard Smart's former office. Elaine Scott became the secretary for both men after a couple of short-term stenographic clerks left Parker Ranch employment.

Despite being ensconced down the hall at a more peripheral post, Kiyome stayed in the middle of office activities that included other stenographic and bookkeeping staff such as Abbie Paro, Paula DeSilva, Betty Spence, and Gladys Nekoba. Kiyome was always there to share the workload of managing the ranch books, despite her busy assignments with the ranch owner's business, social, and travel activities.

One very special service that Kiyome provided for me as ranch veterinarian was the production of the annual Animal Health Report for twenty-five years of its life. These annual reports were usually twenty pages long, had numerous charts, and were detailed manuscripts of a technical nature. The reports recapped the previous year's progress in terms of attaining (or not attaining) goals and reviewing episodes of animal health successes as well as shortcomings. More than preparing the actual reports, Kiyome served as editor, checking on dates, spelling, grammar, and a myriad of other details. While I expressed my sincere appreciation each year for Kiyome's diligent support at the time, I want it clearly recorded in this second volume of *Loyal to the Land* that my lasting gratitude for her fine work continues through this moment, more than a decade after leaving the ranch.

Kiyome Yoshimatsu at her desk, ever available to help those in need. PRC.

Parker Ranch office, with Paula DeSilva, a loyal and longtime employee. PRC.

Kiyome is eternally fond of good humor, and the office complex often echoed with her shrill laughter down the hall, particularly when the amiable Jimmy Kurokawa or Yutaka Kimura regaled her with risqué stories of their youth.

Kiyome loved the occasional countryside excursion, whether it be joining in the blessing of new ranch facilities such as the Holoholokū Feedlot or touring the stallion stables during the breeding season. In the latter venue, the jovial Teddy Bell as horse foreman would invite the office staff to witness the hand-breeding of a handsome stud like Hauli to a choice mare—the closest one could get to an on-ranch floor show. An excellent cook as well as an excellent horseman, Teddy would serve a lunch of salt beef and cabbage or chicken *hekka,* usually accompanied by poi for the office crew.

In the November 1962 issue of the *Paka Paniolo,* Kiyome was heralded as a "Girl Friday of Parker Ranch, [who] can put her hand on records, name the paddocks, spell 10 syllable names, and get you a dance band." Further describing her nature, the newsletter went on to state, "Kiyome is a treasure, one of those indefatigable workers who finds herself involved in the needs of others."

But more often Kiyome was—and is—the compassionate listener, a sensitive sounding board when tragedies occurred on the ranch. She was especially quick to sensitize Richard Smart if anyone in the large ranch family experienced misfortune. For this role, Mr. Smart seemed eternally grateful to Kiyome

in light of his travel and multiple residences. Kiyome was often sent to begin arrangements on his behalf, attending to the bereaved families and individuals.

When Kiyome arranged my formal annual visit with Richard Smart, we often chatted about the ranch, especially its early history as her father Masao recalled it. On one of these visits as I awaited the ranch owner, Kiyome shared with me the enduring kindness Mr. Smart extended to the widow of Matsuo (Mack) Yamaguchi, the assistant Cowboy Gang foreman who met with a fatal accident on the Mauna Kea slopes of the ranch. Richard, she shared, was especially proud of the loyalty demonstrated by Mack's sons Jiro and Ichiro, who were lifelong ranch employees of note. Kiyome wondered aloud about how strange it was that then current ranch management (Hanson and Slater) chose not to hire Jiro's cowboy son Mark, a recent high school graduate who had been working gratis with the cowboys over the past year. Sharing her curiosity, I naively raised the question with the ranch owner in our subsequent meeting.

Richard seemed surprised and dismayed, as he assumed that Mark was already on the payroll. In his own words he described Mark's grandfather Mack, who effectively gave his life to the ranch. Richard was clearly proud that a pure Japanese nisei would rise to a leadership post on the ranch.

Our visits usually touched on animal health progress, humane shelter issues, and, of course, how my wife and family were doing. His reaction about Mark seemed to conjure more thoughts on the Yamaguchi heritage than on Mark as a job seeker. Well—I assumed wrong.

On the following Monday morning I was summoned to Don Hanson's office for probably the worst dressing down I have experienced. In true U.S. Marine fashion, Don left little doubt as to how he felt about my actions. Apparently the ranch owner took him to task that Friday afternoon for not bringing Mark on board, and Hanson felt rightfully blindsided and stewed over it for the entire weekend. "I should fire you, Billy, for such a breach of protocol," was Don's opening volley to me that Monday morning. Expecting sympathy from my wife Pat that evening, again I assumed wrong. In supporting Hanson's position, she reminded me that despite my noble intentions, my direct query to Richard Smart was inappropriate—and in fact could harm Mark's chances of being hired.

Things gradually worked out. Mark was eventually hired on his own merit and grew to become a top hand, leading to his ultimate foremanship of Keʻāmuku. Hanson made his point with me—in fact, he provided a life lesson while typically mandating that we carry on with the ranch mission. Hanson was curt, but he was even-handed and clear.

In recalling these days, I often reflect on whether Mark would ever have been hired if Kiyome had not put a bug in my ear. Moreover, Kiyome was a thoughtful sounding board when my days were not going well—but more enjoyably, she was a fervent student of my raucous Irish humor.

After her retirement in 1990, Kiyome worked for nine months as secretary for Parker Ranch trustee Gaillard Smart, son of Richard Smart, who was relocated to Parker Square. Kiyome served Gil with the same degree of loyalty with which she served his father and was deeply concerned at how he was being treated by current ranch leadership.

Mark Yamaguchi at the Fourth of July races, with Walter Stevens (right) and Godfrey Kainoa (left) after winning the championship relay race. Photo by Leilani Hino.

During my twenty-five years on Parker Ranch, I considered Kiyome an endeared confidant, just as I am certain Richard Smart listed her first as a dearest friend, employee, and Waimea *kamaʻāina*. She shared with me recently that during one of her talking sessions with Smart before her retirement, she applied to Richard—and was hired—to work for him when they meet in the next world. What greater testimony can there be of the bond between an employer and a loyal employee? Kiyome was not only loyal to the land but to the *man himself.*

Men of Leadership

In the generation of leadership that followed such icons as Keoni Liʻiliʻi (John Kawananakoa Lindsey) and James Palaika (James Kaleimaʻemaʻe Brighter), Parker Ranch was blessed with a handful of *kanaka makua*. These men included Harry Kawai, Willie Kaniho Sr., Yutaka Kimura, John "Samoa" Lekelesa, Henry Ah Fong Ah Sam, John Kawamoto, and James Kurokawa. While others may not have served in a leadership capacity, the history of the ranch would be incomplete without chronicling the merits of the quiet background contributions of individuals such as Herbert Ishizu, who is included here as well. For the purposes of this text, Henry Ah Fong Ah Sam will sometimes be shortened to Henry Ah Fong.

The legendary roles played by Harry Kawai, John Kawamoto, Yutaka Kimura, and Willie Kaniho Sr. are recounted in the first volume of *Loyal to the Land*, and to a significant degree they are heralded in this text relative to their respective roles. In the case of Lekelesa, Ah Fong, and Kurokawa, however, their prominent roles under management are worthy of further background.

John Kalaniopuʻu "Samoa" Lekelesa

John Lekelesa joined the family of Reverend John S. Lekelesa and his wife, Cecilia (Kekalia) Alo Lono, at his birth in 1908. Reverend Lekelesa was ordained a Congregational minister at Central Union Church on Oʻahu shortly after emigrating from Samoa with a group of missionaries returning to Hawaiʻi. Although born to the *aliʻi* (ruling) class in Samoa, he was destined for the ministry despite opportunities available to him through his royal lineage. His entire body was adorned with ornate tattoo (*tatau* in Samoan) patterns reflective of his princely status. Handsome, square-shouldered, and tall, the reverend was of fair complexion, *tatau* shades notwithstanding. He commanded respect by his sheer stature and demeanor. His

devout faith provided inroads into the minds and hearts of the Native Hawaiian congregation of Kawaihae proper and Kawaihae Uka, where he began his ministry following Reverend Kalaiwa'a, *kahu* (minister) of the Kalawina (Calvinist) faithful. Nestled alongside Honokua Gulch in the uplands of Kawaihae Uka, the little church provided a peaceful setting for worship.

Reverend Lekelesa's union with Cecilia produced but one child, John Kalaniopu'u, who was destined for a career on nearby Parker Ranch. Tragically, Reverend Lekelesa died in 1910 when John was only two years old. Widowed with a baby in arms, Cecilia received a small monthly pension from the Hawaiian Board of Missions—five dollars in cash and two bags of poi.

Taken in as *lawe hanai* (caring for a child as one's own without formal adoption) by his aunt Helena Awa'a, John grew up in the hills of Kawaihae Uka separated from his half-sisters, who were products of Cecilia's second marriage.

John's upbringing was founded in the Kawaihae Uka home of his aunt Helena Hulupi'i Alo Lono, his mother's sister. His uncle, Samuel Awa'a Sr., raised young John as his own along with his own sons—Samuel II, William (Bull), and Andrew. John's *hanai* sisters were Nancy Keala (Elarionoff), Esther Kawaihalana (Hui), Emily Kaiahua, Daisy Kalanikaumai'iluna (Kaniho), and Helen Kuluwaimakaokalani (Aveiro).

Lekelesa's physical appearance bore a striking resemblance to the Awa'a siblings, giving thought to the possibility that the tall, brawny physique, the square jaws adorned with rows of wide, pearly teeth, the fair skin with a reddish shade, and the almond, greenish-brown eyes could be attributed to the maternal influences of the Lono line, which both families shared through their mothers, Helena and Cecilia.

John's boyhood was filled with the daily activities of his Kawaihae Uka *paniolo* family. Subsistence farming and hunting and salting beef and pork *(ho'o kapī)* for smoking and drying were household chores in which all children participated. Younger children, too young to strip and hang the meat, were charged with the responsibility to *kahili* (swat) flies with *ti* leaves to keep them away from the *pipi kaula'i* (dried beef).

Working as a *hana kokua* (day worker) at nearby Kahuā Ranch during his teen years, John dreamed of life in the merchant marine. That was not to be his calling. In 1931 he was offered a permanent role in the Parker Ranch operation, moving to Humu'ula to work under firm but amiable Henry Ah Fong, a former seaman. At Humu'ula he received a small string of hand-me-down horses and four- to five-year-old green-broken mounts. Being of tall stature, John naturally worked toward developing a string of bigger, brawnier horses that became his mainstay mounts, as the Humu'ula operations spanned more than 25 miles of high-elevation sheep and cattle ranges. As a Humu'ula cowboy, he was expected to tend fences and water resources. The long, cold, weary days yielded a salary of $1.50 with room and board.

Before long, John's worth as a lead *paniolo* was recognized, and he was transferred in 1935 to Waimea to become a member of the Cowboy Gang. Replacing the venerable David (Hogan) Kauwe, who was laid up with a broken collarbone after being bucked off in Pawainui paddock, John had big shoes to fill.

A year later John married his sweetheart, Hannah Keanu Purdy, a marriage that

produced three children—John Lekelesa III, Celeste (Kumalae), and Luana (Ogi). The couple took great pride in their children, who through education sought and achieved careers that brought further respect to the Lekelesa name.

Reporting to cowboy foreman Keoni Li'ili'i, Lekelesa—who by this time was called John Samoa—worked alongside sixteen to eighteen other men and felt privileged to work among Parker Ranch's finest men. After nine years he was promoted to lead the Cowboy Gang—a role he filled for twenty-five years—the longest tenured foreman since his predecessor Keoni Li'ili'i.

Leading the Cowboy Gang was no picnic. Highly experienced and inclined to speak up, the crew at times created intense pressure to "do things the easy way," a philosophy that did not fit with John Samoa's leadership style. Pressure on leadership intensified when Hartwell Carter became ranch manager after his father, A. W. Carter. Unlike his father, Hartwell was inclined to depend to a significant degree on reports from informants regarding the daily activities of supervisory personnel like Lekelesa, Harry Kawai, Willie Kaniho, and Yutaka Kimura. Consequently, these men were frequently "called on the carpet" to explain reported incidences of alleged inappropriate cattle handling. This practice unfortunately created an atmosphere of mistrust, with men in leadership roles constantly on the alert for informants. Nearly everyone was suspect, some were innocent, but a few were very damning in undermining the leadership of the cowboy foreman. Sniping among the men became intolerable and vicious as Hartwell became increasingly dependent on informants.

The undue pressure placed on leadership affected each foreman in different ways. Harry Kawai, a dear and favored friend of Hartwell Carter, rarely acknowledged such criticism; Willie Kaniho usually reversed the tide by chiding Hartwell for encouraging such tattling; and Yutaka Kimura, although humbly accepting the reports, bemoaned the lowly nature of its source.

John "Samoa" Lekelesa taking a break before a branding at Waiki'i Corral. Courtesy of Celeste Lekelesa Kumalae.

An example of the impact of Hartwell's leadership style of encouraging informants occurred under the foremanship of Yutaka Kimura, who was a loyal confidante of the ranch manager. The incident involved moving several hundred replacement heifers to Pa'akainui paddock.

While strict protocol demands that all cattle entering a new paddock be driven to the water trough before release, Yutaka waived this rule in light of the heavy rains that drenched the Waimea plains at the time. He led the Cowboy Gang back to Pu'uhihale Corral for unsaddling at day's end. While the cowboys saddled up and left for home on their

lio ahiahi, Yutaka remained at the stables to doctor an injured horse. Upon entering the ranch office at *pau hana,* he was immediately summoned to Hartwell's office for an explanation of why the heifers were not walked to water troughs before releasing them. Aware of who was attempting to undermine him, Yutaka made his feelings extremely clear to Carter.

The pressure of all this backbiting, which he took personally, took its toll on John Lekelesa's leadership style. He reacted by developing a harsh and abrupt style with his men, frequently relying on expletives to get his point across or when issuing orders.

During the first decade he led the Cowboy Gang, Lekelesa was ably assisted by his former Humu'ula boss, Henry Ah Fong, who had a calming effect on John Samoa and the cowboys. Henry was a quiet, tough, and experienced hand who called little or no attention to himself. By his nature, he was able to play a genuine role in interfacing the cowboys' plight with the harsh leadership of John Samoa. By this time, the Cowboy Gang was downsized to a dozen senior-ranking men, but change was in the wind. When Henry Ah Fong suffered a badly broken leg in a horse accident in Pu'uka'ali'ali, Bob Sakado was promoted to assistant cowboy foreman. Sakado served as John Samoa's assistant and frequent critic. The stabilizing influence of Henry Ah Fong waned and his role was eventually relegated to that of *nānā'āina* (overseer) man.

Despite the pressure, John Samoa retained his leadership role through the tenures of Hartwell Carter, Dick Penhallow, and Rally Greenwell. While his leadership style can be described as hard driving, the larger issue was his fierce loyalty to ranch management, his driven nature in accomplishing his mission as ordered, and his enduring love for 'Āina Paka.

After thirty-nine years on the ranch—thirty-four years on the Cowboy Gang, twenty-five of them as foreman—Samoa ended his career working at the racetrack stables alongside George Purdy. In October 1970, he opted for early retirement and enjoying life with Hannah at their Puakō Beach home. He died at Kohala Hospital at age seventy-nine, after serving the ranch for nearly four decades of the best years of his life.

Henry Ah Fong Ah Sam

When one first hears his name without having met the man, the image of a wizened little man of Chinese heritage comes to mind. Nothing could be farther from the truth. Upon meeting Henry Ah Fong Ah Sam, one would be impressed by his tidy, muscular stature, strong countenance, pleasant demeanor, and noticeably Hawaiian appearance. After learning a little more about the person he was, one would come away impressed even more. He was indeed a very special man.

Born on December 27, 1897, in Ola'a, on the southeastern slopes of Mauna Loa on the Big Island, Henry Ah Fong Ah Sam was the son of an immigrant Chinese meat merchant and a mother of Hawaiian and English descent.

Ah Fong's father plied the meat industry of southeastern Hawai'i on horseback, buying mostly cattle and some hogs in a geographical region that stretched from Hilo in the east to South Point, the southernmost section of the island of Hawai'i. At the peak of his career, he established a meat market in Pāhala that served the communities between Wood Valley and Wai'ōhinu. An only child, Henry was

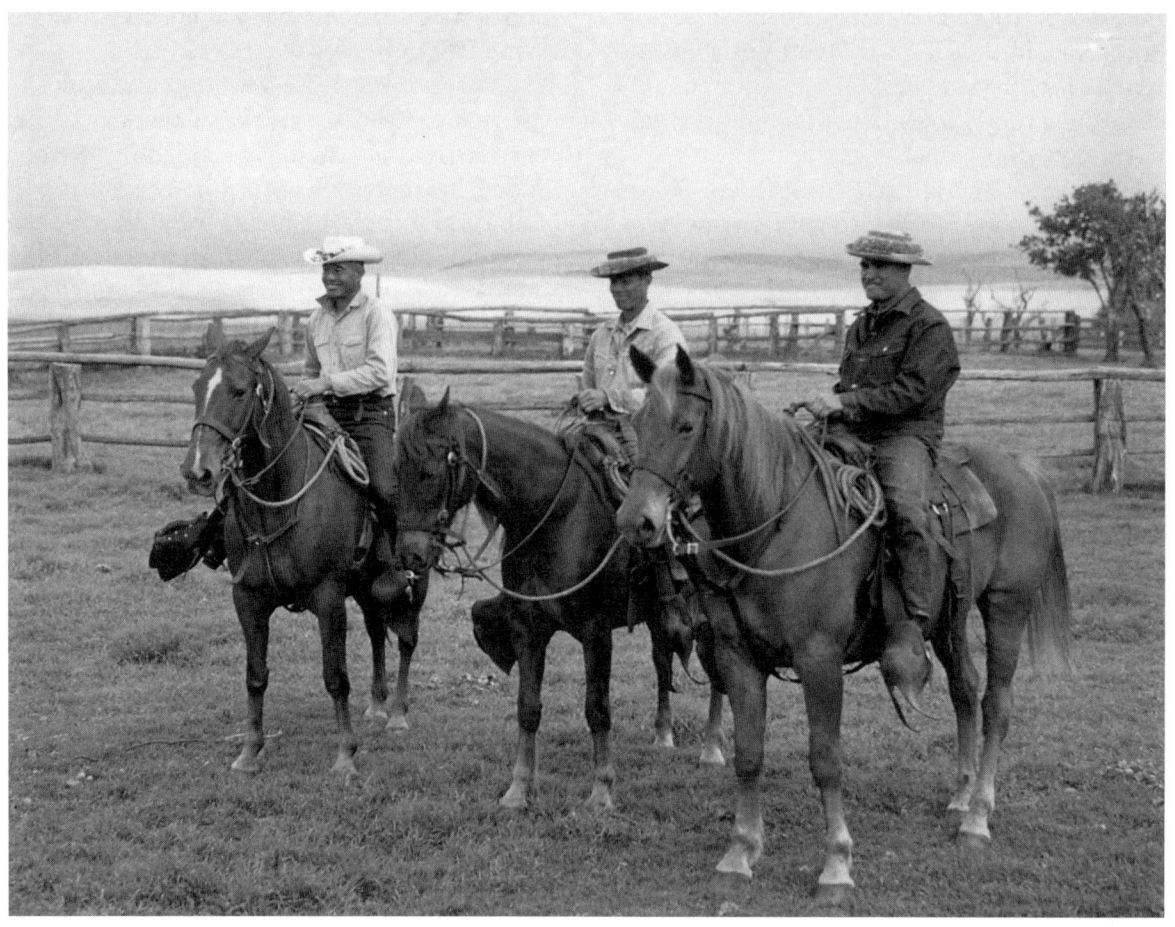
John "Samoa" Lekelesa with Kale Stevens and Dan Kaniho in Waiki'i Corral. Note that each saddle bears long-eared tapaderos. Courtesy of Michelle Hooper.

well educated at both Hilo Boarding School and Kamehameha Schools on Oʻahu. During this period, his father returned to his motherland, China, never to be heard from again.

Ah Fong's first and last place of employment was his beloved Parker Ranch, where he first went to work in 1911.

Ah Fong acclimated to cowboy life with relative ease, promptly gaining the respect of his peers owing to his soft-spoken, considerate, and capable nature. Anxious to serve his country, however, he joined the U.S. Navy in 1918. His two-year tour of duty was rather colorful, as it took an unexpected turn of events. It seems that the navy saw more in his athletic prowess in boxing than in other contributions he could make for his country. This aspect of Ah Fong's talent became evident when he handily decked any shipmate who referred to his Chinese descent in a less than dignified manner. Ushered into the navy's West Coast boxing program for

Bob Sakado at 1982 Fourth of July races being honored as a senior retiree. Photo by Leilani Hino.

Henry Ah Fong branding at Waiki'i Corral. Note his kaula ili *(skin rope). Pat Greenwell collection.*

professional training, Ah Fong trained with intensity and perseverance. He became the West Coast welterweight champion in the following year. In challenging the East Coast champion, Sammy Albright, Ah Fong lost in the eighth round. Undaunted, he returned three months later for a rematch. The match went on for ten rounds before it was ruled a draw. With honors, Ah Fong was discharged from the navy and returned to Parker Ranch on January 16, 1920—happy to be "punching cows" instead of his shipmates. He was assigned to Makahālau Station under the foremanship of Matsu (Mack) Yamaguchi.

On his twenty-fourth birthday, Ah Fong married charming Hilo native Annie Simeona Duncan, a union that produced six children, two of whom retained strong ties with Parker Ranch. A daughter, Elizabeth (Dudu), married Walter Stevens, and son Henry Keehikapa Ah Sam rose to a prominent place in modern Parker Ranch history.

With an opportunity for upward mobility, Ah Fong moved to Maliu Ranch in North Kohala, where he remained for seven years. A. W. Carter sought his return and offered him the foremanship at Humu'ula Sheep Station, where he served with distinction. Many young cowboys went to work under Ah Fong at Humu'ula and were fortunate to be exposed to his calm, deliberate mentorship. Ever an advocate of gentle methods in livestock handling and personnel management, Ah Fong was never known to raise his voice in admonition. In processing livestock, he was correct in noting that "slower is faster"—gentle handling of animals gets the job done in a shorter period of time. Perhaps as a result of his excellent education and life's experiences, Ah Fong, who was fluent in the Hawaiian language, also spoke impec-

cable English—an attribute that undoubtedly contributed to his successful career.

In 1933, Ah Fong was assigned to the Cowboy Gang, pleased to be back in Waimea with his young family. He remained on the Cowboy Gang indefinitely, serving as assistant foreman first to Willie Kaniho and later to John Samoa Lekelesa. Other distinguished assignments included running the Keʻāmuku section and supervising cattle shipments to Honolulu. In this latter capacity he oversaw the transition of Kawaihae cattle shipments from the *hōʻau* method (swimming) to direct dockside loading. When Kawaihae pier was out of commission, Ah Fong oversaw cattle shipments out of Kailua-Kona. Of all his attributes, his humane and gentle handling methods were best utilized in the shipping process in a wide variety of situations.

Paralleling his composure around animals was his demeanor among men during his forty-five years of service to Parker Ranch. Only twice did Ah Fong rise to the challenge of a fight. The first occurred when, as a member of the Cowboy Gang, he was taunted by Alex Akau at the Humuʻula Sheep Station. Stripped to his waist, Henry summoned Akau to the courtyard separating the shearing shed from the Saddle House. His second challenge occurred a decade later during a cattle drive at Hanaipoe when Ah Fong reached the end of his level of tolerance for the manner in which John Samoa Lekelesa verbally abused his men. Henry rode up alongside the cowboy foreman, dismounted, disrobed to the waist, and called for a match. Neither Akau nor Lekelesa rose to the challenge, nor did they ever provoke Ah Fong again.

Henry Ah Fong Ah Sam made his mark on Parker Ranch largely by his soft-spoken nature, quiet confidence, able experience, and high-standard work ethic, underscored by deep loyalty to ʻĀina Paka. Through his son Henry II and grandson Henry III (Tippy), the Ah Fong legacy carries forward—*nā Hanale ekolu* (three Henrys)—all bright, all able, all loyal to the land.

One of the more colorful figures on the ranch that I had the good fortune to know was James Kurokawa. As with most ranch leaders, Jimmy came from humble beginnings to become a giant in his specialty. His work and its influence on the Parker Ranch standard and style are still in evidence today.

Jimmy Kurokawa

Born to Japanese immigrant parents Kiroku and Mura (Murakane), James Masayoshi Kurokawa was born in Paʻauilo, Hawaiʻi, in 1913. Jimmy's mother Mura was the proprietress and head cook of a small but busy restaurant in old Paʻauilo town. She was a master at chop suey and chicken *hekka*; the latter dish was one her son would later master.

Kiroku Kurokawa was already a master carpenter before leaving Japan and promptly found more than enough work as a small contractor, even through the Great Depression years. Part of his work meant living at Kūkaʻiau Ranch, where he developed the first paved road to ʻUmikoa as it meandered *mauka* from the cane fields to the ranch village in the hill country of Hāmākua. Young Jimmy came to know the aura of the mountain mist and the medicinal scent of the eucalyptus trees that marked the periphery of the village. It was through this connection that Kiroku was contracted to build a beach home for plantation manager Leslie Wishard

Sr. The Wailea Beach cottage was likely the first construction job in which Jimmy played a part, carrying tools and equipment along the shore from Spencer Beach to Kawaihae 3 miles west to the Wishard homesite. Young Kurokawa continued school from Pa'auilo on to Honoka'a High School until the end of his freshman year before he left for a life in the construction trade, largely to help support a household of eight brothers and a sister. Jimmy also saw an opportunity to become an apprentice carpenter under his father's mentorship.

Both the Honoli'i and Onomea bridge construction jobs provided intensive experience for him. He shared with me those formative years of working hundreds of feet above the ground and river on scaffolding that swayed with the ocean breeze. He was mortified to have witnessed the fatal fall of one of his coworkers—a fate that tragically took his own life four and a half decades later.

After his bridge-building experiences, Jimmy was prepared to contract out his carpentry services independently. Likely through the connection of Wishard to A. W. Carter, the ranch trustee invited Jimmy to bid on a construction project near the headquarters. Isemoto, another builder, underbid Jimmy's by a wide margin, and he knew that A. W. would likely never call him back again. He was wrong. A year later, A. W. called to lament that by the time Isemoto was done, the job far exceeded the bid, reaffirming the legitimacy of Jimmy's bid. A. W. wanted Jimmy back to bid on several ranch homes to be built for the Pu'ukīkoni Dairy operation near Mānā. Kurokawa went a step further: He designed the homes to a turnkey level and built them under the cash estimate and time scope allowed for the job. A. W. knew that in Jimmy he had a construction man of experience, integrity, and talent. He hired Kurokawa as a full-time employee.

During these early ranch years, Jimmy met and married a petite and pretty Pa'auilo girl named Elaine Nakano. Reverend Kaku Shiba, who knew the couple since their early childhood, ministered the matrimony in a union that brought forth seven children over the next decade and a half.

By this juncture, Jimmy had a moderate-sized crew of carpenters with varying talents, ranging from framing barns to cabinetry of the finest order. In developing his leadership skills, he trained himself in drafting and blueprint disciplines that served Parker Ranch in exemplary fashion over his brilliant career. A refined cabinetmaker himself, in their early marriage Jimmy built a chest of drawers for Elaine of the fine wood, pride of India. Elaine continues to use this bureau today.

Setting the example as an achiever, Jimmy went on to complete his high school equivalency diploma, the GED, the same year his daughter Francine graduated from Hawai'i Preparatory Academy. If time and space permitted, a whole chapter could be devoted to chronicling the successes of all the Kurokawa children, beginning with stellar private high schooling and exemplary college and professional careers. Their successes are indeed testimony to the emphasis placed on education by their parents—with firm but considerate guidance—as well as the personal sacrifices Jimmy and Elaine made for them.

Jimmy's direct relationship with A. W. Carter was further enhanced over the ensuing years, Hartwell's secondary role notwithstanding. As A. W. gradually moved

his pivotal tenure to Honolulu, work orders continued to be made and monitored by the trustee. In A. W.'s waning years, Jimmy was frustrated by Hartwell's vacillating and ambiguous nature. A rift between them came to a head over carpenter wages for his men. When in 1946 Jimmy's repeated overtures for realistic wages for his men were rebuffed by Hartwell, Jimmy turned in his keys and his resignation. At home, Elaine was told to pack up their children and belongings. Had A. W. not intervened, fate likely would have opened up a huge opportunity for Jimmy as a contractor in his own right given the post–World War II building boom. A. W. was in his final weeks of life when he summoned Jimmy to his bedside on Oʻahu with a clear request: Don't ever leave Parker Ranch. Jimmy granted the request with a heartfelt promise that his dedication would not waver.

With the Penhallow era, clear lines of authority were established; Jimmy would report to James Armitage, assistant manager who headed the Engineering Department, instead of directly to the ranch manager, a transition that he handled well. Jimmy also labored under the cloud of Penhallow's proposed outsourcing of skilled carpenter activities both in the construction and motor pool disciplines. While Penhallow's vision, driven largely by fear of unionization, might force Jimmy and his crew into a "contractor" relationship, he remained focused on the projects at hand. Before long, Penhallow was gone and Rally Greenwell's philosophy was more stabilizing than threatening. Jimmy never missed a step, largely due to his diligent focus. Although he reported to Rally through Harry Kawai, the general superintendent, his reputation was beyond question and his judgment beyond reproach.

Jimmy Kurokawa with his Panama hat examining the water heads high in the Kohala Mountains. Courtesy of Elaine Kurokawa.

Jimmy's assistant Tetsuji (Dempsey) Harada and his crew of skilled carpenters are credited for much of Jimmy's success in the field. Most of these men had been dairy workers at the Old Dairy and Puʻukīkoni Dairy.

Notable members of the Carpenter Gang were Chiso Nakanishi, Stanley Tanaka, Ichiro Yamaguchi, and Tetsuo Hiromasa. At Jimmy's urging, Hiromasa became a licensed plumber, a role he filled on the ranch until his retirement.

Separate from the general Carpenter Gang but under Jimmy's supervision were the cabinetmakers—Hichiro (Lee) Uyeda and his nephew, Thomas Kimura—who were charged with the more intricate detail work. Headquartered in the warehouse complex,

Dempsey Harada with Tsuneo Yanagisawa working at the entrance of the old Kahilu Hall theater, site of the present-day Parker School. PRC.

Lee's headquarters were adjacent to the saddle makers' Quonset hut behind my veterinary office. Uyeda and Kimura also produced new mineral houses on a wholesale basis (see discussion on copper supplements later in this chapter).

Dempsey was born and raised in Honalo, Kona, and attended public schools there. He also attended Japanese School at the Daifukuji Mission just north of present-day Teshima's Restaurant in Honalo. By the second grade, he was nicknamed Dempsey after the famed boxer Jack Dempsey of those times. Harada rarely started a school yard fight, but he always made quick work of the class bully, rightfully earning the nickname.

Dempsey came to the ranch in the depth of the Great Depression years as a temporary worker at the Old Dairy under a Mr. Yamashiro, who later counseled him to become a shearsman at Humu'ula during shearing season. Pleased with his work ethic, A. W. Carter asked Dempsey to become a full-time utility worker. From this point forward, Dempsey's history is closely tied to that of Jimmy Kurokawa. Dempsey was a quiet and peaceful man, and respect for him as carpenter foreman was based on his skill, diligence, and even-handed demeanor. Dempsey and Jimmy worked well together, their qualities and skills complementing each other.

There are four distinct project areas in which Jimmy made significant contributions to the success of the Parker Ranch mission: (1) old building relocation and renovation; (2) execution of the architectural vision of Richard Smart (monarchy/*paniolo* theme); (3) commercial building construction and renovation; and (4) serving as a direct and personal building inspector for Richard Smart projects on and off ranch properties.

Building Relocation and Renovation

There is probably no crew in history other than Jimmy's that moved not only spacious bull barns but whole villages from one ranch location to another. The need for relocation of employee bases was practical: Remote stations lacked the schooling, health, and human services support required for the subsequent generations of ranch families. Waiki'i Village is the prime example. Over a dozen homes were boarded and cross-braced, loaded onto flatbed transport trailers, and trucked to Waiemi, forming the nucleus of the 'Ahuli and Little Waiki'i subdivisions. Once placed back on pier blocks, the homes were serviced to county building code for plumbing and electrical facilities, then turned over to the employee in turnkey fashion. Now within walking distance, ranch families could enjoy the amenities of Kamuela town. Other outlying areas such as Makahālau were also affected

by the centralization theme, one that swept across rural America as families sought a better life—notably, the convenience of education, worship, and medical care, needs dear to the heart of Richard Smart. In his Parker Ranch career, Jimmy moved more than three dozen such buildings.

The Monarchy/Paniolo Theme

"Monarchy style" architecture was how Richard Smart described his vision for the visual theme of the Waimea area, the ancestral home of 'Āina Paka. While the Swiss chalet/gingerbread influences underscored the theme, the *paniolo* flavor became ingrained with it, given the hitching post, barn doors with crossbuck fascia, and sprawling *lānai* (verandas).

With painstaking precision, Jimmy adapted Richard's conceptual drawings into blueprints. Out of prime-grade redwood, Jimmy's crew carefully produced the intricate wooden panels that became shutters, railings, and eave trim, as well as doorway dressings.

A classic example of the handiwork of Jimmy and his crew can be seen today in the home of Richard's son, Tony Smart. Aptly called "The Barn" by Tony, the building in Wai'aka was the result of the carpenter crew melding two Waiemi Ranch homes of former employees George Keola and Charles Duncan, who worked in the horse program during the A. W. Carter and James Palaika (Brighter) period. Once it was restored structurally, the Carpenter Gang proceeded to dress up the exterior in true monarchy/*paniolo* fashion. Situated along the Kawaihae Road *makai* and north of Anna Ranch, the visual comfort of "The Barn" evokes fond memories of wonderful days gone by. Another example of their handiwork can be seen in the old Kahilu Town Hall, currently housing Parker School on the corner of Lindsey and Kawaihae Roads. In their own way, the Carpenter Gang under Jimmy's watchful eye and guidance became preservationists at work.

Commercial Building Renovation

Starting with the progressive era of Dick Penhallow and the presence of Richard Smart, appropriately zoned property was being eyed for economic productivity as opposed to idle landscape. While some of the buildings, especially the new (1962) shopping center, were done by independent contractors, it was Jimmy's job to monitor construction and provide change orders. Once finished, nearly 100,000 square feet of floor space fell under Jimmy's purview. By 1970, he was appropriately given the title superintendent of physical properties, reporting directly to business manager Jim Whitman. Requests for repairs, maintenance, and renovation were prioritized by Whitman, then forwarded to Jimmy for execution. The two men enjoyed a good working relationship, their roles being mutually supportive.

Ranch Project Building Inspector

The fourth significant role played by Jimmy was Richard Smart's "inspector general" of any special projects undertaken by the ranch owner. Well aware of the state and county planning codes and building inspector bureaucracies, Richard entrusted Jimmy to closely monitor construction details. He was in a position to question—and at times challenge—project details put forth by some of Hawai'i's finest architects and engineers. Often his points of contention related to weather, wind, and rainfall patterns that required greater attention to safeguard build-

ings and occupants. Much of his sensitivity to such physical factors came from years of experience in the north Hawai'i area, where wind, rain, fog, and flooding have wreaked havoc with the community. Jimmy earned the trust of Richard Smart, just as he did that of A. W. Carter, through loyalty. He retired after forty years of service to Parker Ranch and Richard Smart. He continued to provide inspection services on ranch projects even in his retirement years.

Ironically, Jimmy lost his life in service to Richard Smart. During the construction of Kahilu Theater, he had clambered upon the plywood subroof and was approaching a ridgeline when the partially attached plywood panel collapsed beneath him, sending him to the floor below with nothing to break his fall. Lost to his wife and wonderful children, Jimmy was as much a loss to the ranch and the entire community. Devastated by the news of Jimmy's passing, Richard Smart matched the agony and grief of his beloved family.

No biography of Jimmy Kurokawa would be complete without including some of his unique and often humorous episodes. Having witnessed many of his escapades, I offer one of my recollections that typically illustrates Jimmy's discipline, underscored with compassion and flavored with rascality.

My veterinary clinic had an isolation ward at the rear of the building where cats and dogs were boarded or hospitalized. Joan (Fluffy) Greenwell, daughter of ranch manager Rally Greenwell, was a longtime and dependable employee of the clinic when a cat escaped her grasp and ran out the rear of the ward, dashing through the gate separating the facility from the rear of the warehouse complex. In pursuit, Fluffy was momentarily relieved when the cat ran beneath the cabinet shop of Lee Uyeda and Tommy Kimura. She called secretary Elaine Loo and me to assist in retrieving the feline, crouched deep beneath the floor of the shop. Working at the shop were Lee Uyeda, Tommy Kimura, and ranch saddle maker Yama Horie. We spent fifteen minutes of fruitless attempts at coaxing the cat out from under—all six of us on our knees whispering, "Here puss, here puss," when Jimmy drove up in his green and white Ford Bronco, clearly perturbed at what he saw. I began to feebly apologize for commandeering his men when he stepped from his vehicle and approached the shop. Lee and Tommy appeared sheepish and awkward when Jimmy, in his deep, nasal, very nisei drone growled, "I go show you how!" On his knees and all alone, Jimmy called to the frightened cat, softly growling, "Come pussy, come pussy, come, come, come." Tentatively, but deliberate in its steps toward Jimmy, the cat came up into his arms. Both Jimmy and the cat were purring when he handed the feline back to Fluffy. "See, 'as how you make," were his only words when he drove off with a wide smile.

As gruff, abrupt, and disciplined as Jimmy was, his character was founded on a good heart, an intelligent and sensitive mind, and an indefatigable sense of rascally humor. Sayonara, Kurokawa.

Herbert Masato Ishizu

When I met Herbert Ishizu, he was a pump man assigned to the Pā'ali'i diesel pump facility located in the 'A'ali'i II paddock of the ranch, adjacent to an 11-million-gallon reservoir. Herbert's son Roy made the introduc-

Left to right: Tommy Kimura, Sueo Yamasaki, and Frank Hess taking a coffee break. Courtesy of Leilani Hino.

tion during my first days on the ranch, and over the next decade I grew to appreciate the depth of knowledge held by this quiet but friendly gentleman.

On January 18, 1911, Herbert was born to Keijiro and Tami Ishizu in Pa'auilo Mauka, Hawai'i. The family moved to Waimea shortly thereafter, where Keijiro worked as a gardener at Pu'u'ōpelu, the Parker family home. Little Herbert occasionally played with a boy of destiny, Richard Smart, when he accompanied his grandmother, Aunt Tootsie, to the family ranch.

Herbert had an older brother, Edwin, ten years his senior, who entered employment at Parker Ranch assigned to the Humu'ula Sheep Station. When Herbert was eleven, Tami took ill and longed to return to her homeland. When Keijiro and Tami left for Japan, Herbert and another brother were placed in the care of O'ahu relatives named Sumida. Brother Edwin forwarded a portion of his meager ranch salary to support both his siblings on O'ahu and his parents in Japan. Sadly, Edwin was killed while crossing a storm-ravaged gulch in the Laumai'a section of Humu'ula— since referred to as Ishizu Gulch—where the Wailuku River begins at an elevation of 8,000 feet on the slopes of Mauna Kea. Their mother Tami also died while in Japan. This left the Sumida family to look after Herbert and his brother. By graduation in 1930 from Pearl City High School, young Herbert affirmed that his life be dedicated in service to Parker Ranch.

Returning to the Big Island aboard the SS *Humu'ula* in September 1930, he immediately joined the ranks of the ranch, working at Waiki'i under Donald MacAlister, doing a variety of farming chores. Herbert's technical skills and broad areas of interest became evident to those around him, and soon his responsibilities grew to include poultry raising, hog and cattle feeding, and orchard chores. In 1935, he married Ayano Nakamoto and they produced three children: Roy, Amy, and Irma.

Jimmy Kurokawa at his yakudoshi *(Japanese 61st birthday celebration). Courtesy of Elaine Kurokawa.*

Herbert Ishizu with his ready smile. Courtesy of Roy Ishizu.

Herbert and Ayano worked hard to raise and educate their children. With due pride, both parents witnessed the college graduation of all three children.

Herbert's self-taught technical skills included mechanical, electrical, welding, blacksmithing, and woodworking aspects. These qualities became further expressed when he was permanently assigned to the Pāʻaliʻi Pump Station, where a Caterpillar diesel engine pumped Kohala Mountain water farther upland to the Waikiʻi #10 pump, which finally drove the fluid volume up to the Aipalaoa Tank at the top of Puʻuanuanu paddock. A small line cabin called Pāʻaliʻi House became Herbert's headquarters, where he often slept during the workweek and rode home on weekends on his trusty black mount, Pōpolo. Young Roy occasionally made these treks straddled in the saddle behind his dad. This sealed Roy's love for horses that endures to this day.

Herbert erected a shop behind the cabin where he did handiwork between pumping and maintenance chores. With his lathe he produced *koa* bowls, lamp stands, desks, and other furniture. He crafted bits and spurs as a hobby, but with a forge and anvil he produced gate hinges and hooks. In his leisure he also made *pahiolo* (dehorning saws) for the cowboys, who often had his handmade bits and spurs in their possession. Occasionally, a cowboy would bring him a cowhide to cure to make a *kaula ʻili* (rawhide skin rope), a hobby of Herbert's that he enjoyed with a zest.

Herbert was an active participant in community service activities. Educated and fluent in Japanese, he spent countless hours with immigrant workers at Waikiʻi providing them with counsel in the naturalization

process, taxes, and English language basics as well as providing comfort to these people in their new environment. Aware of his parents' hardship in returning to Japan, Herbert was a patriotic advocate for the American way of life, and through his counsel dozens of Japanese immigrants (issei) were naturalized. Hawai'i, thanks to Herbert, became their permanent home, and the issei thrived in a democratic society. But Herbert's patriotism was challenged in World War II, when he and his Waimea neighbor, Kiyoto Izumi, the principal of the community Japanese Language School, along with several other Japanese Americans from the community, were arrested as enemy aliens and threats to the safety of Hawai'i. Ruth Tabrah addresses the tragedies of those times in her book, *Hawai'i* (W. W. Norton & Co., NY, 1980):

> In Kamuela, the Big Island's cool upland village (better known by its ancient Hawaiian name, Waimea, changed at the request of the United Postal Service), haoles and Hawaiians from Parker Ranch and small ranches in that South Kohala district had been deputized. The area had a large population of Japanese farmers, independent men and women who long ago had turned their backs on plantation life. Many of the Japanese in the Waimea-Kohala community also worked as cowboys or supervisors for Parker Ranch. On the evening of December 7, the new deputies knocked at the door of Japanese Language School principal Kiyoto Izumi, a small, cheerful man who had been the adviser, translator, and community leader for Japanese residents in the area for many years. Izumi was told by men who he had assumed were his friends that he was being arrested as an enemy alien and a potential threat to the safety of Hawaii. He was in his pajamas. He begged that they not arouse his sleeping children. Mrs. Izumi ran to get her husband a heavy sweater. Then the deputies rushed him out of his house and into the open back of a truck.
>
> Next the deputies knocked on the door of Izumi's neighbor, Herbert Ishizu, a Parker Ranch employee who was informed he was suspect because he had a short-wave radio that the ranch asked him to use in communicating to outlying cattle and sheep stations under his supervision. Ishizu was summarily hauled out of bed by deputies who entered the room where he and his wife lay sleeping. He, too, was ordered into the truck. No time for farewells. No chance to change clothes. The two men, with others picked up in the same way in that vicinity rode more than a hundred miles that night—up over the saddle between Mauna Loa and Mauna Kea, through the cold air of the road's six-thousand-foot summit, then down into the humid heat of Hilo and up again into the chill mists of the volcano district and the army's rest camp at Kilauea, four thousand feet above sea level.

Through the efforts of A. W. Carter, Izumi and Ishizu—as well as several other detainees—were released. Especially in Herbert's case, his patriotic fervor was not diminished but enhanced. He was drawn closer to his church, becoming president of the Kamuela Hongwanji Mission. In 1949–1950 he served as president of the Waimea School PTA. In the scouting movement, Herbert

served as Cub Scout leader until his death. A founding member of the Kamuela Young Farmers Association, Herbert served as vice chairman of the Waimea Fair in 1957. This was the heyday of the truck farming industry on the Big Island, and Herbert was right in the midst of things. He personally started the Waimea Bonsai Club with several of his friends, including Yutaka Kimura. Through these associations he quietly placed Kamuela on the map in terms of horticultural activities.

For Parker Ranch, Herbert epitomized loyalty to the company, the land, the animals, and the people. Retiring in 1976 with forty-six years of service, Herbert immersed himself in his hobbies, his church, and his friends and family. Sadly, Ayano and Herbert perished in a car accident on a trip to Hilo in 1978. Herbert died at the mouth of the Wailuku River where it enters into the sea fifty-five years after his brother Edwin perished at the headwaters of the same river—both men ever loyal to the land.

I have always felt that men like Herbert (and the ranch had many of them), who were truly bright and intelligent people, would have become doctors, senators, lawyers, judges, veterinarians, teachers, and professors of their generation if they had had the educational opportunities. World War II and the GI Bill helped many, but not all—especially when their lives were lost in service to their country. Some, like Herbert, could ill afford to further their education.

Often thought of as eccentric by his peers, sort of an "absent-minded professor," Herbert had a level of intelligence above ours in many ways. He chose the simple life spent on a ranch he loved, working for the boss he loved, monitoring an ever-important water system, nurturing grass, plants, and trees while feeding chickens, turkeys, hogs, and calves. With pride in his work, his strong family, and community and church ties, he no doubt left earth a happy and contented man.

Hawaiian Beef Cattle Tours

In 1960, 1962, and 1965, the *Western Livestock Journal (WLJ)*, a trade magazine of top quality, cosponsored tours of Hawaiian ranches by livestock leaders of the continental United States. Dick Penhallow deserves credit for "opening the ranch gates" and allowing the world to witness the splendor of Parker Ranch. These tours were especially successful.

During Rally Greenwell's tenure in January 1965, the largest and most comprehensive tours took place, and Parker Ranch was the centerpiece. Cosponsoring the event with the journal were the Hawai'i Cattlemen's Council (Alex Napier, immediate past president) and the Hawai'i Soil Conservation Districts (Robert S. Sutherland, president).

The January 1965 Hawai'i Beef Cattle Tour had a special advantage: It was the post-convention event for the American National Cattlemen's Association Convention held in Portland, Oregon. More than a hundred attendees from Arizona, California, Idaho, Illinois, Montana, Nebraska, New Mexico, Ohio, Texas, and Wyoming opted for the Hawaiian ranch tour.

Nelson R. Crow, publisher of the *WLJ* and truly the force behind Hawaiian ranching tours, was well aware of the problems common to both insular and continental U.S. livestock operators, such as the cost-price squeeze and growing market pressure from imported beef. Crow appointed his affable editor John Choh-

lis as tour director, a fellow who interfaced very well with Hawai'i cochairs Ernest Gray of Koali Ranch on Maui and Alex Napier of Kahuā Meat Co. Ltd., on O'ahu—current and past presidents of Hawai'i Cattlemen's respectively. Napier was especially adept at opening doors and opportunities, and his friendship with Rally Greenwell did much to expand the horizons of the Parker Ranch portion of the statewide tour.

Napier saw to it that several of Hawai'i's more progressive ranch operations were featured, including the following: Haleakalā Ranch, Maui (Manduke Baldwin, manager), Hāna Ranch, Maui (John Hanchett, manager), Kahuku Ranch, Hawai'i (Freddy Rice, manager), Kīpū Ranch, Kaua'i (Mrs. Pat Rice, manager), Kūka'iau Ranch, Hawai'i (Dick Penhallow, manager), Magoon Ranch, Hawai'i (Eaton Magoon, manager), McCandless Ranch, Hawai'i (Robert Leighton Hind Jr., manager), and 'Ulupalakua Ranch, Maui (James Armitage, manager).

Charles Koontz provided a thorough tour of the recently completed Hawaii Meat Company (HMCo) feedlot at Barbers Point. It was a genuine eye-opener for the continental U.S. ranchers to observe the impact of the ocean freight expense of imported grain on the cost per pound of grain in feedlot finishing of cattle in Hawai'i. They were equally amazed at the high rate of shrink (8 to 12 percent) that occurred during interisland transport of feeders.

Rally Greenwell was a genial host of the group as they toured the purebred Hereford operation at Makahālau and the pasture improvement efforts in Kohala. These tours were very well received throughout the Islands. In the case of Parker Ranch, through the open intercession of Dick Penhallow, mainland

Western Livestock Journal *tour*.

ranchers were given their first glance of the interior of the fabled outfit, hitherto inaccessible save for a few close associates of A. W. and Hartwell Carter. The benefits of tours such as these go far beyond informational aspects. Such hospitality generates goodwill,

A formal portrait of Rally Greenwell during his early years as Parker Ranch manager. Pat Greenwell collection.

brotherhood, and mutual appreciation for the Western way of life. Penhallow and Greenwell are both credited with expanding ranch horizons.

Changes at Hawaii Meat Company

One of Rally's first challenges was the continuity of administrative functions at HMCo. Through Norman Brand, Rally oversaw the interim management of the company in his role as president of the board of directors and simultaneously ushered in a new packinghouse manager on a permanent basis. Rally spent some of his time traveling between the ranch and HMCo headquarters on Middle Street in Honolulu, but then a managerial contract for the packinghouse and feedlot was arranged with Edwin and William Janss of Janss Investment Corporation, owners and operators of the Coachella Valley Feed Yard in Thermal, California. Janss Investment Corporation was also a resort and commercial land developer that likely eyed an opportunity to develop ranch properties. The California Janss feedlot operation accommodated 35,000 head of feeders. From this operation they brought back to Hawai'i Charles Koontz, who had earlier Island experience.

In relief of Norman Brand's dual management roles, Herbert E. Welhener was hired as general manager of HMCo. A third-generation meat purveyor, Welhener left Anderson Development Company (Flying A Corporation) of Scottsdale, Arizona. The Anderson outfit developed cattle ranches in Arizona, California, and Oklahoma. When the Janss management contract expired, Welhener was retained to run the packing plant.

The Janss Consortium

During Rally Greenwell's first year of management on the ranch, he assumed the presidency of the Hawaii Meat Company Board of Directors; Norman Brand was named treasurer. By January 1963, Richard (Manduke) Baldwin replaced Edward C. Hustace on the board, adding the strength of numbers and the business support of Haleakalā Ranch. Hawaii Meat Company was still a struggling concern, and the news that Donald Lau of Pālama Meat Company was merging that company with H &W Distributing Company

added to worries over the present competition provided by Kahuā Meat Company.

As general manager, Herbert E. Welhener had an able assistant in Charles Koontz, who ran the feedlot. Production problems, however, were centered on packinghouse inefficiencies. This scenario provided fertile ground for the Janss Investment Corporation (JIC) to make overtures to the HMCo board for assuming overall management of the feedlot, slaughter and processing plants, and the import and marketing divisions. On January 8, 1963, HMCo unanimously adopted such a resolution. Despite a month-to-month terminable clause basis, this decision would return to haunt them. Ironically, the final product differed from the initial proposal by Edwin Janss for a feeding agreement with Parker Ranch alone.

Working in behalf of Janss, James Daughtry, operator of Pacific Feeds, proposed that over a period JIC would acquire one-third ownership of HMCo stock. That met with little enthusiasm, but to his credit, Daughtry set out some appropriate goals:

1. Allocate $50,000 for improvements to bring the slaughterhouse up to par.
2. Accelerate payments to producers first within thirty days, then twenty-one days, and finally a fourteen-day period, by which time a rancher would be reimbursed for his carcass value. Prior to such a proposal, a sixty-day wait by a rancher for his money was routine.
3. JIC offered to relieve HMCo of responsibility for financing the feeding of producer cattle. JIC offered to finance up to 80 percent of the market value of cattle as they entered the feed yard. The offer also included 100 percent financing of feed cost

at 6 percent simple interest. Much of what the Janss package offered seemed almost too good to be true, but the HMCo board was optimistic.

At the Pu'uloa feedlot, Charles Koontz already expressed concerns for an oversupply of U.S. Good–graded carcasses as opposed to U.S. Choice grade, a superior marketable product. This problem was emphatically stated in an October 22, 1963, report to the HMCo board; the poor grading would not be resolved over the next three decades despite a litany of management, genetic, and nutritional changes.

Many of Daughtry's proposals on behalf of JIC were visionary, especially in regard to the relocation of the Pu'uloa feedlot and mill and the slaughter plant to Campbell Estate property at Barbers Point. What was sought involved a 125-acre parcel to be leased for fifty years and located on the *makai* side of Lighthouse Road. Using an option approach, the land would be incrementally improved over a sixteen-year period.

Complicating the matter was 'Ewa Plantation Company, which held the master lease from Campbell Estate. In order to interest the sugar company, it would be offered the existing 181-acre Pu'uloa land after it was vacated. In the interim, 'Ewa Plantation Company would clear the Campbell Estate parcel and provide labor for construction of the cattle pens. Once done, the sugar company would pay an annual lease of $17,500 for continued use of the Pu'uloa parcel. Owning the Pu'uloa parcel in fee simple, HMCo would be free to use the land no sooner than eight years after the final lease period commenced.

The most aggressive part of Daughtry's proposal was for a new slaughter plant to be

erected at the Campbell Estate site. On August 8, 1963, the HMCo board approved a motion for management to proceed with groundwork, architectural services, and regulatory studies for the construction of a new slaughter plant at Barbers Point. In the interim, parent company Castle and Cooke entered negotiations on behalf of 'Ewa Plantation Company regarding the Campbell Estate/Pu'uloa interrelated transaction. With their pencils sharpened, the Castle and Cooke agents proposed a less desirable option, but as Daughtry stated in an October 18, 1963, HMCo board meeting, "This isn't as good a deal as we originally spoke of but what are our alternatives?" In two years and two months, Leonard Bennett would arrive on the scene, exploring genuinely diverse alternatives.

Plans for the new packing plant at Barbers Point were moving forward. On October 16, 1964, bids were let on the new abattoir designed by Henschien, Everds, and Crombie that already had preliminary approval of the Meat Inspection Division of the USDA. Later in the same year, the new Hawaiian Milling Corporation (MillCorp) was formed for the purpose of milling feed grains of HMCo as well as Pacific Feeds. A new mill for the Barber's Point complex was contracted to Sprout-Waldron of Muncie, Pennsylvania, while the Nordic Construction Company was awarded the packinghouse construction project. As for the feed yard itself, a facility with a 7,500-head capacity was in the final planning stages to gradually phase out the Pu'uloa facility.

In January 1965, the principals of Janss Investment Corporation, Hawaiian Milling Corporation, and HMCo signed a feed yard management agreement. In exchange for managing the feedlot at Barbers Point, JIC would receive the following:

- 50 percent of profits of the first $50,000
- 40 percent of profits of the next $50,000
- 33 1/3 percent of profits of the next $50,000
- 25 percent of profits of the next $140,000

Signing on behalf of HMCo were Rally Greenwell and Norman Brand, while Herbert E. Welhener and Don Devine signed for MillCorp. In future years, Arthur Reinwald achieved the dissolution of this contract with the technical expertise of Leonard Bennett.

By early 1965, HMCo had made a 10 percent down payment of $111,300 on the Sprout-Waldron contract of $1,163,000 for construction of the new mill. A loan for construction of the proposed Barbers Point slaughterhouse was projected at $1.8 million. Aaron Chaney, realtor, was free to list for sale the 711 Middle Street packinghouse for $1.5 million.

Still serving as manager of HMCo, Welhener explored loan options from several sources for what was projected to be a cost of $3.5 million for building out the Barbers Point complex. One such offer came from Equitable Life Assurance Society of the United States. At an HMCo board meeting on May 27, 1965, the offer for financing was predicated upon each individual stockholder personally guaranteeing the loan. As expected, the stockholders were not receptive to this offer. By this time, the total loan package had increased to $5 million dollars.

An alternative offer came from the Federal Land Bank, in which Richard Smart would mortgage the fee simple lands of Parker Ranch (excluding coastal properties) to provide the funding for construction improvements. HMCo would in turn service the note by paying Richard Smart an additional interest percentage over and above. It should

Rally Greenwell with Janns and Welhener, signing the management contract for Hawaii Meat Company operations. PRC.

be noted by the Hawai'i cattle industry that Richard Smart was willing to step forth and provide for the *entire beef industry* a state-of-the-art cattle feeding, processing, rendering, and marketing complex by mortgaging the very ranch he so loved.

In a bittersweet turn of events, the tragic death of Herbert C. Welhener put the entire expansion process in limbo. Within two months of Welhener's demise, Leonard Bennett gathered the reins of the struggling meat consortium and provided a turnaround program of heroic proportions. On December 16, 1965, Bennett entered the pivotal scene with consideration, clarity, and gusto. By New Year's Eve, he had convinced the HMCo board to do all of the following:

1. Cancel the $5 million loan for construction.
2. Move 75 percent of the Pu'uloa Mill to Campbell Industrial Park.
3. Convert this mill to a batch-type facility in order to serve the dairy industry as well as remaining a feedlot.
4. Call for a refund of the $111,300 down payment to Sprout-Waldron.
5. Redirect construction plans to upgrade the existing slaughterhouse on Middle Street and in effect cancel the sale listing with Aaron Chaney. Middle Street improvements recommended were the following:
 a. Install rail-dressing facilities
 b. Build a new cooler
 c. Build additional office facilities
 d. Provide restroom and welfare facilities for all employees
 e. Improve loading and transport facilities
 f. Reroof the entire complex
 g. Redesign cattle holding corrals
6. Reorganize the render plant arm into a highly productive unit.

Instead of leaning on Richard Smart and Parker Ranch for a $5 million dollar loan, Bennett requested a $150,000 loan at 6 percent to help launch the restoration project on Middle Street, a location he described as very strategic in the meat purveying business on O'ahu. It was a diamond in the rough, but he converted the 1929 facility into an efficient unit over the ensuing three decades. In his own words, Bennett's goal was "a slow drift away from a salvage operation to volume merchandizing of marketable beef." He saw genuine challenges before him and faced them realistically, albeit at times brusquely.

Hawaii Meat Company packing plant in the early 1960s. By 1970, Leonard Bennett had built the facility to the curbside of Middle Street. PRC.

Hawaii Meat Company chill room, a part of the slaughter plant that was constantly upgraded to maintain the highest standards. PRC.

Leonard Bennett Arrives

The impact of Leonard Bennett on Hawai'i's beef industry was profound and enduring. Few men are more deserving to have their place documented in the history of Parker Ranch and the state cattle industry. Leonard's story is a captivating one that needs to be told. The man who knew him best—his son, Leonard R. Bennett III—recounts it here.

> Leonard R. Bennett Jr., Len or Lenny as most of his friends called him, was born August 2, 1916 in Hampton, Virginia. Most of his childhood was spent in the northern Virginia, Washington, DC area, with a brief stint in Tampa, Florida where his father became involved in real estate development. Bennett Sr. made and lost several fortunes in various endeavors during the twenties and thirties. Len Jr.

The Rally Greenwell Era

quit day school to go to work when he was 16 in order to help with the family finances. He completed high school at night and was a devoted Eagle Scout and Scoutmaster during his spare time. By the mid thirties he was driving a truck and delivering milk in the Washington area. During this period he befriended one of his insomniac customers and was catapulted into the biggest adventure of his life.

The military attaché to the Paraguayan Embassy in Washington, DC was a regular milk customer who slept very little. Invariably, he would be up during Len's early morning rounds and would invite him into the house for coffee. They became friends and shortly thereafter, the "general" was re-assigned back to Paraguay, where he and a few of his colleagues decided to overthrow the government and form a "Junta." There being no pasteurized milk in Paraguay at the time, the "general" wrote Len and invited him to come down and set up a pasteurizing plant. Having no better offers or prospects, and not knowing anything about the pasteurizing process, Len obtained engineering sketches, quit his job and embarked for South America.

Leonard successfully set up a small pasteurizing operation and was rewarded with a working cattle ranch in lieu of pay. Len settled in and looked forward to a future in the ranching business. Typical Paraguayan ranches at the time were thousands of hectares in size with some into the tens of thousands of hectares. In any case, while the size of Bennett's ranch is unknown, it was large enough to draw attention to the new "Patron

Leonard Bennett (left) and Randolph Crossley at a 1966 HCA Bull and Horse Sale. Courtesy of Len Bennett III.

Americano." When a fourth general decided to overthrow the Junta and form his own government, Bennett fled.

He saddled one of his horses, spent three months crossing Paraguay, northern Argentina, and entered southern Brazil. He rode into the city of Rosario do Sul, Brazil, and went to work as foreman on the kill floor of the Armour & Co., the packing plant in that city. After a year or so in Rosario, Leonard relocated to Rio Gallegos in Patagonia, Argentina, where he continued work for Armour & Co., packing lamb and lamb products. Most of the product was destined for the war in Europe. Leonard received a military deferment as a skilled worker critical to the war effort. On a couple of occasions, he let it slip that in his spare time he helped spot and identify Nazi shipping through the Strait of Magellan.

Bennett did well and rose through the ranks. He worked in plants that killed in

excess of 25,000 head of cattle per day during the war. While in Argentina, he met his wife of 53 years Jennie Noeli Galloway on the golf course in Gonet (close to La Plata) and married her in 1944. In 1946 he was transferred back to Brazil as Superintendent of the plant in Rio Grande, again, in southern Brazil, where their first and only son, Leonard III was born.

From Rio Grande, Bennett transferred to the US in 1950 where he spent two years running packing operations in Chicago and fighting impossible union labor situations. He hated every minute of it and asked to be re-assigned. Desiring to keep him, Armour assigned him to Australia. Len and Jennie packed their goods and just as they were about to ship off, problems in South America forced the company to change its mind. They re-directed him to Argentina where he knew the operation, the people and the language.

Swift & Co. soon thereafter bought Armour and the combined companies became International Packers Ltd. From 1952-1963 Bennett assumed expanded responsibilities, ultimately becoming Vice President of Operations for all of Latin America. His daughter Patricia Noeli was born in 1956.

In 1963, Leonard decided it was time to return to the US to ensure the proper education of his two children. During his last ten years in Argentina, he had witnessed the rise of Peron to Dictator of Argentina, the near "sanctification" of his ambitious wife, Evita, the ruin they inflicted on the economy and the descent into political chaos.

Leonard loved to tell of his meetings with Evita, and one of Peron's most ardent cabinet members, Lopez Rega, who was continuously holding up multinational companies to fund their pet projects and their private coffers. The issue was always the transfer price of beef and beef products to Europe. The two would threaten or create major labor issues until the company acquiesced and "voluntarily" paid money into whatever cause they were peddling. Len said: "We kept peeling off the bills until they said stop."

Len returned [to] the US in late 1963 and assumed international quality control for IPL. Bennett felt promoted into a non-job and was frustrated. In 1965 when the company asked that he return to South America to deal with another crisis, he said he had had enough and agreed to take early retirement. Suddenly, at the age of 50, having spent twenty-five years overseas with the same company, he found himself out of work, with a mortgage and a son and daughter soon to enter college.

Len's perseverance would continue to reward him and he would soon find work in Hawaii with Hawaii Meat Co., Ltd., Hawaiian Rendering Ltd. and Hawaiian Commodities Inc. as President and General Manager. He became close to Richard Smart, whose confidence empowered Len to make the changes and decisions that would propel those companies to record sales and profits in two decades.

Leonard retired in 1986 at the age of 65 and died in Honolulu of cancer in 1997, one day after his 81st birthday. Wife, son and daughter were with him to the end.

Cartoon: Drought conditions with Greenwell.

With Bennett settled in with firm tenure at the helm of Hawaii Meat Company, Rally focused attention on the ongoing drought crisis that was approaching emergency proportions.

The Drought of 1962

Rally came on as manager fully consumed with the pressure of a lengthy and intensive ongoing drought. He delayed shipments of grass-fed steers to HMCo until they were finished to the Parker Ranch standard while readily forwarding lightweight feeders to the feedlot to relieve the forage on the ranch. The young horses under training at the Breaking Pen were turned out as the Rough Riders became fence men, opening up new and hitherto unused marginal forest land.

The devastating drought of 1962 was a profound tragedy. Emergency measures were necessary to combat the drought. Parker Ranch was providing water to its own cattle, plus supplying water to the forty-eight Hawaiian Homes ranchers and their livestock. Catchment water from the state and county was down to a trickle, and the town of Kamuela, with its many produce farmers, was on a day-to-day alert. For Parker's water personnel, the drought meant juggling water resources among the three *mauka ʻahawa* (water heads)—Alakahi, High Pressure, and Low Pressure. The Kohala sections of Puʻuhue and Puakea struggled with minimum water in the Kohala and Kehena Ditches. From Humuʻula to Keanakolu, waterholes were down to slurry—a mixture of water and dirt particles—in other words, thin mud.

When juggling among the water heads no longer worked, the ranch's water personnel pumped or siphoned water from swamp to swamp toward the closest *ʻahawa* in the Kohala Forest Reserve area above Kamuela. The Main Ranch reservoirs also dropped down to slurry. It was eighteen months before the rains came, bringing rainfall averages to near normal. Then the drought returned, a malevolent force that was just as severe and prolonged as before. Rally witnessed a drop in

calving percentage from 86.8 percent in 1961 to 82 percent in 1962. Considering the ongoing drought, this was still a respectable production rate. The ranch supported more than 40,000 head of cattle (including cows, bulls, yearlings, and two-year-olds) during this period. Despite the prolonged drought and its potentially devastating effects, this time the ranch had a plan.

Rally's Water Plan

In the A. W. Carter era, gravity and pump pressure carried water to the upper foothills of Mauna Kea, but there was no livestock water in the 4,000- to 7,000-foot elevations, except for rainfall and fog mist. Cow herds were not inclined to graze too far upland from the middle-elevation water troughs, and verdant stands of grass were left in fallow. Drought conditions compounded these problems.

In the early days of Rally Greenwell's tenure as ranch manager, a three-point plan was hatched that would deliver water beyond the existing reach of the High Pressure, Low Pressure, and Alakahi water heads. First, a new intake was developed where the Upper Kohākōhau Stream was partially dammed with concrete and tapped with an underground 12-inch pipe that would carry water to the second stage of the plan: a new 7-million-gallon reservoir built adjacent to Richard Smart's home in Pu'u'ōpelu. From the reservoir, water would be pumped through a 4-inch pipeline to the third stage of the plan: a new 400,000-gallon tank at the 7,000-foot level in the upper reaches of the Pu'uanuanu paddock in a place called Aipalaoa. From this tank, water would be delivered via gravity through the continued new 4-inch pipeline across the Waimea-facing slope of Mauna Kea. Frequent intermittent "T" points distributed water along the entire 8-mile course, which became known as "Pipeline Road." It meandered from Pu'uanuanu through Kaniho pen, Kemole II, Kemole I Mauka, Hanaipoe, and ended just inside the Kalōpā State Park lease. Later the service would be hooked up with existing water service in Mānā, providing a circle effect. This final phase climaxed a distribution network that expanded the use of grass on Parker Ranch's high country. It also completed a system that linked the struggling Low Pressure and Alakahi intake lines that served the eastern sections of the ranch, such as Makahālau, Po'o Kanaka, Honoka'ia, Ka'ala, Mahiki, and Lālākea. The system was now "full circle," as water needs could be readily served from both the eastern and western ends.

Before this plan could be executed, some hurdles had to be overcome. The Department of Land and Natural Resources (DLNR) had to be convinced that further tapping of Hawai'i's mountain water was justified. A disagreement reaching back to the A. W. Carter era revolved around how much water the Parker Ranch was entitled to from streams traversing its fee simple land. Carter failed to resolve the problem. Norman Brand, the ranch's business manager during this period, was more successful, but only on the specific issue of the Kohākōhau intake above Anna Ranch, which was a critical component of Rally's water plan. Rally in turn, as livestock manager, had the daunting task of convincing Richard Smart to approve and finance this major undertaking. With Richard Penhallow gone, Smart assumed the role of general manager over Brand and Greenwell. While Smart eventually relinquished his day-

Right: High-pressure water head in the Kohala Mountains. Bill Case photo.

Bottom, left: Alakahi water head in the Kohala Mountains. Bill Case photo.

Bottom, right: Upper Kohākōhau Stream. PPS.

Puʻuōpelu Reservoir and the surrounding landscape complemented the home of ranch owner Richard Smart. PPS.

Aipalaoa Tank construction, a 400,000-gallon steel facility. Note internal scaffolding. PRC.

Aipalaoa Tank exterior. According to Kurokawa, 20,000 galvanized bolts were used in its reassembly. PRC.

Pipeline Road from Kaluamakani to Waiki'i. Hualālai can be seen in the distance. Bill Case photo.

to-day management role, the water master plan decision was his alone.

Greenwell sought the assistance of his close confidant, Willie Kaniho, who was responsible for the ranch breeding herds, to help launch this effort. The herds would greatly benefit from the enhanced water service in the high meadows. Rally and Willie made on-site inspections and took Smart on a long day's horseback ride from the 7,000-foot Aipalaoa site above Waiki'i along the proposed pipeline road to Kalōpā. From this viewpoint, Richard Smart got a close-up look at the vast meadows of underutilized forage, unavailable to cattle at these upper elevations for the lack of water. On these steeper slopes of high mountain meadows, roughly 5,000 to 6,000 acres were undergrazed.

Sixteen miles along Mānā Road, Tomo Fujii, a Humu'ula/Waiki'i cowboy and Caterpillar operator, driving Smart's Lincoln station wagon, met the party. Tomo mounted Willie's horse and led the other two horses home to Waiki'i stables, arriving at dusk. Saddle weary, Smart drove his men home,

Makahālau Pump House and its 400,000 gallon tank, a twin facility to the Aipalaoa Tank, August 1979. Bill Case photo.

now convinced of the necessity for the water master plan.

After the project was completed in 1962, the drought continued, but the improved water service proved a godsend, an enduring contribution of this management period. In later years under Charlie Kimura, more water resource concessions took place, and there was significant resolution of the water rights questions between the Parker Ranch and DLNR.

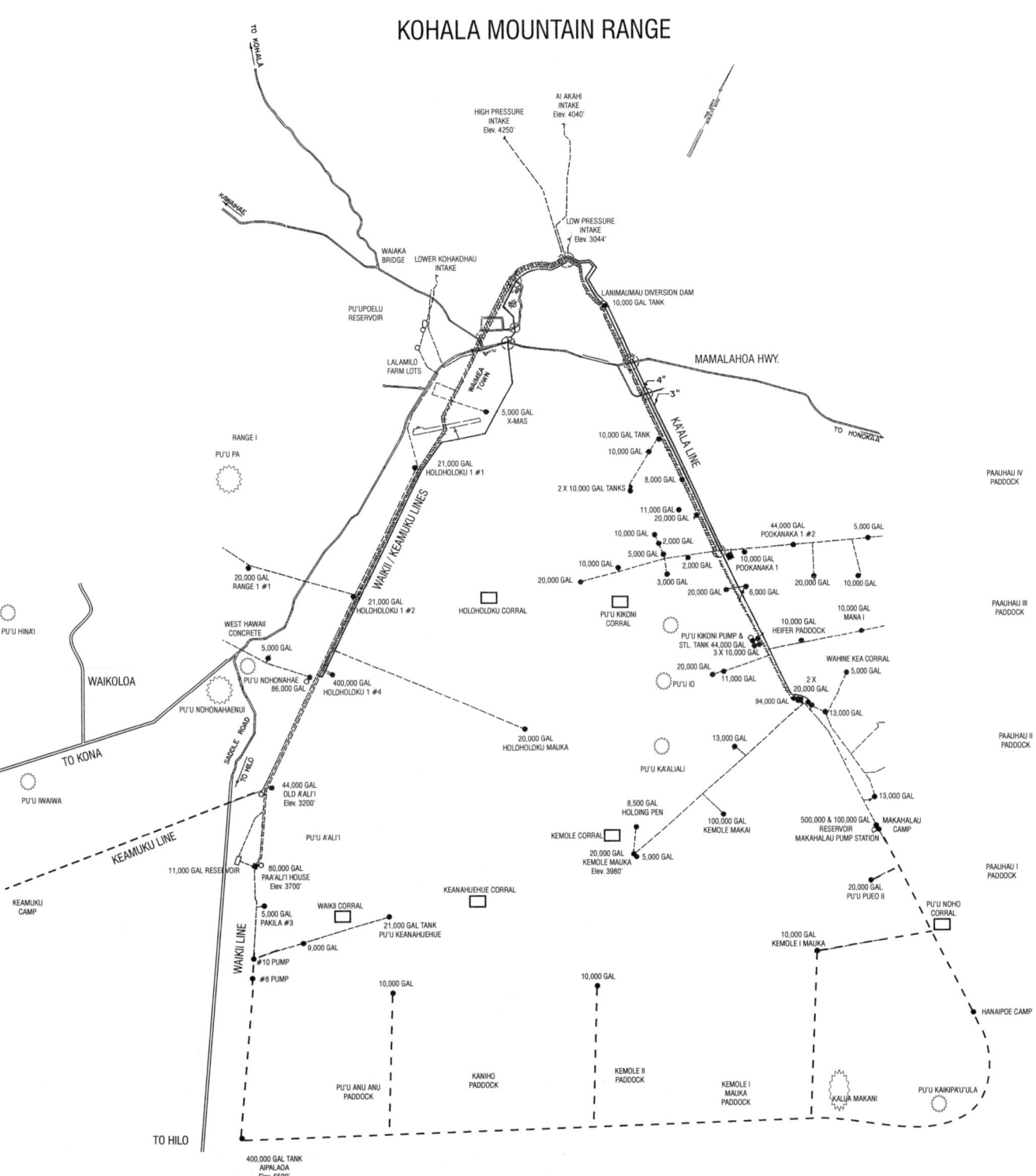

This map illustrates the extensive Parker Ranch water system of the verdant Kohala Mountains, stretching from Keʻāmuku to Honokaʻa Mauka.

Twilight of the Sheep Operation

With the closing of sheep operations at Humu'ula, there was more room for cattle. Declining wool prices and a shrinking market for lamb spelled the end of sheep production, and the decision to close was practical but painful. Rally closed the books on a fifty-year history of sheep flocks that sometimes numbered nearly 30,000, including the feral crosses, spread over some 42,000 acres of Mauna Kea's eastern countryside. But there was no sentimental crying over the end of the era, especially among the men charged with shearing, packing the wool, and dipping the sheep. There had been, in fact, some difficulty in finding willing hands to spend the springtime in Humu'ula carrying out these chores. The heifer-growing program soon was expanded on lands that once knew the bleating of sheep.

Beyond the failing wool and lamb market, Rally Greenwell—known for his disdain of the "woolies"—had four reasons for closing down the sheep operation. First and foremost, the financial return on the Hawaiian Homes Commission lease of the 33,185 acres would be significantly higher from cattle than from sheep. Second, the shearing plant at the Humu'ula Sheep Station was obsolete due to shopworn conditions and the slow rate of operations. A new shearing plant would not be cost-effective given the low return on wool. Third, lamb losses due to wild dogs and pigs routinely averaged 5 percent of the crop, and control of feral predators was frustratingly poor. Packs of wild dogs often killed sheep "for the sport," dropping the sheep with a single wrench in the throatlatch and then leaving the animal to die and decay. Both pigs and dogs savored a meal of newborn lamb, snatching it from its dam upon delivery from the birth canal. Calves alongside mother cows were afforded greater protection and thus their losses were curtailed to some degree. Fourth, it had become increasingly

Willie Kaniho at Ke'āmuku in a photograph taken by Patricia Greenwell in 1963.

The SS Humu'ula *loading out sheep—rams, lambs, and ewes—making the final shipment to Hawaii Meat Company in 1963. PPS.*

difficult to staff the shearing crews due to the remote location and the distasteful, arduous nature of the work.

Ironically, the final shearing in 1963 reflected a record high production of 145 bales of wool totaling 33,289 pounds, which surpassed the 1908 record of 30,000 pounds. This exceeded the 1962 wool clip by 5,000 pounds.

The final shearing was nearly ceremonious as a result of the sentiment of some of the senior shearers, who witnessed a dying industry. Tetsuji (Dempsey) Harada was top shearer that year, clipping 114 sheep in a five-hour period, averaging 2.72 minutes per animal. Isami Nishie was a close second, with 112 sheep during the same period. For Isami, it was his twenty-fourth consecutive year as a shears man. Humu'ula foreman Pete L'Orange, who oversaw the final shearing, recorded the best day of the shearing season at 608 sheep shorn.

Humu'ula Set Aside for Heifers

The heifer-growing program depended on the absence of bulls, except for the risk of Shipman Ranch *'āhiu* (wild) bulls moving *mauka* from Pu'u'ō'ō and Pu'u 'Akala, from Huikau through Pu'u'ō'ō, Laumai'a, Hopuwai, and Keanakolu, all on Humu'ula lands. Superior forage and reservoir resources were available. Consequently, weaned heifers were walked or trucked to Humu'ula and over a year's time were rotated around the mountain, reaching Keanakolu when they were eighteen months old. These robust heifers were

walked to Hanaipoe House, divided between replacement and feeder heifers, and driven by Waimea cowboys to the appropriate pastures. Sometimes the Humu'ula personnel received young heifers at Hanaipoe and walked them back to their new home at Humu'ula, and the cycle began again with the next year's heifer calves. This occurred in 1963, when about 600 weaned heifers took a three-day jaunt to Keanakolu. The first day took them from their home at Second Gate to Makahālau; the second day from Makahālau to Hanaipoe for another night's rest before trekking to Keanakolu House, where the cowboys also rested. The Humu'ula Gang joined them for the night before a two-day walk took the heifers to their new home at Kalaieha, the headquarters.

I was familiar with this part of the mountain, since much of my youth was spent working for Shipman Ranch at both the Pu'u'ō'ō and Pu'u 'Akala sections, comprising a 20,000-acre entity *makai* of Parker Ranch, stretching from the Saddle Road all the way to Honohina paddock next to the Hopuwai section of the Humu'ula outfit. I observed a natural system of growing-out heifers with the nominal absence of bulls. When the occasional wild bull traveled *mauka*, it was a pleasure to rope him, bob his horns, castrate him, and lead him back *makai*. The Humu'ula men under Willie Kaniho savored these opportunities for excitement, and generally these bulls did little damage among the heifers because of frequent riding-out by Willie and his men, including Francis Pelekane, Samuel Awa'a Jr., Louie Akuna, Jimmy Watt, Fred (Tolo) Kauwe Jr., Thomas (Sapo) Liana, Tomo Fujii, Take Horie, and others.

In 1972 the heifer-growing program was abandoned; new ranch management went to a cow-calf division by breeding the mature heifers.

Many old-timers have opined that it was the sheep flocks that had kept out an infestation of gorse. In the thirty years after the sheep were gone, those warnings proved all too true—but for other reasons, as the indestructible plant took over the Humu'ula area completely. The steady gorse control efforts (2,4,5-T application) had been suspended. No man familiar with the area years ago can today pick out the ravines, ridges, or stone outcroppings that were landmarks in the area. *Minamina . . . aloha no!* (it is to be regretted).

One of the more colorful characters to emerge from Humu'ula was Louie Akuna, who rose from a high school dropout to become a significant leader on Parker Ranch. His role is worthy of a detailed history.

The Louis Akuna Story

If I had to choose a peer/contemporary, Louis Akuna would likely be the individual with the earliest/longest interrelationship. Louie and I were just a month apart in birthdates. At age nine, I became immersed in the household of John Holi Ma-e. Directly across the road from Holi's home in the quaint village of 'Umikoa, the headquarters of Kūka'iau Ranch, was the home of Holi's cowboy counterpart, William (Willie) Miranda Sr. Louie Akuna developed a more than routine presence in the Miranda home since his mother Annie was a lifetime friend of Willie's wife Dorothea, a schoolteacher whom everyone called "Aunty Dot." I found playmates among the Miranda boys Melvin and Jimmy, and Louie was a frequent cohort, along with Ronald (Ronnie) Montero. Our greatest ex-

citement would come when Uncle Holi and Willie would butcher and *hemo* hair (remove the hair from) hogs for a pending *lū'au*. Willie also operated a piggery about a mile north of the Kūka'iau Ranch Dairy, an operation that supplied all twenty-one homes in 'Umikoa village with a gallon (if you brought your own bottle) of fresh milk each morning. Willie used the dairy by-products to add to the ranch garbage that was enhanced with *pipinola*, papaya, and *honohono* grass gathered by all the boys.

Louie quickly became enamored with the cowboy skills of his Uncle Willie, much like I did with Uncle Holi. When we returned to Hilo to continue schooling, Louie and I hung around the Ho'olulu Park racetrack stables, where elderly "John Silva" (John De Silva) kept a string of gentle academy horses for rental. Doing chores for the "Old Man" afforded us an hour's trail ride—often to Old Waiākea town, where we would wave readily to envious classmates riding home to Keaukaha on the sampan buses. Thus Kūka'iau Ranch and Ho'olulu Park were common launching pads for the coming careers of Louis Akuna Jr. and Billy Bergin. Later, the Humu'ula Sheep Station and Pu'u'ō'ō Ranch became common ground for both of us.

Louie's parents were reared in opposite corners of the Big Island. His mother, Annie Ung Kau Wong, was born to Chinese immigrants near Hawī in North Kohala. Another first-generation Chinese American girl was born a few days later: Dorothea Soon Yee (later Mrs. Dorothea Miranda). In their early school years, the two girls became inseparable, referring to their relationship as "mud pie friends." Making use of their parents' gardens, the girls trekked among the different ethnic plantation camps peddling fresh produce. Through high school, Annie and Dorothea excelled academically, but the latter young lady was college bound, fulfilling her dreams of a career in teaching.

Annie, on the other hand, went to work in the fields of the plantation, but not for long; she soon met and eventually married a tall, firm, but gentle Native Hawaiian man from Kalapana, Louis Manu Akuna Sr. Louis Sr. descended from a Puna couple, Lily Pu'umoewa and Charles Ka'ahakapu Akuna.

Louis Sr. and Annie made their home in Hilo, where he went to work in the Territorial Road Department. Not long after finding permanent residence on Kamana Street, the Akuna family was begun. Louis (Louie) Manu Akuna Jr. was born on December 18, 1940 (a month and three days later, I came into the world at Laupāhoehoe Hospital). Shortly afterward a daughter was born—Dorothea, named after her mother's childhood friend.

Young Louie's first interest in animal care was focused on raising chickens for domestic use. His supportive father built sturdy coops, encouraging his son to be dutiful in caring for these birds. This interest in poultry gradually shifted toward cockfighting as Louie approached adulthood. By his teens, young Louie's presence at the Ho'olulu Park racing stables became routine, where on occasional weekends Parker Ranch cowboys could be found browsing among the shed rows sharing stories of the famed ranch and the legendary Willie Kaniho of Humu'ula Sheep Station. Through these informal contacts, Louie was able to secure weekend opportunities to camp out at Humu'ula, and these trips became pivotal moments in the direction of his career—a Parker Ranch cowboy working under Willie Kaniho, the tough-

est of them all. Willie took an immediate liking to the ruffian Hilo boy, and before long Louie was spending whole summers in the mountain ranges from Humuʻula to Keanakolu, while I worked immediately *makai* for Puʻuʻōʻō Ranch in the paddocks spread below Humuʻula to the bottom of Parker Ranch's Hopuwai lands.

Determined to quit school after his junior year, Louie's entry onto the ranch payroll was not without the intervention of Willie, who drove to Hilo to visit the Akuna parents at their Kamana Street home. Willie was aware of the Akunas' desire to have Louie complete high school, but they were also practical in realizing where Louie's true love lay: in the foothills of majestic Mauna Kea. Comfortable with the fatherly oversight of Willie Kaniho, the Akunas gave young Louie their blessing, and in 1957 he became a Parker Ranch cowboy stationed at Humuʻula.

Louie remained at Humuʻula for a decade, during which time he developed relationships—not all good—with cohorts such as Fred "Tolo" Kauwe Jr., Donald Balucan, Jose Cumlat, George Pahiʻo (aka Keoki Liana), Thomas (Sapo) Liana, Jimmy Watt, Samuel Awaʻa Jr., Francis Pelekane, Francis Hui, and Anthony Oliveira. During different times, Willie's leadership roles transferred to Peter L'Orange and Alex Penovaroff. By this time, Louie's reputation as a horseman was well known, with many of his mounts competing in rodeos and horse races. Although he allowed an occasional mean streak to enter into his training technique, his finished products were well groomed and mannered. Also by this time, Louie had forged a close relationship with another Parker Ranch horseman—Donnie DeSilva.

Louie loved pretty horses, and he sought a pretty wife. In 1969, he wed the love of his life, Patricia Elizares of Kalopā, youngest daughter of Manuel and Dora Elizares Sr. Donnie DeSilva, quite likely the closest friend Louie ever had, served as best man. Louie and Pat had two delightful children: daughter Tioni, who inherited Louie's feisty personality, and Lou-Boy (Louis Manu Akuna III), who grew to become a tall, handsome, and gentle image of his mother. Both children were ranch raised but had interests apart from horses and cattle. Lou-Boy has a son, Louis Manu Akuna IV.

Ranch management during Louie's formative years progressed from Hartwell Carter and Dick Penhallow to Rally Greenwell, who kept careful watch on the budding career of the Humuʻula horseman. Rally was aware that despite his marriage, Louie continued with a rowdy lifestyle between horse races, cockfights, and attendant gambling. Louie, having somewhat of a senior presence at Humuʻula, was too frequently found in the middle of arguments and brawls with his workmates. On occasion, his abusive treatment of animals was a more than significant issue. Rally knew that the rigid mentorship of Willie Kaniho kept Louie in line and directed toward a leadership development role. Without Willie's firm counsel, Louie lacked focus and self-discipline.

As a friend and veterinarian to Louie, I reflect frequently on the paradoxical relationship he had with animals, especially the ones he loved. A dog or horse trained by him that failed to reach its full potential was not passed on to a friend or cohort who could find use and purpose for the animal. Louie chose instead to put the animal away—usually with a swift bullet. He was just as quick to shoot wild dogs or strays, even if he knew the

Louie Akuna at Humu'ula riding a Sappho filly. Courtesy of Louis Manu Akuna III.

animal's master—oftentimes a cohort. This emotional paradox, often resulting in the life of animals he so loved, was sadly repeated in his own demise and that of his beloved wife many years later.

Ranch manager Rally Greenwell saw great potential in Louie and felt that leaving him in Humu'ula was a waste of Louie's life and that he could be of greater value to the ranch elsewhere. Rally ordered him back to the home ranch, where he could be kept under watchful eye while working at the Breaking Pen alongside his compadre, Donnie DeSilva. In 1967, only a decade after joining the ranch, Louie earned the right to become foreman. In the eyes of many, Louie had matured into a leadership role, and his rough-and-tumble habits would be held at bay.

During these years at the Breaking Pen, Louie's horsemanship reputation expanded, largely because of greater exposure, a large population of horses coming through the Breaking Pen, and a sharp increase in the number of rodeos, horse shows, livestock sales, and horse racing, both on and off Parker Ranch. Louie was often the flag judge at major rodeos, and people respected his judgment.

While most ranch horses went unshod, Louie and Donnie were exemplary in keeping their work strings well shod, as they often helped the Cowboy Gang on major drives or competing in shows, races, and rodeos, where good foot care is essential. At one of these sessions, Louie lost the sight in one eye when a nail fragment inadvertently flicked off and lodged in the cornea of his right eye. Ralph King, office attendant, immediately drove Louie to Hilo to be attended by ophthalmologist Garret Ludwig, a high school contemporary who became the Big Island's foremost

A proud Louie Akuna at the Fourth of July races in 1983 winning best horseman and best horse trophy categories. Courtesy of Louis Manu Akuna III.

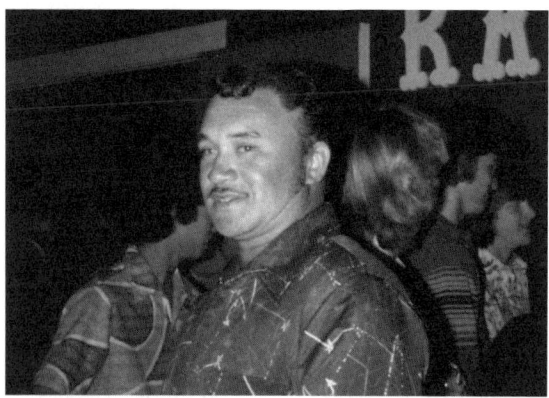

Louie Akuna at Brady Bergin's first birthday party at Kahilu Town Hall in 1978. He had lost sight in his right eye. Courtesy of Louis Manu Akuna III.

eye doctor. Despite Ludwig's efforts, Louie's eye was lost, and the painful ordeal took its toll on him and on his family.

Louie refused to be set back by the loss of an eye. He never missed a step in his horse training work and continued as an accurate and award-winning calf and team roper. His ability as a firm, fair, and insightful rodeo judge caused many veteran rodeo contestants to note that Louie "saw more with one eye than most judges could see with both eyes."

The horse department of Parker Ranch was soon mandated by Richard Smart to combine the Thoroughbred operation, breeding programs, and horse training, which included the Breaking Pen. The Breaking Pen came under the management arm of Alex Penovaroff, and Louie seemed challenged in "finding a fit" in the new structure. Aware that his former Humuʻula boss Penovaroff would cut him no slack, he left the ranch in 1970 in a tempest storm, leaving behind the land, livestock, and lifestyle he so dearly loved. Louie seemed to move from job to job over the next few years, with Pat assuming the role of breadwinner as she developed a career in nursing.

With constant encouragement on my part, the Rubel/Lent management team agreed to take Louie's plight under consideration. Middle-level management seemed unsure about bringing him back, some being concerned about his headstrong nature, while others recounted his loyalty and hard work for the outfit. Walter Slater was willing to take Louie's reapplication for employment under advisement. With the possibility of acquiring Seamountain Ranch in Kaʻū, Walter was looking for men willing to take on the challenge of the wild and woolly land and livestock of the former C. Brewer Ranch.

In late 1975, Louie reentered ranch employment, working under Charlie Kimura at Makahālau. A strong work ethic was never a problem for Louie, so the transition went smoothly. Moreover, Louie's love for ʻĀina

Paka was overwhelming. The Akuna family moved into the sprawling Makahālau home formerly occupied by Bull Johnston. The ranch put in a new fireplace, parking garage, and diesel generator. Louie quickly put together a new string of green-broken horses, and life was soon getting better, with wife Pat transferred to nearby Lucy Henriques Medical Center.

In the coming year, the Ka'ū expansion of Parker Ranch was becoming a reality. With Charlie Kimura named manager of the Ka'ū Division, Louie was selected by Charlie to join his Kapāpala team as foreman of the operation that would spread from Volcano (Keauhou Ranch) to South Point (Ka'alu'alu Ranch). Louie and his family bundled up their belongings and moved to Ka'ū.

Louie's leadership role in Ka'ū was launched with gusto. He had a supportive and able-bodied crew of Waimea cowboys, handpicked with the advice and counsel of some of the better former C. Brewer ranch hands: Johnny Pieper, Buzz Andrade, Leighton Freitas, and Buster Enos. In the first year, Louie and his men harvested large numbers of cattle, from premium feeders to wild bulls and stags. An occasional personnel fracas would surface, however, and management became concerned that morale was beginning to plummet. With confidence in Louie's leadership compromised, he was returned to his former position in Makahālau, which seemed to suit him just fine.

Louie was likely aware, due to his grassroots contacts, that a secret investigator was circulating in the shadows of 'āina Waimea. For whatever reason, he took genuine issue with the investigator's role and in frustration tendered his resignation to then ranch livestock manager, Charlie Kimura. Although Charlie tried to counsel Louie into thinking over such a terminal matter more thoroughly, Louie insisted on signing off immediately. His impulsive action was regretful, as within a day, Louie returned to Charlie's office for reconsideration. Charlie's position was firm: Louie had been forewarned of the finality, and the decision was not rescindable. Louie later pursued a wrongful termination settlement.

Such a tumultuous series of events took its toll on the entire Akuna family—especially Pat. In the ensuing months, Louie moved from job to no job and back. Some of these were great opportunities, such as becoming farm manager at the Kulani Correctional Facility, which included a beef cattle herd and swine herd—right down Louie's alley. Again under rigid regimental and regulatory boundaries, Louie was challenged to fit in, despite the good salary/benefit package and civil service positioning.

By this time, Louie and Pat had become estranged. With his employment status again in limbo, Louie's only hope was a settlement in his favor via the Labor Relations Board for his charge of "wrongful firing" by the ranch. Louie had a good attorney who gleaned a modest settlement, which he squandered on gambling, trucks, trailers, and horses. Louie was nearing the end of the line, and he knew it was time to say goodbye.

One day he rented a car and proceeded gradually to circle the island, bidding his compadres aloha under the guise of just coming by to say, "Hi, howzit brah!" All through Hāmākua, Waimea, Kohala, Kona, Ka'ū, Puna, and finally his *one hanau* (land of his birth), Hilo, Louie presented a joyous face, his *kolohe* (mischievous) grin, with one eye greenish brown and sound, the other opaque

and blind—the one he gave to Parker Ranch. As was his habit, he brought something to each of his friends, whether it was a ziplock bag of his special *char siu* smoked pork or a fine horse bit knowingly cherished by a buddy.

The next day, Louie called Pat, seemingly interested in putting their problems behind them and starting over. They met at the Pana-ewa Quarantine Station, an isolated, private, and neutral ground. It was there that Louie took first her life and then his own. While such a tragic act may have brought Louie's life of personal agony to an end, few friends could fathom his taking the life of the loving, caring wife, mother, aunt, and most notably nurse and caregiver to the sick and less fortunate —Patricia Elizares Akuna. For Louie, Pat was his alone and could not be loved, appreciated, or adored by anyone but himself. Was it an act of senseless futility or an expression of misdirected but supreme love? Who can know what Louie was thinking when he took the life of the individual who brought him the greatest happiness and goodness in his life, as well as a fine pair of beloved children? It was nonetheless a tragic end to each of their lives. Both Louie and Pat had so much to live for.

Despite this sad conclusion to his troubled life, Louie in his prime made significant contributions to Parker Ranch. Thus the history of Parker Ranch could not be recounted without including Louis Manu Akuna Jr. *Aloha 'oe*, Louie and Pat.

The Cow-Calf Operation Enters Maturity

Other changes took place on the ranch, one of them being a shift from a partially grass-fat outfit to a purely cow-calf operation that opened up more pasture and made for an increase in the cow herd. Rally had mandated an increase from 14,000 to 18,000 cows. He had a five-point plan to accommodate an expanded cow herd. It began with an end to the grass-fat era.

As of October 1963, the last grass-fat cattle were shipped to Hawaii Meat Company, availing the premium grazing resources to an expanded mother cow herd. The second thrust was already underway: a profoundly expanded water system in volume, pressure, and comprehensive servicing of additional water troughs.

The third initiative was agronomic: disc plowing of paddocks, followed by intensified grass and legume planting. Fertilization in the form of aerial delivery soon followed. Some of these efforts began in the Penhallow era and were further executed during Rally's tenure.

The fourth step involved significant reduction in horse breeding coupled with expediting sales. The Thoroughbred program, also a Penhallow initiative, was spun off under the direction of Alex Penovaroff, and several significant race horses left the ranch for successful careers on the West Coast. Rally, however, returned to service a popular Morgan stallion named Junior that had been stabled during Penhallow's enthusiastic horse breeding program. The ranch horses, in the era preceding the use of trailers, were enhanced by the stamina typical of the Morgan breed. The Thoroughbred influence made them good travelers.

The final component of the expansion plan was the mandate for more pen space at the O'ahu feedlot to accommodate a full calf crop of feeders in the years to come. Progress

Spraying the cow herd for horn flies at Puʻuhihale Corral. Penhallow collection.

was gradual. In 1964, Rally carried 16,000 cows with an 85 percent calf crop.

Plans were already under way to accommodate a larger cow herd, producing a larger calf crop that was wholly destined for feedlot finishing (except those retained replacement heifers and bulls). By the time an 18,000-cow mandate was achieved, water, grass, and feedlot resources were already standing by.

Historically, Hawaiʻi's ranchers weaned their calves and set aside premium growing pastures in hopes of a seven-month-old, 450-pound weaner developing into a 1,000-pound three-year-old with a fat cover adequate to satisfy the packinghouse. This was the grass-fed program of my youth—steaks that were not so tender but very flavorful. By the late 1950s, the tradition of pen feeding reached Hawaiʻi, and HMCo opened its feedlot in ʻEwa on Oʻahu in 1957.

Pen feeding with mainland grains allows a rancher to ship a 600-pound yearling feeder to the feedlot for a five-month finishing period. This accelerated feeding of a high-energy ration ideally results in the distribution of fat into the muscles, a marbling procedure that produces excellent flavor. In this program, the feeder is butchered as a two-year-old, providing tender beef based on its youth, confinement, and high-carbohydrate diet.

For the rancher, this process means shaving off perhaps a year of pasturing in getting his feeders marketed. He realizes that there will be a feed bill, with luck offset by the added value of the grain-fed animals. Meanwhile, he has created more room on the range for mother cows. This is precisely what happened with Hartwell's 12,000 mother cows on a grass-fat ranch, to Richard Penhallow's 14,000 mother cows on a ranch slowly converting from grass to grain finishing, and with Rally's 18,000 mother cows on a ranch whose calves became almost entirely feedlot finished. To be fair to the enthusiasts of grass-fed markets, Parker Ranch always kept a small but significant grass-fat program to satisfy local markets, and to many, range-finished beef is still more *ono* (delicious).

As cows increase in numbers, sacrifices are made in quality because borderline heifers must be retained. To temper this loss of quality, the ranch had to dip into feeder heifer groups for replacement numbers, and it was the eye and experience of the stockmen that struck the balance. The ranch had several

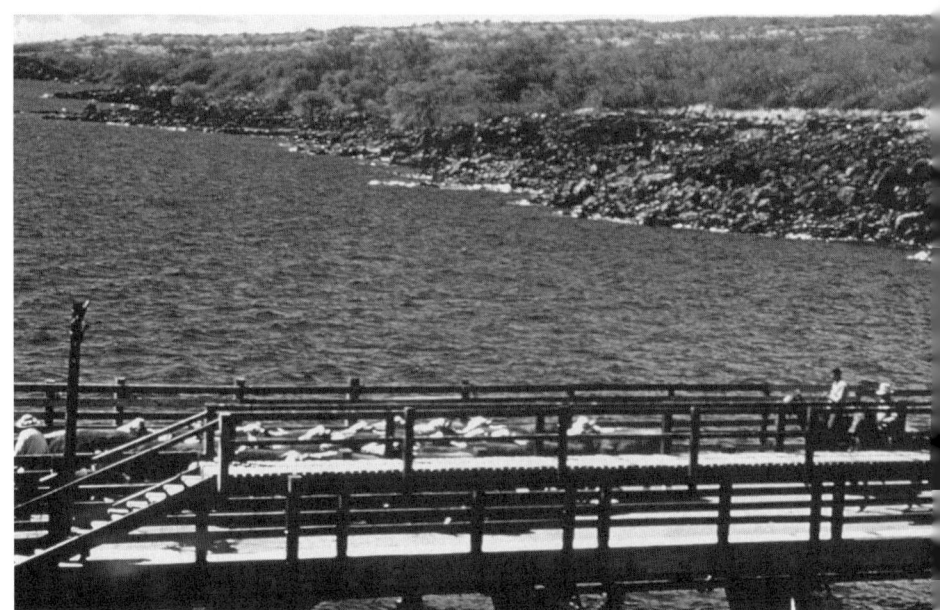

Last of the grass-fat cattle at Finger Wharf in Kawaihae. Courtesy of Kamuela Museum.

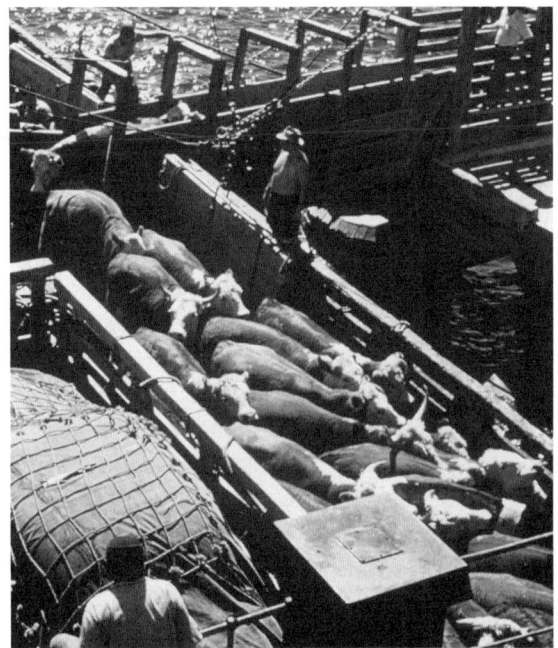

Last of the grass-fat cattle boarding the SS Humu'ula. *Courtesy of Kamuela Museum.*

Frequent water spraying of grass-fat cattle made the trip to Honolulu more pleasant. Courtesy of Kamuela Museum.

Hereford weaners at Puʻuhihale Corral, 1960. Note band of workhorses in the background. PPS.

such men in its ranks. Often this deeper cut into feeder heifer herds for replacements was done by Rally, but he had the support of field men such as Harry Kawai, Yutaka, and later Charlie Kimura.

Whether picking feeders, replacement heifers or bulls, a high level of uniformity was an important Parker Ranch standard. Even within a single breed such as the Hereford, achieving uniformity took skill, experience, and consistency of judgment. Some thousand additional replacements a year were kept over a four-year span to reach the goal of an 18,000-mother cow herd. The registered Hereford herd was returned to Makahālau from Waiemi under the continued supervision of Charlie Kimura. The large Waiemi bull barn was again dismantled and transported by flatbed truck back to its original foundation at Makahālau, the heart of the Parker Ranch purebred Hereford operation. In disrepair, the barn remains there today.

Santa Gertrudis Crossbreeding Program

By 1965, the mother cow herd reached 17,000 females, part of which included a significant number involved in the crossbreeding program. A relatively new breed of cattle—Santa Gertrudis—entered the ranch in the Penhallow era.

Kale Stevens in foreground looking back, Adam Quintal looking forward. Francis Pelekaue is in the background; Mauna Kea in the distance. PRC.

Gathering bulls at Puʻuʻio paddock. Pat Greenwell collection.

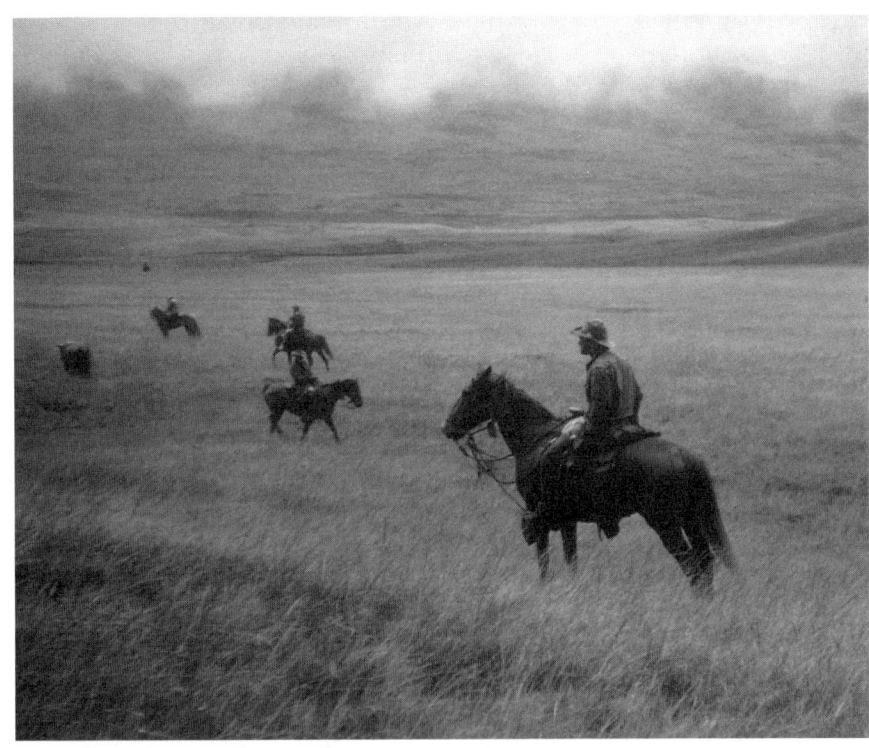

Kale Stevens giving oversight. Pat Greenwell collection.

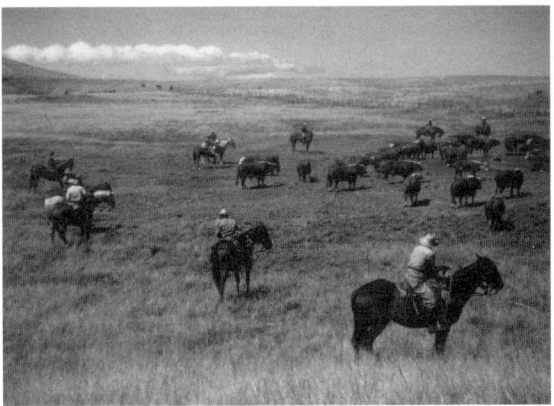

Above: Cowboys working as kiaʻi *(herd holders). Pat Greenwell collection.*

Right: Bulls being selected for different cow herds. Pat Greenwell collection.

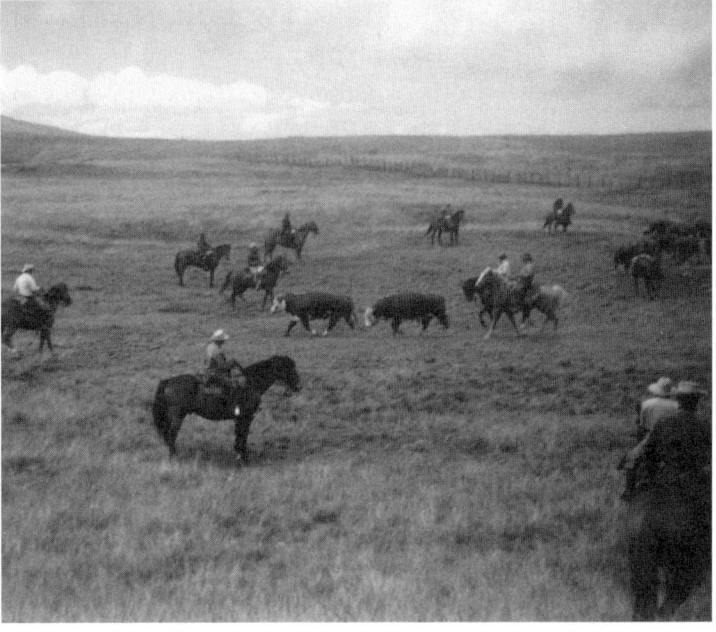

The Santa Gertrudis herd of some 400 cows was home on Range I, *makai* of the Waimea-Kohala Airport and Hawai'i Belt Road, almost to Saddle Junction, on down to the stone wall stretching from above Kawaihae Village and southwest to the area that was to become Waikoloa Village. The arid hills above Kawaihae (Kawaihae Uka I through IV) were also home to the Santa Gertrudis crossbred herds. The range did not lend itself well to becoming an annual and permanent cow-calf area because of its severe seasonality. Additionally, the Santa Gerturdis crossbred calves, while hardy enough, were not grading out after finishing at the HMCo feedlot and packinghouse. By this time, Leonard Bennett had become the well-established manager of HMCo, which included the packinghouse/feedlot complex, the latter of which became known as Hawaiian Milling Company. The outlay for the feedlot was more than a million dollars, plus $700,000 for its feed mill. The Santa Gertrudis program was a worthy experiment, but its continuation won little support, especially from Bennett, as the breed was inherently inefficient in converting a grain diet to well-marbled beef. Consequently, the range was restored to its historic and seasonal use: turning out large herds of resting bulls, growing steers, or even weanling colt bands—but only after the annual Kona storms, in which feed would be plentiful for several months. In 1999 an effort to convert Range I to an annual cow-calf venue met with disaster.

Changes Abound at Hawaii Meat Company

By the end of 1963, the winds of change came about for Hawaii Meat Company. On December 1 the Janss packinghouse management contract ended, but a seven-year agreement for continued oversight of the feedlot was executed, with HMCo retaining Herbert E. Welhener as manager of the kill plant. Charlie Koontz continued to run the feedlot when it moved from 'Ewa to Campbell Industrial Park at Barbers Point.

The new 125-acre site was secured with a fifty-year lease from Campbell Estate. Pens were built to accommodate 15,000 head of feeders, with space specifications for groups of 75 and 150 head. A new feed mill and storage bins were built at a cost of $200,000. The bins were designed to accommodate 12,000 tons of grain. Available to all interested ranchers, the first lot of Parker Ranch feeders was due on February 1, 1963.

Completion of the adjacent Campbell deep-draft harbor at Kalaeloa was intended to allow large delivery of cattle directly from Kawaihae and other neighbor island ports to the Barbers Point harbor. But regulatory, business, and political issues—the ever-present factors in Hawai'i's economic struggles—kept the direct shipment of all neighbor island feeders from ever becoming a reality. Many of HMCo's good fortunes, however, were due to the practical but firm legal advice of board counsel Arthur B. Reinwald.

A product of Chicago, Reinwald graduated from Drake University in Des Moines, Iowa, with a BA degree with honors. A member of Phi Beta Kappa, Arthur graduated from its law school a year later with a JD in law.

After practicing in Iowa for a few years, Reinwald entered law practice in Hawai'i in 1955. Over the following years, Reinwald was admitted to the U.S. Tax Court (1959), the U.S. Court of Appeals for the Ninth Circuit (1962), the U.S. Court of Claims (1980), again to the Ninth Court of Appeals (1982), and finally, Reinwald was admitted to the U.S. Supreme Court (1983).

Having taught at Drake University Law School, it wasn't long before he became adjunct professor at the William H. Richardson School of Law at the University of Hawai'i. In 1955 he became an associate and partner of Robertson, Castle and Anthony, which later became the present law firm of Reinwald, O'Conner and Playdon.

The presence of Garner Anthony in the original firm Reinwald was with has historical significance as it relates to Parker Ranch, A. W. and Hartwell Carter, and most notably, Richard Smart. When the torch was passed from Anthony, Reinwald was the logical choice to become personal counsel to Richard Smart, as well as to serve on the Hawaii Meat Company Board of Directors. Tax law and estate planning have been his career specialties.

Throughout his meatpacking career in the Islands, Leonard Bennett had a close friend in Arthur Reinwald.

Reinwald served admirably on the board of Hawaii Meat Company during trying times as well as times of resounding success, through the tenures of Bennett, Jimmy Greenwell, John Newcomber, and Ron Rea. This tenure continued for more than two decades. Reinwald, who described himself as a student of the meat-packers course, "Packing House Economics 101," was especially impressed with the business acumen of Bennett. A salient example of Bennett's sense for the business coup was his preordering immediately a two-year supply of grain for the Hawaiian Milling Company feedlot. Why did he do this? Bennett's early knowledge of President Richard Nixon's promise and delivery of huge U.S. grain stores to Mao's regime in China would cause a resultant spike in national and international grain markets. This action to prebuy the grain supplies not only saved the feedlot millions of dollars, but the cost of feeding ranchers' cattle was held very low while their mainland counterparts were later paying premium prices for the limited supply caused by the massive China export by the U.S. government.

In the mid-1970s, Richard Smart chose to move his personal counseling service to Ted Riecker, who not long thereafter became a trustee of the ranch's holdings. Reinwald's role in HMCo continued until his retirement from the board in 1984.

Bennett Challenges

Competition for market share was possibly Bennett's greatest passion. Well established by this juncture were the Kahuā Meat Company and Pālama Meat Company, and winning over meat producers' goodwill was heavy on his mind. Bennett acted on an initiative originally proposed by James Daughtry. Bennett wanted to accelerate payments for slaughtered beef back to the rancher. His reasoning in reducing the payment interval from thirty to seven days was spelled out in a March 6, 1966, statement:

1. We will be operating on our own capital rather than that of others.

2. Prompt payments encourage greater rancher and dairy consignments.
3. Further capture the market back from Australia and New Zealand.
4. Ranchers are expected to pay their feed bills on a current basis therefore, we should pay them accordingly.

In the first ten days of April 1966, Kahuā Meat Company closed its feedlot in Waialua. Acting on their behalf now was James Daughtry, who proposed that HMCo provide a letter of intent guaranteeing Kahuā space for 1,700 head of feeders, with a minimum of 1,000 head at any given time. In an April 28, 1966, board meeting, concerns were raised regarding the impact of extended droughts that might leave stockholders' and regular customers' cattle relegated to a secondary position behind Kahuā Meat's lot space. The minutes of the meeting state that "It was the consensus of the Board not to give Kahuā a Letter of Intent at this time, but to handle their cattle in the same manner as any other feed yard user."

This issue was not destined to go away but to grow into perhaps the most serious wedge that drove Hawai'i ranchers into one of two camps—either Hawaii Meat Company or Kahuā Meat Company. Unfortunately, Richard Smart and Parker Ranch were seriously wounded by the crossfire, which at times was reduced to personal attacks.

Busy working with the Hawai'i State Legislature was master lobbyist Alex Napier, who initiated House Bill 1160 and Senate Bill 1107, which were designed to reduce gross income tax on feed yard sales by about 97 percent. Napier was steadfast in pursuing these bills over several years until they were passed. When they were finally adopted, all producers in the state were granted tax relief on a par with mainland ranchers and meat purveyors.

One problem Bennett inherited was the rendering plant, which was 50 percent owned by HMCo and 50 percent by a California concern, Baker Commodities. Hawaii Meat Products Corporation was the name of the joint venture, which converted the offal and other slaughter by-products into tallow form that was containerized in 55-gallon drums. Marketing of tallow typically takes place via large tanks and pumps and is moved in volumes of 1,000-gallon units. Not only was the marketing of drummed tallow complicated, so was the management, repair, and maintenance of the rendering facility adjacent to the packinghouse on Middle Street. Bennett had a plan: Move the rendering facility to the Barbers Point property and find a niche market for tallow in 55-gallon drums.

Another challenge facing Bennett was finding a cheap local source of roughage to mix with grain for the feedlot rations. While the pineapple industry was still supplying pineapple bran for such purposes, other resources were under exploration, including the buying of cane stripping (leaf matter) from the sugar industry, hay from Moloka'i, or green chop (fresh-cut forage) from O'ahu growers. By 1967, Bennett projected the need for a 5,000-ton annual supply of cane stripping from 'Ewa Plantation alone.

Realizing that the feed yard and mill at Barbers Point and the packinghouse at Middle Street were the major components of the HMCo long-range capital improvement program, a $1,650,000 loan had been secured through Parker Ranch and Richard Smart. A million dollars of the proceeds were divided equally between the feed yard/mill improve-

ments and the Middle Street facility. After considerable research and deliberation, a contract to build a new feed mill was granted to Williamson and Strohsner. It would utilize much of the old mill components from the Puʻuloa facility. At a fraction of the cost of the previous Sprout-Waldron venture, Bennett secured the capital improvements for both facilities and reorganized and moved the rendering plant to a site adjacent to the feedlot at Barbers Point. All told, the $1,650,000 HMCo loan through Richard Smart and Parker Ranch was a twenty-five-year mortgage at 6.3 percent, with a gratuity of four-fifths of 1 percent going to the ranch owner. In the process of expanding the facilities at Barbers Point, a point came at which Mill-Corp became a stand-alone entity responsible for both the feed yard and the feed mill, the former of which had been operated by HMCo. All assets located at the Barbers Point facility were transferred to MillCorp. Taxes were the basis for this change, which brought about greater clarity of the function of the packinghouse on the one hand and the milling and feeding operation on the other.

Choice grading was Bennett's favorite topic since his arrival in the Islands in 1965. It was a genuine issue regarding nearly all cattle produced in the Islands, with Parker Ranch being no exception. The market for choice beef in Hawaiʻi was unlimited. The supply of fat cattle coming out of the feedlot was far from Bennett's goals in grading, uniformity, and consistency. In an October 12, 1966, board meeting he lamented that "It is impossible to dispose of 300 head of U.S. Good cattle in one week and no choice beef and then the next week no U.S. Good cattle and all choice beef. Between Kahuā and HMCo we can dispose of 100 U.S. Good cattle per week; with Hawaii Meat Company disposing of 80 of the 100 head." But, he said, the realization is that "Choice beef is the desirable product at this time and they [the supermarkets] are determined to sell this grade. This grade of beef is available in California and a telephone is all that is necessary to obtain this product with deliveries within seven to ten days. It is no longer necessary to order carcass beef as beef is now available to the markets in primal cuts."

Bennett was clear in setting a goal of producing 80 percent U.S. Choice beef from Island producers through the Hawaiian Milling feedlot. Reaching this lofty but market-based goal was a cause he constantly championed but never achieved.

Another major hurdle that Bennett strove to overcome was the dependence of Hawaiʻi's cattle feeding industry on the resources of local grain brokers. Bennett figured out how to go direct, whether it be Australia, Canada, or the U.S. mainland. Prepurchasing large volumes at market lows, he urged expansion of feed warehousing to serve not only imported grains but locally produced pineapple bran and Molokaʻi hay.

By November 1967, ground was broken for the new mill, which in turnkey shape would cost $468,000. Strohsner Machine Works, Inc., moved forward with construction. The facility design would include dairy ration fixtures in the event that such a market would develop.

While Janss Investment Corporation in earlier years offered to finance the feeding of HMCo cattle, Bennett made arrangements for a $250,000 loan from American Security Bank to bring such producer support in-house. A revolving fund was secured at 6.5 percent interest. Producers that marketed

their cattle through HMCo would pay the 6.5 percent interest, while ranchers who sold their carcasses elsewhere (Kahuā Meat, etc.) would pay 7 percent interest on financing feeding charges for their cattle.

A specific arrangement was made in late 1967 to accommodate Kahuā Meat Company feeding charges. HMCo granted Kahuā 90 to 120 days to settle feeding charges on cattle fed for their producer accounts. Kahuā was charged three-quarters of 1 percent per month (9 percent per annum) on all delinquent feeding charges. Guaranty of payment by the actual owners of the cattle was furnished to HMCo in light of there being no carcass as lien. Eventually Kahuā secured its own financing.

Bennett Turns the Corner

By 1967, Bennett was able to report significant increases in earnings for HMCo ($8 million in sales) and MillCorp ($3 million in sales) and in the number of cattle slaughtered and marketed—23,477 head.

The third component of the consortium, the rendering plant, was restructured in both form and function and given a new name: Island Commodities, Inc. (ILCo). In 1967, ILCo rendered a splendid year profitwise, despite the lowest tallow and meat meal prices in history. Bennett converted the disadvantage of drummed tallow into a marketing advantage by securing several smaller markets in the Far East that were unable to handle large-volume quantities. This was the niche market he was looking for!

Other issues for the year included a $70,000 settlement on cancellation of the Sprout-Waldron contract. JIC had by this juncture been purchased and renamed Diamond A Cattle Industries. With its management contract still in place with HMCo, it received slightly more than $34,000 in fees. Bennett was soon to zero in on the worthiness of continuing such a management contract with the remote Arizona firm.

Bennett saw an opportunity to pick up 4,000 additional cattle by purchasing the Kawaihae Elevator Company assets from Theo H. Davies Co., Ltd. The cattle committed to the Kawaihae feedlot would be redirected annually to Hawaii Meat Company. These sources included 2,200 feeders from Kūka'iau Ranch, 800 feeders from Big Island homesteaders, and 1,000 head that Parker Ranch had contracted to the Kawaihae feedlot project during Dick Penhallow's management. HMCo sought to acquire Kawaihae Elevator for $130,000 by proposing to issue treasury stock at $300 per share to Theo H. Davies, giving them ownership of about 5 percent of the common stock. Davies preferred the cash—two payments of $65,000 were made over the next two years. The larger picture for Bennett was the campaign to increase and stabilize the number of feeders from the Island ranchers into the MillCorp feedlot and the HMCo packinghouse, with by-products thereof flowing on to the ILCo rendering plant. Leonard Bennett saw the long and wide view, and if his efforts benefited the Kahuā Meat Company, then so be it: Both parties would gain.

Implementing his plan for international grain purchases, the first shipment of Australian barley arrived in 1969, effectively beginning a drive to lower prices paid to local handling sources. Over 6,000 tons of Australian barley arrived that year at $63 per ton in contrast to the $70 per ton paid for U.S.-produced barley. All consignors at the feed

yard gained from these savings, regardless of where their cattle were slaughtered. Cost per pound gained at the feedlot was reduced by 5 cents across the board. Later the same year the Hawaiian Grain Company, a local broker, offered to match the Australian barley price, reflecting Bennett's growing reputation as a serious negotiator.

All meat purveyors of these times felt the growing pressure of beef coming into Hawai'i from the mainland (primal cuts, block ready) and Australia, as well as New Zealand, which provided boneless cow beef and trimmings. Going to boxed beef via the HMCo Cut Meat Department was one solution. The other move Bennett made was having HMCo become an agent for beef coming out of Australia and New Zealand.

By early 1971, the HMCo Cut Meat Department had ramped up their facility to compete effectively with the block-ready imports by boxing beef according to cut, portions, or grade as desired by the markets.

With progress in feeder numbers into the 12,000-head capacity feed yard reaching a peak in early 1970, HMCo put a hold on incoming shipments until the 1,400-head overpopulation was fed through the system. Expansion of the feed yard was not a consideration at this time because it was assumed that the current glut of feeders was more a fluke than a true producer expansion. On the Kahuā side of the equation, good growth was being experienced, and a request for additional space was soon forthcoming. Independent ranches such as Hāna Ranch were not only phasing out of the butchering business but also expanding their herds. By mid-1970, the following parties and agreements were forged:

- Johnny Hanchett, Hāna Ranch manager, requested 1,000-head space
- Hāna Ranch's projection was for 1,800 more spaces the following year
- At peak production, Hāna Ranch may forward 8,000 feeders
- Kahuā Ranch requested and received an increase from 1,500 to 3,000 spaces

Hāna Ranch's accommodations became complicated, as the agreement implied that their cattle go to HMCo only for slaughter. Hāna Ranch also brought a connection to Holiday Mart, a former client of HMCo.

It was a busy time for the feedlot, which was experiencing its fourth managerial turn since 1963 when Charlie Koontz came out to the Islands in behalf of the Janss Consortium. Carl Jorgensen and Frank McSwan, whom I came to know and found pleasant to deal with, followed him. It was a time in the beef industry when feedlots throughout the western United States were expanding in great proportions, and opportunities back home were calling.

At this time, Bob Johnson moved to O'ahu from Parker Ranch to become the feedlot manger of longest tenure. McSwan's departure was the final vestige of the Janss' historic involvement, and the continued contractual relationship with the mainland firm came under even closer scrutiny. In a November 24, 1970, board meeting, Bennett was requested to forward a letter to Diamond A Industry advising them of the need to either strongly revise the management contract or cancel it. Complicating the matter was part and parcel of the assets. Joe W. Lackey of Diamond A Cattle Co. shunned Bennett's offer of a $150,000 settlement.

Although it took over a year to finally

rescind the Diamond A contract, the diligent skill of Arthur Reinwald and Bennett took what could have been an $800,000 satisfaction of contract and reduced the settlement figure to $162,500. Bennett was now in full control of the feeding, milling, marketing, and rendering complex, in which annual profits were approaching record highs.

In a November 16, 1972, statement issued by Richard Smart, he noted: "By unanimous vote the following matters were passed by the Board: 1) that Mr. Bennett receive for his splendid work not only in the litigation of Diamond A, but in advancing the company over the last four years that a bonus be declared; the bonus to be payable either in 1972 or 1973 to be determined by the chairman, the bonus being in the amount of $20,000." A substantial salary increase was also proposed at that time.

Winds of Change

By 1968, Rally's full mandate of 18,000 mother cows was achieved. There was a continuing but limited crossbreeding program using the Angus breed, centered in the Kohala section of the ranch under the direction of Johnny Kawamoto, the foreman who started with the ranch soon after it acquired Puakea Ranch from the Wight estate in 1934. The crossbred calves were destined to become feeders, and no heifers were kept as replacements.

During this time, Richard Smart acquired the registered Angus herd of Randolph Crossley, a prominent Honolulu businessman and politician who also owned a small ranch called Koa Ridge Farm in Kunia, on O'ahu. It is likely that pressure to introduce more Angus crossbreeding, which enhances carcass quality, came from Leonard Bennett, who was becoming increasingly influential with Richard Smart. It also is likely that Crossley wanted to depopulate the herd and sell his ranch, for he apparently offered to include his manager, Bob Johnson, as part of the package. The deal was struck quickly. The Angus herd moved to the Big Island, as did Bob Johnson, his wife Betty, and their two children. Johnson was named assistant manager of the ranch, a Richard Smart decision that received little enthusiasm from Rally Greenwell. While Penhallow used his assistant manager, Armitage, on land issues effectively, Rally was more inclined to keep broader control over all facets of the operation. If he had picked an assistant, it probably would have been Harry Kawai, who was functioning in that capacity. Johnson, who entered the picture with a background mostly of dairy and small ranching, had little or no operational experience of the magnitude of Parker Ranch. His assignment to an experimental feedlot on the ranch seemed appropriate. A brief sketch of his experience follows.

Robert A. (Bob) Johnson

On July 1, 1969, Robert (Bob) Johnson was appointed by Richard Smart as assistant manager under Rally Greenwell, general manager of Parker Ranch. Johnson came to the ranch after a six-year stint managing the agricultural holdings of O'ahu businessman/politician Randolph Crossley, which included a registered Black Angus operation that was integrated with nursery and container stock as well as turf grass projects.

Born in Bellaire, Ohio, Johnson attended schools in Tiffen, Ohio, during his early years, while his college years were spent at

California Polytechnic College in San Luis Obispo, where he earned a BS degree.

During his college years, he immersed himself in the field of livestock judging. A member of several college judging teams, he served with distinction as the chairman of the All College Judging Conference in beef, dairy, sheep, and hog competition. While on campus, Johnson also played varsity football and baseball, as well as serving as a member of the Boots and Spurs Club and Gamma Pi Delta Fraternity.

Livestock judging continued as an avocation beyond his college years. He was a member of the Western Fairs Livestock Judge Association, which regulated judging at many county fairs in the American West, the most noted of which was the grand Los Angeles County Fair. After a four-year stint in the Marine Corps, Johnson attended IBM School in Washington, D.C., but office work was not his career choice. He soon joined Roger Jessup Farms, managing the San Joaquin Valley Operations Division in California. This was a Holstein cattle operation with an emphasis on commercial dairy heifer replacement production that integrated agronomic projects, including farming alfalfa, cotton, corn, and sorghum. Security First National Bank, also in California, beckoned Johnson toward a career in agricultural financing, an opportunity that provided solid experience in that realm of the business world. The dairy farming industry provided the predominant clientele of his banking experiences. After a year or so, however, the lure of the outdoors and a new career opportunity called him to Hawai'i.

On O'ahu, Johnson was charged with the construction and launching of the Meadow Gold operation. During this two-year period, he began a long career in community service that included working with 4-H, PTA, Boy Scouts of America, Future Farmers of America, and the American Scandinavian Foundation. In the ensuing years, he found time to coach both Little League Baseball and Pop Warner Football.

After his Meadow Gold stint, Johnson went to work for Randolph Crossley at his Koa Ridge Farm and was elated at being back in the cattle industry. He became active in the Hawai'i Cattlemen's Association, serving terms as president and secretary of the O'ahu Chapter. An opportunity arose at Parker Ranch, calling him to the Big Island for a year's exposure to the vast ranges of one of the largest ranches in America.

Holoholokū Feedlot

Johnson wholeheartedly took on the assignment of operating the experimental feedlot at Holoholokū, near the present West Hawaii Concrete plant near the Saddle Road junction. One Charles Christiansen, ranch agronomist, had started the feedlot project but had left the ranch to enter graduate school at the University of Idaho. Johnson seemed the right man for the job.

The idea behind the program, a logical brainstorm of Norman Brand, was to prefeed groups of cattle for fifty to sixty days on a ration of corn silage before they went to final finishing at the Barbers Point feedlot. This would likely shorten the latter period and thereby reduce costs. An Iowa farmer named Wallace Coleman agreed with the ranch to grow corn in Waiki'i and store it in trench silos dug into the flank of a low-lying knoll immediately windward of the feeding pens. The silos were lined with black vinyl sheeting and served by a front-end loader. It was

Holoholokū feedlot. PRC.

Harvesting green chop corn at Waikiʻi. PRC.

Trench silo for storing green chop. PRC.

Feedlot field trip. Left to right: Charles Christiansen, Kiyome Yoshimatsu, Norman Brand, Sam Kimura. PRC.

Charles Christiansen, Holoholokū feedlot manager. PRC.

Left to right, Rally Greenwell, Charlie Onaka, the author, and Buck Brown reviewing the feedlot operation at Holoholokū in 1971. Courtesy of Dr. Dennis Macy.

reasoned that the prefeeding would acclimate the feeders to both confinement and bunker feeding. With some supplemental grain as part of the silage ration, the digestive tract microorganisms of the feeders could begin to prepare for a higher energy ration at the Oʻahu feedlot, where the current five-month feeding period could be shortened. The idea seemed sound and Johnson seemed capable—but the program was not to be.

The feeders were difficult to settle down to bunker feeding on the pungent corn silage, despite the grain dressing. Further, there was no windbreak to stop heavy dust from infiltrating the bunkers, blown by the incessant winds of this historically windy plateau. The dust made eye infections rampant and respiratory disease a nuisance. Johnson's heightened concerns about these feeders put him at odds with Dr. Wallace T. Nagao, the ranch veterinarian, and Nagao was not one to back away from a challenge. The later mysterious deaths of a half-dozen feeders were the subject of armchair diagnoses by many, while Dr. Nagao and his team confirmed the losses to be due to enterotoxemia (a form of botulism). The contretemps took their toll on both men, and the prefeeding feedlot experiment was abandoned a few months later. The brainchild of Norman Brand, it was poorly conceived and had inadequate resources, which destined it to fail through no fault of any single person. By this time, Bob Johnson had left the ranch; later, with Richard Smart's blessing, he was hired by Bennett to run the Hawaiian Milling feedlot. Dr. Nagao moved to Oʻahu, where he was later appointed chief state veterinarian.

Early Land Sales

In the last few weeks of 1962, private discussions were under way for the sale of two of Richard Smart's oceanside properties, one to Laurence S. Rockefeller and the other to Mrs. William P. (Lurline) Roth.

A New York developer, Rockefeller had already secured a ninety-nine-year lease on 2,000 acres of adjacent property, where he appropriately envisioned a multimillion-dollar luxury resort. He had long been interested in outright purchase of the adjacent Hāpuna Beach, a 35.62-acre parcel used by ranch employees for recreational purposes. Smart, in accommodating his workforce, had built six A-frame cabanas, dressing and bathing rooms, and a longhouse for gatherings. When employee beach privileges were moved to ʻAnaehoʻomalu, subsequent to the sale, similar shelters were built for their comfort there.

The Roth purchase involved an 18-acre parcel north of Rockefeller's Mauna Kea Beach Hotel development at Kaunaʻoa Beach. According to William Roth, director of Matson Navigation Company, the property would be developed as a family vacation home. Mrs. Roth was the daughter of the late Captain William Matson who founded Matson Navigation Company.

The beginning of significant property sales signaled some immediate community concerns that the ranch was for sale, and owner Smart worked hard to dispel such a notion. He repeated in public statements that the cattle ranching aspect would always be at the heart of his holdings. Further, he described these peripheral parcels as marginal grazing or devoid of productive agricultural purpose. Rally Greenwell was not one to argue with the ranch owner's decision to sell his land; he was aware that the ranch was becoming land rich and cash poor.

To the general public, however, things seemed doubtful when Signal Oil of California purchased options on large parcels in Lālāmilo and especially Waikiʻi. Options were also purchased from Smart for between 25,000 and 30,000 acres in Waikoloa by Boise

The Hilo Tribune-Herald *attempting to dispel rumors about Parker Ranch lands.*

Cascade Corporation. Other development groups such as Dilrock-Eastern had also made similar gestures.

While Richard stated that ranching would remain foremost, it was easy to see that his lifestyle demanded significant and constant financial support, and despite the land and cattle largesse, periodic cash infusion was needed. To be sure, he often earmarked windfalls in land sales for massive ranch improvements such as water systems, development of property for employees, shopping centers, and certainly big-hearted benevolence to the community at large. Rally Greenwell saw value in these actions. Smart was adamantly avoiding the playboy lifestyle of his great-grandfather Samuel Parker Sr., and his giving back to the ranch and the community set him clearly apart.

Richard was even philosophical about Parker Ranch losing its place as the largest privately owned ranch in the United States, which was an honor often called into technical question by bona fide mainland ranchers. The Boise purchase reduced the ranch from a 252,000-acre holding to roughly 225,000 acres, with options still out there, such as Signal Oil and Dilrock-Eastern.

In a December 8, 1968, *Honolulu Advertiser* article, Richard expressed foresight: "The continuation of cattle ranching and certain land developments, utilizing the strong potential of the Ranch, will contribute to a very bright future for the Ranch." Just as thoughtfully, he opined, "These surrounding communities that grow up will be separate, individual, instead of one big urban mass."

The Boise Cascade Corporation project was a huge incident for the heart of the Big Island, not to mention Parker Ranch.

In a May 28, 1968, *Honolulu Advertiser* article, the giant mainland development corporation unveiled plans for a resort and a new city of 20,000 people near the Mauna Kea Beach Hotel, stretching from the sea at ʻAnaehoʻomalu Bay *mauka* to Māmalahoa Highway.

With his enduring aloha for the working *ʻohana*, Richard retained a 40-acre parcel on the west end of the bay where shelters and bathing facilities were built. The employee's last stand for seaside recreation ended in 2001 when the trustees sold this parcel after a day on the market. During the annual Hoʻoponopono (IV), promises were made by trustees to the employees to relocate similar seaside facilities for their use at Honoipu Bay near Puakea Bay Estates. To date, no effort has been made to fulfill these promises, unlike the kind and thoughtful tradition established by the ranch owner in the past. The Kohala beachfront continues with its jagged, rough, and uninviting shoreline, not conducive to family outings, with facilities remaining from the old U.S. Coast Guard premises. Only modest efforts had been made to accommodate the comfort and safety of the few ranch families that venture there. Placed on the sale block, the Honoipu parcel was soon gone. Such trustee/management promises and statements left many employees disillusioned and uncomfortable with the administration's use of the term *hoʻoponopono* when factual and diligent follow-up never occurred.

Robert Pummel, who approached the Hawaiʻi County Planning Department for a change of zoning, a process that would take a few years to materialize, led the Boise group. The request was centered on permission to

urbanize a 5,000-acre portion of land at the 800- to 1,200-foot elevation; hence the birth of Waikoloa Village as it is known today.

From a grazing standpoint, the area southwest of the village was used seasonally prior to the land sale. One of the first land initiatives of Gordon Lent was to lease back the area for ranch use, making 8,000 to 10,000 acres available for seasonal pasture of the Ke'āmuku cow herd. That arrangement continues today, but the grasslands are left in fallow for several years.

One significant glitch in the Boise Cascade sale was a suit filed on February 26, 1970, by O'ahuan Abraham Kaulaku McAulton, claiming he held a one-half undivided interest in the property along with Richard Smart. His claims were based on a complicated genealogy pathway that was submitted in the suit.

Defended by Dennis O'Connor of the law firm Hoddick, Reinwald and O'Connor, Richard Smart responded on September 14, 1970, with a motion for summary judgment. Under advisement, Judge Benjamin Menor examined the case and on July 9, 1971, granted Richard Smart summary judgment. McAulton, to no avail, appealed to the Supreme Court. While McAulton's claim of undivided interest in property belonging to Richard Smart was a first but feeble attempt of this nature, the ranch owner a dozen or so years later would face a serious, comprehensive challenge from some of the heirs of John Palmer Parker I and Kipikane.

Unions Threaten

Part of the fallout from the land sales and the hotel and golf course development was the lure of higher wages, causing the loss of some of the ranch's finest, such as Joe Hui of the Cowboy Gang.

A more onerous sequel, however, was the ranch's sudden vulnerability to union infiltration, given the progressive recruitment of the International Longshoreman's Workers Union (ILWU) into the adjacent hotel ranks. It seemed as though Dick Penhallow's greatest fear—ranch unionization—was about to be realized.

From 1960 to 1970, external forces impacted on the level of comfort enjoyed by ranch rank and file. These forces included employment opportunities in hotel development along the "Gold Coast" between Kawaihae and 'Anaeho'omalu Bay. There also were opportunities in the construction industry as the lavish Mauna Kea Beach Hotel and golf course were built. Ranch employees and their spouses eyed the higher-paying jobs and benefits that went beyond the standard offerings of the ranch.

Labor unions were a significant presence in both hotel and construction industries. Parker Ranch employees previously were exposed to organized labor in the neighboring sugar plantations of Kohala and Hāmākua, but the hotel and construction unions were unable to access the homes and hearts of ranch employees. In the early and mid-1960s, the ILWU maintained a subtle but relentless effort to organize Parker Ranch. Despite Richard Smart's demonstrated compassion for his employees, the union made its way into the ranch in the fall of 1969. The ILWU quietly infiltrated some of the ranch's ranks, following up with an attempt to be recognized as the single bargaining unit for ninety-nine ranch workers.

Richard Smart and the ranch management were devastated, considering it an insult for a ranch whose pride in employee care was deeply grounded. Ranch administrators wasted no time in calling in the Hawai'i Employers Council to review the situation and provide advice and direction. Robert R. (Bob) Kenny, a former marine, became the lead person for the council. The council focused on the benefits that Parker Ranch provided to employees, including free housing, medical care, meat and poi, and such amenities as hunting, fishing, and camping on ranch property. This provided dramatic testimony of the owner's commitment to his people.

In early spring 1970, the election was held and the union movement was defeated by an eighty-eight to eleven vote of ranch employees. Thereafter, and until recently (2000–2001), there was little need for workers to seek the protection of trade unions because the ranch initiated training and communications that enhanced relationships between management and employees. Ranch management seized the moment to move beyond mere prevention of unionism to a comprehensive development of programs for employees, foremen, and supervisory staff.

Bob Kenny moved quickly to become a consultant to Parker Ranch in human resource development. The ranch bolstered employee benefits, including profit sharing, enhanced medical and dental plans, and scholarships for children of employees. Kenny and ranch business manager Jim Whitman worked at eliminating the philosophical gaps in ranch thinking and the "them vs. us" attitudes that surfaced during the union's initiative. Whitman was key to the success of the preunion and postunion negotiations, given his "local boy" compassion for the rank and file and his upbringing in the sugar community of Onomea.

By the time I arrived on Parker Ranch in July 1970, many of these programs were under way and apparently effective in improving morale. "Profit sharing" became an oft-heard term among the employees and could be used pointedly in instances of wasted resources. The process evolved into sustaining the caring culture of the ranch instead of someone doing something to someone. From Richard Smart and Rally Greenwell down to the lowest-paid employee, everyone worked to improve morale and effectiveness.

This was a significant departure from the autocratic days of A. W. Carter and Richard Penhallow and a welcome contrast to the management style of Hartwell Carter, who depended on key informants, which ultimately eroded the administrative structure.

The Dawn of Air Shipment of Cattle

In March of 1969, Rally put a test group of feeder calves aboard a DC-8 flight designed by the carrier Trans-International Airlines for transporting cattle. In the well-ventilated cabin, the calves mingled snugly within aluminum-paneled pens for the four-and-a-half-hour flight and were received by rancher Tom Mee of King City, California. They were immediately put onto good feed, were virtually free of stress, and showed only minor shrinkage—which is the subclinical loss of body water concomitant with the transportation of livestock. Five more flights followed in June, using the same carrier, with Clovis, California, livestock consultant Bill Verdugo in charge of the logistics. Shipped were 1,100 head of 400-pound calves that enjoyed

the same comfort and careful handling as the first group. The success of these flights created a new avenue for Hawaiian cattle to leave the Islands. Verdugo's firm, Pacific Airlift, became the leading air transporter of livestock to and from the Islands. Today it is managed and partly owned by Vince Genco, Verdugo's close protégé, under the name Verdugo-Genco, Inc., and continues to provide the quality service for which it is known.

While mainland air transport became available, the maritime industry had not prepared accommodations for large groups of cattle—that is, several hundred per trip. Shipping was less costly, but animal shrinkage and stress were significant. But by the mid-1980s, the industry had developed double-decker stock trailers equipped with automatic feeding and watering. A pioneer in this area was Elmer Rabin, and many who followed him are still in business today, some using modified Matson shipping containers (aptly dubbed "cow-tainers"). One industry leader is Pono von Holt, son of Ronald von Holt of the old Kahuā Ranch.

Leonard Bennett of HMCo understandably did not support mainland shipping of Parker Ranch calves because it took away corresponding numbers of feeder cattle from Hawaiian Milling Company and fat cattle from the packinghouse. Bennett was quick to remind Richard Smart of the 1967 investment of almost $1.7 million to build the feedlot and mill, plus the expenditures of $100,000 to $200,000 at a time for periodic upgrades of the slaughterhouse on Middle Street.

I arrived on the Parker Ranch a month after the June shipments, and my judgment was that except for a limited few, Hawaiian ranchers could not effectively grow out the weaners (accelerate their growth from weaning weight to feedlot in-weights). The cow-calf operator can be effective in weaning a reasonable percentage (85 percent) calf crop of 450-pound average calves at seven months old, but he cannot place these animals on quality forage that will more than sustain them and generate weight gain and growth. Our forage in Hawai'i is fine for the lactating dam, but it is too moist and low in both dry matter and protein to provide the required daily nutrition for weaned calves. However, there always seemed to be business and politics that kept the industry from wholesale deportation of weaners to the mainland—except for replacements and grass-fat animals—where the latter would be placed on superior forage for rapid growing out to slaughter weights. Only when the Barbers Point feedlot of Hawaiian Milling Company and the Pa'auilo feedlot of Hawai'i Beef Packers, Inc., shut down did large numbers of weaners leave the state for greener pastures on the mainland United States or Canada. This not only opened up new space for increasing numbers of cows but also provided breathing room for those ranchers already overstocked. It also helped the prudent stockman under drought conditions.

The mainland flights of Parker Ranch cattle continued for years on a limited basis, often providing the "back haul" for flights importing livestock.

The Changing of Veterinarians

While Rally Greenwell managed Parker Ranch, I became ranch veterinarian. This was a role I never aspired to nor dreamed of ever achieving.

I got to know Rally while accompany-

Transcontinental Airlines arrival with horses flown in. Left to right: Tommy Goto (holding horse), Lucky Puhi, the author, and Bill Verdugo. Carl Carlson, Huʻehuʻe Ranch manager, is in the background. PRC.

Bulls transported via Transcontinental Airlines. Kim Dochin is in the felt hat, next to Kale Stevens, checking bulls bound for Puʻuwaʻawaʻa Ranch. PRC.

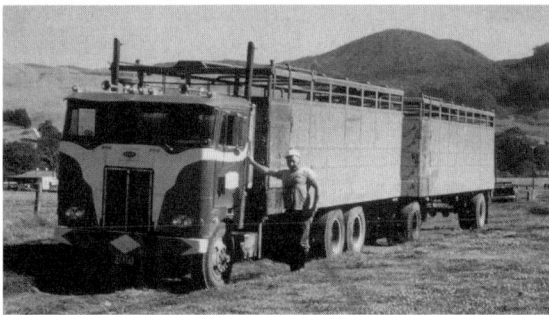

Big Red with Alex Bell, preparing to load Parker Ranch calves for transport to California. PRC.

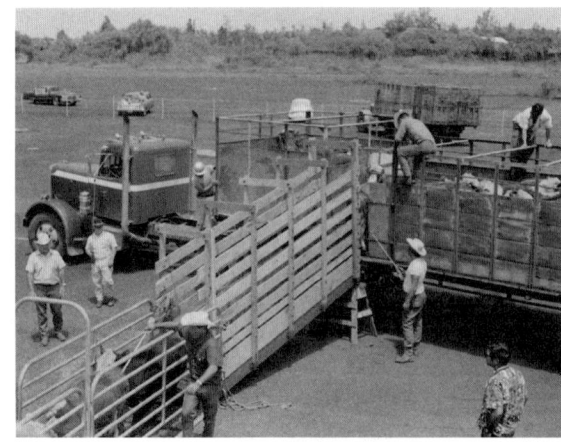

Off-loading Parker Ranch feeders. Hiroshi Ryusaki's truck was often used on such shipments out of Hilo Airport. PRC.

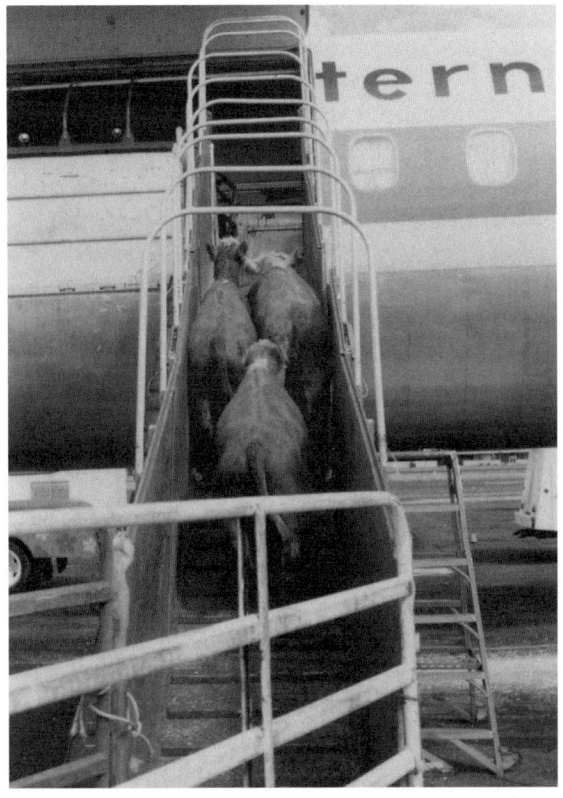
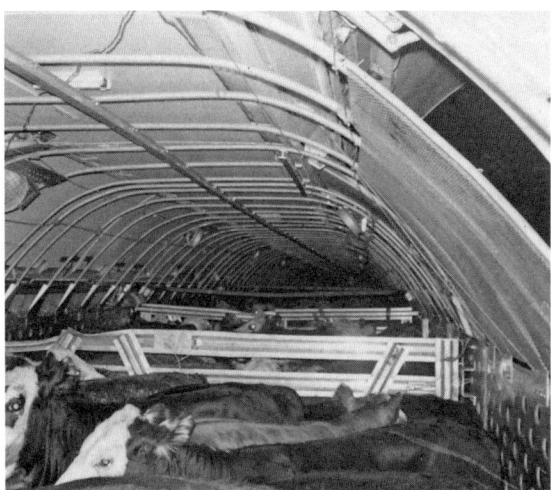

Left: Loading Parker Ranch feeders for California. PRC.

Above: Panelized interior of aircraft. PRC.

ing Holi Ma-e at calf crop dispersal from Hawaiian homesteaders back to the ranch. We became reacquainted in 1959 when I worked under George M. Lindsey as a ranch hand at Pukalani Stables before leaving for college in Kansas for nearly a decade. I also got to know Dr. Wallace T. Nagao, the ranch veterinarian who followed Dr. Leonard Case, and I have high regard for both men.

When I returned home in 1968 to practice, I was drawn to Kona because of the strong livestock industry there as opposed to the limited ranching business in my hometown of Hilo. In addition, Mrs. Barbara Cox Anthony had a recently built veterinary clinic available for my use on Hualālai Ranch. Shortly after I moved there, a home was built near the highway for my small family, which included my wife Pat and our two Kansas-born children: Erin, four, and two-year-old Bill. Soon we were blessed with baby Holi, at which time Pat's mother, Maude, moved in with us to help look after the children.

Kona was good for me—lots of work, plenty of good horses and cattle, and a growing clientele. Dr. Kid McCoy practiced veterinary medicine out of a clinic attached to his home in Keauhou, but there was plenty of work to go around. Most of my veterinary interrelationships were with Dr. Nagao in Waimea, a thirty-five-minute drive north of my home and clinic in Ka'upūlehu. Dr. Nagao

was kind enough to involve me in the Holoholokū feedlot investigations of cattle deaths. He also brought in Dr. Fred Lynd, state veterinary pathologist, state veterinarian Dr. Ernie Willers, and several deputy state veterinarians, including Dr. McCoy. It was a good experience, but it caused me concern when I learned of the discomfort between Dr. Nagao and Bob Johnson, a man I'd never met, and it was hard for me to imagine anyone disagreeing with Dr. Nagao. This was the period in which Richard Smart seemed under Johnson's influence and apparently believed the problem lay with Dr. Nagao, the ranch veterinarian.

In March 1970, horse foreman Alex Penovaroff invited me for an evening drink, during which he told me how close he was to Dr. Nagao, not only as a godparent to his children but because of their lifelong interest in boxing. When he asked if I would be interested in becoming the Parker Ranch veterinarian, he already knew my reaction would be a negative one. He had been asked by Richard Smart to confidentially pose this question to me. I too enjoyed a close relationship with Dr. Nagao and owed him my allegiance.

Because of the confidential and sensitive nature of these discussions, the only person with whom I could talk about the situation was my father, the recently retired founder of Hilo Medical Group, who stated emphatically that I should stay out of the situation—and as usual, it was good advice. Also staying clear was Bob Eastman, the ranch business manager and a confidant of Dr. Nagao. I am sure this was a difficult time for Rally Greenwell, who to this day considers Nagao a good friend.

In May, I was surprised to receive a phone call from Richard Smart, who told me that a decision on Dr. Nagao's departure had been made, and he was to be replaced. Richard said he knew I wasn't interested in the position but wanted me to at least give him direction in finding someone. With this information, I felt free of any involvement in Dr. Nagao's departure and felt a concomitant obligation to help the ranch find qualified veterinary candidates. I met in Waimea with Richard and Rally and offered three candidates: Dr. Ted Cleghorn, a recent Colorado State University graduate practicing on Maui; Dr. Lynn McKinney, a seasoned practitioner from Wai'anae and currently HMCo feedlot veterinarian (I considered him a shoo-in); and Dr. Guy Tucker, a recent Washington State University graduate who was just leaving Hāna Ranch.

Richard and Rally wanted a resident veterinarian solely employed by the ranch and asked me to reconsider. I tactfully explained that after seeing what happened to Dr. Nagao, I could not consider such a position. The two of them were appreciative of the background and names I had offered, and I went home expecting an announcement as to who my neighboring colleague would be.

Word of a new veterinarian never came. Instead I was called back to Waimea to meet with Richard and Rally again, whereupon they asked under what circumstances I would become Parker Ranch veterinarian. Would I reconsider? I elaborated two positions.

First, I had watched resident veterinarians on Kentucky horse farms wither professionally because there was no incentive to excel for their patients or client on a fixed income/solo client basis. I was twenty-nine years old and foresaw a bright future at home, and I wanted to grow professionally—to excel for my patients and not simply be paid whether or not a program succeeded.

My second reason was based on my observation that for most resident veterinarians, replacement is tragic, whereas a retained veterinarian with other clients can keep functioning even if a major client such as Parker Ranch is lost. Dr. Nagao, fortunately, was on a retainer with the ranch and had a significant private clientele as well as state responsibilities. Like him, I had always avoided putting all my eggs in one basket, and this did not seem to be the situation to change that. Richard dropped the residency requirement; Rally proposed a retainer instead. I felt comfortable in accepting his offer, having honored Dr. Nagao's relationship by staying out of the picture and by proposing veterinarians other than myself. If I were to be the choice, I wanted to protect my independence via a retainer instead of a residency. I was then offered a contract; I said it wasn't necessary. I wanted to be free to leave with a month's notice if I chose to do so. Similarly, I wanted the ranch to have the flexibility for termination of our relationship.

A Veterinary Prelude

Upon assuming the reins of the Animal Health Program of Parker Ranch, I engaged in and applied certain standards of professional conduct based on sound ethics, livestock industry economics, advanced veterinary medical technique, and evidence-based decision making, with stewardship of the lands, the animals, and their caregivers being the fulcrum upon which all factors were balanced.

On entering practice, first in Kansas in July 1967, armed with a standard of ethics that came down from my father's lifelong devotion to the health of the people of Hawai'i, as well as the fine faculty of the College of Veterinary Medicine at Kansas State University, I readily applied the veterinary oath in my daily routine. Arriving home on February 2, 1968, and engaging in private veterinary practice in Kona, I focused on the livestock industry and its economic bases. In those times, weaned calves (450 pounds) of good quality were bringing only 18 to 20 cents per pound, and the Barbers Point feedlot was the consigned finishing point for 75 percent of the feeder cattle (600 pounds). Hawaii Meat Company and Kahuā Meat Company were the major players in marketing fat cattle, and Kona was a stronghold of the Kahuā Meat Company's consigning ranchers. This provided the economic framework of those times, with progressive beef producers having little or no flexibility to market their calf crops. My goal was to help streamline the process by applying preventive medical techniques such as preconditioning—experience that would blend well with the needs of Parker Ranch in a couple of years to come.

Consistent with these standards was the desire to arrive at decisions and recommendations on livestock health in concert with management or at times ownership, based on scientific evidence and research. Again this posture blended well, as I assumed the animal health responsibilities of the Parker Ranch herd of over 50,000 head of cattle, where the slightest decision could render profound economic results, good or bad. Hence the value of my graduate studies beyond a DVM degree—notably an MS in veterinary physiology—was invaluable in terms of providing scientific standards by which all decisions would be made.

Stewardship of the land and the animals and their caregivers was a foundation built upon my experiences since childhood,

through adolescence and early adulthood, when environmental impact statements were unknown phenomena. Much of this sensitivity to the vulnerability of the environment to man's management was largely influenced by noted Native Hawaiian men such as John Holi Ma-e, whose father had witnessed the eclipse of the Great Mahele in his lifetime, bidding aloha to old Hawai'i's uniquely successful standard of resource management. This handed-down responsibility spanned Holi's lifetime and was passed on to mine, in which the leaders of the livestock industry of those times adhered to grassland management standards based on appropriate and prudent stocking rates, rotation, rest, and recuperation as well as the introduction of new and improved grasses and legumes.

In my youthful career, I worked on the ranches of W. H. Shipman, Ltd., where men such as John Peacock and Tom Lindsey prudently executed the range and resource management oversight of Herbert Shipman, the noted environmentalist and preservationist. Later it was men such as Fred and George Schattauer, Johnny Pieper Sr., Kuakini Cummins, and Johnny Medeiros Sr. who rounded out my Big Island exposure to every ecosystem available to the livestock industry. Rally Greenwell and his brother Robert provided consistent examples of the Native Hawaiian theme, *mālama ʻāina* (care for the land).

It is appropriate that I include here the sage advice and wisdom of my father, Dr. William N. Bergin, MD, who routinely reminded me of the relationship of animal to man and of animal health to public health, each discipline having an effect on the environment. A healthy environment makes for healthy animals and people, but the responsibility for an enduring, positive relationship lies purely with man and his appropriate management of resources in perpetuity. Before his time, he spoke of conservation medicine—whether it was man or animals—with foresight. He, too, witnessed the transformation of the Hawaiian Islands from a homesteading *(kuleana)*, agrarian lifestyle to the intensive industrial farming of the sugar and pineapple industries, the latter of which provided the patient base for his medical career. He witnessed the transformation of the Big Island shorelines of Hāmākua, once bountiful with shellfish, fish, coral, and seaweed to a barren coast with sealife replaced by muddied waters and profuse flotsam of bagasse, leaf waste, soil, and related contaminants. No longer could he justify the inconsiderate impact of industrial farming on the *kahakai* (shoreline), the pristine waters upon which he surfed, swam, and fished as a boy. The end failed to justify the means.

Armed with his counsel and that of others, I looked to a career in veterinary medicine on my home island as a unique opportunity to address the integrated relationship of the biomedical sciences (both animal and man) in a context that championed conservation and environmental protection while prudently maximizing livestock production. My colleagues in this process became the ranch owners, managers, and in some cases, willing trustees of landed estates. Clearly, my incorporation of the health and welfare of the caregivers of these lands and livestock was uniform and unwavering, embracing the zeal handed down from great men who came before me.

I entered Parker Ranch gifted with philosophical instruments that included the ethical and evidence-based application of sound principles of livestock health, founded on sen-

sitivity to the perpetual relationship of man and his animals to the habitat of Hawai'i nei. A quarter of a century later, I left the ranch comforted by my consistent devotion to these principles.

Early Days on the Ranch

On July 1, 1970, I added Parker Ranch to a growing list of client accounts, including Jimmy Stewart's Ho'omau Ranch in Honomalino (George Schattauer, manager), Hu'ehu'e Ranch (Roger Williams, manager), Hualālai Ranch (Roy Keast, manager), and Pu'uwa'awa'a (Johnny Medeiros Sr., manager). Soon after opening my office in Waimea, I was retained by Kahuā (Monty Richards, manager), Kūka'iau (Eddie Rice, manager), and Schutte (Kalani Schutte, manager) Ranches. Other accounts followed, along with homesteaders and small and large animal clients.

We continued to live at Hualālai for a few more years, until we built a five-bedroom home and arena on a Pu'ukapu homestead we bought from Rosie Correia, mother of longtime rancher/client Jack Ramos. During these early years on the ranch, I had some specific requests from Rally. The first one was to ride the entire ranch on horseback and report back to him regarding the overall animal health status and any related concerns. One of my main guides was Henry Ah Sam, who oversaw what was called the Main Ranch. Henry's mission, as outlined by Rally, was to make sure Kauka (my new name as bestowed by Ah Sam and others) was exposed to a complete visual and historic overview of the yellow calf problem on the ranch.

There was a parallel overview taking place at Hāna Ranch by the firm of Rubel and Lent and including their consulting veterinarian, Dr. Jim Savoini, all out of Arizona. Later I was to learn that Leonard Bennett put this group in touch with Richard Smart because he thought the ranch needed a thorough management evaluation. This study took place over the following year, with visits made to neighboring ranches by Rubel and Lent. Kahuā Ranch was one of them.

I was directed to work closely with Alex Penovaroff on all aspects of the horse program and with Charlie Kimura on the marketing program, where all feeders were sent weekly to one or two lots of 150 steers or heifers, as uniform as peas in a pod.

Drs. Case and Nagao had orchestrated the development of an appropriate vaccination program (three-way clostridial/Pasteurella) for branding and weaning calves. I added vitamin A injections for pinkeye (bacterial eye infection) problems and bolstered the deworming with repetitive doses of thiabendazole, thinking that the scrawny, taggy yellow calves were just wormy. I was wrong about that.

I reported to Rally that there were three areas to be concerned about. First, there certainly was a problem with the yellow calves. In 1969, shortly before I came to the Parker Ranch, two dozen of these calves were sent to the University of Hawai'i Experimental Farm in Waialua, O'ahu, and results were pending. This experiment was conducted at the request of Rally and Dr. Nagao, and mineral deficiency was highly suspected. Second, the ranch was overpopulated with horses, especially broodmares, all of which in the interim needed to be on vaccination, dental, and deworming programs. Third, ranch feeders were at risk by not preconditioning them for the feedlot with appropriate vaccinations against viral diseases such as infectious bo-

vine rhinotracheitis, bovine virus diarrhea, and parainfluenza diseases, in addition to the vitamin A and booster deworming. All were important to Rally and the ranch, but solving the yellow calf syndrome, as it became known, was my paramount assignment.

Yellow Calf Syndrome

In January 1971, Rally approved a comprehensive experiment using 140 calves from Kemole II, where the yellow calf disease was prevalent. The research team was made up of myself, representing the ranch, and Drs. James Carpenter, Jim Stanley, Charles Campbell, Yusuf Tamimi, James Nolan of the University of Hawai'i College of Tropical Agriculture, and its cooperative extension services agent, Clarence Garcia. I became aware that an earlier University of Hawai'i experiment on the calves pointed toward mineral deficiency. From our on-ranch experiment, I realized that the basis of the yellow calf problem was the same as many other infectious and physiological diseases: a fundamental nutritional failure.

The morning of the first step of the experiment started before dawn for the cowboys driving the Kemole II paddock, corralling the cattle and separating the calves. A random selection set aside 140 calves for the experiment. They were again randomly segregated into six treatment groups and a control group. All received an atypical branding regimen of only vaccinations. Colored ear tags coded each of the six treatment groups; the control group was independently coded but received no treatment. Injectable products were all commercially available.

The first group was dewormed, the second received selenium/vitamin E injections

The author with his son Holi Bergin at the Breaking Pen, 1972. Photo by Hisa Kimura.

for deficiency, the third received vitamin A, D, and E injections, the fourth group received copper injections, the fifth group was given iron injections, the sixth group combined copper/iron injections, and the seventh group remained treatment free. The calves were weighed, graded for color and condition, and returned to their dams in Kemole II.

At weaning time four months later, the results were observed and recorded. The symptoms of yellow calf syndrome are barely noticeable at the branding age of two to three

Yellow calf syndrome in a Black Angus calf. Note the rough, bleached coat, fecal-tagged tail, and unthrifty condition. WCBC.

months, but there is dramatic bleaching of the coats to yellow in the Hereford breed (which was used in this trial) and silver-gray in Angus and Brangus breeds by weaning time. Range calves have become ruminants by three or four months, depending more on forage than on their dams' milk. Although a good dam continues to lactate heavily during the calves' weaning age of seven months, the calves themselves become more dependent on forage, as by then they are 450-pound animals. But the grass may be deficient. By weaning age a calf with this yellowing disease is only 60 percent of his potential weight, has a loose stool, a taggy (dingle-berried) tail, and a bleached coat—all reflecting a diet of forage that is copper deficient.

After four months, the herd of 140 experimental calves was gathered for weaning, weighing, and grading. Being separated for processing, there were twenty heavy, dark red, robust, clean-tailed calves that stood out dramatically. This was the group that had received the copper injections. All six of the other groups were yellow, with loose bowels and taggy tails. As we recorded weights and grades, the "copper" calves were hands-down winners in pounds and condition. I was humbled by having missed my original diagnostic target (worms) but excited about what copper could do for growth and productivity at Parker Ranch and all other affected ranches in the state. My entire veterinary thrust altered toward mineral nutrition and supplements. From that point onward, I used University of Hawai'i personnel in any significant tests, and to this day I consider them heroes for their good work. I also salute Rally and Dr. Nagao for their acumen and persistence in the matter of the "yellow" calves. It all paid off.

Copper Turns to Gold

After the effect of the copper supplement on calfhood became known, I was charged in addition with designing a mineral supplement to take care of the broader needs of Parker Ranch cattle, which included calcium, phosphorus, and other supplements, with emphasis on deficiency affecting calves in a 45,000-acre tract called the Yellow Calf Belt, running northwest to the northeast slope of Mauna Kea from Pu'uanuanu to Hanaipoe. The ranch had no comprehensive mineral program for the 18,000-head mother cow herd, although there was considerable data over the previous seventeen years concerning soil and forage analysis for minerals.

Designing a mineral program from "square one" brought complications. Copper deficiency was occurring in two ways: one was simply an inadequate level of copper in the soil and forage, another when copper levels were adequate but the presence of molybdenum tied up the copper and made it unavailable for the calf. The Yellow Calf Belt had areas where both problems existed, so I needed very high levels of copper supplementation to overcome the problem.

Another complication was regulatory and legal: Oral copper supplementation had not been adequately researched and described by the National Research Council, which in turn advises the Food and Drug Administration (FDA) regarding nutritional intakes and requirements. The FDA in turn regulates allowable levels of minerals and other nutrients.

Some professional nutritionists worked with the University of Hawai'i staff to develop the mineral mix—notably Dr. Bob Brown of the International Mineral Corporation (IMC) of Libertyville, Indiana, and Brawley, California. IMC joined me in inquiring of FDA authorities as to allowable levels, and they shuddered at the possibility of feeding .75 percent to 1 percent copper sulfate in a loose mineral mix designed for 1–2 ounces a day per animal unit. The mixture is predominantly salt (75 percent sodium chloride). It had never before been done in the United States under range conditions. The only alternative was a veterinary prescription until the National Research Council could develop the data on appropriate levels of copper—which took another two years for regulatory approvals.

With faith in the experimental protocol and with Rally's unqualified support, I endorsed the prescription, and we were under way in producing the mix for shipment to the ranch.

As an alternative to oral supplementation, there was an injectable copper. The copper product used to inject the experimental calves was a commercially available pharmaceutical from Cutter Laboratories called CuMol. A routine side effect was significant irritation and occasional infection at the injection site. Further, a calf could die when even mildly overdosed, and to use such risky procedures was contrary to my training. I knew that one should avoid the use of foreign matter that caused significant irritation in meat animals to be used for human consumption. Consequently, I looked for a better way to supplement calves that were copper deficient. I chose the oral route, using a specially designed mineral mix that hopefully would avoid the need for CuMol injections. This issue surfaced later when a management change at the ranch brought pressure to bear in favor of copper injections.

Parker Ranch was using about 6 tons of generic mineral mix per month, with section foremen using it as they saw fit. Some sections simply used salt blocks; some used no supplementation at all. Salt blocks provide limited intake by cattle for two reasons: They are made almost completely of sodium chloride and are bricklike in makeup. Both these factors severely limit consumption. This changed with the prescribed mineral program, which called for a consumption goal of 2 ounces per head per day, every day of the year. In the form of a salt block, such intake is very limited due to the hardened density of the supplement. A loose (granular) mineral mix allows significant tongue adhesion, making for very efficient consumption with a few cowlicks.

Bagged mineral supply eventually translated into delivery of two 21-ton Matson mineral containers of material a month. Mineral houses built by Hichiro (Lee) Uyeda's small crew had numbered only seventy-five on the entire ranch, and now the program mandated these units at one for every 250 head of cattle, meaning a crash construction program. But there was a glitch. Bob Eastman, ranch business manager at the time, arbitrarily stopped production of mineral houses because he felt they were a waste of resources. He was unaware of the dramatic results from the copper experimentation. Jim Whitman, the office manager, alerted me of this concern. Someone counseled Eastman about the accrued benefits of supplementation, and production resumed.

I learned at this juncture that an integral part of my role as ranch veterinarian was to be a strong advocate for the health and welfare of the cattle and to become increasingly willing to challenge management decisions that might potentially place livestock at risk.

It took a few years before the complete program was up to 42 tons of minerals each month. In the interim, the mineral supplements were having a dramatic effect. Across the entire ranch there was enthusiasm for the animal health program, as there was now a sea of dark red weaners where there had been a proliferation of yellowed shaggy calves a few years before. It was great for morale on the ranch. Copper supplements since 1972 had added literally thousands of tons of beef to the ranch at a cost of just 3 cents per animal unit (a cow and her calf, two yearlings, or three weaners) per day. Soon, the entire industry in the state became aware of the profound benefits of appropriate mineral supplementation—especially copper. This was accomplished through my efforts combined with those of University of Hawai'i personnel via the annual Animal Health Conferences. Copper had indeed turned to gold.

The Horse Program of 1970

Alex Penovaroff is a consummate horseman. He became ranch foreman of the horse program after a long and exciting journey from cowboying at Humu'ula and Makahālau and eventually assuming responsibility as foreman for both sections at different times. The horse was—and is—the centerpiece of his working life, as well as his hobby, his passion, his path to excellence.

Alex was foreman only a short time when Richard Smart gave him a free hand to streamline the horse-breeding program from the large and cumbersome broodmare band. This was 1962, and redemption of Parker Ranch's role in producing racing prospects for the mainland market was part of his mission. There were still more than 300 of these horses when I came to the ranch, and many of them were barely halter broken. There were weanlings, yearlings, and two-year-olds, some of which showed good quality and conformation, but beyond castration and/or branding, they had never had a dental alignment or been routinely dewormed or vaccinated.

Of the stallions, Kaaba, a Thoroughbred sire of wobbler colts, had been sent back to his mainland owner, as was Sun God III, another Thoroughbred. The most prominent of the Quarter Horse sires, Peppy Deedee, was to be gelded, along with his sons Peppy Koa and Ali'i Dee. Famous polo player and horseman Billy Linfoot, DVM, brought Peppy

Mineral house construction. Bill Case photo.

Mineral house construction. Bill Case photo.

Mineral house construction. Note mineral house on far right, brought in for repair from bulls fighting. Bill Case photo.

Deedee to the ranch as part of Penhallow's efforts to enhance the horse program. I did not mind gelding the sons, but I dreaded castrating Peppy Deedee because I felt he had been so valuable in producing gentle, dependable ranch workhorses. Some senior horsemen opined that his progeny were not noted for longevity, rarely holding up to hard work beyond their tenth year. Others deemed him indispensable.

Anna Perry-Fiske was scheduled to buy the two sons of Peppy Deedee on condition they would be gelded. Castration and healing were completed when she notified Alex that she was no longer interested! The geldings eventually were sold to local horse enthusiasts.

Alex worked hard to depopulate the broodmare bands, but in some cases of older crippled mares, euthanasia was the only recourse. In the near future, management changes would take place, and Alex left the ranch for a career training racehorses in California. A young West Virginian named David Ashcom assumed Alex's role in oversight of the horse operation.

The Feeder Preconditioning Program

By the time I arrived at the ranch in 1970, I had become convinced that preconditioning of feeder cattle before they were shipped to the feedlot made clear common sense. Such was the opinion of Dr. Lynn McKinney of HMCo's feedlot at Barbers Point. "Preconditioning" meant to provide earlier immunity to the feedlot diseases of infectious bovine rhinotrocheitis (IBR), bovine virus diarrhea (BVD), and parainfluenza virus (PI3) infections.

Preconditioning in this context involved a series of vaccinations, a booster deworming, and an external parasiticide two to three

The author at Animal Health Conference held at the new Kahilu Theater at the Parker Ranch Shopping Center. Hisa Kimura (PRC).

weeks prior to shipping from the port of Kawaihae. The brief rest period before shipping is enough time for immune response and flushing of external and internal parasites. Preconditioning in a mainland context means feeders receive supplemental feed as part of the treatment regimen. This was not included in the ranch program as forage was readily available in holding paddocks. Rally's reaction to the new vaccination/deworming proposal was hesitant, but he did agree to some trials. His hesitation was understandable, since it meant adding a third processing increment to branding and weaning, which already involved comprehensive vaccinating and deworming. The added cost of medication and labor needed to be considered.

I made a courtesy call on Bob Johnson, the new manager at the feedlot in Honolulu, and was concerned by his cool reaction to preconditioning of Parker Ranch cattle, especially when his retained veterinarian, Dr. Lynn McKinney, was an advocate. I had hoped McKinney would intercede with Johnson, but he did not get involved at this point.

At the time it was not uncommon for nonvaccinated feeders to be afflicted with respiratory diseases a week or two after they arrived at the feedlot at Barbers Point. The common feedlot diseases—IBR, BVD, and PI3 —as well as secondary bacterial infections caused by organisms such as Pasteurella, were known to often be the cause of "shipping fever" in feeders. Parker Ranch cattle entering the Barbers Point feedlot after a twenty-four-hour truck, barge, and retrucking experi-

ence typically were dehydrated, having lost 8 to 15 percent of their body weight. Drought on the ranch, bad ocean conditions, and late barging exacerbated this dehydration.

The already stressed feeders then entered a feedlot where the presence of airborne viruses and bacteria infected the group (referred to as a "lot" in feedlots), usually of 150 steers or heifers. Within a few days, clinical disease became evident in coughing, runny eyes, and noses. High fever, drooling, a loss of appetite, and diarrhea were often spread among the lot. Weight loss coupled with further dehydration would be followed by chronic respiratory disease, and recuperation was slow despite aggressive and expensive antibiotic and other treatment by feedlot personnel.

Parker Ranch traditionally shipped four lots of 150 head per week, and the incidence of disease on their arrival varied greatly; some lots had minimal sickness while others had outbreaks of 25 to 50 percent infection, and up to 5 percent of them died. Some of Johnson's reluctance may have stemmed from the loss of feedlot income derived from postarrival processing and treatments. I had to convince both Rally and Johnson of the logical course: Precondition the feeders at the ranch to provide early immunity against exposure to feedlot diseases. This was a genuine challenge.

In starting trials on alternate lots of 150 feeders there were acceptable variables, such as location of their growing period, condition, and breed—the latter a minor consideration since they were predominantly Herefords. I knew that trial results would not be conclusive based on a half-dozen or so of the lots, but that perhaps a full year's study was needed for statistical authenticity. This lengthy statistical examination was necessary to alleviate concerns of the ranch and the feedlot managers regarding the necessity and benefits of preconditioning.

As luck would have it, the first couple of vaccinated lots broke with pneumonia, and the feedlot manager was quick to confirm his position. I was not particularly discouraged, knowing how variable and biological animals are. Rally was still cautious but patient enough to let the facts evolve over the coming year. After several hundred preconditioned feeders entered the feedlot with sustained and improved health performance, results of this program reinforced the value of modern preventive veterinary medicine.

But the coming year was one in which Rally would leave Parker Ranch. The Rubel and Lent team presented their review of ranch organization and management to Richard Smart, which at first blush appeared to be a recommendation for reorganizing management as it existed. The final product, however, was to be a total change, with Gordon Lent named as general manager and Rally and Jim Whitman reporting to him. Rally chose to leave the ranch. Shortly thereafter, the Rubel and Lent team endorsed a full preconditioning program of all Ranch feeders.

During this period, a void in regulatory veterinary support for west Hawai'i was gradually coming to light, as blood testing, import/export, and meat inspection services—the areas ably covered by Drs. Nagao and Case—were left unmanned. Fred Erskine, incoming chairman of the Department of Agriculture, requested that I fulfill those responsibilities, and on April 16, 1971, I was appointed deputy state veterinarian. This additional role caused me from that point forward to

carefully examine my professional conscience, with concerns for ethical conduct and conflicts of interest notwithstanding. It became a tightrope to walk, but I managed the challenge by being open and forthright with all parties involved.

The Greenwell-Lent Transition

It is no exaggeration to say the Rubel and Lent management team took the Parker Ranch by storm. I was unaware that the group had been conducting reviews of all aspects of the ranch, and many felt somewhat betrayed by the sheer secrecy of the campaign. As noted earlier, major shifts in ranch administration create emotional upheaval among the rank and file. It takes months, sometimes years, to overcome the impact on the employees, and some never make the adjustment and leave the ranch. Additional management disruptions often occurred because trustees were sometimes also replaced at the same time. Despite the changes, ranch employees for the most part demonstrated flexibility and patience in such stressful times, never losing sight of what it means to be a part of the extended ranch family. Gordon Lent personally did much to alleviate apprehension among employees.

As Rally's time melded into the early days of the Rubel and Lent management, he was kept in the picture by the new team.

Lent was critical of the system in which nearly twenty foremen or lead individuals met daily with Rally or indirectly through the recently retired Harry Kawai. It was a system that empowered the general manager over many disciplines beyond livestock, from trucking to water fencing, and it seemed to work—not only for Rally but also for his predecessors, including Penhallow (to a lesser degree), Hartwell Carter, and A. W. Carter.

In proposing a new plan that involved four livestock superintendents, Lent wrote: "One man very effectively may be able to decide policy, teach, and give leadership to four or five men, but it is impossible for him to serve this function with 17 to 20 foremen as he is now called upon to do so." He went on to say,

> Only through the delegation of authority, responsibility and accountability can close supervision be obtained on any large ranch. Since the cattle are the money-making asset of the business, close supervision is essential. The supervising and welfare of the cattle must be the prime responsibility of each cattle division head. At the present time, there are 98 men under the supervision of the Livestock manager, which is a ration of 1 man to 312 cow units. Probably only 29-30 men are directly involved as cowboys working cattle, which is ratio of 1 man to about 1,000 cow units. On most efficiently run cow-calf operations, we feel this ratio should be about 1 man to 500 or 600 cows or cow units. This would relegate 1 man to every 1,200 to 1,500 yearlings.

Lent's recommendations were as follows:

> The cattle station foreman should have the responsibility for the personnel, physical properties, and welfare and working of all cattle on his station. If ad-

ditional help is needed, it should be furnished by the roving cowboy gang. The cowboy gang would be decreased in size, with probably two lead men. They could then work in two different areas at the same time helping the station managers. When the gang is working at a station, *the station foreman would have full authority.* He is responsible to his superintendent for the welfare of the cattle. A large part of the labor force is being used *ineffectively* as fence builders. This function should be coordinated under one head working out of the Main headquarters. At the present time, again using the example of Waikii, the foreman's only real job is to supervise a five-man fencing gang. This change of responsibilities at the stations will result in several positive benefits:

(a) Each station head will be directly responsible for the welfare of his cattle and station.

(b) Each station head will be accountable for all the cow work, including branding, weaning, health program, etc.

(c) Each station head will be accountable for his cattle inventory.

Cowboys assigned to these stations should be on a permanent basis as the care and needs of these various classifications of cattle are different....

As rapidly as possible and where it is practicable, the houses on the stations that can be brought up to liveable Parker Ranch standards, will be used to house the cowboys and their families who are working on that station. This move should result in a continuing increase in working efficiency and the men feeling more responsible to their jobs and to the livestock under their care. (Lent's emphasis)

Lent's argument made business sense, but it is hard to refute a system that allowed Rally and his predecessors to keep absolute control over and in-depth knowledge of daily operations of a massive spread. It became a difference in management style, one that was maintained for the previous seventy years. In the early years of the new millennium, Parker Ranch attempted to return to such a pyramidal structure, but management and field personnel lacked the experience and depth of knowledge, and the results were chaotic.

Senior Leadership Draws to a Close

Changes were coming, however, and Rally chose not to be a part of the upheaval of a system he knew since coming to the ranch in 1934 as a twenty-year-old cowhand. He reflected on his thirty-three years on the ranch, the nine-year hiatus as assistant manager of Kahuā Ranch, and his nine years as manager of Parker Ranch. In a cordial manner, he shared his thoughts with Richard Smart, expressed his gratitude at the opportunity to serve the ranch, and then was gone. I maintained a close professional relationship with Rally thereafter, in deep appreciation of the knowledge that he shared unselfishly and comprehensively.

A historic moment came on March 31, 1971, when L. Radcliffe Greenwell stepped down as president of Hawaii Meat Company, a role he served quietly and loyally over the

Rally Greenwell at his desk before leaving Parker Ranch. Pat Greenwell collection.

past decade. In this meeting, Richard Smart entered these comments for the record: "A vote of thanks from us all to Mr. L. Radcliffe Greenwell for the number of years he had tenure of office as the President and he has done a momentous job and has helped greatly in the prosperity we have been able to achieve at this point and I think we all owe Rally a debt of gratitude. Thank you—sure needed your *kokua*."

Ironically, Leonard Bennett later admitted that he expected the Rubel/Lent report to be only consultative, and, at the wish of Richard Smart, he would assume management of the ranch, HMCo, and Hawaiian Milling Company. In retrospect, I am convinced that Bennett truly had the experience, strength, and business acumen to put it all together. Bennett envisioned restoring the ranch to the greatness achieved by A. W. Carter. However, Rubel and Lent convinced Smart that their extensive livestock experience would bring about that greatness once again, while some viewed the mainlanders as opportunists.

In the ensuing years, managers came and went. They were all good people, and I learned from each of them. I had a few donnybrooks with them, but my respect for their wisdom and their contributions to the ranch never waned, especially when I knew the challenges they had to endure. The same may be said of the feedlot and packinghouse managers.

Greenwell Summation

There is no question that Rally Greenwell left a huge legacy on 'Āina Paka, and his contributions during his nine-year management tenure merit highlighting.

Resolving the Yellow Calf Syndrome

Rally's relentless effort first to pinpoint the cause and second to provide supplementation was nothing short of heroic. Annually,

the Yellow Calf Belt produced 5,000 runty, bleached calves having only half the weight of their peers from other ranch sections. Conservatively, these calves were 200 pounds lighter at weaning, costing the ranch a million pounds of beef production each year. If any calf then was worth 50 cents per pound (half of present market value), the cash loss was $500,000 a year. Within twelve months of the copper-fortified mineral program execution, 85 percent of the calf crops rendered uniform dark red, 450-pound weaners in the Yellow Calf Belt at a cost of 3 cents per animal unit (a cow and calf, two yearlings, or three weaners). For a penny a day spent on supplementing Parker Ranch calf crops, he added 200 pounds to the weaning weight of 5,000 calves.

Rally was driven as much by good stewardship as he was by curiosity. He wanted a diagnosis, and it was my task to find it—his to fund it. Later, Charlie Kimura as ranch livestock manager was equally fervent in determining how to supplement copper without the use of injectable products. As with Rally, Charlie funded and supported research to bring resolution to the copper deficiency.

Rally and Charlie share a remarkable distinction in the history of Parker Ranch managers since A. W. Carter. They championed professional research to resolve problems, relying on objective research data that was soundly produced and reproduced. More remarkably, they are the only managers to have served in this awesome leadership role without college educations. It is ironic that their quest for resolution of problems through research outflanked their graduate counterparts by immeasurable margins. Was it sheer curiosity or their desire to strive for excellence in livestock stewardship? I believe they were driven by both factors. The fact that both men were born to the cowboy life—one in Kona and the other in Waimea—undoubtedly provided them with innate skill for animal caregiving of the highest order.

Water Resource Development

Only a Kona boy who grew up on rainwater catchment from redwood tanks would so ardently conserve water resources. This is not to be interpreted to mean that Parker Ranch had been lax in water development. What Rally's water posture does speak to are his vivid memories of his grandfather W. H. Greenwell's cowboys having to ration the precious water supply by intermittent closing of valves so that the whole cow herd would have at least a minimum drink. The bellowing ʻōpaha (gaunt) cows with bawling calves at their side were commonplace in the high mountain ranges of Hualālai and Mauna Loa, where water catchments were sparse, requiring rationing during dry times and frequent extended droughts. Firmly fixed in his mind as a twenty-year-old cowboy on Parker Ranch, water remained Rally's theme as the first requirement of good animal husbandry.

Rally's three-pronged attack on Parker Ranch's water system brought more than ample cool water from the Kohala Mountains across the Waimea plateau, climbing to the 400,000-gallon water tank perched at the 7,000-foot Aipalaoa flat. Water then flowed east to cover the area from the Hanaipoe end of the ranch and west to service all of Waikiʻi and Keʻamūku. This plan revolutionized cattle distribution, increasing grazing efficiency by a wide margin. He capped off his water

Puʻuokumau Reservoir reflecting the twin hills Puʻukalāhikiola. It is also reflective of the high level of water, land, and animal stewardship of the Carter, Penhallow, and Greenwell eras of Parker Ranch management. Bill Case photo.

resource development by building dozens of reservoirs across the ranch, from Humuʻula to Pāʻaliʻi, creating more than 200 million gallons in storage.

Rally was a naturalist who viewed Mother Nature as our matron and believed her integrity should not be violated by overstocking or overgrazing—a code he lived by. He believed in having a back door or fallback plan that could come in the form of reserve paddocks and forest reserve permits for the breeding herd. For the yearling cattle, it could mean accelerated shipments to the feedlot to save grass on the home ranch. In the worst situations, the sale of yearlings via shipment to the mainland was a measure he was unafraid to take if it meant saving the core mother cow herd—the company factory. Retrospectively, in a 2002 interview with Anna Loomis, Walter Slater elaborated on the lesson he learned from Greenwell:

> When I first got here, it looked like there was just lots and lots of feed. Which there was. It was green. I learned one thing from Rally Greenwell. We were in a meeting one time, and he mentioned that you always want to have some grass

left over. Because you'll need it some day, because there'll be a drought, and these old cows can live on that old, dead, kikuyu just to have something in their belly. A little salt and water and this old, dead grass will keep them from dying.

As the Rubel and Lent team made its entrance, they convinced Richard Smart that a full cattle inventory was necessary; in their words, "the Ranch records lacked integrity." Rally's response was a soft smile and, with his very Greenwellian humor, a simple statement: "Be my guest." As history has shown, the ranch cattle records were impeccably kept, as confirmed by the imposed inventory.

Further affirmation of the integrity of the overall ranch management at the time came from Walter Slater, incoming livestock manager on the Rubel/Lent team, in the same 2001 Loomis interview at his induction into the Oʻahu Cattlemen's Association Paniolo Hall of Fame. When asked what he thought of the operation as the new team took over in 1971, Slater conceded that very little in the way of operational failure was evident. In his words, "It was in good condition. There's nothing ever been wrong with the Ranch. Probably it'd have been just about the same if it had been operated just like it was being operated. Of course, everybody that comes in wants to change something. Some of it was for the best, and some of it eventually turned right back to the way they were doing the Ranch operation before."

These comments from a credible source affirm the good condition in which Rally left Parker Ranch, positioning the new Rubel/Lent team to move the ranch to a new and even higher plane. It also provides insight into the naiveté of owner Richard Smart in accepting a critical consultative report at face value without an opportunity for rebuttal from proven management. This was not uncommon practice for Smart, who executed profound management changes on more than one occasion in the three decades since his return to the ranch and becoming involved in its management.

Rally chose vindication by fact, and the exacting inventory findings provided that. As Rally left the ranch of his own volition, he turned his efforts to supporting capital improvements on a family outfit, Palani Ranch, managed by his compadre, Johnnie Rapoza.

Over the thirty-five years since Rally left the ranch, I have been afforded meaningful counsel via late afternoon visits that occur on a biweekly basis at minimum. As a resource, I could find no finer. When asked to recall events, incidents, or people, he's quick to say, "I don't know" when that is the case; but when he comes forth with what he does know—dates, times, names (including those of horses), places—the data is factual and often accompanied by names of other witnesses.

When reflecting on his days at Parker Ranch, he is more inclined to recall the great men of the ranch, names that flow frequently through the texts of Parker Ranch history. Of the great stallions he speaks with pride; of the top horsemen, he speaks in reverent tones.

As he relaxes on his *lānai* with the panoramic view of Mauna Kea before him, he points out the *puʻu* (hills), *kualapa* (ridges), and *pahua* (flats), invoking their names in a soft litany, while sipping gently on his small jelly-glass cocktail of Ten High, a dash of warm water, and a teaspoon of sugar, while I

savor my O'Douls. He has been more than a resource and friend; he is a teacher who credits Mother Nature as the matron of our destiny. "Work with her, not against her—leave the land better than you found it," he says.

Rally Greenwell's love for 'Āina Paka is founded on unbridled affection for the land, the animals, and the families. Loyalty to the land is an emotion that he has epitomized in his actions, contributions, words, and thoughts over the last seventy years during which he has made Waimea his home. Aloha, Hipa Laho!

PŌLEHULEHU
The End of the Day

Parker Ranch, when viewed in the panorama of these two decades, underwent a final but less than subtle transformation from the Carter dynasty of the past half century to the tenuous grasp of the Parker scion, Richard Smart.

While he was grateful to the Carter men for providing stewardship of the estate, there were some indications that Richard Smart may have begrudged the fact that the outfit was becoming more of a Carter ranch than Parker. Not only did the Carters effectively gain and maintain control of the largest single nonroyal holding in the Territory of Hawai'i, they presumptively implied ownership. An example of this was A. W. Carter naming the ranch social hall in honor of his daughter Barbara. Once home, with swift action, Richard rechristened the building in honor of his mother, Thelma Kahilu'onāpua'api'ilani—hence the Kahilu Hall that houses present-day Parker School. In the final years of Hartwell's tenure, he bore the brunt of the indignation that may have clouded the real value of his diligence in keeping the outfit intact and growing. The days of unquestioned Carter authority had come to an end.

Richard Smart, upon his return, sought and achieved direct control over the destiny of his beloved Parker Ranch, a jewel in the crown of the Hawaiian Islands. He prescribed the manner in which the town of Kamuela and the greater community of Waimea would be developed. Despite his penchant for acting on a whim and his impulsive nature, he achieved progress through the minds and hearts of three managers—Carter, Penhallow, and Greenwell—before resorting to leadership by individuals from outside the state.

Carter, Penhallow, and Greenwell each in his own way sought to build a bigger and better ranch. In a magnanimous way, they did so by increasing the cow herd by 50 percent within a two-decade span while clinging dearly to uniformity and quality in cattle. Each had his peculiar taste for good horseflesh, and the ranch was better for it. They witnessed the demise of the sheep operation, bringing modern-day experts to question the impact of that decision on gorse infestation of epidemic proportions. The managers had reasons for the strong decisions they made and, in most cases, calls were made with the wholehearted support of the ranch owner.

Driven largely by the demands of packinghouse leadership for more and better cattle, all three men were aware that the marketing arm, Hawaii Meat Company, had become the profit center for the ranch owner, whose lifestyle demanded financial liquidity.

Conversely, Richard Smart poured back millions of dollars into the ranch and community, in addition to the packinghouse and feedlot operations—for the good of all.

There were certainly parallels between Smart and this series of managers—the last of the true *kamaʻāina* leaders who served for the two decades leading up to mainland management. All four men had great respect for the workingman and the families they sought to feed, clothe, nurture, and educate. Even Penhallow set aside his plantationesque posture in expressing how much the welfare of the workingman meant to him. While paternalism was becoming an ugly word in industrial circles, Smart, Carter, Penhallow, and Greenwell stood tall for the *makaʻāinana* (common man). Probably more than any other factor, this caring genre set the tone and further reinforced the image of Parker Ranch as a leader in personnel welfare.

As Richard Smart developed an increasingly sensitive ear to Leonard Bennett, who pulled the packinghouse out of the ashes and restored cash flow, his sense of direction for the ranch followed Bennett's lead. Acting on Bennett's suggestion of a mainland consultative study of the ranch operation, Smart was enthralled by the report and its architects, bypassing the packinghouse boss that brought him liquidity. This was a lost opportunity—the progressive work of Rubel and Lent notwithstanding. Given the opportunity, Bennett had the proven business acumen and potential for bringing all of Smart's holdings greater financial security and growth. Moreover, in Bennett, Smart had the unceasing loyalty and singular strength that the organization needed.

As Rubel and Lent assumed leadership of the ranch, significant departure from historic practices occurred in several avenues, and except for the infusion of the Mitchell Hereford line, they were good changes. The forthcoming third volume of *Loyal to the Land* that will cover the period from 1971 to 1992 will chronicle the changes over the next two decades that came with management's discovery of an untapped market: Canada. In homage to Richard Smart, the third volume will close in the year of his death—1992.

GLOSSARY

The everyday language of the *paniolo* was a form of spoken Hawaiian unique to them and to their work environment. They frequently substituted or shortened words to get a point across quickly. Words from other ethnic groups were commonly interspersed with Hawaiian because they were more descriptive and provided greater clarity. Theirs was a colloquial Hawaiian language that worked well in effectively communicating work orders, giving directions, describing locations and conditions of cattle and horses, and in alerting one another to potential danger. Because this book is about the *paniolo,* this glossary uses the colloquial Hawaiian language of the Hawaiian cowboy and also includes some of the terms borrowed from other languages that are used in the text.

Pukui and Elbert's *Hawaiian Dictionary* (1971) served as the primary resource for the Hawaiian diacritical markings—*kahakō* (macron) and *'okina* (glottal stop)—used in this book. When information was not available regarding correct placement of these macrons and glottal stops, they were not included to avoid changing the intended meaning.

'ahawa: water head, intake at beginning of a watercourse

ahiahi: evening

'āhiu pipi: wild, untamed, or feral cattle

ahupua'a: land division

'āina: land, earth

'Āina Paka: Parker lands

aloha 'āina: love or reverence for the land or one's country

aloha nō: greetings, farewell, alas

aloha 'oe: farewell to you

alu ka laina: slack the reins

'anae: mullet fish

'āuna: herd, large group

'awe'awe: braided rawhide rigging of the "Hawaiian tree" cowboy saddle

barriga: Portuguese term for beer belly or potbelly

caballero: Spanish term for a horseman

coup de grace: a deathblow or death shot administered to end the suffering of one mortally wounded

furo: Japanese hot bath

Hakuwela: Hawaiian name for Hartwell (Carter)

hale kope: coffee shack

Hale Mānā: Mānā House—the Parker home in Mānā

hānai: adopt, raise, feed

hana kipikua: pickax work

hana kokua: daywork at no wage

hana kolohe: make mischief or trouble

hao komo: ingrown horn

hapa haole: half Caucasian ancestry; usually refers to Hawaiian/Caucasian ethnicity

hapa laho: cryptorchid; undescended testicle

hapa laka: half broken (said of a horse not fully broken)

ha'uōwī: weedy verbena commonly known as Joe weed

hele kahakai: go to the beach

hemo: remove

hipa laho: male sheep, ram (Hipa Laho was a nickname for Rally Greenwell due to his woolly hair)

hō'au: to swim

hō'au pipi: process in which cattle were led by a cowboy on horseback from shore into the ocean and swum to a waiting boat called a lighter

holo haole: slow lope on horseback

holo kuku: trot on horseback

honohono: a grass common to wetter areas, called wandering Jew *(Paspalum dilatatum)*, of marginal nutritional value

ho'o kāpī: to sprinkle as salt, sugar, sand; to salt meat or fish

ho'oponopono: to correct, make right

inoa kapakapa: nickname

kāhili: to brush or fan gently

kahu kalawina: minister of Calvinist religion, Congregational Church minister

ka'imi: a kind of Spanish clover

Kalama'ula: same as Humu'ula, a place on the slopes of Mauna Kea; red jasper stone used in adzes; place name on Moloka'i

kama'āina: native born

kanaka makua: one that behaves and speaks as an adult; usually refers to a young person

kanaka pipi: homestead cattle

kānalua: doubtful

kani kāō: to call out when in difficulty

kapolena: tarpaulin

kauka: doctor (Kauka was often the term used to refer to the author)

kauka lio: horse doctor or veterinarian specializing in the horse; equine practitioner

kaula hele: a rope used to hobble the lower saddle stirrups to each other below the girth, giving the rider an advantage

kaula ho'ohei: lariat, roping rope, lasso

kaula 'ili: skin rope, rawhide lariat

kaula 'ōpū: front saddle cinch

kaula waha: bridle

kaula waha hao: bit or horse's mouthpiece, part of the bridle

kaula waha kekake: refers to a snaffle bit, "jackass bit," or "broken bit"

kīa'i: to guard cattle herds

kiawe: the algarroba *(Prosopis pallida)*, a large leguminous tree that makes excellent fence posts, firewood, and lumber, brought to Hawai'i in 1828

*from Peru; known as mesquite in the southwestern United States

kīkānia: the cocklebur weed *(Xanthium);* a type of spur rowel (wheel) with many fine needlelike points that resemble a cocklebur

kini'ai: lunch pail

kīpuka: canyon or land definition; clear oasislike opening among lava fields or forests; also the *honda* or loop of the lariat opened in preparation to rope

Kīpuka 'Āinahou: an oasislike clearing in the lava in 'Āinahou

koa haole: common roadside shrub *(Leucaena glauca)*

kokua: help, assist

kolohe: rascal, mischievous

kualapa: ridge

kūkaehoki: a rattlepod *(Crotalaria incana);* mule dung; also called *pī kakani*

kuleana: right, privilege, responsibility; estate, homestead, small piece of property

kūpe'e: to hogtie; also hobbling of a horse

lā'au lio: horse medicine

la brida: Spanish riding style in a straight-legged fashion

lahilahi: slim, lanky

laho'ole: a neutered male of any livestock species

laho pe'e: hidden testicle, cryptorchid

laina palaka: block line or reins

Lāpule: Sunday

lauhala: pandanus

lawe hānai: to adopt or raise a child as one's own

lei papale: hat lei, floral hatband

likelike: stilted gait

lina 'awe'awe: rigging strings

lio ahiahi: evening horse

los vaqueros: the Mexican cowboys

maka'āinana: commoner, people in general

makai: seaward, toward the sea

maka'u: fearful

mālama 'āina: take care of the land; preserve

māmane: native leguminous tree *(Sophora chrysophylla)* that grows high on Mauna Kea and Mauna Loa, excellent for fence posts, firewood, and as a building material

Mānā: site of Hale Mānā, the Parker ancestral home

mānienie: Bermuda grass *(Cynodon dactylon),* found in lawns and pastures at lower elevations

ma'ū: cool, as in weather; damp, moist

mauka: toward the mountains; upslope, inland

mauka 'ahawa: water head in the highlands of Parker Ranch

minamina: to regret, be sorry; to grieve for something lost; sorrow

minuke'ole: less than a minute

mō'ī: king, sovereign, ruler, queen

montura: saddle gear

nakeke ka'ili: crackling skin

nāki'i: to tie a lariat end, as knotted to a saddle pommel

namunamu: to grumble or complain

nānā'āina: to watch over the land

nēnē: Hawaiian goose

neneleau: native Hawaiian sumach

ohi: young female, maiden

'ōlelo kanaka: to speak the Hawaiian language

'ono: delicious, tasty

o'oe ka hewa: it is your problem; your fault or mistake

'ōpaha: gaunt in appearance

'opihi: limpet; favorite Hawaiian delicacy served at gatherings

oi, 'owī, or *ha'uōwī:* Joe weed, a weedy pest of rangeland that is also used for cuts and bruises

pa'a: tied snug or tight

pa'akai grass: spiny amaranth

pā'eke: corral, livestock enclosure, small pen

pahiolo: saw

pāhu'a: flat or clear area in the fields

palaka: block; also refers to block and tackle effect of reins

palaka laina: block lines; rope reins threaded through snaffle bit rings and tied back to the rigging rings on both sides

pale huelo: rear saddle covering, rump covering; vestige of the *vaquero anquera* or *conquistador anquitera*

pani maka: blinders, used to cover eyes of fractious horses when saddling, mounting, or dismounting

pānini: cactus fruit, prickly pear *(Opuntia megacantha)*

paniolo: cowboy

pau hana: end of work, usually the end of the workday

pēheuheu: sideburns

piko: umbilicus, point, end point, poll; end of a rope, point

pipi 'āhiu: wild cattle

pipinola: squashlike vegetable that grows on vines

pohā: sinkhole

pohe: marsh pennywort *(Hydrocotyle verticillata),* cheese weed

poi: Hawaiian staff of life made from pounded, cooked taro corms mixed with water into a paste-like substance

pono'ī: one's own; as in employee-owned horse

pūnuku: horse halter, hackamore *(jáquima),* noseband of a bridle *(bosal)*

pu'u: hill, peak, or mound

Pu'upā: hill, Waiki'i section, Kohala, Hawai'i

Pu'uhīna'i: cinder cone, Puakō section, Hawai'i

sayonara: Japanese term for good-bye, farewell

tatou: Samoan for tattoo; Hawaiian *kākau*

tutuman: grandfather

uhiwai: fog, heavy mist

ukana: baggage, luggage, gear, supplies

uluhua: weary, discouraged, displeased

'umi'umi: beard, mustache, whiskers

'upena kiloi: throw a net as in fishing

vaquero: Mexican cowboy

wāwae: leg; trousers

Wililaiki (Wilelaika): Willie Rice

wali: mix till smooth

REFERENCES

Bergin, Brady James. "The Birth of Hawai'i's Cattle Industry." History term paper, Hawai'i Preparatory Academy, Kamuela, Hawai'i, November 10, 1995.

Brennan, Joseph L. *Paniolo.* Honolulu: Kupa'a Publishing, 1978.

———. *The Parker Ranch of Hawaii: The Saga of a Ranch and a Dynasty.* New York: John Day Company, 1974.

Brundage, Lucille. *Alfred W. Carter: Hawaii's Dean of Cattlemen and Notes on Hawaiian Livestock.* Hong Kong: Cathay Press, 1971.

Carter, A. H. Taped interview by Clemson Lam. Kamuela, Hawai'i, 1983.

Carter, A. W. Personal correspondence, 1900–1949.

Clayton, L., J. Hoye, and J. Underwood. *Vaqueros, Cowboys and Buckaroos.* Austin: University of Texas Press, 2001.

Doyle, Emma L. *A. W. Carter: The Story of Alfred Wellington Carter, 1867–1949.* Compiled from original sources by Emma Lyons Doyle. Privately printed (Honolulu Star-Bulletin), 1951.

Greenwell, James M. *One to Eighty-One: My Personal Story.* Hilo, HI: Petroglyph Press, 2000.

Greenwell, L. Radcliffe. Personal interviews by the author, 1996–2002.

Hawaii Meat Company. Minutes. October 18, 1963; April 28, 1966; October 12, 1966; November 16, 1966.

Hawaii Meat Company. Report. October 22, 1963.

Honolulu Advertiser. July 15, 1962; December 8, 1968; May 28, 1968.

Honolulu Star-Bulletin. May 27, 1962.

Hosaka, Edward Y. *Noxious Weeds of Hawaii.* Honolulu: Board of Commissioners of Agriculture and Forestry in cooperation with the University of Hawaii Agricultural Experiment Station, 1945.

Jordan, Terry G. *North American Cattle Ranching Frontiers: Origins, Diffusions and Differentiation.* Albuquerque: University of New Mexico Press, 1993.

McLaury, Buster. *The Texas Cowboys: Cowboys of the Lone Star State—A Photographic Portrayal.* Ketchum, ID: Stoecklein Publishing, 1997.

Motooka, Phillip. *Weeds of Hawaii's Pastures and Natural Areas.* Honolulu: College of Tropical Agriculture, 2003.

Paka Paniolo. (Parker Ranch newsletter.) Various dates as noted in text.

Paniolo Hall of Fame. Oral History Interviews, 1999–2002.

Parker Ranch Handbook. Privately printed (Parker Ranch), 1961.

Pukui, Mary Kawena, and Samuel Elbert. *Hawaiian Dictionary.* Honolulu: University of Hawai'i Press, 1971.

Pukui, Mary Kawena, Samuel Elbert, and Esther T. Mookini. *Place Names of Hawaii.* Honolulu: University of Hawai'i Press, 1974.

Slatta, Richard W. *Comparing Cowboys and Frontiers.* Norman, OK: University of Oklahoma Press, 1997.

Theo H. Davies News Today. July–August 1964.

Whitney, L. D., E. Y. Hosaka, and J. C. Ripperton. *Grasses of the Hawaiian Ranges.* Honolulu: Hawaii Agricultural Experiment Station Bulletin 82, 1939.

INDEX

agronomists: Baybrook, Harold, 5, 80, 83, 86, 116, 118, 127, 129, 137; Christiansen, Charley, 81, 269; Garcia, Clarence, 114; Hosaka, Edwin, 111, 113–114; Kimura, Hisa, 269

Ah Sam, Henry Ah Fong, 3, 86, 137, 218–219, 221–224

Ah Sam, Henry Ke'ehikapa, 42, 283

Akau, Abraham (Manny), 16, 20–21, 24–28

Akau, Alex (Ahileka), 21, 224

Akau, Rita Puhi, 24

Akau, Theodore (Akeni, Sonny), 20–22, 30, 34, 39, 86

Akau, Theodore Akeni, Sr., 21

Akau, William Paul Mahinauli, 21, 152

Akuna, Louis (Louie), 16, 160, 250–256

Alameida, John, 50

Alapa'i, 21

American Quarter Horse Association (AQHA), 9, 14, 43, 160

animal air transport, 276

Animal Air Transportation Association, 45

Animal Health: Program, 3, 281; Report, 215

Anthony, Barbara Cox, 279

Armitage, James, 107, 135

artificial insemination, introduction of, 111

attorneys: Carter, A. W., x–xi; Garner, Anthony, 97, 263; Quinn, William E., 97, as Governor, 69; Reinwald, Arthur B., 3, 237, 262–263

beef, brands of: Hawaiian Warrior, 183; Kahuā Ono, 184; Maile, 184; marketing of, 179

Bell, George Thomas William Kamukamu, 140

Bell, Kepā, 139

Bell, Theodore (Teddy), 40, 112, 140–143, 159–160, 164, 216

Bennett, Leonard, 2–3, 185, 187, 238–242, 262–266, 277, 294, 300

Bergin, Dr. William N. (Bill; author's father), 208, 280, 282–283

blacksmithing, 73, 75–76, 140, 231

Boise Cascade Corporation, 274–275

Boteilho, Kacy, 30

Bowles, Stephen P., 138–139

Brand, Norman, 138–139, 193, 206, 211, 215, 235, 269, 272

branding, 19–20, 76; photos of, **174**

Breaking Pen, 16–17, 26, 29–30, 33–34, 38, 42, 83, 101, 140, 242, 254

breeds, cattle: Angus, 5–6, 45, 85, 89, 108, 173, 178, 200, 268, 285; Hereford, 4–7, 11, 67, 84, 88–89, 108, 173, 200, 259, 285; longhorn, 6; Santa Gertrudis, 7, 89, 173, 178, 259, 262; Shorthorn, 85, 89–90

breeds, horse: Arabian, 143; Morgan, 3–4, 11, 14, 86, 139, 143, 164; Palomino, 11, 14–15, 139; Percherons, 15; Quarter Horse, 3, 11, 14, 40, 44, 139, 143, 159, 164, 167; Standardbred, 14, 139, 164; Thoroughbred, 3–4, 8, 13–15, 34, 40, 112, 136, 139, 143, 161, 163–165, 167, 254

breeds, sheep: Merino, 137, 167; Suffolk, 137, 167; Targhee, 167

Brighter, James Kaleima'ema'e (Palaika), 30, 72–73, 105, 218

Brighter, William (Willie Palaika), 20

Brown, Morgan (Buster), 25

Brown, Morgan (Buster's son), 184

Bureau of Agriculture and Forestry (BAF), 127

Camp Tarawa, 45–52, 123, 154–158, 167

Carter, A. Hartwell: departure, 101–102, 206; Hawaiian Home Commission, 97; personnel, 136–137, 184, 208, 228, 252, 276, 292; water, 113

Carter, A. W.: cattle, 5, 70; death of, 86; grassland development, 116, 119, 121; Hawaii Meat Company, 180–181, 186–187; horses, 10; Kawaihae Harbor rebuilding, 55; stewardship, x–xi, 1, 4, 97, 186, 196, 294, 299; weed control, 127

Carter, Becky (Mrs. A. H. Carter), 88, 90, 92

Case, William N. (Bill), 75–76

Case Memorial Veterinary Hospital, 76, 94

cattle: crossbreeding, 5–6; grading, 265; horned vs. polled, 6, 16; superherding regime, 118–119, 122; swimming (*hōʻau pipi*), 6, 15, 31, 60, 182, 229; wild, x, 6, 141, 145, 249–250, 255

C. Brewer: Hawaiian Agricultural Company, 15, 180; Hawaiian Ranch Company, 191. *See also* ranches, Kaʻaluʻalu, and Kapāpala

Civilian Conservation Corps Camp (Puʻukapu), 46

Colorado State University, 78

conservation: medicine, 282–283; soil, 94; wildlife, 99

Cornell University (New York State Veterinary College), 69, 76

Correia, Daniel, 63

Cowboy Gang, 16–17, 29–32, 34, 83, 86–87, 107, 142, 161, 176, 208, 210, 219–220, 224, 253

cow/calf operation, 110–111, 250, 256–257, 262

cow horse, standard of, 14, 143

dairies: Palihoʻoukapapa (Old Dairy), 83; Puʻukapu (Mānā Road), 198; Puʻukīkoni Dairy, 225

Daughtry, James, 236–237, 263–264

Davies, Theo H. and Company, Ltd., 266

Department of Hawaiian Home Lands, 46, 99

DeSilva, Donald G. (Donnie), 16, 164, 252–253

diseases (animal): anthrax, 70; bastard strangles, 72; big head disease (osteomalacia), 117; blackleg, 70–71, 79; brucellosis (Bang's disease), 70, 72, 79; cancer eye, 7; cerebromeningitis, 70; cholera, 70; copper deficiency (yellow calf disease), 3, 79, 283–287; enterotoxemia (botulism), 272; frothy bloat, 122; glanders, 70; infertility, 7; lameness, 7; pneumonia, 291; shipping fever, 290; tuberculosis, 69–70, 73–74, 79

Dochin, Yaroko, 107, 167

Doi, T., 29

Dowsett, James Alexander, 85, 132

Dowsett, James I., 85

Eby, William, 45

farrier, 41, 176

feedlots: Barbers Point, 234, 236, 262, 264–265, 269, 271, 277, 281, 289, 290; emergence of, 7; Holoholokū, 269; Paʻauilo, 277; Puakō, 194, 196–197; Puʻuloa, 236; Waialua, 277

foundation families, xi

442nd Regimental Combat Team, 77

freight, hauling of, 75

French, William, 55

Fujii, Goichi, 43, 132

Fujitani, Shiro, 90–92

Gallagher, Joan (Mrs. Bill Verdugo), 44

Gomes, Willy, 85

Gouveia, Freddy, 41

grasses: bermuda (*mānienie*), 119, 183; brome, 120; buffelgrass, 116–117; fountain (pampas), 86, 116, 123, 126; green panic, 117, 121; guinea, 113, 117, 121; kikuyu grass, 81, 113, 116–117, 122; natal redtop, 119; orchard grass (cocksfoot), 120, 123; pangola, 81; para, 118; rattail, 116; Rhodes, 118; rye grass, 119–120; star, 119; sweet vernal, 119, 121; wild oats, 120; Yorkshire fog, 121

grass-fat marketing, 120, 176, 178; feedlot finishing, switch to, 186, 256–258

Greenwell, James M. (Jimmy), 2–3, 182, 184–187, 190–193, 206

Greenwell, Norman, 107

Greenwell, Rally: assistant to Penhallow, 135; and grass, 119; at Kahua Ranch, 184, 293; management era, 3, 187; personnel, 17, 23, 40, 45, 75, 114, 137, 163, 175; succeeds Penhallow, 2; weed control, 132

Hanaipoe, 20, 36–37, 40, 65–66, 68, 83, 97–98

Hanson, Don, 45, 179, 187, 217

Harada, Tetsuji (Dempsey), 226–227, 249

Hawaiian Beef Cattle Tours, 233–235

Hawaiian Home Lands Riding Club, 142
Hawaiian Homes Commission (HHC), 4, 66, 68, 97, 99, 109, 112, 248
Hawaiian Milling Corporation (MillCorp), 262, 265–266, 277
Hawaiian tree saddle, 151–152, 160
Hawaii Beef Packers, Inc., 184
Hawaii Cattlemen's Association, 45, 88, 94, 192, 269; rainmaking committee, 94
Hawaii Cattlemen's Council, 233–234
Hawaii Meat Company (HMCo), 2–3, 41, 111, 175, 187–193, 235–238, 241, 262–267, 299
Hawaii Meat Producers Cooperative, 188–193
Hawaii Saddle Club, 30, 86–87, 159
Hawaii Veterinary Medical Association, 79
Hawi Meat Market, 182
Hilo Harbor, 56–57
Hilo Market Company, Ltd., 180
Hilo Meat Company, 180, 188
Hilo Paniolo Club, 159
Hind, Robert Leighton, I (Leighton), 82–83
Hind, Robert Leighton, II (Bobby), 82, 88
Hind, Robert Leighton, III (Robbie), 45, 187
Homestead Farm, 88, 92
Ho'okahi, Beatrice (Mrs. Manuel Nobriga), 41–43
Ho'okahi, Larry, 43, 160
ho'oponopono (to make right), 22, 274
Horie, Yama, 229
horse gear: blinders (pani maka), 34, 38, 144–145; lariat, 31; rope halter (kaula pūnuku), 31; skin rope (kaula 'ili), 31–32, 37, 145, 151, 231; spurs, 37; stirrup hobbles (kaula hele), 38
horses, geldings: Bearcat, 35; Paniolo Country, 35
horses, race: Billy Boy, 27; Lightning, 27
horses, stallions: Bel Canto, 165–166; Coconut Island, 145; Diablo, 14–15; Eastertide, 13; Frolic, 10, 13; Gold Oak, 13–15; Hauli, 165–166, 216; Heine, 14, 19, 23, 31; Herodiones, 14; Lindsley, 19, 23; Lucky Tom, Jr., 145; Maunalani, 10; Nearco, 166; Ormesby, 10, 165; Peppy Dee Dee, 143, 287, 289; Querido, 10, 86; Rodgers, 10; Sappho, 11, 14
Hosaka, Edward Y., 111, 113, 114, 116, 126
Hui, Joseph Kekahuna (Joe), 20–22, 28–30, 34, 160, 275
Humu'ula Sheep Station, 10, 28, 37, 40, 66, 98, 108, 126, 137, 163, 167, 219, 251–252; conversion to cattle, 248
Hussey, Mabel K. (Mrs. Leonard N. Case), 70, 74

Ignacio, Big Joe, 82
'Imiola Church, 46, 81, 112
Imperial Palace Riding Club of Tokyo, 161
Inter-Island Steam Navigation Company, 181
Iokepa, Russell, 50
Ishihara, Isami and Matsuyo, 92
Ishii, Iwataro, 83
Ishizu, Herbert (Masato), 218, 229–233
Ishizu Gulch, 230

Island Commodities, Inc. (ILCO), 266

Janss Investment Corporation (JIC), 235–237, 262, 265–267
Jastrom, Bob, 176
Johnson, Bob, 267–269, 280, 290–291
Johnston, Edwin (Bull), 81–86, 175

Ka'au'a, Archibald Cleghorn, 85, 98, 152–153
Ka'au'a, Archibald Spencer, 98–99
Ka'au'a, Edward Stanley (Blue), 57
Kahuā Meat Company, Ltd., 185–187, 263–264, 266, 281
Kainoa, Johnnie, 97
Kaleikula, Isaac (Aikake), 21–22
Kamehameha III, 145, 150–151
Kamuela Meat Market Company, 107, 167
Kamuela Young Farmers Association, 233
kanaka makua (men of leadership), 218
Kaniho, Daniel, 26, 142
Kaniho, Jane (Mrs. Alex Penovaroff Jr.), 162
Kaniho, Willie, 3, 28–29, 31, 40, 105, 113, 137–138, 142, 163, 209, 218, 220, 224, 250–252
Kaula, David, Jr. (Bud), 20–22, 30, 33–36
Kauwe, David (Hogan), 219
Kauwe, John Keaniani, 161
Kawai, Carol Iwalani, 29
Kawai, Harry, 3, 16–17, 30, 97, 105, 139, 211, 218, 220, 226, 259, 292
Kawaihae Elevator, Inc., 195, 266
Kawaihae Harbor, 47, 54–63, 196
Kawamoto, Johnnie (Masato), 3, 81, 108, 218, 268

Kawamoto, Masa, 108, 159–160
Kawamoto, Yoshi, 108, 159
Keʻakealani, Robert, Sr., 82
Keʻakealani, Sonny, 33
Keʻāmuku (Keamoku) Division, 35, 54
Keʻāmuku Section, 50, 141, 208
Keanuʻiʻomanō Stream, 112
Keawe, Mary Mililanionapuahekila, 21
Kimura, Charlie, 45, 83, 92, 135, 137, 163, 175–177, 187, 254–255, 259, 295
Kimura, Hisao (Hisa), 43, 116, 131
Kimura, Yutaka, 3, 5, 90, 105, 137, 141, 163, 175, 206, 218, 220, 259
King David Kalākaua, 35
Kohala Meat Market, 182
Kohala Section, 6
Kurokawa, James (Jimmy), 107, 218, 224–229

Lālāmilo, 2, 4, 51, 53–54, 272
land, sales of, 121, 272–275
legumes: big trefoil, 118, 122; clover, 121–123; greenleaf desmodium, 118, 122; *koa haole*, 117, 121
Lekelesa, John (Samoa), 3, 34, 42, 83, 86, 211, 218–221, 224
Lent, Gordon, 45, 187, 215, 275. *See also* Rubel/Lent
Lincoln, Bob, 75, 107
Lindsey, Albert Uiha, 16, 30
Lindsey, Allen Hartwell (Uku), 160
Lindsey, Anna (Mrs. Lyman Perry-Fiske), 99–100
Lindsey, Betsy Kaipukai (Mrs. John Pieper), 141
Lindsey, Charles Notley I, 132
Lindsey, Edwin Keao, 50

Lindsey, George Kynaston, 29
Lindsey, George M., 279
Lindsey, John Kawananakoa (Keoni Liilii, Keoni Poko), 105, 152–153, 218, 220
Lindsey, John Kuakini, 105
Lindsey, Theodore, 50
Lindsey, Thomas Weston, 162
Lindsey, William M. S., Sheriff, 99
lio ahiahi (evening horse), 21, 32, 34, 107, 221
Loomis, Anna, 16, 63
L'Orange, Peter, 83, 108, 135–138, 167, 172, 249, 252
Louzada, Spencer and Company, 55
Low, Eben, 153
Low, John S. (Jack), 152–153

MacFarlane Sheep Ranch (Keʻāmuku), 131, 208
Ma-e, John Holi, 61, 67–69, 72, 99, 101, 250–251, 279, 282
Maertens, Fred (Nepia), 38
Mainaʻaupō, Kalikowehiwehi Percy, 21, 28
Main Ranch, 109–110
Makahālau Section, 6, 66, 68, 83–84, 88, 112, 163, 175
Marks, A. Lester, 63, 65
Matsu, Piʻilani (Mrs. Teddy Bell), 141–142
Mauna Kea Beach Hotel, 198
Mauna Kea Soil and Water Conservation District, 2, 94
McAulton, Abraham Kaulaku, 275
Merseberg, James (Dictionary), 139–140
Metropolitan Meat Company, 180
Mitsunami, Gene, 50
Morifuji, Saichi, 20, 36, 40, 83–84, 163

Motooka, Dr. Philip, 126
mules, 135

Nakano, Ernest and Hatsu, 214
Nakata, Tadao, 163
nāʻnāʻāina, 122
Napier, Alexander, 183–184, 264
nēnē, 99
New York State Veterinary College. *See* Cornell University
Nishie, Isami, 249
Nobriga, Joe, 40, 41
Nobriga, Manuel, 20, 40–43
Nobriga, Senator William J., 63

Oʻahu Cattlemen's Association, 28, 297
Oʻahu Railway and Land Company, 182
Okimoto, Tsueno (Mrs. Saichi Morifuji), 37
Onomea Sugar Company, 93
ʻŌpae Gang, 123, 175
ordnance, clearing of, 50–51
Osorio, A. M., 63

Pāʻauhau, 66, 68
Pāʻauhau Sugar Plantation, ix
Pacheco, Joe, 16, 30, 40, 65, 87, 90, 92, 132, 137
Pacific Airlift, Inc., 45, 277
paddocks, 39, 47, 111–112, 200
Pai, Daniel, 86
Paka Paniolo, 93, 143, 199, 216
Paka Paniolo Horsemen's Association (PPHA), 159–160
Pālama Meat Company, 183, 235, 263
palehuelo (rear saddle covering), 22
Palomino Horse Association, 14
Paniolo Hall of Fame, 28
Parker, Annie Thelma K.

(Thelma Smart, Mrs. Henry Gaillard Smart), x, xi, 180, 299
Parker, Ebenezer, ix
Parker, Elizabeth Dowsett (Aunt Tootsie, Mrs. Knight), x, 85
Parker, John Palmer, I, ix–x, 55, 275
Parker, John Palmer, II, ix–x
Parker, John Palmer, III, x
Parker, Rachel Keliʻikipikanekaholoaka (Kipikane), 275
Parker, Samuel, Sr., ix, 10, 274
Parker School, 201–202, 205
Payton, W. E., 192–196
Penhallow, Richard (Dick): cattle, 257, 266; goals, 2; land, 65, 228; legacy, 201; "opening gates," 233; personnel, 40, 45, 67, 75, 226, 252, 275–276, 292; succeeds Hartwell, 88; vision, 102–103
Penovaroff, Alex, 135, 162–166, 252, 254, 280, 287, 289
Perreira, Joseph (Mickey), 20, 37–38, 42, 84
plants, medicinal, 73, 133
Pōhakuloa Training Area, 2, 4, 50–52, 54, 58, 208
Prisoner-of-War camp, 53
Pukalani Stables, 72, 89, 101, 140, 279
Purdy, George, 16, 21–23, 25–26, 29–30, 33, 38, 42, 90, 92, 140, 160
Purdy, Ikua, 152–153

Quintal, Adam, 20, 30–33
Quintal, Jordan (Red), 20, 30–31

ranches: Anna, 243; Chow, 85; FR Quarter Horse, 89; Hāna, 74, 267, 283; Honouliuli, 182, 185, 187; Hualālai, 85, 89, 279, 283; Huʻehuʻe, 84–85, 123; Kaʻaluʻalu, 94; Kahuā, 46, 81, 84–85, 94, 97, 111, 181, 183–184, 208, 277, 283; Kahuku, 6, 70, 132, 159, 208, 234; Kapāpala, 10, 15, 94, 180; Kealakekua, 208; Keauhou, 28, 98, 132; Kualoa, 28; Kūkaʻiau, 67–68, 72, 82, 93, 97, 101, 140, 152, 202, 234, 251, 266, 283; Molokaʻi, 11, 161, 185, 191; Palani, 41, 119, 206, 208, 297; Puakea, 187, 268; Puʻuʻōʻō, 15, 28, 99, 109, 141, 162, 172, 249; Puʻuwaʻawaʻa, 81–82, 84, 86–87, 123; Seamountain, 176, 254; Shipman (Puaʻ Ākala), 37
Remount Stallion Program, 9–10, 14, 15, 17, 23, 43; military standards, 11
Rice, Freddy and Sally, 89
Richards, Atherton, 181, 183, 186
Richards, Monty, 183–184
Rockefeller, Laurence, 198–199, 272
Roughrider Gang, 16–20, 27–29, 34, 43, 144–145, 161, 242
Rubel/Lent, 3, 36, 88, 105, 167, 175, 210, 254, 283, 291–294, 297, 300
Rycroft, Walter, 87, 132

saddle makers: Kama, Peter, 183–184; Kauwe, John, 161
Sakado, Bob, 42, 86, 90, 92, 221
Sanborn, Percy, 85, 183–184
sections of ranch, map of, **110**
Serrao, Frank G., 63–65
sheep: estrus synchronization in, 172; final shearing, 249; shearing tables, 108; wool clip, 167
Shipman, W. H., Ltd., 99, 282
shrubs: cocklebur (kīkānia), 134; fireweed, 81, 122, 127; lantana, 113, 129–130; ōwī (verbena), 126–127, 133
Slater, Walter, 3, 45, 63, 179, 187, 215, 217, 296–297
Small Ranchers Association, 63–65
Smart, Annie Thelma K. Parker (Mrs. Henry Gaillard Smart). See Parker, Annie Thelma K.
Smart, Anthony (Tony; Richard Smart's son), 165, 228
Smart, Gaillard (Richard Smart's son), 217
Smart, Henry Gaillard (Richard Smart's father), xi
Smart, Richard Palmer Kaleioku, xi; architecture, 227–228; control of ranch, 1, 210, 299–300; Greenwell, Rally, 206, 294; Hawaiian Homes Commission, 68, 97; Hawaii Meat Company, 193, 237, 264, 277; horses, 17, 161, 165; lawsuits against, 275; military, 51, 54; Penhallow, Richard, 101–102, 186, 195, 202; personnel, 2–3, 85–86, 215–218, 229, 263, 272, 275, 276, 280
Sorenson, O. L. (Ollie), 103
stations: Humuʻula, 17, 25; Kohala, 17, Makahālau, 32; Paʻauhau, 17, 43; Waiemi, 112; Waikiʻi, 17, 25
statistics of Parker Ranch: when A. W. C. took over, x; when Rally Greenwell took over, 209
Stevens, Charles (Kale), 32, 34, 139, 141
Stevens, Walter (Wala), 39, 86

taxes, 94
Tongg, Rudy, 187

unionization, threat of, 275–276
Union Market, 181
United Meat Company, 184
University of Hawai'i, 89, 93, 111, 113, 126; College of Tropical Agriculture, 283–287

Vancouver, Capt. George: sheep and cattle import, 54
vaqueros, 44–45, 145, 150–151
Varsity Victory Volunteers (Triple Vs), 77–78
Verdugo, William (Bill), 43–45, 88, 276
veterinarians: Adams, O. R., 78; Bergin, Billy (Kauka), 2–3, 215, 217, 277–291; Case, Leonard N. (Kauka), 3–4, 69–77, 279, 283, 291; Kaufman, Alan, 89; Linfoot, Billy, 143–144, 160, 287; McCoy, Kid, 279; McKinney, Lynn, 289–290; Nagao, Wallace T., 3, 73, 76–79, 89, 110, 137, 211, 272, 279–281, 283, 285, 291; Weight, Leslie, 70–72
Vierra, Frank, 83
Vierra, Tony, 136

Voluntary Separation Program (VSP), 107
von Holt, Pono, 277
von Holt, Ronald, 85, 94, 181
Vredenburg, Theodore, 84, 105

Waiau, Chucky, 160
Waiemi: stables, 112; Station, 47
Waiki'i Section, 141–142
Waikoloa Maneuver Area, 51
water: A. W. Carter era, 243; department, 76; development, 3, 112–113, 138–139, 201, 295–296; Drought of 1962, 242–243, 246; flood control plan, 94; Greenwell's plan, 243–246; Hawai'i Island County Water Supply, 68, 100; in Ka'u, 177; supply extended to HHC ranch lots, 68, 100; system map, **247**; Waimea District municipal resources, 49
weeds: *a'ali'i*, 131; berries, 132, 137; cactus (prickly pear, *panini*), 81, 86, 113, 126; castor bean, 132; control of, 81, 86, 107, 113, 122–123, 128–129, 250; emex, 113–114, 128–129; fireweed, 81, 122, 127; fountain grass, 123–126; gorse, 81, 127; guava, 131; *kīkānia* (cocklebur), 134; *kūkaehoki* (rattlebean), 135; lantana, 113, 129–130; *pa'akai* (spiny amaranth, pigweed), 134; *pohe* (cheeseweed), 134
Welhener, Herbert E., 235–238, 262
Whitman, James (Jim), 3, 228, 276, 287, 291
Williams, Roger, 67, 93, 101–102
Wong, Annie Ung Kau (Louie Akuna's mother), 251
Wright, Stanley, 84

Yamaguchi, Ichiro, 217
Yamaguchi, Jiro, 159
Yamaguchi, Mark, 217
Yamaguchi, Matsu (Mack), 217
Yano, Sanshiro, 87
Yoshimatsu, Kiyome, 211, 213–218
Yoshimatsu, Masao, 213–214
Young Brothers, 63, 75

About the Author

DR. BILLY BERGIN was born and raised on the Big Island of Hawai'i. He attended Kansas State University, receiving his Doctor of Veterinary Medicine degree in 1967. Dr. Bergin established the first private large animal veterinary practice on the Big Island in 1968 and served as the chief veterinarian of the Parker Ranch from 1970 to 1995. From 1971 to present, he has been appointed the Veterinary Medical Officer with the Livestock and Disease Control Division, State of Hawai'i Department of Agriculture. He also maintains an active private veterinary practice in west Hawai'i. Dr. Bergin belongs to numerous professional and community organizations. He served a four-year appointment as a member of the University of Hawai'i Board of Regents. In 1999 he organized the Paniolo Preservation Society, a nonprofit organization dedicated to the heritage of the Hawaiian cowboy. Dr. Bergin and his wife, Patricia Cockett Bergin, live in Kamuela on the Big Island, in the shadow of Mauna Kea.

HAWAII Production Notes for Bergin / LOYAL TO THE LAND
Mediaeval, with display type in Davison Americana
Composition by Copperline Book Services, Inc.
Printing and binding by Thomson-Shore, Inc.
Printed on 60# Finch White Offset, 500 ppi